Art and Labour

Historical Materialism Book Series

The Historical Materialism Book Series is a major publishing initiative of the radical left. The capitalist crisis of the twenty-first century has been met by a resurgence of interest in critical Marxist theory. At the same time, the publishing institutions committed to Marxism have contracted markedly since the high point of the 1970s. The Historical Materialism Book Series is dedicated to addressing this situation by making available important works of Marxist theory. The aim of the series is to publish important theoretical contributions as the basis for vigorous intellectual debate and exchange on the left.

The peer-reviewed series publishes original monographs, translated texts, and reprints of classics across the bounds of academic disciplinary agendas and across the divisions of the left. The series is particularly concerned to encourage the internationalization of Marxist debate and aims to translate significant studies from beyond the English-speaking world.

For a full list of titles in the Historical Materialism Book Series
available in paperback from Haymarket Books, visit:
https://www.haymarketbooks.org/series_collections/1-historical-
materialism

Art and Labour

*On the Hostility to Handicraft, Aesthetic
Labour and the Politics of Work in Art*

Dave Beech

Haymarket Books
Chicago, IL

First published in 2020 by Brill Academic Publishers, The Netherlands
© 2020 Koninklijke Brill NV, Leiden, The Netherlands

Published in paperback in 2021 by
Haymarket Books
P.O. Box 180165
Chicago, IL 60618
773-583-7884
www.haymarketbooks.org

ISBN: 978-1-64259-423-2

Distributed to the trade in the US through Consortium Book Sales and
Distribution (www.cbsd.com) and internationally through Ingram
Publisher Services International (www.ingramcontent.com).

This book was published with the generous support of Lannan
Foundation and Wallace Action Fund.

Special discounts are available for bulk purchases by organizations and
institutions. Please call 773-583-7884 or email info@haymarketbooks.org
for more information.

Cover design David Mabb. Cover art Dave Beech from *(Untitled) part of
the "Thyssenkrupp Allee 1, 45143 Essen" series*, montage 210mm x 297mm,
print size varies (2021).

Printed in the United States.

10 9 8 7 6 5 4 3 2 1

Library of Congress Cataloging-in-Publication data is available.

Dedicated to the memory of
Neil Davidson 1957–2020

∴

Contents

Acknowledgements

The argument for this book has undergone considerable transformation more than once as I have tried it out in various public contexts and benefitted from the private (and sometimes anonymous) comments of a substantial community of critical thinkers.

My initial hypothesis about the relationship between art and labour was developed within a discussion with Mark Hutchinson, Kim Charnley and Ben Fitton which became the basis of a panel at the 2016 Historical Materialism conference and a special issue of *Art and the Public Sphere* (Vol. 5, No. 1). I had previously tried out some ideas for a new theory of art's relationship to revolution understood as a transformation of the social relations of labour in a paper I delivered in Dublin titled 'Public Art and the Jacobin Revolution' in 2014, which was later published under a modified title after receiving excellent editorial comments from Daniel Jewesbury.

An early draft of my thinking about the critique of the critique of alienated labour in Minimalism and Conceptualism against the defence of handicraft in Abstract Expressionism appeared in *Art Monthly* (July-August 2017, No. 408), as did my preliminary ideas about the art boycott as a withdrawal of labour. I gave the first presentation of my research on alienated labour at USB, Vancouver in 2017, at the invitation of Gareth James, and my tetchiness on that occasion in response to well-informed questions that challenged the underlying assumptions of my inquiry led me to do more historical research that I had not previously realised was necessary. I want to thank Jaleh Mansoor for revealing weaknesses in my argument. My investigation into the history of the hostility to handicraft in the Fine Arts and art in general were sharpened in dialogue with Esther Leslie and Alberto Toscano while preparing an essay titled 'Art and the Politics of Eliminating Handicraft' published in *Historical Materialism* journal in 2019 (Volume 27: Issue 1).

My review of the literature on non-alienated labour was significantly extended and improved by several prompts by Andrew Hemingway over email, for which I am deeply indebted.

I would like to thank Steve Edwards for commissioning the book *Art and Labour*, as well as my previous book, *Art and Value*, for the Historical Materialism Book Series and for his continued support of my inquiries over a number of years. Also, I am grateful to Simon Mussell, Hilde Kugel, Jennifer Obdam, Lydia Bax and Danny Hayward for their help in preparing the manuscript for publication.

I am keen to thank Marina Vishmidt, Benjamin Fallon and Kirsteen McDonald for the exchange of ideas on matters relating to this book that we shared

while acting as co-editors of the Parse research 'arc' on art and work for the University of Gothenburg. I have also benefitted from exchanges with Sarah Brouillette, Jason Bowman, Andrea Phillips, Mick Wilson, Lisa LeFeuvre, Tom Cubbin, Josefine Wikström, Bruno Gullì, Kerstin Bergandahl, Liam Gillick, Dani Child, Andy Conio, Martha Rosler, Malcolm Quinn, Susan Kelly and Charles Esche.

Introduction

This book 're-narrativises'[1] the relationship between art, craft and industry by reconstructing certain episodes in the history of the transition from workshop to studio, apprentice to pupil, guild to gallery and artisan to artist. My aim, originally, was to answer the question posed by my book *Art and Value*[2], whether the artist belonged to a feudal mode of production that has survived in capitalism or whether the artist is a modern category of commodity producer for the market. What this inquiry reveals, instead, is that the history of the formation of art as distinct from handicraft, commerce and industry in the seventeenth, eighteenth and nineteenth century carved out a specific mode of production that is neither a remnant of pre-capitalist production nor an example of capitalist manufacture. This history is significant because the politics of labour in art today can be traced back to the passage from the dual system of guild and court to the modern condition of art's fragile autonomy within the constellation of the gallery, museum, university and art fair. This history needs to be revisited in order to rethink the categories of aesthetic labour, attractive labour, alienated labour, non-alienated labour and unwaged labour that shape the modern and contemporary politics of work in art.

I have written this book during a period in which the class politics of labour has been in decline and a micropolitics of work has established itself among the common sense of contemporary political discourse. In one sense, therefore, a book on art and labour is topical and yet my Marxist methodology and emphasis on class analysis will be read by many as dated convictions. For this reason, the purpose of the introduction is to flag up a number of pressing questions. Is art a colonial category? Has the politics of anti-work undermined the legitimacy of the politics of labour? Does the historical investigation into the passage from handicraft to art presuppose a linear view of history? Is the concept of labour the principal means by which the working class bound itself to the work ethic? What counts as labour after the expansion of the concept of work by second wave feminism?

This introduction attempts to situate the book within the present conjuncture in which class and labour have lost their erstwhile predominance in emancipatory struggles. My proposal is neither to *adapt* a class politics of labour to the methodologies of identity politics nor to affirm class politics *against* the politics of intersectionality. Instead, I will confront the historical condi-

1 I take the idea of 're-narrativisation' from Stuart Hall. See Hall 1996, p. 250.
2 Beech 2015.

tion which has set class politics against diverse emancipatory struggles and attempt to reset the Marxist politics of labour as vital to the urgencies of the contemporary political arena. My investigation inserts these questions into a new narrative of the formation of art as a category within disputes about labour in which they return as markers of division and difference within the category of work itself. Before addressing these questions directly, therefore, I want to say a few things about the contemporary politics of work.

The most conspicuous political discourses of labour in the years when I was researching and writing this book were, on the one hand, the anti-work movement, and on the other, the campaign against unpaid work in art. Part of the purpose of this book was to put these two conflicting political projects within a broader set of political discourses on labour that have a longer and more diverse history than contemporary debates imply. Among other things, I wanted to ask whether the demand for an artists' wage (and related issues) criticise capitalism or extend it. Likewise, I wanted to examine the politics of anti-work not only from the perspective of the affirmation of labour in the aesthetic critique of industrial production (and anti-art's negation of this) but also from the perspective of Marxist value theory. This latter sheds light on the kind of work that needs to be rejected for the abolition of value production and therefore the supersession of capital and capitalism.

The emergence of the micropolitics of work in art has taken place under conditions in which the politics of labour generally has been in crisis. It is the purpose of this book to re-examine the political category of labour through the lens of art and to re-examine the category of art through the lens of labour (i.e. as a specific social form of labour, rather than a set of objects i.e. works of art). Art and labour, I want to argue, are intertwined from the outset. Labour, as it is first formulated as an abstract category in the eighteenth century, is connected to the theory of aesthetic activity or play primarily through tropes of divergence. Nevertheless, art emerges as an abstract category on the basis of the intensification of attention paid to the special kind of activity that produces works of art which parallels the attention paid to the shared qualities of artworks produced within the various specific Fine Arts.

In the passage from the socialist politics of the aesthetic transformation of labour to the pragmatic micropolitics of work, debates on labour in the 1970s mark a turning point. Intimations of the refusal of work, which is simultaneously the rejection of the workers' movement, can be traced to the 1950s when Guy Debord wrote 'ne travaillez jamais' (never work) on a Paris wall, or back further still to the 1870s to the expression of this same idea by Rimbaud from whom Debord took the phrase. The Endnotes collective is correct to trace a bohemianism in this original scene of the refusal of work, although it is indic-

ative of an ignorance of the historical specificities of the politics of labour in art that this is immediately characterised as 'a romanticised vision of … déclassé artists and intellectuals who had become caught between traditional relations of patronage and the new cultural marketplace in which they were obliged to vend their wares'.[3] In my reconstruction of the historical formation of art as a specific social form of labour I hope to demonstrate that the hostility to work expressed by artists and intellectuals (and the reconciliation with work by those artists and thinkers who oppose them) is not the result of a flight of fancy but the recognition of the actual social basis of artistic production.

However, the refusal of work takes on its full significance in contemporary political theory when it is accompanied by the deliberate act of absconding from the workers' movement. While proponents of this theory emphasise the strategic and logical basis of the rejection of trade unionism, social democracy and the communist movement, I will insist that this needs to be explained historically. Alongside the multi-pronged neoliberal assault on the workers' movement, feminist and postcolonial struggles have displaced the worker as the pivotal agent of emancipatory struggle and extended the realm of work beyond the factory. During the same period, Marxism itself has been subject to a shower of both internal and external critiques – technological, political, philosophical and economic – that question the centrality of labour and the labour movement to the emancipation from capitalism. On the face of it, the class politics of labour appears to have a nostalgic attachment to an obsolete stage of industrial production and its distinctive forms of political resistance that privileged the interests of the organised working class.

A line can be drawn from Jean Baudrillard's accusation that Marxism presupposes and reproduces the system that it attempts to decipher and abolish,[4] and contemporary communisation theory which, as well as claiming that it is 'not obvious from the historical record that the workers' movement points in the direction of communism',[5] echoing the position of Moishe Postone,[6] argues that the abolition of capitalism cannot be brought about by 'the self-affirmation of one pole within the capital-labour relation'.[7] Within this post-'68

3 Endnotes 2008, p. 5.

4 Baudrillard 1975. For instance: 'By presupposing the axiom of the economic, the Marxist critique perhaps deciphers the *functioning* of the *system* of political economy; but at the same time it reproduces it as a model' (Baudrillard 1975, p. 66).

5 Endnotes 2010, p. 101.

6 See Postone 1993, p. 27. Postone says: Since 'the basis of capital is and remains proletarian labor … labour, then, is not the basis of the potential negation of the capitalist social formation'.

7 Endnotes 2008, p. 213. The rejection of labour as a political force against capitalism can

tradition, contemporary theorists of the politics of work present an urgent choice between the emancipation *through* work and the emancipation *from* work. The advocates for the emancipation through work are dwindling and therefore the choice appears to be settled in favour of a general post-work imaginary and a cornucopia of anti-work campaigns.

The preordained choice between work and worklessness is guided by a vivid narrative of the supersession of a politics of labour ascribed to the 'traditional left' in which struggles over work are conceived narrowly as concerned with securing the jobs, wages and working conditions of white working-class men. Accordingly, an expansive and inclusive micropolitics of work appears to have all but replaced the class politics of labour. This reconfiguration of the politics of work is the discursive conjuncture from which this book is written. Although I will argue that the choice is false and the narrative is misleading, my study of the intersection of art and labour does not reject the micropolitics of work in favour of a class politics of labour but spans the two.

Aesthetic activity served as an emblem of freedom in the late eighteenth century by the philosophers and poets of German Idealism. Here, art signified either the workless work of the artist or the self-realising activity of the viewer's aesthetic experience of artworks. Art and work, for this tradition, are hostile to one another. From Utopian Socialism to the Arts and Crafts movement, however, the nineteenth-century politics of work is characterised by sev-

be challenged in two ways. First, the error is to replicate the reductive logic of classical political economy which Marx accused of considering the worker 'only as a worker ... It does not consider him when he is not working, as a human being'. It is not in its capacity for value production that the worker is assigned a revolutionary by Marx, but in her capacity as a human being. The second rebuke is comparative. Compare this political logic of non-affirmation of one side of a systemic social division with the equivalent affirmation of women and people of colour in feminism and anti-racism. For instance, 'Black Lives Matter' is not a slogan for replicating racism and the racial distribution of power and wealth but a necessarily partisan confrontation of a system in which black lives do not enjoy the full status of humanity. The partisan affirmation of black lives under the current condition should not be extrapolated to an ahistorical and permanent affirmation of black lives and blackness that eventually stands as a blockage on the abolition of racial categories. Likewise, the affirmation of women today should not be abstracted from the conditions of struggle that require this affirmation. If there is a theoretical error in affirming the working class or work that has lodged itself within certain quarters of the workers' movement, this needs to be understood in conjunctural terms as historically necessary rather than in absolute terms as always already a block on the abolition of capitalism. This failure to acknowledge the historical justification of affirming the dominated pole of a specific social configuration is the most graphic manifestation of what Alberto Toscano has dubbed 'the anti-political character of communization theory' (Toscano 2011, p. 92).

eral waves of struggle against industrialisation that aspires to a convergence of work and pleasure. Emancipation is envisioned not as taking sides with work against art but through a process of reconciliation in which work is aestheticised. In its weakest version, work is simply made attractive through variety, and in its strongest version, work is remodelled on the modern subjectivised discourse of aesthetic pleasure. If the 'work ethic' represents both the employers' regimentation of work and the official dogma of a supine workforce, the aestheticisation of work in the socialist tradition – and in some cases, a recasting of the worker as artist – represents a demand formulated precisely to be impossible to fulfil within the industrial capitalist mode of production.

However, the aestheticisation of work for the worker could only signal a world beyond capitalism by limiting the range of the politics of work. Not only does the merging of work and pleasure have the effect of reducing the extent of the potential agency of the post-capitalist worker but also it can be compatible with the preservation of the gendered categorisation of work and nonwork that is crystallised by the twentieth-century development of Fordism. To predicate the revolutionary politics of work on the transformation of work itself – particularly as the emancipation of the worker through the morphological transformation of the labour process – does not satisfactorily address the politics of the distribution of paid and unpaid work, the exclusion of domestic labour from the wage and the naturalisation of the social and global division of labour through gendered and racial norms. As such, if the nineteenth century witnessed a confrontation between the official ethos of work and the radical tradition of its complete transformation, the twentieth century was the era in which workers' organisations secured a level of legitimacy and social agency that meant the workers' movement became a justified target from feminist and postcolonial struggles.

By the 1970s, work was a hotly contested category. Domestic labour, immigrant labour, structural unemployment and the passage from Fordism to Post-Fordism generally, undermined many of the assumptions on which large sections of the workers' movement had been operating. Since 2000, the politics of work has been radically reconfigured as a much broader and more diverse arena of struggles. As well as rejecting the complicity of Trade Unionism in the Fordist ethos of work, the utopian notion of the convergence of work and pleasure, now referred to in diluted form as the injunction to 'do what you love', has been singled out as the perfect alibi for 24/7 exploitation of precarious workers. Art and aesthetic activity lose a significant portion of the political promise that they held within the socialist critique of industrialisation and the struggle against mechanisation, the assembly line and deskilling within the factory.

Exemplary in this challenge to the masculinist discourses of work and art is Linda Nochlin's studies of the representation of work and the work of representation, such as her essay 'Morisot's Wet Nurse'. Nochlin reconstructs the painted scene as only half of an encounter in which 'two working women confront each other'[8] and two types of work resonate with the politics of paid and unpaid housework and the activity of the painting as work. Nochlin highlights the social construction of the opposition of motherhood and waged labour (evident in paintings of mothers and children by other – male – impressionists), and the gendering of both work and the act of painting. Nochlin's feminist analysis of *The Wet Nurse and Julie* also points out that the painting enacts an encounter between a 'poor country woman'[9] and a member of the Parisian 'upper bourgeoisie',[10] and therefore inscribes into the artist's gaze contrasting relations to work and the wage between two women belonging to the same household.

Julia Bryan-Wilson draws out precisely these issues in art critic Lucy Lippard's feminist politics of labour which was 'white, educated, middle class, urban'[11] and yet inspired in Argentina by the unity of artists and trade unions and radically committed at home to 'the *un*working or non-working class – the unemployed'.[12] Art and work are rearticulated by feminist artists and critics in the 1970s not as their male counterparts did in identifying with and mimicking industrialism. Work, for feminists, was more capacious. 'Women often have three jobs instead of two', Lippard wrote in her 1971 essay *Twenty-Six Contemporary Women Artists*, 'their art, work for pay, and the traditional unpaid "work that's never done"'.[13] Even 'those arts which appear most "private" and individual',[14] Janet Wolff wrote, require a substantial body of 'support personnel'. Wolff's sociological project in *The Social Production of Art*, which was to replace 'the traditional notion of the artist as creator with one of the artist as producer',[15] in which 'the concept of creativity is used in a metaphysical and non-historical way',[16] was rooted in the feminist critique of the heroic male artist and the gendered division of labour as well as the Marxist tradition of the social history of art. No account of the intersection of art and labour can be

8 Nochlin 1989, p. 38.
9 Nochlin 1989, p. 46.
10 Nochlin 1989, p. 45.
11 Bryan-Wilson 2009, p. 129.
12 Lippard, letter to Martha Rosler (1977), quoted in Bryan-Wilson 2009, p. 138.
13 Lippard, quoted in Bryan-Wilson 2009, pp. 163–4.
14 Wolff 1981, p. 33.
15 Wolff 1981, p. 137.
16 Wolff 1981, p. 118.

taken seriously that fails to acknowledge how fundamental these issues are for the category of art and the historical forms of artistic labour that have accompanied it.

Today, with the resurgence of interest in the politics of unpaid labour, precarity and a post-work future, feminist debates on work have been revisited by a new generation of thinkers and activists. Autonomist feminist theories of work by Mariarosa Dalla Costa, Selma James and Silvia Federici have been essential to the critical reassessment of the historical debates on labour which dominated political thinking from the English, American and French Revolutions to the debates following the Russian Revolution. 'Work is still work, whether inside or outside the home', Dalla Costa and James argued, and yet 'getting a job outside the home [is] part of the problem, not the solution. Slavery to an assembly line is not a liberation from slavery to a kitchen sink'. As such, the 'wages for housework' campaign, which Federici describes as 'the refusal of housework as women's natural destiny',[17] was always a political movement consisting of two joint proposals, *wages against housework* and *housework against wages*.

Angela Davis also points out that 'women of color – and especially Black women – have been receiving wages for housework for untold decades'.[18] Insofar as the objective of the campaign was to 'force the state to recognize that domestic work is work',[19] and thereby to extend the political agency of the critique of capitalism beyond industrial workers to 'workers who appear to be outside the wage relation: slaves, colonial subjects, prisoners, housewives, and students'.[20] It is not immediately clear whether the artist can be appended to the list of unwaged workers but the feminist politics of work can be repurposed in the analysis of artistic production as a form of labour. In place of the workless work of the heroic, original genius-artist, today's artworld is acknowledged as reproduced by a diverse network of unheralded and unpaid or underpaid workers who suffer, at least in part, by the dogma that cultural workers do what they love rather than work for a wage. Art, therefore, has been radically transformed by the renovation of the politics of work that has been underway since the 1970s.

Following on from the feminist and postcolonial disclosure of the full extent of ancillary work required for the capitalist mode of production to keep ticking over, the contemporary politics of work in art acknowledges art workers such

17 Federici 2012, p. 1.
18 Davis 1983, p. 237.
19 Federici 2012, p. 8.
20 Ibid.

as technicians, studio assistants, fabricators and suppliers as well as the ped-
agogical and service work required to produce and reproduce the artist and
the 'dark matter'[21] of workers who constitute the artworld in which the artist
operates. Dani Child has aptly labelled these unheralded workers the 'invisible
hands'[22] of art production. Indeed, labour activism in the artworld today con-
sists largely of pragmatic campaigns by and on behalf of an array of workers in
museums, universities, galleries and art magazines as well as studios who have
customarily been dirempted from the discourses of artistic activity under the
sign of aesthetic experience.

Today, art historical scholarship has begun to pay as much attention to issues
around work as would previously have been reserved for works of art. Julia
Bryan-Wilson has chronicled the intersection of the artist and the worker in
political self-organisation of artists in New York in the early 1970s, Robert Bailey
has charted the debates staged by the conceptual art group Art & Language
in the 1970s on the relationship between the artist and worker, Caroline Jones
touches on similar questions in her historical study of the abandonment of the
studio in the art of the 1960s, and John Roberts has reinvigorated these issues
as they played out in the work of Boris Arvatov in Moscow in the 1920s.

Instead of art acting as the basis of a transfiguration of labour, work has
become a trope within art's discourses as the basis of the emancipation from
the myth of the artist which bolstered a system characterised by self-subsidy
and self-exploitation. At the same time, contemporary debates on work in art
extend the theatre of work in art and multiply its cast of characters beyond the
aesthetic labour of the artist and the viewer. If, historically, the politics of labour
in art excluded most work undertaken in the production, circulation and dis-
play of works of art as a result of an over-emphasis on the aesthetic activity of
the artist, the expansion of the diversity of work within the artworld has not
only diminished the place of aesthetic activity within the politics of work in
art but suppressed it completely.

The artist, therefore, has been recast as a worker within a social division
of workers necessary to the reproduction of art and its institutions. The res-
ult is a condition exemplified by the introduction to the e-flux publication 'Are
You Working Too Much? Post-Fordism, Precarity and the Labor of Art' which
presents its politics of work in art in the form of an imperative: '[the] idea of
a "higher value" that presides over – and indeed fuels – an idea of art labor
as free labor must be contested'.[23] In place of the hoped-for transformation of

21 Sholette 2010.
22 Child used this phrase in her paper at the AAH conference in London in 2018. For a study
 of the variety of unheralded art workers see Child 2019.
23 Aranda, Wood and Vidokle 2011, p. 6.

work into art or the normative regulation of art's integrity against the degradation of wage labour, both of which now appear to be romantic 'myths', this contemporary politics of work in art is modelled on the politics of wage labour.

While the critical reassessment of the romance of the artist and the myth of its distinctive forms of labour is the culmination of feminist, postcolonial and Marxist critiques that gained prominence in the critical milieu of post-'68 art history, sociology and art criticism, today the insistence that the artist is a worker regularly serves as a precursor to the limited but urgent demand for artists to receive adequate remuneration for their work. Certainly, the assertion that the artist is a worker today plays down the economic exceptionalism of artistic labour outside the wage relation[24] and reasserts relations of dependence, exploitation and authority within the artworld as a system. Hence, the potential for including art within a loose political alliance with shared interests in a critique of the wage system has diminished. It is possible to detect within this trajectory a trading-in of the critique of capitalism for a call to extend the capitalist system insofar as the demand for artists to be independent from the market has metamorphosed into a demand for the wage.

In general terms, therefore, a romantic anti-capitalism has come to be rejected not in order to install a more thoroughgoing critique of capitalism but in order to reconcile the artist with the wage system, commodity production and the business of making money. The rise of this tendency can be explained as corresponding to a gear change in political theory but it also seems to be predicated on the erosion of the welfare state and the public subsidy of art, the professionalisation of the artworld, the increasing debt burden of art graduates and, more generally, the weakened likelihood of the revolutionary supersession of capitalism and the decline of the workers' movement.

The Marxist politics of labour appeared to be utterly discredited by the pace-setters of postmodern theory in the mid-1970s. Baudrillard's polemic, *The Mirror of Production*,[25] is emblematic of this triumphant opposition to Marxism and the prominent agents of the workers' movement (trade unions, political parties and left-wing scholarship). Baudrillard's 'break with Marx' is announced, in the first line of the preface: 'A specter haunts the revolutionary imagination: the phantom of production. Everywhere it sustains an unbridled romanticism of productivity'. Baudrillard, therefore, accused the workers' movement of contributing to its own exploited condition and charged the Marxist theory of labour with condemning the workers to a life of work.

24 For the argument that artistic production is economically exceptional to the capitalist mode of production see Beech 2015.

25 Baudrillard 1975.

'Marxism assists the cunning of capital', he said, by convincing 'men that they are alienated by the sale of their labor power, thus censoring the much more radical hypothesis that they might be alienated *as* labor power'. Regardless of whether Baudrillard successfully snares Marx in his own contradictions by discovering a common denominator for capitalism and its critique, the accusation has stuck.

Kathi Weeks quotes Baudrillard directly within her critique of 'the problem of work'. 'What Baudrillard identifies as Marxism's commitment to productivism', she says, is 'its inability to break from the work values that have developed alongside and in support of Western capitalist social formations'.[26] This, she argues, 'represents a failure of both critical analysis and utopian imagination'.[27] Weeks goes further than Baudrillard in her critique of the workers' movement. 'This is a potential problem with both of the long-standing feminist strategies regarding work and its dominant values: the demand for inclusion in the form of "real" (that is, waged) work for women and the demand to expand the category of work to include what has been mischaracterized either as idleness and leisure, or as private, intimate, and spontaneous acts of love – but in any case, as nonwork'.[28]

This critique of the politics of labour has been reiterated most recently by Andrea Komlosy, in her book *Work: The Last 1,000 Years*. Komlosy differentiates her theory of work from the traditional left by saying the labour movement stuck to a very narrow concept of work. Housework and subsistence work were not included, she says, and so their definition of work and their conception of exploitation and appropriation implies the denial of non-paid labour, household work and care activities as legitimate forms of work. She claims that a feminist and postcolonial framework allows us to include all types of work and labour including commodified labour, reciprocal or subsistence labour and tributary labour.

Despite the erosion of the Marxist politics of labour after 1968, a parallel discourse took shape in the 1970s and 1980s in which the production and consumption of art appeared to point to a post-capitalist form of labour through individual self-realisation. This is a largely philosophical trajectory with little or no direct correlation with the workers' movement that reinterprets Marx's theory of labour through Hegel specifically or the discourses of German Idealism generally.[29] This tradition has been revitalised more recently by drawing on poststructuralist post-Marxism rather than Hegel and Schiller in Bruno Gulli's

26 Weeks 2011, p. 82.
27 Ibid.
28 Weeks 2011, p. 68.
29 See Gould 1978, Kain 1982, Arthur 1983, Cohen 1988.

ontology of labour in which art and the aesthetic regains its nineteenth-century prominence.[30] One of the findings of my inquiry into the historical formation of art as distinct from handicraft and commerce, which may sound like a riddle when presented ahead of the argument that supports it but which I believe is vital to the politics of labour in art, is that the antagonism between art and capitalism precedes capitalism and that, ironically, the real freedoms which the artist subsequently wins to remain independent from the capitalist mode of production are gifts of industrialisation itself.

The 1970s represents a protracted debate on the virtues and limitations of a politics of labour including the feminist politics of housework[31] and the Weberian critique of the work ethic[32] but also, against this, the argument that art is a paradigm of non-alienated labour.[33] However, the persistence of a Marxist philosophy of labour throughout the 1970s and 1980s, and the continued thematisation of art within it, should not be taken to mean that now, parallel with the feminist, Weberian and postcolonial politics of work, the Marxist politics of labour continued unabated. The abstract and speculative tenor of the Marxist debate on labour during this period reflects the downturn of the labour movement and the displacement of the politics of work from its basis in the working class. At the same time, it can also be noted, the leading discourses on art redirected questions of labour into a study of the construction of images. When postmodernists insisted that all images were constructed, however, they did so through an emphasis on meaning rather than the labour of the producer of images. Labour dissolved in the emphasis on signification, desire, codification, subject-formation and the so-called 'co-production of artworks' through practices of reading. That is to say, a shadow play of production was rhetorically preserved within the study of the social and subjective processes of consumption.

The historical passage of post-'68 politics can be described as the birth of micropolitics. Identity politics, civil rights, feminism and race politics changed the political map of class for good. The distinction between micropolitics and structural social change that I am driving at here is theorised clearly by Paul Gilroy. Gilroy argues that whenever 'lived crisis and systemic crisis come together, Marxism allocates priority to the latter while the memory of slavery insists on the priority of the former'.[34] In so doing, Gilroy simultaneously plays down the structural analysis necessary for an understanding of the integration of racism

30 Gullì 2005.
31 See Dalla Costa and James 1972, Federici 2012.
32 See Anthony 1977.
33 See Sanchez Vazquez 1973 [1965], Jauss 1975, Brantlinger 1975, Morawski 1974 and 1977.
34 Gilroy 1993, p. 40.

within capitalist modernity and under-represents the attention paid to the subject, experience and culture within Marxism. Slavery is a form of labour, of course, and therefore the Marxist analysis of social forms of surplus extraction has a legitimate contribution to make to its political discourse.

Gilroy suppresses the politics of labour in the analysis of slavery and its legacies to expedite a gravitational shift within cultural studies from class to race but the Marxist theory of primary accumulation (mis-translated as 'primitive accumulation') – especially as this is understood as a permanent feature of capitalism rather than as a stage in the pre-history of capital accumulation – is a powerful tool for theorising the systematic integration of race and class within a world system characterised by uneven but combined development on global, regional, national and local scales. If my study conforms to the paradigm of the Marxist writer who stresses systemic analysis, this is not to push against the study of the subjective, cultural and experiential 'patterns of feeling' in the experience of racism, sexism, homophobia and anti-semitism, but to articulate the social and historical framework in which these patterns have developed.

Class can survive within the political imaginary of identity but when the contestation of the discursive production of identity is prioritised over the confrontation of social systems and structures (or the latter is believed to be realised through the former), then class struggle is diminished. Insofar as the micropolitics of everyday life has permitted a great deal of emancipatory struggles to thrive, the idea of a micropolitics of work is positive because it allows work to be a theatre of contestation for identities other than workers, including the anti-worker identity of workers themselves. If we only understand the post-'68 conjuncture in terms of its deviation from Marxism and the workers' movement, then the Marxist critique of intersectionality, micropolitics and the contemporary politics of work appears to be part of the backlash against the bulk of the emancipatory politics of the last 50 years.

Although this political reorientation appeared to spell the eclipse of the politics of labour, the result, in retrospect, was a replacement of a class politics of labour by a micropolitics of work. However, there is a difference between adding a micropolitics of work to the politics of labour and replacing the politics of labour with a micropolitics of work. If you do the latter, I want to suggest, class struggle is squeezed out of the politics of work and, at one extreme, all that is left is a fight against a perceived *prejudice* against the working class (what has been called 'classism'[35]). I want to suggest another way of describing the passage from the 1970s to the present. Rather than diagnosing the reorienta-

35 For an example of this use, see Radical Education Forum 2012, p. 4.

tion of the politics of work based on two rival traditions, I want to question the way in which that demarcation has been characterised. I will not choose between a class politics of labour and a micropolitics of work. To have both, however, means challenging the perception that Marxism has only developed a narrow conception of labour which corresponds to the waged labour of white heterosexual working-class men (without assuming that the workers' movement was immune to racism, sexism, anti-semitism, homophobia and the prioritisation of wage labour at the expense of all other political discourses and movements).

The concept of the traditional left, which represents multiple real traumas, also crystallises historical falsification. When political theorists after '68 refer to the traditional left as a narrowly conceived class politics, the term traditional left is deployed to identify only that portion of the Socialist and Marxist traditions that remains once the new political movements have been deducted from it. As such, it distorts the history of the left by representing the socialist and communist traditions from the perspective of their incommensurability with all non-worker struggles. When the workers' movement aligned itself with anti-colonial, feminist, ecological and peace movements, for instance – which it did from the start and regularly throughout – these instances are extracted from the traditional left as if they did not belong there. Recent studies of the relationship between identity politics and the Marxist tradition have challenged this assumption and opened up the possibility of having both.[36]

The politics of work today is at a crossroads. With the decline of a class politics of labour, two post-Marxist tendencies prevail. Both are well represented within the critical discourses of art. As well as the pragmatic politics of art as work (including the campaign against unpaid interns and the activism of precarious cultural and educational workers), the contemporary political theory of work in art has also been transformed by the discourses of the refusal of work, anti-work and the post-work imaginary. Theoretically these two tendencies appear to sit uncomfortably with one another. Simply put, the demand for an increasing variety of activities to be acknowledged as work appears to contradict the vision of a world without work. What the two have in common, however, is the displacement of the politics of work from the labour movement and its discursive traditions. What the politics of work requires, I would argue, is not only the scope and scale to contain both the pragmatic micropolitics of work and the envisioning of a post-work future, but also a class politics of labour. No analysis of the politics of labour in art is adequate without all three.

36 See Lewis 2015, Haider 2018, Bohrer 2018, Hudis 2018.

 This book has been written within the conjuncture that I have been attempt-
ing to describe but it concerns itself primarily with the reconstruction of the
historical preconditions of the specificity of art's mode of labour and its dis-
contents. I call this a reconstruction because it assembles the discursive, norm-
ative, institutional, social, economic, technological and spatial dimensions of
a contested historical transition. This inquiry departs from the standard nar-
ratives of the birth of art as a discursive classification of the Fine Arts, the
subjective turn of the aesthetic, the economic transition from patronage to
the art market, or the transformation of the artisan's workshop into an artist's
studio. Although these episodes in a history of the formation of the category
of art indicate important developments, the reconstruction of the historical
transition cannot be assembled by sewing these parts together into a single
cloth.
 In reconstructing the historical processes that form the specific modern
dialectic of art and labour I aim to intervene in the contemporary politics of
work and in so doing to provide a new basis for the politics of labour in art.
While acknowledging that the argument that art is work and the artist is a
worker is first formulated as a critical alternative to the romance of the artist as
an autonomous, expressive and sovereign individual, my investigation neither
reverts back to the modernist myth of creativity nor subscribes to the pragmatic
micropolitics of the artist as worker. First, I want to show that the conflation
of art with work has established an ahistorical relationship between art and
labour that obscures what has been a changing dynamic in which art has been
formulated and reformulated in relation to handicraft, mechanisation, wage
labour, the handmade, industry and commodification. And second, despite
critical advances, the disenchantment of artistic labour reinforced a natural-
isation of the category of work.
 When it is asserted that art is nothing but work, the problem of the existence
of earlier conceptions of art as distinct from work or hostile to it is typically
explained away as ideological, false, mystification, irrational, faith, belief, and
the like. This is unsatisfactory not only because it neglects the material effects
of ideas in the formation of social relations and therefore becomes blind to
how even false and irrational perceptions and discourses can shape institu-
tions, economies and social hierarchies, but also because it fails to trace the
social forces and structural conditions that inaugurated and maintained such
discourses. That is to say, rather than dismissing the myth of the artist as a
myth we need to reconstruct the historical conditions under which the myth
is regarded as preferable to a preceding condition. This is not to substitute a
'history of ideas' for social history but the linguistic and discursive dimension
of history should not be underestimated.

The literature on art and labour is marked by social upheavals that are not expressly thematised in, for instance, the seventeenth and eighteenth centuries that promote the Fine Arts as belonging to the liberal arts rather than the mechanical arts or texts in the nineteenth century that differentiate the artist from the industrial worker and codify changes in the social division of labour. Reading the *marks* left by social change on discourse is not a method of passing quickly over the text in order to speak of the social world to which it belongs, as Paul de Man complained, but of performing a textual analysis in which language is one of the social frameworks that is undergoing historical change. Such a reading is rhetorical in the broad rather than the narrow sense: it unites social change and linguistic change as elements of an integrated and contradictory process of historical transformation.

Neal Wood makes a similar point in his methodological introduction to *John Locke and Agrarian Capitalism*, saying 'ideas and actions are mutually dependent and interpenetrating, forming a seamless web'.[37] When faced with texts by historical authors, Wood advises that the social historian ask what, if any, 'is the relevance of productive forces, the relations of production, the division of labor, and the mode of surplus extraction to an understanding of their views?'[38] The point is not to reduce the meaning of texts to expressions of a pre-allocated position within the division of labour but to insert the texts, as far as possible, into the social struggles and historical tendencies which prompts them. Confronted with the notorious difficulty of accounting for the hyperbolic discourses of the artist and genius in the eighteenth century, for instance, I have not turned to the theory of ideology as false consciousness, as might be expected, but examined, instead, the changing social relations of the production of works of art in order to explain the rise of such discourses within specific historical confrontations over material and symbolic resources. Or 'material intercourse', in Marx and Engels's apt phrase.

My inquiry is a distant cousin of the social history of art. It is necessary, therefore, to say something about methodology. Arnold Hauser's social history of art, for instance, which has been consistently criticised for its 'grand generalizations',[39] was social insofar as its history of art was simultaneously a history of society. Hauser's methodology, therefore, in which art is indexed to a sequence of historically specific social forms denoted by their distinctive patterns of thought, combines the art historical detection of style in artworks and the historical analysis of successive *Weltanschauungen* pioneered by his friend

37 Wood 1984, p. 2.
38 Wood 1984, p. 4.
39 Hemingway 2014, p. 10.

Karl Mannheim. Styles of thought that appear to belong to specific historical forms of society are parcellated by Hauser as containers for styles of painting, composing, making and so forth. Despite its hazards, Hauser's methodology allows him to fix his focus on art's role within the hegemonic cultural formations that are essential to the reproduction of society.

It is of no concern to me in this study whether artworks reveal the social conditions of their production. Francis Haskell, whose reconstruction of patterns of patronage in the seventeenth century constituted a pathbreaking departure in how the relations between art and society can be studied, can be seen as belonging to a subsequent wave of social art history in which philosophical and sociological generalisations were substituted, as far as was possible, with archival evidence. Typically, the social history of art was never a history of the social structures and forces that have been played out within art itself. My inquiry, by contrast, focuses exclusively on changes in the social configuration of artistic labour. In this regard, my work is both an example of the social history of art and rejects the emphasis on artworks that has always bent the social history of art into socially informed art history.

There is another limitation of the social history of art that needs to be addressed: insularity. Eric Hobsbawm, who did not go far enough in this direction, admitted in his book *Industry and Empire* in the 1960s that 'an insular history of Britain ... is quite inadequate'.[40] Despite the fact that Hauser's social history is global, it represents in significant ways an insular Western account of culture according to a largely linear development. Even when the social history of art confronts accepted norms and knowledges within the discipline of art history, it has tended to confirm the canon and reiterate the Eurocentric insularity that has dogged the discipline of art history since its inception. My response to this difficulty is to locate the formation of art as a specific mode of production within colonial modernity without reducing it to the culture of the colonial centre. In part, the problem, as I see it, is that the model of exclusion lacks the explanatory power to analyse a condition of conquest, settlement, mastery, hegemony, regulation and mobility.

It is often claimed that art is a European concept. This compelling idea needs to be revised. Let us say that art as a category was formulated within the heart of the colonial powers. As Marx pointed out in his critique of the comfortable fable of 'primitive accumulation' – in which economists claimed that the original accumulation of capitalist wealth was itself the result of a combination of work and abstention from spending – colonialism is the chief prerequis-

40 Hobsbawm 1968, p. 19.

ite of capitalism. 'The discovery of gold and silver in America, the extirpation, enslavement and entombment in mines of the indigenous population of that continent, the beginnings of the conquest and plunder of India, and the conversion of Africa into a preserve for the commercial hunting of blackskins, are all things which characterise the dawn of the era of capitalist production'.[41] The industrial mode of production cannot ignite itself without the prior accumulation of capital and this is achieved not through the capitalist mode of production strictly speaking but with the slave trade, imperial conquest and colonial settlement.

Likewise, the category of art as a class of objects (works of art) was prompted by global flows of goods and people. Art was first devised as a category in response to imperial looting, global trade and settler colonialism. Discourses on the 'noble savage', which Stelio Cro argues 'sets the stage for the "querelle des anciens et des modernes"'[42] and the genre of utopian literature (the absence of laws produces justice[43] and the absence of private property produces community[44]), also provides a template for the concept of the genius-artist (as lawless, spontaneous and free). At the same time, works of art circulate on the paths laid by imperial conquest and perpetuated by colonial settlement. When the abstract category of art replaces the Fine Arts it is not as a name for the cultural products of the Western European colonial centre but, in principle, as a universal global and timeless culture of the whole of humanity. This is the colonial basis of C.L.R. James's insistence that Beethoven 'is now part of the human heritage'.[45] Imperialism 'made the world one',[46] as Edward Said recognised, but it also provided the frame for art to be constituted as a single global culture. The colonial asymmetries of the abstract category of art are not produced through an act of exclusion but through a regime of unequal inclusion that is, in part, a response to the modern global reality of the mobility of works of art. Culture could no longer be thought of as restricted to geographically separate units (e.g. British culture, German culture, European culture, Indian culture, Asian culture) but was something shared by them all (i.e. culture).

If the history of the expansion of the category of art as universal and global is the product of a violent process of 'primary accumulation', this does not show up in the discourses of the passage from the arts to art *via* the Fine Arts

41 Marx 1990 [1867], p. 915.
42 Cro 1990, p. 22.
43 Cro 1990, p. 23.
44 Cro 1990, p. 24.
45 Said 1993, p. xxviii.
46 Said 1993, p. 4.

in the early modern period. Art in its general abstract sense was formulated within an experience of flows of works of art and anthropological specimens that arrived in Europe from around the world and through a sense of commonality with and differentiation from indigenous populations experienced through their products. Chinoiserie in the seventeenth and eighteenth centuries is emblematic of the complexities of this burgeoning perception of the value of the non-Western alongside or through the development of racialised tropes of orientalism. If exemplary specimens of the arts can be found everywhere and everywhen in world history – and picked up by imperial conquerors, colonial settlers and global traders along routes funded by the slave trade – the seventeenth-century regime of the Fine Arts sought to set itself apart from the kind of artisanal skills that were evidently as well developed in the colonies as they were in Western Europe. However, the late-eighteenth-century category of art in general was initiated in an unstable attempt to re-establish the global universality of the arts within the elevated framework of the Fine Arts.

The artist becomes an emblem of freedom by being off-set from the slave but by deploying the connotations of the noble savage. Tragically, the artist represents the freedom that is suppressed in Haiti and exemplifies the rights of man which are denied to women but vindicated within a rhetoric of the general inhumanity of slavery. Within this condition the category of art is simultaneously universal and a guarantee of colonial asymmetries. Individual works of art, particular portraits of imperial governors and the like, were transported from the centre to the periphery. Edmond Amran El Maleh observes that modern painting was imported to Morocco 'in the trunks of the colonists', albeit not on the scale of the looting of world culture that came in the opposite direction, but the canonical forms, practices and institutions of art were exported to the peripheries as an integral part of the civilising and modernising campaign of domination.

Gilroy has rightly argued that 'the reflexive cultures and consciousness of the European settlers and those of the Africans they enslaved, the "Indians" they slaughtered, and the Asians they indentured were not, even in situations of the most extreme brutality, sealed off hermetically from each other'.[47] Also, Partha Mitter has demonstrated how the opposition of centre and periphery was translated directly into evaluations of works of art in which artists from the centre are credited with a kind of originality for their integration of 'primitive' influences whereas 'the impact of European naturalism on Indian artists,

47 Gilroy 1993, p. 2.

for instance, is viewed simply as a superior culture dominating an inferior, passive one'.[48] The project, therefore, is to insert the historical emergence of art and the artist into the colonial world system.

The slave trade, colonial goods such as sugar, spices, tobacco, tea and coffee, and the export of domestically produced goods to colonial markets all contributed to the changed global status of Europe in the period when art and aesthetics were formed. Hence, art and its cognates can be understood, if not one-dimensionally as the cultural logic of colonial modernity or simply as an expression of colonial asymmetries, then certainly as correlated with the colonial geographical and temporal order. All attempts to read art as a concept that encodes colonial realities into a falsely universal form are inadequate because they fail to insert art as a set of institutions, exchanges, relations and forms of labour within a contested colonial condition.

Colonialism and world trade precede the formulation of art by several centuries but the birth of art as a category corresponds precisely to the shift from a largely Mediterranean model of colonialism exemplified by Italy, Portugal and Spain (but latterly dominated by the Netherlands) towards the maritime states of Europe (dominated by England and France[49] though not excluding countries such as Germany). Art is marked by colonialism not by being exclusive to Europe and Europeans but by being at least formally inclusive of the highest achievements of world culture universally throughout history albeit under the dominance of Europe and European culture. As such, art is not a designation for European culture even at the point at which it appears as a new term within European scholarship.

Art is born as simultaneously European and global, and as both modern and ancient, insofar as modernity appears to be limited to the colonial centres while ancient art is characteristic of the colonised regions and the subordinate nations of Europe. 'There is no modernity without coloniality', as Walter Mignolo argues, and modernity does not reside 'solely in Europe or in the colonies but in the power relation that straddles the two', as Hardt and Negri put it. We might add that there is no category of art without modernity and therefore no art without colonialism or that art is formulated as a category that connects Europe and the rest of the world in a specific colonial relationship. Prior to the Industrial Revolution breaking out in England, a new system of fissures and flows put England at the heart of an historically unparalleled scale of exploitation in which Europe conquered, looted, settled, subjugated and enslaved the rest of the world.

48 Mitter 1994, p. 6.
49 See Hobsbawm 1968, p. 52.

Art is not a European idea but a category formed within the colonial con-
dition of the eighteenth century and in the wake of discourses on modern-
ity. However, it is unsatisfactory to lump these developments together. Des-
pite its polemical power in the writings of Mignolo and others, it is a mistake
to propose a single undifferentiated account of capitalist colonial Enlighten-
ment modernity. As Ellen Meiksins-Wood points out, it is necessary to 'unravel
the conflation of capitalism and modernity'[50] and, we might add, colonialism,
because 'the Enlightenment project belongs to a distinctly non-capitalist – not
just pre-capitalist – society'.[51] Art is first formulated in the image of the Fine
Arts according to a set of circumstances that 'belong to a social form that is not
just a transitional point on the way to capitalism but an alternative route out
of feudalism. In particular, the French Enlightenment belongs to the absolutist
state in France'.[52] Colonialism was and is compatible with modes of production
other than capitalism and social formations other than modernity; Enlighten-
ment was more complex and contradictory than an intellectual anticipation of
the bourgeois political revolution or a cultural imposition of the values neces-
sary for capitalist rationality. Hence, it is imperative not to conflate modernity,
colonialism, Enlightenment, bourgeois revolution and capitalism,[53] and essen-
tial to acknowledge the complex intersections of them for the historical inquiry
into the formation of art as a category.

The formation of art as a universal category is made possible by a colonial
spatiality in which peripheral regions were simultaneously credited with and
looted for their contribution to the history of art. At the same time that artefacts
were drawn from the peripheries to the centres of a colonial global order, art
and the aesthetic were emerging in Western Europe in a category that bound
together the centre and periphery in a specifically colonial mutation of uni-
versality. When a connoisseur such as Kenneth Clark believes it is his duty to
remark, 'I don't think there is any doubt that the [Greek] Apollo embodies a
higher state of civilisation than the [African] mask',[54] we see how the univer-
sality of art is reconciled with colonial asymmetries through the hierarchical
ordering of a world system of culture that is internalised and expressed in a

50 Wood 2002, p. 183.
51 Ibid.
52 Ibid.
53 This point is made by Ellen Meiksins-Wood as part of her support of Robert Brenner's
 argument against the assumption that the 'lineage of capitalism passes naturally from the
 earliest Babylonian merchant through the medieval burgher to the early modern bour-
 geois and finally to the industrial capitalist' (Wood 2002, p. 5). For a critique of this tend-
 ency within the Marxist discourse on the origin of capitalism, see Davidson 2012.
54 Clark 1979 [1969], p. 2.

display of taste. Art, then, is not a modern name for European culture but is simultaneously universal and structurally implicated in colonialism. This is why art is a category that must continue to be contested.

Literature, likewise, is a category that remains tethered to a colonial universality. The category of 'English literature' has not survived unscathed from debates within postcolonial studies. New categories such as 'world literature' and 'global literature' have been proposed as replacements for the Eurocentrism embedded in the discipline itself. And this is why Franco Moretti is right to insist that, 'world literature cannot be literature, bigger; what we are already doing, just more of it. It has to be different. The categories have to be different'.[55] World literature differs from English literature not merely quantitatively but qualitatively: the postcolonial category of literature should not be merely an ever-increasing body of texts but an integrated global field contorted by asymmetric power geometries. Alexander Beecroft argues that world literature 'is not the sum total of the world's literary production, but rather a world-system within which literature is produced and circulates'.[56]

The Warwick Research Collective share the same starting point, saying, 'we are suggesting that world-literature be conceived precisely through its mediation by and registration of the modern world-system'.[57] They draw on Wallerstein but extend the analysis through the Marxist theory of 'combined and uneven development'.[58] The advantage of modelling world literature on the theory of uneven and combined development is that it acknowledges what Neil Davidson describes as 'the "unity" of the world economy and the "interdependence" of the imperial powers and the colonial and semi-colonial world'. Just as world capitalism has been described as a single system of asymmetrical flows, world literature and the category of art can be described as cultural systems that reproduce the core and periphery of colonial capitalism.

In the colonies of India and Africa the emergence of the category of art occurs in a double or split form. In one sense, art is a category that the colonisers bring with them to orchestrate a modern distribution of artefacts in which, roughly speaking, some indigenous ancient productions are ascribed the status of art while most contemporary indigenous craft production is not. And in another sense, the institutions and norms of art are introduced as part of colonial modernisation resulting in the reorganisation of production and a realignment with the world market. It is not that the artisans of India and

55 Moretti 2000, p. 55.
56 Beecroft 2008, p. 88.
57 Warwick Research Collective 2015, p. 9.
58 Warwick Research Collective 2015, p. 10.

Africa had had no contact with the leading painters and sculptors of Europe since the Renaissance but that the new phase of colonialism is accompanied by a new category of art that at appears simultaneously to underline the division between the coloniser and colonised and yet appears to join them together in a shared but unequally distributed culture.

Art, therefore, is neither simply the name given by Enlightenment and Romantic Europeans to the white, Western culture that was being produced for the recipients of colonial super-profits nor was it the neutral and universal heading under which the highest achievements of world culture was collected. The theoretical framework of uneven and combined development emphasises the simultaneity of geographically displaced events and the system of exploitation, violence and prejudice that binds them. Therefore, while recognising the urgency of desegregating the canon by turning our attention away from the established category of art, my project is concerned primarily with reinserting the category of art into the historical realities of the world system of colonial capitalism. No part of the canon is completely free from the colonial encounter that forms the category of art. Nor can the specific social form of artistic labour, despite its otherworldly hyperbole, be completely cordoned off from the colonial peripheries as if it belonged only to the colonial centre.

Among the labour power, goods and capital that passed from the periphery to the centre of colonial world trade were the treasures of a world culture including artefacts that came to be categorised as art. The influx of artefacts from across the world was met simultaneously with a growth in sales and a sharpened regimentation of the Fine Arts. Since the Academies protected the status of painting and sculpture as liberal arts by excluding water colour painting, pictures made from human hair, paper cutouts and other crafted objects from the annual Salons, the artefacts that flowed in from the colonies were not typically considered examples of the Fine Arts on arrival but they would be displayed alongside paintings and sculptures in private collections. The field grows and contracts simultaneously. Works of art were found in every region that was colonised. This is not proof that art is timeless but identifies the condition under which the category of art was formulated. The formation of art as a universal category of cultural production is marked by a colonial spatiality in which peripheral regions were simultaneously credited with and looted for their contribution to the history of art.

And yet, even if England played a significant role in the formation of the new category of art in this period, and Italy retained its status, established since the Renaissance, as the leading European nation in matters of painting and sculpture, it was France and Germany that went furthest in formulating the new category of art. As Moretti observes: 'In the 18th and 19th centuries, the long

struggle for hegemony between Britain and France ended with Britain's victory on all fronts – except one: in the world of narrative, the verdict was reversed, and French novels were both more successful and formally more significant than British ones'.[59] There is no direct correlation between levels of colonial exploitation and the intensity of effort in replacing the old system of the arts (painting and sculpture etc.) with the new system of art and neither colonial (or postcolonial) theory nor the orthodox Marxist history of the transition from feudalism to capitalism is sufficient to account for the emergence of art as a new category in the middle of the eighteenth century. Something stranger and more mediated takes place. This is partly because the transition from the arts to art is not achieved principally through either colonial or capitalist mechanisms and partly because it cannot be plotted against a linear history of stages of development. The Warwick Research Collective suggest a more nuanced model in their study of the category of 'world literature'.

What this means is that world literature must be understood not only as literature on a world scale but as an ordering system for literary production and consumption that structurally intersects with the colonial world order. In other words, 'the world-system exists unforgoably as the matrix within which all modern literature takes shape'.[60] Hence:

> To grasp world-literature as the literary registration of modernity under the sign of combined and uneven development, we must attend to its modes of spatio-temporal compression, its juxtaposition of asynchronous orders and levels of historical experience, its barometric indications of invisible forces acting from a distance on the local and familiar – as these manifest themselves in literary forms, genres and aesthetic strategies.[61]

One of the reasons why the micropolitics of work is unsatisfactory is that the concept of work lacks the subcategories through which it is possible to distinguish different social forms of labour. Marxism, however, has provided a matrix of subcategories of labour which are useful in differentiating types of work. For Marxism, labour is differentiated not by virtue of their labour processes but their social relations. The concepts of dead labour and living labour, concrete labour and abstract labour, necessary labour and surplus labour, productive, unproductive and useful (sometimes referred to as reproductive) labour, and

59 Moretti 2003, p. 77.
60 Warwick Research Collective 2015, p. 20.
61 Warwick Research Collective 2015, p. 17.

so on, allow us to analyse specific social forms of labour that appear, on the face of it, to be merely instances of work. If we agree that making art (conceiving it as well as manufacturing or performing it, and regardless of whether these are all realised by the same person or distributed across a large social field) is labour, it remains to be decided (on a case by case basis, perhaps) what social form of labour it is.

This book interrogates the relationship between the artist and the worker, the unpaid labourer, the amateur, the scholar and the artisan through an historical reconstruction of several episodes in the intellectual and institutional reshaping of the production of art as noble, uncommercial, free and individual. While the tropes of artistic labour that developed out of the historical developments covered in this study are often rejected today as romantic, ideological, masculinist, colonial and workerist, my purpose is not to revive the idea of the genius or recover the old socialist optimism in artistic labour but to supply a more detailed map of the terrain on which the politics of labour intersects with art. My claim is that the history of art and labour sheds light on current tendencies.

The purpose of this book is not to show that the artist is a special case but that the anomalies of the transition from the artisan to the artist, which occurs differently in different parts of the world and across a relatively long period of time, are real and continue to have effects on art and artists. Rather than simply rejecting inherited ideas about art and the artist as examples of ideology, I locate them within the heterogeneous and contested transformation of production in the historical passage to capitalism. This re-narrativisation of the specific historical emergence of art and the artist cannot be proposed without addressing the general problems of the two dominant narratives of the emergence of capitalism. My goal is not to claim that the passage from the artisan to the artist exemplifies the passage from feudalism to capitalism. Rather, my study is intended to add to the case against the stageist linear history of transition that promotes a narrow and insular account of a European development that stands as the paradigm of the origin of capitalism.

Jairus Banaji[62] and Harry Harootunian[63] have rightly taken issue with the 'parochialism' of Western Marxism's theory of the homogeneity of capitalism and have shown, by contrast, that each – geographically and historically specific – capitalist social formation is comprised of various parallel economic regimes and the world is characterised by multiple modes of production. Similarly, stories of the dawn of the 'primacy of work'[64] and the 'disciplined attach-

62 Banaji 2011.
63 Harootunian 2015.
64 Anthony 1977, p. 45.

ment to working for a wage'[65] associated with the Weberian tradition do not adequately chart counter-tendencies, anomalies and global geographical variations. Both the Marxist explanation of the historical transition from feudalism to capitalism, contested by traditions associated with Maurice Dobb and Robert Brenner, and Weberian reports of the origin of capitalism by the implementation of a 'work ethic' derived from Calvinist doctrine, fail to account for the simultaneous emergence and transformation of subordinate modes of production parallel to the instalment of industrial capitalism as the dominant mode of production.

Studying the transition from the arts to art and from the artisan to the artist goes against the assumption that capitalism is a single global mode of production for which there is no outside or no substantive internal alternative. The key is to recognise that the capitalist mode of production is the *dominant* mode of production in capitalism, not its *only* mode of production. Paying attention to the anomalous development from the guild system to the gallery system of artistic production is consistent with the view that the capitalist mode of production is the dominant mode of production within a world system of multiple modes of production rather than the only mode of production of a putatively globalised capitalism. No analysis of artistic production can be adequate that fails to register the many ways in which art and its institutions are adapted to capitalist conditions but it is a mistake to over-identify art with capitalism on the strength of the evidence of the existence of the art market, for instance, or the power of corporate sponsors on art's public institutions. Any adequate explanation of the emergence of art and the artist must be able to capture both the heterogeneity of modes of production within capitalism and the shared character of the metamorphosis of both capitalist and non-capitalist production in the eighteenth and nineteenth century. A dominant mode of production does not assert its power only by replicating itself (i.e. abolishing all subordinate modes of production); a dominant mode of production dominates subordinate modes of production by setting the conditions under which they continue to operate.

Chapter 1 lays the foundation for the inquiry by establishing the shared basis of the category of art in general and the category of labour in general by drawing on the Marxist theory of 'real abstraction'. Chapter 2 differentiates between the arts, the Fine Arts and Art as social forms of artistic labour that belong to distinct systems of artistic production. Chapter 3 reconstructs the historical confrontation between the organisation of painting and sculpture

65 Frayne 2015, p. 27.

by guild, court and academy. Chapter 4 extends the historical reconstruction of the formation of art in general by tracing the emergence of a public for art in the emergence of the social forms for the display of works of art in the eighteenth century. Chapter 5 revisits the discourse of genius and its discontents as a lens through which to understand the social figure of the artist as occupying a dialectical relationship to wage labour. Chapter 6 retraces the discourses on aesthetic activity and in contrast to work in German Idealism while Chapter 7 reconsiders the interpretation of attractive labour in Utopian Socialism and the early communist thought of the mid-nineteenth century. Chapter 8 provides a reinterpretation of Marx's theory of alienated labour as a double critique of the theory of labour in classical economics and the theory of alienation in German Idealism. Chapter 9 reassesses the Marxist notion of non-alienated labour in terms of the prerequisites of the supersession of capitalism. And Chapter 10 re-examines the refusal of work and anti-work through the subcategories of labour in Marxism, contemporary Marxist value theory, and a critique of the aesthetic subject implied in a politics of worklessness. The Conclusion repositions the politics of work in the light of the politics of labour in art and the politics of aesthetic labour.

Art, Labour and Abstraction

This chapter interrogates the concepts of art and labour as examples of material discourse. Art and labour are politically loaded terms. Both have been liable to objections about what they include and, more pointedly, what they exclude. If art is taken to be a category of objects distinct from the anthropological, the popular, craft and the everyday, and if labour is taken to be characterised by industrial wage labour (and not unwaged labour, domestic labour, etc.), then the intersection of art and labour covers an offensively reduced territory. Against this we can counterpose the widest expansion of the terms so that art can no longer justifiably be opposed to design, manufacture, entertainment and life in general, and labour refers to every paid and unpaid human and non-human activity of production, reproduction, thought and life in general. This seems preferable but begs the question why the old terms 'art' and 'labour' would be retained to label such boundless categories of activity and inactivity. The more that art and labour are opened up to the diversity that has been historically precluded from them, the greater the pressure to replace these terms with words that connote openness. Just as, for some, art history became 'visual studies', music has been renamed 'sound' and dance has been re-categorised as 'movement', there is a case for replacing art with culture, creative practice or the social production of collective meanings, perhaps, and substituting labour with activity, praxis or, more colloquially, doing.

Vocabularies must keep pace with technological and social developments. Art and labour are, in modern usage, eighteenth-century terms. It would seem feasible, therefore, to expect a great deal to have changed in the interim. Guided by critical theory, it would certainly seem overdue. And yet, since these terms were coined during the era of bourgeois revolution to acknowledge certain emergent social systems, there is a prima facie case for arguing that these terms are required to recognise the persistence of the institutions of art (studio, gallery, museum, art school, art magazine[1]) and its discourses (art criticism, art history and aesthetic philosophy), and the tenacity of capitalist social relations

1 While each element of the bourgeois apparatus of art – studio, gallery, museum, art school, art magazine – has been subjected to radical critique and appears to be continually in crisis, the absence of a revolution in art's bourgeois mode of production is signalled by the reiteration of their negation rather than their replacement with a rival set of institutions or social relations.

(capital/labour, class division, the wage system, value, etc.) that prompted the
formulation of the concept of labour in general in the first place. Art and labour
may be unsatisfactory concepts but the use of more adequate terminology gives
the false impression that the social condition of the art system and the capital-
ist mode of production have already been superseded or are on their last legs.
We can anticipate their disintegration and envision forms of culture and activ-
ity that might replace them, but if we are to base our political analysis on an
account of the existing social structures in place today, art and labour are indis-
pensable.

Art and labour are abstractions. Like Man, Being, Substance, the Idea, Rea-
son, and Good, those Enlightenment terms which were so often capitalised,
art and labour present contingent and arbitrary concrete social activities in
abstract form, as universals. Today, in an intellectual *milieu* alert to how 'lofty
European ideals of Enlightenment-based rational progress and emancipation
rest on the world-historical phenomena of colonialism, imperialist conquest,
and trade in slaves, women, animals, and earth resources',[2] abstractions such as
art and labour cannot be taken at face value. Universal abstractions delegitim-
ise and drive out the specificities of the subaltern. For instance, the Enlighten-
ment concept of Man not only marginalises women but also people of colour,
prisoners, the mentally ill, children and the working class. Accordingly, it has
seemed, at least since the 1970s, that no adequate critical thought is incommen-
surable with universal abstractions and therefore there has developed a polit-
ically charged empiricism in the radical political theory of Michel Foucault,
Pierre Bourdieu, Jacques Derrida, Gayatri Spivak, Giorgio Agamben, Gilles
Deleuze, Judith Butler, Jack Halberstam and others.

The abstractions of the humanist tradition of the Enlightenment are Euro-
centric and imperialistic. They have been subjected to critique and under-
mined time and time again by the specific content of feminism, de-colonisation
struggles and queer politics, for instance. Typically, within this intellectual
tendency, Marxism has been bundled up with the opponents of emancipatory
politics, the cheerleaders of empire and 'the sycophant[s] of capital'.[3] Accord-
ing to Braidotti, '[w]hat is targeted is the implicit Humanism of Marxism, more
specifically the humanistic arrogance of continuing to place Man at the centre
of world history'.[4] Misrepresentations of Marx and Marxism aside,[5] posthu-

2 Braidotti 2013, p. 527.
3 Marx 1990 [1867], p. 932.
4 Braidotti 2013, p. 23.
5 Marx specifically rejected the emphasis on Man in German Idealism and, to put it bluntly,
 substituted Man with worker at a time when the working class was universally regarded (i.e.

manist political thinking and the range of poststructuralist thought to which it is attached disclose the hidden particularities in Enlightenment abstractions and develop ontologies and epistemologies that are vigilantly opposed to abstraction and its false universality.

The abstraction of the category of art and the Eurocentric content of Enlightenment universals, however, remains contentious. Jimmie Durham, a prominent international artist who controversially identifies as Cherokee, gave a paper at the inaugural conference of INIVA in 1994 entitled 'A Friend of Mine Said That Art is a European Invention'. Durham's friend appears to state a fact, even one that could appear to belong to a militant critique of art as an imperial abstraction, but Durham calls the statement into question. The statement that art is a European invention is itself constituted by components that do not refer to particulars but to contested abstractions. 'In the main', Durham said, 'I do not disagree with him. It is only that I am not sure about three of the words in the statement: "Art", "European", and "Invention"'.

What Durham shows is that the terms used to designate a determinate point of historical origin are themselves products of deeply contested and ongoing historical processes. A long shadow is cast by Enlightenment abstractions such as 'art' and 'European' or the modernist norm of 'invention'. On the one hand, to insist on art as European in origin is to dispel the myth that art belongs to all universally and indiscriminately as a world culture of the finest products of humanity, but on the other hand, to narrate the origin of art as an exclusively European story is to echo another myth, namely that the economic, intellectual and cultural development of Western Europe in the eighteenth and nineteenth centuries can be adequately accounted for as exclusively European events. Abstraction has become an intellectual taboo and the accusation of the academic trade in abstraction has become an efficient means of attack.

Foucault's methodology of 'genealogy', which derives from Nietzsche, is a recipe for the conversion of abstractions into the meticulous study of practices, institutions and discursive formations. In *The Use of Pleasure*, for instance, he

by the dominant class) to be subhuman. Braidotti's misreading of Marx – which is typical of the tradition to which she belongs – resumes when she argues that Marxism 'under the cover of a master theory of historical materialism, continued to define the subject of European thought as unitary and hegemonic and assign him (the gender is no coincidence) a royal place as the motor of human history' (Braidotti 2013, p. 23). Marx, of course, argued that class struggle, not man, is the motor of history, and it was not the 'subject of European thought' but workers in concrete social conditions that had central place within the critique of political economy and the political project of abolishing capitalism. I take this issue up again in Chapter 8.

rejects the construction of a history of 'what might be true in the fields of learn-
ing, but an analysis of the "games of truth", the games of truth and error through
which being is historically situated in experience; that is, as something that
can and must be thought'.[6] Agamben has endorsed Foucault's focus on partic-
ularity, saying he 'always refused to deal with the general categories or mental
constructs that he calls "the universals", such as the State, Sovereignty, Law
and Power'.[7] In the place of these universals, Foucault and Agamben situate
particularity in multiple positive ensembles that they call 'discursive forma-
tions', 'apparatuses', 'paradigms' or simply 'knowledge'. Foucault did not offer
definitions of these terms, but Agamben does, explaining that this means 'neut-
ralizing the dichotomy between the general and the particular' moving 'from
singularity to singularity'.[8]

Foucault and Agamben, therefore, are the heirs of Max Stirner, who Marx
and Engels criticised for believing that particularity was the cure for abstrac-
tion. Marx and Engels explain the matter as follows.

> The production of ideas, of conceptions, of consciousness, is at first dir-
> ectly interwoven with the material activity and the material intercourse
> of men, the language of real life. Conceiving, thinking, the mental inter-
> course of men, appear at this stage as the direct efflux of their material
> labor. The same applies to the mental production as expressed in the lan-
> guage of politics, laws, morality, religion, metaphysics, etc, of a people.
> Men are the producers of their conceptions, ideas, etc – real, active men,
> as they are conditioned by a definite development of their productive
> forces and of the intercourse corresponding to these, up to its furthest
> forms. Consciousness can never be anything else than conscious exist-
> ence, and the existence of men is their actual life-process. If in all ideology
> men and their circumstances appear upside-down as in a *camera obscura*,
> this phenomenon arises just as much from their historical life-process
> as the inversion of objects on the retina does from their physical life-
> process.[9]

It is in this context that Marx and Engels assert that 'morality, religion, meta-
physics, all the rest of ideology ... have no history' except the history of material
production and material intercourse. In the language of Agamben this means

6 Foucault 1990, pp. 6–7.
7 Agamben 2009, p. 7.
8 Agamben 2010, p. 31.
9 Marx and Engels 1996 [1845], p. 47.

singularities need to be reconnected with the ensemble of singularities in material intercourse (which is what Foucault and Agamben do) but also with the material production of real history.

What is the problem with universals for Marx and Engels? Marx and Engels did not reject abstraction in the way that Stirner did. Instead, they sought to relocate universals within the lived experience that they appeared to hover over. 'As soon as this life-process is described, history ceases to be a collection of dead facts as it is with the empiricists (themselves still abstract)', Marx and Engels say, 'or an imagined activity of imagined subjects, as with the idealists'.[10] As such, Marx and Engels took the problem of universals and the relationship of abstract ideas to real existence and combined them in an unprecedented way. What Marx and Engels argue, against both positions, is that if you want to know the 'essence' of something, then you should look neither to the idea nor to the particular, but to the ensemble of particulars to which the particular belongs.

The ensemble of particulars just is material intercourse embedded in material production. Hence, ideology critique traces the social life of ideas in which the most abstract thought derives their content and value from the world in which they circulate, including the way that abstract ideas are set off from everyday life by the division between manual and mental labour. 'Viewed apart from real history', they said, 'these abstractions have in themselves no value whatsoever'.[11] We can add, though, that specifically when 'viewed apart from real history' these abstractions appear to have a value all of their own. This apartness is the signature of what Marx and Engels call ideology and it is the elimination of this apartness that is the aim of ideology critique. Abstractions are separated from real history and therefore the critique of abstraction reconnects abstractions with the real histories that form them.

The historiography of the emergence of art in the eighteenth century (including the overstated transition from patronage to the art market), has traced the emergence of art as an abstraction without reconnecting it to the ensemble of particulars to which it belongs. At the same time, this historiography has not deviated from the Eurocentric narratives of art's modernity. If the 'birth of art' is charted as a European trajectory, the solution is not to assert that this abstraction is secretly a cover for Eurocentric hegemony since the problem is to narrate the colonial history of modernity as an exclusively European history. Since modern Europe cannot be understood fully within exclusively Western terms because their economies, policies, military campaigns and culture unfold as a result of colonial enterprises, competition over colonial territories and the

10 Marx and Engels 1996 [1845], p. 48.
11 Ibid.

accumulation of wealth from the slave trade, profits from colonial goods, it is essential that art in general – that is, art as an abstraction – must be reinserted into the ensemble of colonial relations.

Grasping the fundamental interpenetration of colonialism and art cannot be reduced to reporting on how art is deployed within colonial rule. It is essential to acknowledge 'the paramount importance of culture in consolidating imperial feeling',[12] as Edward Said put it in *Culture and Imperialism*. Art becomes an abstract and universal category within a colonial world order but it does not, thereby, refer only to one part of that world system. Just as Stuart Hall called for a 're-narrativisation' of the established literature on the unfolding of modernity in Western Europe, and just as postcolonial theory 'displaces the "story" of capitalist modernity from its European centering to its dispersed "peripheries"',[13] so the history of the emergence of art as an abstract category cannot be told only 'from the point of view of Europe as the protagonist',[14] to use Doreen Massey's phrase.

One of the problems with saying that art is a European invention or a European category, therefore, is that this statement obscures the fact that Europe, at the time when the category of art was first formulated as distinct from the arts, was in no sense isolated from the rest of the world. In other words, any radical response to art as an abstraction which rejects it on the basis that it is code for Eurocentric culture merely exchanges one kind of abstraction for another. Extracting Europe out of the total ensemble of colonial relations is itself a form of abstraction. Additionally, formulating a single approach to all abstractions, regardless of whether they are intellectual abstractions or 'real abstractions' (see below), is methodologically abstract.

Historical accounts of the birth of art, aesthetics, taste, genius and so on that chart developments within Western Europe abstract art from the world system that gave rise to it. Eighteenth-century Europe was characterised by its colonial relationships, aesthetic discourse was stamped with racial tropes, and modernity is first formulated in contrast with the ancient world under a colonial ordering of the world. Henry Louis Gates Jr. has demonstrated the presence of colonial discourses in the formative literature on art and aesthetics, and this is important work, but I want to go further. Art is not just marked by racism and is not only a repository of colonial values, codes, characters and ideas but is, I will argue, a colonial category. That is to say, the abstraction of art in general is an effect of coloniality itself.

12 Said 1993, p. 249.
13 Hall 1996, p. 250.
14 Massey 2005, p. 63.

My argument that art arises as a category at the intersection of colonialism, modernity, Enlightenment and capitalism deliberately goes against the tendency to narrate the so-called invention of art as an historical episode within and strictly internal to European cultural, social and political developments. The most respected insular account of art as a specifically European invention is Paul Oscar Kristeller's reconstruction of the formulation of 'the modern system of the arts'. Kristeller, who was one of the greatest historians of Renaissance humanism, has set the tone for studying the historical origins of art as a category. His narrative of the gradual grouping together of the five Fine Arts under a single heading (which is unheard of before the seventeenth century and is not fully formed until the mid-eighteenth century but has its roots in the category of the arts of design in Leon Battista Alberti's theory and Giorgio Vasari's academy in the Renaissance), remains, in large part, the accepted account of the extended historical passage through which the modern category of art is formulated.

Kristeller said 'the term "Art", with a capital A and in its modern sense, and the related term "Fine Arts" (Beaux Arts) originated in all probability in the eighteenth century'.[15] This is an important starting point for the investigation into the historical formation of the category of art but Kristeller reinforces the abstraction of the emergent category of the Fine Arts rather than reinserting it into the ensemble of particularities insofar as he gives an uncritical emphasis on the emergence of the 'term' art and reiterates the narrative of European protagonists in the transformation of cultural classification. For Kristeller, the Fine Arts (and art, which he does not systematically distinguish from the Fine Arts) is an intellectual or noetic abstraction: it is nothing but the classification of certain arts (painting, sculpture, music, architecture and poetry).

Kristeller halts the inquiry before the Fine Arts metamorphosed into the transition to art in general. While the category of the Fine Arts, and especially the concept of Fine Art in the singular, appears to be synonymous with art in certain contexts, the history of modern and contemporary art cannot be adequately understood without a category of art abstracted from the Fine Arts and therefore no longer identical with them. Not only is art, as an abstraction, a more capacious category than the Fine Arts, but it is also a prompt to artists (including poets, musicians, and others) to deviate from the art of painting, the art of composing, the art of drawing and so on. That is to say, the category of art must be differentiated from the Fine Arts because the Fine Arts remain arts whereas art, in a curious but fundamental sense, does not. Art is neither one of the arts nor does it consist of a grouping of the arts.

15 Kristeller 1990 [1951], p. 164.

Regardless of whether the difference between the Fine Arts and art in general is regarded as a critical and ontological milestone or a regrettable and corrupt development, the difference must be acknowledged and its history can be traced. In my analysis, the difference is not primarily conceptual or theoretical but is constituted through the transformation of art's social relations of production.

My reconstruction of the historical emergence of art in general (in the wake of the Fine Arts) focuses on an analysis of the changing social form of artistic labour. Art is an abstract category but it is formulated, I want to argue, as part of the reorganisation of work on the threshold of industrialisation. Rather than dismissing the myth of the artist as a myth (a form of abstraction that appears to obscure the actual social conditions of artistic production), I will relocate the emergence of the Enlightenment and Romantic discourses on the artist within the world system marked by the slave trade and subject to the parallel historical passage 'from artisan to worker'[16] within the transformation of work through the abolition of the guild system.[17]

In this broader material framework, Kristeller's remark that 'for Aquinas shoemaking, cooking and juggling, grammar and arithmetic are no less and in no other sense *artes* than painting and sculpture, poetry and music',[18] can be read also as indicating that the Fine Arts and art in general not only *elevated* the arts of painting and sculpture above shoemaking and so on, but also, insofar as shoemaking and cooking can stand in for artisanal production worldwide, that the Fine Arts exhibited a special kind of hostility not only to artisanal production in Europe but handicraft globally. This is why it is essential to weave this history of the abstract category of art through the contested history of work that was characterised by the coeval existence of slavery, the apprentice system of indentured work, the guild regulation of freedoms, wage labour, child labour, the idle rich, vagabondage, beggars and the working poor. That is to say, my reading of the historical episode narrated by Kristeller consists of a remapping exercise in which I interweave his history of ideas with the historical, economic and sociological analysis of the transformation of art within a wider history of the reorganisation of work.

My inquiry, therefore, attempts to reconstruct the historical transition from the premodern system of the arts to the modern category of art in general and therefore reinserts art as an abstraction into the world system under which

16 See Fitzsimmons 2010.
17 See Sewell 1980.
18 Kristeller 1990 [1951], p. 176.

art is formed as a specific social form of labour that is neither reducible to a remnant of feudal guild production nor an example of the emergent industrial mode of production.

To interrogate art as a category that was forged originally within and according to the contours of the colonial world system is to approach the relationship between culture and the global division between centre and periphery quite differently from the reading of the intertwinement of culture (specifically literature) and imperialism in the work of Edward Said, for instance. Said focuses on colonial and imperial narratives within the nineteenth-century novel and, in doing so, pays particular attention to the representation of empire in culture and the formation of an imperial ethos through culture. Conrad and his characters, for instance, become narrators of imperialism and witnesses of its mechanisms or specimens of its normative horizons.

Culture, for Said, is an active force within the imperial formation of national and racial identities. Hence, culture represents empire to itself in a dynamic process of social and subjective construction. 'What I want to examine', he wrote, 'is how the processes of imperialism occurred beyond the level of economic laws and political decisions',[19] in which this 'beyond' of economics and politics is conceived of as the realm of culture through which subjects are formed and their relations are delineated. Said explains that this conception of culture goes against the grain of the official perception of culture 'as a realm of unchanging intellectual monuments, free from worldly affiliations'.[20] Even so, his investigation of culture is primarily a reading of works rather than an analysis of the formation of its constitutive institutions, the construction of its operative categories or its specific division of labour.

'What are the *cultural* grounds on which both natives and liberal Europeans lived and understood each other?',[21] Said asked. This variant of cultural politics assumes the categories of art and culture, forming its critical and subversive re-readings within them rather than charting the historical formation of them within political history. It is true that Said rejected culture as a separate sphere and he attached the perception of culture as elevating, formulated vividly by Matthew Arnold in the 1860s, to the deployment of culture within processes of xenophobia and national identity.

However, in order to grasp the structural alignment of art and culture with colonialism and imperialism we must shift the focus from the interpretation of works to the analysis of the conditions under which works are made. That

19 Said 1993, p. 12.
20 Ibid.
21 Said 1993, p. 241. Emphasis added.

is to say, we can invert Said's question: instead of inquiring into the cultural grounds of colonial encounters, we can investigate the colonial grounds of the categories of art and culture.

Gilroy has highlighted how 'questions of "race" and representations have been so regularly banished from orthodox histories of western aesthetic judgement, taste, and cultural value'.[22] This blindness can begin to be redressed, Gilroy argues, through the kind of close reading undertaken by Sander Gilman who has identified 'the history and image of the black in … the aesthetics of Hegel, Schopenhauer, and Nietzsche (among others)'.[23] What Gilroy, Gilman, Gates and others demonstrate so brilliantly is that the infrastructures and codifications of nationalism, race, colonialism and imperialism leave their mark on art and aesthetics not despite their alleged autonomy but precisely because of it. This is an important contribution to the critical insertion of art and its discourses within the structures and economies at large not as a structural intersection but as the traces of social asymmetry left on texts and artworks themselves.

As well as acknowledging how the social relations that make a mockery of culture's formal universalism come to penetrate that culture even in its most exemplary expression, it is also possible to investigate the historical formation of the conditions and categories of art and its discourses which themselves were, in turn, shaped by the advance of empire, modernity and capitalism. Arguably, this means no longer being able to seek refuge in art and culture in the way that Gilroy does in his rejection of the allegedly Marxist concept of labour. Gilroy refers to 'the simple fact that in the critical thought of blacks in the West, social self-creation through labour is not the centre-piece of emancipatory hopes', and opposes this directly to 'artistic expression' which he associates with 'autobiographical writing, special and uniquely creative ways of manipulating spoken language, and, above all, the music' which he identifies as 'the means towards both individual self-fashioning and communal liberation' for 'descendants of slaves'.[24] His faith in culture and 'artistic expression', which has its justification in the subjectivities and subcultures of what he calls the 'black Atlantic', is rooted also in a very particular form of universalism that expresses the experience of the colonial encounter from the perspective of the West.

Art, as a category, is shaped by colonialism not simply by virtue of being a synonym for or subcategory of culture and its correlates (civilisation, the

22 Gilroy 1993, p. 9.
23 Gilroy 1993, p. 8.
24 Gilroy 1993, p. 40.

aesthetic, literature, and so on). If culture and its prevailing discourses in the nineteenth and twentieth centuries had operated according to a principled split between the interpretation and evaluation of works of art and the social structures and systems through which they passed, there exists now a considerable body of writing that persuasively argues that culture and its correlates are fundamentally and thoroughly intertwined with colonialism, imperialism, nationalism, racism and underdevelopment. What I want to suggest is that it is not only the transfer of wealth and goods and slaves across the globe that gave Europe its material dominance over the colonial world system, but also that these very same relations gave shape and sense to the development of a colonial variant of cultural universality. Hence, the story of the complex relationship between art and labour that emerges in Western Europe in the eighteenth century and is not fully established until the early twentieth century cannot be told merely as an episode in European history.

In the place of the study of the classification of a certain category of objects (works of art), I inquire into the historical processes that differentiated *a specific form of labour necessary for the production of works of art* (artistic labour, for short). Although there is no distinctive type of work that produces art, there is nevertheless a social form of artistic labour. Therefore, the missing thread that integrates the established narratives of the birth of art but is missing from them all, I want to argue, is the metamorphosis of labour in the formation of art's specific mode of production. The focus of the investigation, however, is not the labour processes themselves. It is not the techniques of painters and sculptors that is decisive, here, but the social relations of production, the social division of labour and the spatial distribution of work. Nor does the remodelling of the consumer of works of art from patrons to dealers and collectors drive the social elevation of the artist above the artisan or set the agenda of the hostility of art to handicraft or bring about the dissolution of the workshop and the establishment of the studio. Underlying all these tendencies, I want to argue, is the fundamental social reorganisation of the material basis of the production of works of art.

The identity of certain artistic practices and certain social forms of labour cannot be decided on the basis of a similarity of the labour process alone rather than the social relations of production. For instance, the likeness of painting and handicraft or relational aesthetics and the service sector, which is a matter of shared techniques, scales of production, tools and so forth, are quite distinct when analysed in terms of the social division of labour and the economic relations of production. As such, my investigation into art as a social form of labour is not, as it were, based on what happens in the studio but interrogates the studio itself as a spatial form within a specific social division of

artistic labour. Or, at a different scale, the question is not what artists do but what kind of social order gives rise to the artist.

I want to reconstruct and reinterpret the historical emergence of the category of art, or the so-called 'invention of art', as an episode in the history of labour and, at the same time, therefore, add a neglected dimension of the history of labour. That is to say, I am claiming that the social history of art can be enriched by examining the transformations of artistic labour and the history of labour can also be augmented and clarified by tracing the multiple ways in which art and artistic labour figure within the discourses and practices of the politics of work. By doing so I intend to provide not only a vivid lens through which to see both art and labour but to remap art within a world system of the social division of labour. By looking at the social division of labour rather than focusing on labour processes themselves – for instance, artistic technique and processes of deskilling – it is possible to acknowledge in full the contribution of the global workforce, including unpaid domestic workers, in the spatially dispersed processes necessary for the production of art. This means we cannot restrict the analysis of artistic labour to the activities that take place within the artist's studio.

What we need, I would hazard, is not an ontology of art (i.e. an account of the properties of artworks) but a history of the uneven and combined development of art and artistic labour as part of the political history of labour that confronted the capitalist mode of production and the emerging factory system as they impacted on the European centres of industrial capitalism and the colonial peripheries that were transformed differently within the same world system. From the European point of view, the emergence of the artist from the crisis and dissolution of the guild system, therefore, represents a non-standard trajectory of a *subordinate* mode of production within colonial capitalism, but from the point of view of the colonised, artistic labour confronts indigenous and slave labour as a privileged activity. That is to say, the artist is simultaneously the construction of an unprecedented demarcation of freedom (partly understood as freedom from traditional and modern forms of production) that amplifies colonial divisions.

While it is well known that Marx was the first to point out in the *Grundrisse* that labour in general 'is as modern a category as are the relations which create this simple abstraction',[25] it is less well known that art, as a general category distinct from the manifold specific arts (painting, sculpture, etc., but also cooking, war, shoemaking and so on), was formed at the same time as labour in general.

25 Marx 1973 [1857–58], p. 103.

For clarification I should say, Marx did not argue that labour was modern, only the category of *labour in general*, which I will explain shortly. And similarly, I am not arguing that art did not exist prior to the eighteenth century, only that the category of art is developed then. Whereas the category of art is conventionally understood by art historians and aesthetic philosophers as a class of objects, I will attempt to narrate the emergence of art as a specific social form of labour. As such, art in general and labour in general are not merely the same age and share certain characteristics (abstraction, generality, etc.), they are also implicated in one another's formation.

Kristeller, who studies changes in the literature, argued in the early 1950s that the Fine Arts were formulated as a modern classification of five arts – painting, sculpture, music, architecture and poetry – within a history of ideas. For him, the Fine Arts had long existed prior to the category in which they came to be united and therefore the category was primarily an idea or a concept. More recently, Peter Osborne has argued that the inquiry into the 'ontological distinctiveness of the work of art'[26] is inaugurated philosophically by the young philosophers of Jena Romanticism in the second half of the 1790s. Insofar as Osborne argues specifically that 'the *philosophical* concepts of art and criticism … derive from this small group in this brief period',[27] he is correct, but such an approach risks conflating art as an abstraction with the abstractions of thinking of the arts in their generality. In my analysis of the advent of the category of art, on the contrary, art is principally determined by the social arrangements – particularly the social division of artistic labour – that takes shape within and against the capitalist mode of production.

When I refer to the category of art, I am not thinking of a classification of a certain type of object. Neither the category of art nor the category of work is a concept: both categories are formed in the eighteenth century primarily through novel forms of social organisation. Labour in general and art in general are abstractions. Labour, in this general sense, is abstracted from the specificities of labouring. This is not accomplished in thought – by thinking about labour in its generality rather than as this or that particular labour process. The abstraction of labour results from the capitalist mode of production itself. This is because value, which is defined as the average socially necessary labour time required to reproduce them, converts labour from being so many qualitatively distinct activities to exchangeable quantities of labour-time. Abstraction is sovereign in the capitalist mode of production because, under this system, the

26 Osborne 2013, p. 43.
27 Osborne 2013, p. 56. Emphasis added.

individual worker who takes 3 hours to complete a job that on average can be completed in 1 hour discovers, through the market for labour or commodities, that she has produced only 1 hour's worth of value in 3 hours.

Marx assigns two distinct categories of labour to each of these forms of labour. 'Concrete labour' refers to the actual labour and the actual time that the individual performs, while 'abstract labour' refers to how the same activity is mediated by value. In the words of Alfred Sohn-Rethel, 'labour, when determining the magnitude and substance of value, becomes "abstract human labour"'.[28] Unlike the abstractions of philosophy and social science, for instance, labour in general, like value and money, 'is a *real abstraction* resulting from spatio-temporal activity'.[29] Both concrete labour and abstract labour are real, however. In capitalism abstract labour dominates over concrete labour, so, although concrete labour persists in capitalism, labour in general (i.e. abstract labour) is the distinctively modern and capitalist form of labour.

Real abstraction differs from a mental or noetic abstraction insofar as it is 'abstraction not as a mere mask, fantasy or diversion, but as a force operative in the world'.[30] What's more, it functions by virtue of the relationship between the part and the whole. Real abstractions are relational, structural and over-arching. Marx developed the concept of real abstraction in order to steer a course between the positivist assertion of concrete reality and the idealist assertion of the essences of things abstracted from things themselves. Labour, for instance, appears to classical economists as a timeless category that overrides all the different forms of labour that have appeared in specific historical modes of production but for Marx the category of labour in general is formed historically through a specific set of relations, that is to say, labour becomes abstract only through its transformation by capital. Labour in general, therefore, is not a type of labour but a relationship between this instance of labour and the totality of living and dead labour.

Benjamin Noys summarises the emergent discourse of real abstraction in Marxist philosophy in a single phrase: 'real abstraction as the ontology of capital'.[31] Noys reads the techniques, institutions and agencies of financialisation, speculation, digitalisation, dematerialisation and spectralisation as evidence that 'capitalism itself is a directly theoretical or philosophical matter'.[32] Even if this is true, the assertion appears to deliberately smudge the difference

28 Sohn-Rethel 1978, p. 18.
29 Sohn-Rethel 1978, p. 20. Emphasis in original.
30 Toscano 2008, p. 274.
31 Noys 2012, p. 10.
32 Ibid.

between real abstraction and noetic abstraction by presenting the real abstractions of capitalism as objects for philosophical reflection. Nevertheless, Noys recognises that the financial crisis 'indicates both the power and vulnerability of real abstractions'.[33]

Of course, the credit crunch is no more abstract than the sale of labour for a wage or the purchase of pencils at the pound shop but it is important to acknowledge that the virus of concrete impoverishment and the avalanche of waste that every financial crisis produces is the effect of the operation of real abstraction in the concrete practices of daily life. And this is why Noys is right to stress that 'the crisis is revelatory of the ontology of capital, at once spectral and real, empty and material, voided and differential'.[34]

Labour in capitalism is dominated by the abstract measurement of value. Every living act of abstract labour is mediated by real forces that impose an abstract measure of specific activity thereby ridding that activity, for the sake of exchange, of all of its specific qualities. Money, similarly, is wealth abstracted. All treasures have specific material qualities, and therefore wealth in non-monetary form never completely takes the form of quantity rather than quality. Money is wealth as quantity without qualities. Two gold sovereigns, as money, are not compared with one another in terms of the quality of craftsmanship gone into them, as comparisons of treasure would, but only weighed to see if one has been clipped. When money is merely a means of exchange and a measure of value it is already a real abstraction, since, as the universal equivalent, it is an abstraction from all particular use values and forms of wealth. However, when money becomes an end in itself, then it becomes a real abstraction.

What Marx says about labour as an abstraction is true also for art although not for the reason that it is directly dominated by the law of value. Artworks do not represent socially average necessary labour time but the category of art in general is a 'real abstraction'. Art, like labour in general, takes on an abstract social form that gives the impression that it is free from these specific modern social relations. Art, therefore, can be described in exactly the terms that Marx used to describe the ahistorical concept of labour in classical political economy, namely that it 'expresses an immeasurably ancient relation valid in all forms of society, nevertheless achieves practical truth as an abstraction only as a category of the most modern society'.[35] Art, therefore, when it is abstracted from the manifold specific arts (first by elevating itself above handicraft in the

33 Noys 2012, p. 12.
34 Noys 2012, p. 13.
35 Marx 1973 [1857–58], p. 105.

seventeenth century and then dissolving the specific arts in a single, general category of art in the eighteenth century), appeared from that point forward to be immeasurably ancient and valid in all forms of society.

Nevertheless, just as Marx showed that it is only 'in the most modern form of existence of bourgeois society' – Marx singles out the United States – that 'the abstraction of the category "labour", "labour as such", labour pure and simple, becomes true in practice',[36] so art achieves practical truth, that is to say, becomes a real abstraction, only under social conditions in which the abstract category of art is the principle by which art is produced and circulated and through which its producers and consumers are produced.

Art in general is art abstracted from the arts. Art, in this sense, may be an example of painting, sculpture, music, dance, drama or any one of the arts but also may consist of none of them, since art in general is a category that includes all the Fine Arts but is not limited to them. It is the social division of labour that sets up art in general as an abstraction from the several specific Fine Arts. Indeed, Postone has claimed that 'the historical emergence of abstract thought, philosophy, and natural science' is strictly related to the historical emergence of 'abstract social forms'.[37] 'This example of labour', Marx said, 'shows strikingly how even the most abstract categories', despite their validity for all epochs 'are nevertheless, in the specific character of this abstraction, themselves likewise a product of historic relations, and possess their full validity only for and within these relations'.[38] This is also true of art.

Marx says 'labour loses all the characteristics of art; as its particular skill becomes something more and more abstract and irrelevant, and as it becomes more and more a *purely abstract activity*'.[39] Marx argues that labour 'ceases to be thinkable in a particular form alone'.[40] This is an emphatic formula for a contested process in which the persistence of thinking about particular forms of labour such as the various artisanal traditions or agricultural handicrafts lose their social basis and become utopian, romantic, sentimental or nostalgic. It would be similarly exaggerated to claim that the Fine Arts cease to be thinkable in their particularity after the abstract category of art in general is established from the eighteenth century onwards.

In my analysis of the emergence of artistic labour as a specific form of labour, I will speak of art as a category rather than a concept precisely to undermine

36 Ibid.
37 Postone 1993, p. 179.
38 Marx 1973 [1857–58], p. 105.
39 Marx 1973 [1857–58], p. 297.
40 Marx 1973 [1857–58], p. 104.

the prevailing ontology within the critical literature on art and the artist in which social differentiations are described as symbolic ones. Art is not merely a concept or a conceptual framework that is deployed to transform otherwise mute material. One of the reasons why art appears to be a discursive construction is that the history of critical thinking on these matters, including the social history of art and the philosophy of art's ontology, has focused almost exclusively on art as a category of objects. Since such objects appear to be only contingently distinct from other objects, then the category of art objects appears to be a conceptual rather than a material designation. My analysis of the category of art, however, is based on an historical reconstruction of a specific social division of labour that is, as we will see, constituted, amongst other things, through the geographical dispersal of previously integrated activities, the formation of specific institutions and the reordering of the social *milieu* for works of art.

Art, the artist and artistic labour emerge historically by virtue of and in opposition to the capitalist mode of production. It might be expected, therefore, that art will die with the development of post-capitalism. However, the blueprint for art (and the first step in the differentiation of painting and sculpture from handicraft, mechanisation and industry), namely the Fine Arts as they were regulated by the Academy system in the seventeenth and eighteenth centuries, were pre-capitalist. In some sense, therefore, even though the social division of artistic labour (the artist, the critic, the dealer and the tutor in the studio, the art magazine, the gallery and the art school) is specifically modern (and arises only with capitalist specialisation after the abolition of the guild system), there is a normative dimension of the art system which is translated very fluently into anti-capitalism because it derives from a pre-capitalist formation. Art is not born with commodification and the so-called transition from patronage to the art market, as some would have it, but from the outset preserves a noble version of the rejection of commercial transactions.

This is not to imply that each social system (pre-capitalism, capitalism and post-capitalism) is economically, socially and culturally homogeneous and that, therefore, the transition from capitalism to post-capitalism must mean the complete and utter abolition of everything that existed under capitalism. Nor do I mean to suggest that art corresponds to the capitalist mode of production and that that is why it might be expected to perish with it. Rather, the dominant mode of production always co-exists with multiple subordinate modes of production. Since artistic labour has never been subsumed under capital and therefore has not been converted into abstract labour, the survival of art is not incompatible with post-capitalism.

Nevertheless, the preservation of the particular disciplines of the Fine Arts within the contested field of art is real but unthinkable insofar as, for instance,

the formula 'painting as an art' is replaced with the formula 'painting as art'. In other words, the preservation of the Fine Arts within art depends upon the former's re-articulation in terms of the latter. While painting, drawing, carving, casting and composing do not themselves become anachronistic with the transition from the arts to art in general, the social institutions of the several specific arts (the guilds, livery companies, artisan workshops, Academies of painting and sculpture, and so on) survive through processes of adaptation to a cultural, social and economic system no longer structured by the hierarchy of the arts. Even where artisanal social relations flourished, such as in India, the practices of painting and sculpture came under the new heading of art, albeit according to a colonial hierarchy that placed Western art in a privileged position within the modern category of art.

Art as a real abstraction had been misrecognised in historical accounts of the elimination of handicraft within modernist and avant-garde art. In place of the historical transition from the several specific arts to the category of art in general (i.e. art as an abstraction), the study of the hostility to handicraft as expressed artistic technique rather than the social relations of production gives the false impression that the transition to art in general occurs in the twentieth century. The Duchampian rupture with painting is usually taken as emblematic of a break with and abstraction from the artisanal. Following Duchamp, Thierry de Duve says, 'you can now be an artist without being either a painter, or a sculptor, or a composer, or a writer, or an architect – an artist at large'.[41] Here, the artist is more abstract than the painter and art is more generic than paintings, sculptures, etc. Simply, art is a more abstract and general category than painting, sculpture, music, architecture and poetry since it is either the common heading under which they each operate or indicates fields of practice beyond the traditional disciplines of the Fine Arts. If, as I claim, art is a real abstraction then the Duchampian theory of art in general presents this not as a transformation of art's social relations but as an accomplishment of critical thinking and self-reflexive technique.

John Roberts argues that the advent of an 'art beyond artisanship'[42] is a distinctly twentieth-century event. Following Hal Foster's temporality, in which he argues that 'rather than cancel the historical avant-garde, the neo-avantgarde enacts its project for the first time',[43] Roberts' account, which ostensibly turns on the revolutionary impact of the readymade from the early twentieth century, dates the critical moment to 1960. Focusing on these episodes in twen-

41 Duve 1999, p. 154.
42 Roberts 2007, p. 52.
43 Foster 1994, p. 20.

tieth-century art history, Roberts and others detect the transition from the arts to art in general within artworks and the techniques used to produce (or procure) them, rather than on the social relations of artistic production. Art in general is not the historical effect of the technical transformation of artworks. On the contrary, the possibility of deskilled, anti-artisanal artworks is an effect of the historical reorganisation of artistic production outside and hostile to the organisation of handicraft and manufacturing. As such, the elimination of handicraft from artworks in avant-gardism *presupposes* that the historical confrontation with the artisanal mode of production has already delivered the artist into a social division of labour in which handicraft appears to be obsolete. In other words, the classificatory abstraction of post-Duchampian art as distinct from painting and sculpture is dependent on the real abstraction of art which the analysis of such works fails to thematise.

Jean-Luc Nancy dates the transition prior to modernism and avant-gardism, saying '[w]e have been saying "art" in the singular and without any other specification ... only since the romantic period'.[44] He makes this observation, however, not to provide an historical account of the transition from the social relations of handicraft painting and sculpture to the specific social form of art in general but simply to turn his back on modern usage, preferring the specificity of the multiple arts of painting, sculpture and so on rather than the abstract concept of art. Janet Wolff also argues that 'we have a generic term "art" which directs us to class together these diverse enterprises and activities'.[45] She objects to the abstract category because her 'generic sociology of the arts' requires an analysis that is 'sensitive to diversity in art'.[46] In doing so, Nancy and Wolff suppress the material embodiment of the general concept of art in the specific institutions of the art museum, the art magazine, the art history journal, university departments of art and art history and the art market. Within the actual circumstances of a culture ordered by the concept of art in general, the insistence on the specificity of the various arts betrays, ironically, a nostalgic attachment to an abstract principle against a real abstraction.

Labour in general is abstract labour because it is regulated by value, i.e. average socially necessary labour time. Art in general is abstracted from the specific arts (both the liberal and mechanical arts generally and those classified as the Fine Arts in particular) not by being subject to the law of value but by being exempt from it. Hence, the inquiry into the historical conditions for the emergence of the specific social form of art in general is an inquiry

44 Nancy 1996, p. 4.
45 Wolff 1981, p. 4.
46 Ibid.

into the normative, institutional and social basis of art's economic exception-alism.[47] Although arising from very different social processes, the producer of art in general shares a remarkable feature with the wage labourer. For the worker within the capitalist mode of production, Marx explains, '[i]ndifference towards specific labours corresponds to a form of society in which individuals can with ease transfer from one labour to another, and where the specific kind is a matter of chance for them, hence of indifference'.[48] Art in general, which has its roots in the seventeenth-century hostility to guild handicraft and the mechanical, culminates in a display of indifference towards any specific kind of work.

The narrative of the transition from the arts to art in general can only be told, I want to argue, by turning our backs on artworks and reflecting, instead, on the social relations of artistic production. This is not disclosed either by read-ing artworks as hieroglyphs of social developments nor by a close reading of the literature as evidence of the dawning consciousness of art in general's real abstraction. It shows itself in the myth of the artist and anxieties about com-merce, the rise of scholarship and fears about the public, hyperbolic expres-sions of artistic freedom and accusations against artisans copying works of art, and it shows itself in institutions, legislation, disputes and economic transac-tions. However, it would be wrong to assume that the transition from the arts to art consists of a one-dimensional break with the past.

Both art and labour are distinctively 'modern', in Marx's terms, precisely insofar as their modernity is bound up with the concealment of their historicity. That is to say, both art and labour are abstractions insofar as they universal-ise the specific social conditions of a world system dominated by a handful of Western powers. If we can say, with Marx, that political economy is foun-ded on the assumption that labour in its modern abstract form is evident in all societies throughout history, art is formulated as a modern category with the assumption that art is not only present in all societies but is exemplified by certain ancient societies in which the concept of art was absent. Art does not appear in its singular and abstract or general form until the middle of the eighteenth century and yet it is presented by those who first formulate it both as a break and a bond with the history of the arts of painting, sculpture, poetry, music, theatre and architecture that preceded it. What's more, we can say, these individual arts survived by submitting to the hegemony of art in general and operating henceforth within the institutions of art as a real abstraction.

47 See Beech 2015.
48 Marx 1973 [1857–58], p. 104.

Adorno is correct to assert that 'the arts ... do not disappear tracelessly in the general concept of art',[49] because art executes its break from the history of the arts precisely by bonding the arts together under the unprecedented category of art in general. No clear line is drawn between art and the arts in the eighteenth century or since because art as an abstraction is a category that is sufficiently general to accommodate the entire history of painting, sculpture, music, literature and, at least in principle, all the other arts. The smudging of the line between the arts and art in general, which expresses the break and the bond between art and the arts, is a specific instance of what Marx described as the simultaneously modern and timeless character of real abstractions.

If the transition from the arts to art *via* the Fine Arts is integrated with the metamorphosis of the artisan into the artist, then the formation of the category of art cannot be narrated adequately without tracing the upheavals in the mode of production generally and the specific transformation of the social relations of artistic production on the threshold of colonial modernity. Insofar as the literature on the emergence of the Fine Arts and art in general tends to emphasise the formation of the category of a certain set of objects, specifically as these objects are experienced rather than produced, the historical and social processes that are operative in the formation of the categories are minimised or eliminated from the account and therefore the global significance of the transition from the arts to art is lost.

It is not necessary for artistic production to become an instance of capitalist commodity production in order for it to adapt itself to capitalism. The degree to which artistic production subordinates itself to the capitalist mode of production or the capitalist mode of circulation is never stabilised and is constantly contested and therefore cannot be determined in advance or through *a priori* principles. And this is why it has been impossible in this chapter to explain in any detail what I mean by art in general being a real abstraction: the decisive factor in art becoming a real abstraction is the social organisation of artistic production, which I will consider in the next chapter.

Such changes to artistic production and art's institutions have not been completely neglected by art historians and sociologists. However, when they have been studied, it seems to me, the analysis of modes of production has been overlooked in favour of interpretations of changing perceptions of the artist (e.g. discourses of genius) and changing modes of consumption (e.g. from patronage to the art market). The metamorphosis of art has been understood primarily through (1) the process of deskilling, or reduced to (2) the processes of

49 Adorno 2002, p. 199.

adjustment between relations of patronage and the emergence of the dealers, gallerists and collectors that make up the art market; (3) the rise of a bourgeois idiom of the aesthetic with its concepts of taste, Fine Art and so on; (4) the formation of a public for art within the broader condition of the bourgeois public sphere; and (5) the emergence of institutions such as the national public art museum which transpose art socially from an aristocratic luxury to an officially universal culture.

In the analysis that follows I interrogate episodes in the history of the transformation of artistic labour which I interpret through the Marxist emphasis on the social form of labour rather than on labour processes or technique in the narrow sense. By assembling these fragments of an incomplete narrative I hope to demonstrate that art, understood as a distinctive social form of labour that does not correspond to any specific labour processes or techniques, is not only abstracted from the arts and all other concrete forms of work, but that this real abstraction constitutes a subordinate mode of production dominated by and resistant to the capitalist mode of production.

CHAPTER 2

The Arts, Fine Arts and Art in General

In this chapter I want to revisit the philosophical inquiry into the ontology of art from the perspective of the politics of labour. The question 'what is art?' is novel in the eighteenth century because this question is either absurd or trivial when addressed to the several specific arts (painting, sculpture, literature, music, etc.) either collectively or individually. We can ask what is painting, what is sculpture, what is poetry and so on, but these have a technical specificity prior to the advent of art in general. As such, the ontological question of art is precipitated by the emergence of the abstract and general concept of art charted in the previous chapter. In this chapter I will investigate the advent of art in general (more accurately, art in the singular and general) through a reconstruction of struggles over the kind of labour involved in the production of works of art.[1]

First, a snapshot of how the concept of art is understood conceptually – that is to say, in the absence of an analysis of transformation of the relations of production that took place in the passage from the arts of painting, sculpture, music and poetry to art in general. The ontology of art is posed by the Jena Romantics as the question 'what is literature?' not narrowly as one of several arts but with an unprecedented generality: 'art considered as literature ... [and] literature considered as the essence of art'.[2] The early German Romantic philosophers, therefore, both laid the foundations of the modern theory of art and gave new impetus to the fledgling discipline of art criticism. The practice of art criticism, which Niklas Luhmann calls 'the self-description of the art system',[3] was integral to this new isolated, self-conscious and universal conception of art. 'The emergence of criticism, inseparably tied to that of aesthetics, puts an end to the ancient, objective representation of the beautiful'.[4] Aesthetic philosophy and art criticism are required when 'the fact that there is music or sculpture in a society does not mean that art is constituted as an independent category'.[5]

1 The phrase 'work of art' was used to refer to the products of the mechanical and liberal arts and continues to be used as a synonym for 'artwork', a term which was coined only with the birth of the concept of art in general, which I am tracing here.
2 Lacoue-Labarthe and Nancy 1988, p. 83.
3 Luhmann 2000, p. 286.
4 Ferry 1993, p. 45.
5 Rancière 2004, p. 51.

The qualities of art in general correspond to the imputed qualities of a par-
ticular type of producer – the artist. While prior to the eighteenth century, there
was no such thing as artistic labour *as such*, only the specific skills of painting,
carving, printing, drawing and so on, by the beginning of the nineteenth cen-
tury the producer of art was no longer conceived of as a worker at all but as a
special kind of subject. The artist comes to exemplify the fulfilment of a certain
conception of the subject because he – rarely she – is increasingly understood
during the eighteenth century to be engaged in artistic labour in general rather
than one of the various Fine Arts. The disciplines of painting, sculpture, music
and poetry continue to structure art in general but practitioners of each dis-
cipline now consider themselves to be artists rather than painters, sculptors,
musicians or poets.

The difference between painting (or sculpting or composing) as an art and
painting (or sculpting or composing) as art is codified in the concept of the
artist, as distinct from the artisan, through a formulation of the labour of the
production of art as an emblem of freedom. Artistic labour, or the labour
of producing art in general rather than one of the several specific arts, is
initially conceived of as an eruption of the individual subject through the
crust of convention, tradition, academia, mastery and market demand. The
artist is not modelled on conceptions of work but character. The escalation
and abstraction necessary for the transition from questions of handicraft to
questions of subjecthood itself reaches its peak in the notion of the genius
but it is not eliminated by talking about the artist or the artist as producer
instead.

Art does not emerge from the arts in a once and for all rupture – a revolution
of the means of production or a seizure of control over who controls artistic
production – but according to an uneven and combined development. It is
important to note, for instance, that art in general does not emerge first in
Italy or Holland where merchant capitalism and the art of painting had been
dominant from the Renaissance until the seventeenth century. Although the
erstwhile centres of the arts of painting and sculpture retained their status even
as they were being eclipsed by developments elsewhere, the consolidation of
the attempt to elevate painting and sculpture above handicraft took place in
France in the seventeenth century, and the transition from the Fine Arts to art
in general was pioneered in the German-speaking principalities and in Eng-
land.

Insofar as I am concerned above all with transformations in the social rela-
tions of artistic production, I do not take my cues from a sequential history
of the quality of artworks or the rise of national and regional schools, nor is
this historical investigation into the changing social relations of artistic produc-

tion narrated through the evidence these social changes leave on the surface of artworks (in changes of style and content, for instance) or insofar as they are embodied in artistic technique. In this sense, I am interested less in what individual artists do in their studios than I am in the historical formation of the studio itself.

Hence, the metamorphosis of artistic production that I am tracing is, in important respects, a spatial or geographical process. When I speak of art's social relations of production, therefore, I have in mind the spatial organisation of artistic labour and the spaces in which artistic labour takes place and through which artworks are circulated. The so-called transition from patronage to the art market, therefore, might be more accurately understood as the transition from the artisanal workshop to the artist's studio, or better still from the integration of a range of activities within the guild workshop to the spatial dispersal of activities that come to take place within and between the studio, gallery, art school, museum, fabricators workshop and all the supply chains that provide their tools, machinery and materials.

In order to insert the historical transformation of artistic labour into the changing world system during the contested transition to the capitalist mode of production, I want to suggest that the arts, the Fine Arts and art in general need to be distinguished with some clarity. In order to get to grips with the historical transformation of artistic labour during the passage from the guild system to the gallery system, the decisive changes in the transition are not discursive or terminological but configurational or relational. Hence, I will say, distinct social configurations of artistic labour can be identified and they produce distinctive discursive formations and modifications of the vocabulary. Evidently, these terms do not go out of use once a new social form of artistic production has been developed and so they appear, more often than not, as synonyms. I will use these terms somewhat unnaturally, therefore, as having a more distinct referent than common use allows. My aim is not to police the language or to impose conceptual clarity on a contingent reality but to highlight discursive changes that parallel and contribute to changes in the social makeup of artistic labour.

How does art in general emerge from the manifold specific arts? Kristeller says '[t]he various arts are certainly as old as human civilization, but the manner in which we are accustomed to group them and to assign them a place in our scheme of life and of culture is comparatively recent',[6] pointing out that the modern 'system of the five major arts ... did not assume definite shape before

6 Kristeller 1990, p. 226.

the eighteenth century',[7] namely in Charles Batteux's *The Fine Arts Reduced to a Single Principle*. Nevertheless, Kristeller clearly says it 'seems to emerge gradually and after many fluctuations in the writings of authors who were in part of but secondary importance'.[8] 'In the course of history', he says, 'the various arts change not only their content and style ... but also their relations to each other, and their place in the general system of culture'.[9]

Kristeller privileges theoretical contributions over social transformations. Three of the five arts that would be grouped as the Fine Arts in the Batteux's writing in the eighteenth century 'were for the first time clearly separated from the crafts' in the Renaissance triumvirate of painting, sculpture and architecture. Although this does not match his template for the modern grouping of the Fine Arts, Kristeller acknowledges its significance within the history of the gradual formulation of the modern order of the arts. Even so, Kristeller traces this historical step as a discursive innovation, namely Vasari's theory of the Arti del disegno. It is this 'change in theory', he argues, that later 'found its institutional expression in 1563 when in Florence ... the painters, sculptors and architects cut their previous connections with the craftsmen's guilds and formed the Academy of Art (Accademia del Disegno)'.

Although, today, the academy is generally considered to be an institution that occupies a building, initially academies were events. Like symposia, seminars and lectures, academies were a certain kind of assembly rather than a place in which groups assembled. The first academies in sixteenth-century Italy were elite literary associations that discussed Latin and vernacular poetry.[10] Giorgio Vasari's *Accademia delle Arti del Designo* mimicked these in a calculated bid to pierce the dividing line between the mechanical and liberal arts. Academies of Painting and Sculpture, which appeared in seventeenth century France, modelled themselves on their Italian predecessors and for precisely the same strategic purpose. Kristeller's argument that the academies of the sixteenth and seventeenth century 'replaced the older workshop tradition with a regular kind of instruction that included such scientific subjects as geometry and anatomy',[11] derives from Nikolaus Pevsner's study of the academies.

Decisive for Kristeller is the culture of reception for the arts. It was the development of the 'amateur tradition' that brought these arts together, not grouped around their techniques of production or pedagogical processes but the nature

7 Kristeller 1990, p. 165.
8 Kristeller 1990, p. 196.
9 Kristeller 1990, p. 226.
10 See Kristeller 1951, p. 511.
11 Ibid.

of their consumption. Poetry, music and painting were 'grouped together as pursuits appropriate for the courtier, the gentleman, or the prince',[12] and therefore these arts were seen as having an affinity because of the similarity of their 'effect upon the amateur'.[13] The conflation of art with the Fine Arts, like the anachronism of treating the Renaissance as the origin of the modern category of art, depends upon the analysis of concepts and categories in the literature that resonate with modern discourses of art.

For the history of ideas and similar methodologies this appears to be sufficient but an analysis of the mode of production for works of art requires a different kind of analysis. Kristeller's notion of a 'grouping' puts a strong emphasis on processes of categorisation but is rooted methodologically in the history of ideas and his account documents above all a rift in discourse. Kristeller does not explain the inception of this modern grouping of the arts through the establishment of the modern institutions of art, changes in their economic structuring or in broader social ruptures, as a social historian of art would, although he mentions the 'founding of the Academies'[14] in seventeenth-century France and elsewhere only insofar as they seem to represent an acknowledgement of the grouping of the five Fine Arts, which he dismisses as 'apparent rather than real'.[15] Kristeller confines himself to the theoretical grasping of the concept of the Fine Arts whereas my analysis focuses on the historical transformations of the social relations of the production of works of art.

Kristeller did not pursue the historical passage from the arts to art in general any further than the development of the Fine Arts, saying 'the term "Art" comprises above all the five major arts of painting, sculpture, architecture, music and poetry'.[16] Larry Shiner, however, extends the historical passage that Kristeller narrates to include later developments in which 'the replacement of patronage by an art market and a middle-class public',[17] took place as part of the development of 'more general relations of power and gender'.[18] Shiner has plotted some of the key elements of the development of art out of the arts within the broader development of capitalism. Like Kristeller's stress on the classification of the arts, Shiner focuses on the circulation and consumption of artworks rather than transformations to the mode of artistic production.

12 Kristeller 1990, p. 185.
13 Ibid.
14 Kristeller 1990, p. 191.
15 Ibid.
16 Kristeller 1990, pp. 164–5.
17 Shiner 2001, p. 7.
18 Ibid.

The emergence of the category of Fine Arts, charted by Kristeller and others, not only needs to be inserted into the colonial world system in which the Fine Arts and later art in general operate as a world system of culture, they need to be woven into the broader social history of the transformation of manufacturing that consisted of the collapse of the guilds and livery companies with the consequent elimination of the arts as a mode of production. While this transition of production is commonly narrated as an internal development within Western Europe as the passage from feudalism to capitalism, it is vital that the transition from the arts to art is lodged within the formation of a world system of uneven and combined development.

Instead of contrasting the artisan with the artist in terms of some purported superiority in quality or inspiration, I will examine differences in the social relations of labour that take a specific spatial configuration. I do not define the artisan or the artisanal with a certain type of labour process – highly skilled, specialist, handwork with tools, etc. – but with a certain social and spatial organisation of labour. Artisanal production, historically speaking, takes place in a workshop occupied not only by an artisan but also apprentices and day-labourers. The modern craftsperson, therefore, who works alone and purchases materials and tools from suppliers, is not an artisan from the perspective of the social relations of production. Artisan painters, for instance, serve apprentices in which they learn to grind their own paints, make their own pencils and so forth, and go on, as master artisans, to have apprentices and artisan day-labourers complete these tasks for them. In that respect, the spatial condition for artisanal production is the workshop.

The politics of labour in the production of works of art is mediated in the Renaissance through the rhetorics of the mechanical and liberal arts which gave provisional value to handicraft but a higher value to design, composition, invention and judgement. Normally these processes would bracket handicraft (setting it up and finishing it off) but in remarkable instances, they would run through handicraft itself, transforming it into something divine. The struggle between the guild and the court took a specific shape in the Renaissance in which certain individuals secured their emancipation from the guilds through the establishment of a number of small academies operating within the guild system. This struggle takes on another specific shape with the emergence of the Fine Arts.

What is at stake in the disagreement about whether the modern figure of the artist is born in the Renaissance or art in general emerges in the eighteenth century or through the voluntary deskilling of the artist in the twentieth and so forth, is the question of the social forces at play in art's institutional differentiation from handicraft. Instead of searching through the historical documents

for the turning point or the single event or the exemplary figure that signals the advent of the modern category of art, it is vital to understand the transition from the arts to the Fine Arts and to art in general as an historical process in which the contestation over the mode of production for works of art is played out. My extrapolation of the timescale of the transition from handicraft to art *via* the Fine Arts deliberately refutes the (implied) claim that art is formed by great individuals (philosophers, artists, art critics) and the (false) impression that the change occurs through a process that resembles a decision. I am thinking, here, of how the standard narratives of the 'invention of art', the elimination of handicraft in art or the development of 'art in general' appear as single episodes or the delayed results of single episodes. In some cases, Romanticism is the name given to the episode in question, and in others it is art's commodification or Duchamp's readymades.

So, while the terms art, Fine Art, the Fine Arts and the arts are commonly used as roughly interchangeable today, I am assigning them to different modes of artistic production within an historical struggle over artistic labour that has already lasted five hundred years. The arts, for my purposes, are all the handicraft trades organised within the guild system. The Fine Arts consist of a certain grouping of the arts that have been elevated above the guild in an indeterminate location between the mechanical arts and the liberal arts. Art is abstracted from the Fine Arts and therefore is not reducible to any but retains an affinity with them all as well as including their negation and an infinity of techniques outside them.

When writers refer to the transition from patronage to the art market, for instance, without describing the protracted social processes through which this transition was accomplished and contested, the effect is to imply that there is regime change in art's social relations. Perhaps the intention is to imply that the French Revolution or the bourgeois revolutions in general brought about a revolutionary overthrow of relations of patronage in art which were replaced with a laissez-faire system of the market at the speed of the guillotine? I may even have subscribed to such a view at the outset of my study. Certainly, I underestimated the scale and complexity of the historical disaggregation of art from handicraft as well as the extent to which this remains an unfinished project or a persistent condition for the politics of labour in art. The elimination of handicraft from the artwork and therefore from studio practice presupposes the separation of the artist in the studio (which is to say the transition from the artisanal workshop to the artist's studio has already taken place), and that the artisanal elements of artistic production (grinding of paints, manufacture of pencils and paper, framing and so on) have been expelled from the studio and are no longer the responsibility of the artist. The exodus from

the studio and the modern and contemporary form of critical vigilance called 'deskilling', in which generation after generation of artists unearth countless traces of handicraft within artistic technique itself, demonstrate that this historical struggle over art's mode of production is ongoing and remains politically significant.

The period of the transformation of the arts into art *via* the Fine Arts runs from the Middle Ages to the beginning of the nineteenth century. This is unwieldly and necessitates an episodic approach. Taking my cue from the Marxist concept of the wage system, I will distinguish between three systems of artistic production. The guild system forms part of the feudal mode of production in the urban centres of Europe in which the arts are hierarchically ordered into the liberal arts and the mechanical arts. The academy system, which has precedents in Classical Greece and has its roots in the Renaissance, is systematised in the middle of the seventeenth century in France and is rolled out across Europe in the following century as the principal institutional apparatus of the Fine Arts. The gallery system, which is not reducible to the art market, consists primarily of the modern division of labour that separates the artist as a specialist from the dealer, critic, professor, supplier of art materials, assistant, technician, and so on.

Although the guild system precedes the academy system, one does not immediately replace the other and they form a specific dual system from the middle of the seventeenth century to the end of the eighteenth century. Prior to the emergence of the academy system the guild system operated within a dual system of guild and court. Similarly, the academy system survives the inauguration of the gallery system and they operate for some time as a second dual system. And when the academies are fully incorporated into the gallery system, the gallery system reveals itself to be a new dual system of market and public.

As well as overlapping and contesting one another, the various systems of artistic production preserve and rejuvenate elements that were developed previously. One example of this, which I will focus on in more detail later, is the transposition of the hostility to commerce that is present in the Renaissance court system and formalised into an imperative within the academy system and eventually reiterated within bohemianism and the avant-garde within the gallery system. However, it is important to acknowledge that the hostility to commerce is first formed as part of the bid to elevate painting and sculpture from the mechanical art to the liberal arts according to an aristocratic ethos of activity. Although displays of the antipathy to the market by painters and sculptors from the Renaissance to French Revolution resemble the anti-capitalist and anti-bourgeois protests of modernity, the former has to be understood as a pre-capitalist affirmation of nobility.

Although the historical sketch that I have just provided is inadequate in many ways and cannot hope to summarise the contested histories of the organisation of the arts, the Fine Arts and art in general across several centuries, I present it as a preliminary model of how to inquire into the historical transition from the guild organisation of the mechanical arts to the gallery system of modern and contemporary art. Despite its shortcomings, I want to highlight two advantages of studying the historical formation of art in general in terms of rival and superseding systems. First, it calls for a reconstruction of the specific forms of social organisation of art (or the arts or the Fine Arts) rather than overstate the significance of the intellectual origin of key ideas. And second, it calls for a differentiation of the institutions of art (or the arts or the Fine Arts) rather than to conflate them, as is done, arguably, in both the institution theory of art and the contemporary discourses of institutional critique.

Naturally, the terms that I am differentiating here in order to signify changes in the social configuration of artistic labour are usually merged with one another. James O. Young, for instance, conflates the Fine Arts with art in general, using the phrase 'Batteux's ideas on the concept of art'[19] to refer to Batteux's theory of the Fine Arts without verifying whether Batteux also regarded art to be a synonym of the Fine Arts. Shiner also slips into treating the Fine Arts and Art as interchangeable, even as he points out that art had been elevated above the Fine Arts by the 1830s.[20] Art, he says, 'was no longer simply a generic term for any human making and performance, as under the old system of art [i.e. what I am calling the liberal and mechanical arts], nor even shorthand for the category of Fine Art [note: in the singular] constructed in the late eighteenth century [in my narrative the Fine Arts is first formulated in the seventeenth century and in the plural not the singular] but had become the name of an autonomous realm and a transcendent force'.[21]

If the terms Fine Arts and art (in general) become interchangeable or synonymous, I want to suggest, this is only after the establishment of art as a mode of production comes to subsume the Fine Arts. Fine Art in the singular is initially nothing more than a term for referring to one of the Fine Arts but after the formation of art as a real abstraction the term Fine Art appears as a synonym for art in general. Likewise, the conflation of the arts and art is only possible after the abstraction of art from the arts as the hegemonic term under which the arts continue to operate. It is, therefore, understandable that old terms continue to be used in new circumstances and accumulate in this way, but when

19 Young in Batteux 2015, p. lxviii.
20 Shiner 2001, p. 189.
21 Shiner 2001, pp. 193–4.

they do, they conceal the historical transformations that leave a mark on them. My aim is not to overstate the differences but to use them as a guide in the reconstruction of the social history that they barely signify.

In that literature that recognises some kind of transformation of the category of art, the dating of the historical transition under question varies considerably. Kristeller identifies the break with Batteux's *The Beaux Arts* in 1746 because his analysis focused attention on the 'grouping of the visual arts with poetry and music into the system of the fine arts', a category, he notes, that 'did not exist in classical antiquity, in the Middle Ages or in the Renaissance'.[22] Luc Ferry charts the related 'birth of aesthetics'[23] in the middle of the eighteenth century as grounded in an earlier and broader development of the 'subjectivisation of the Beautiful'[24] or the 'subjectivisation of the world'[25] during the Enlightenment. Michael Carter fleshes out the context of this transition by saying 'societies that started to become dominated by industrialised methods of production, as Europe was in the 19th century, the making of Art starts to be organised and understood in different ways to that of general production'.[26] In particular, he says, art came to be 'seen as an activity with a high degree of individual control of the making process and with the increase in individual responsibility'.[27] Other temporalities have also been proposed.

Clearly, the lack of consensus on dating the transition from the arts to the Fine Arts or to art in general is connected to disagreements over what constitutes this passage. In some accounts, the narrative is a string of conceptual events, whereas in others it is a sociological or economic transition such as the shift from patronage to the market. Rancière identifies a stratified and complex historical process, saying:

> Art as a notion designating a form of specific experience has only existed in the West since the end of the eighteenth century. All kinds of arts and practices existed before then, to be sure, among which a small number benefitted from a privileged status, due not to their intrinsic excellence but to their place in the division of social conditions. Fine Arts were the progeny of the so-called liberal arts. The latter were distinguished from the mechanical arts because they were the pastime of free men, men

22 Kristeller 1990, p. 224.
23 Ferry 1993, p. 20.
24 Ferry 1993, p. 45.
25 Ferry 1993, p. 19.
26 Carter 1990, p. 51.
27 Carter 1990, p. 13.

of leisure whose very quality was meant to deter them from seeking too much perfection in material performances that an artisan or a slave could accomplish. Art as such began to exist in the West when this hierarchy began to vacillate.[28]

Rancière emphasises art as a 'notion' and focuses on processes of designation that differ from processes of classification only insofar as ideas and categories are not understood as the product of the individuals who formulate them but the social and historical 'partition of the sensible', which characterises the specific ordering of the world for a given society. In this way Rancière is able to pass fluently from issues within discourse to social systems and the revolutionary historical processes by which one system replaces another.

By separating the alleged 'intrinsic excellence' of the Fine Arts from 'their place in the division of social conditions', Rancière builds his account on either the assumption that artistic practices themselves did not change or a theoretical indifference to such changes given that the significant development under question is one of designation and placement. This position appears to be feasible because the specific labour processes of drawing, painting, carving and composing do not change significantly during this period, but this neglects real changes in the social relations of artistic production. However, a different narrative is required to capture the transformation of the social form of artistic labour.

Studies of the transformation of art in the long passage from feudalism to capitalism, when they pay attention to economic changes, tend to stress modifications in modes of circulation and consumption rather than the metamorphosis of artistic production itself. Typical of this tradition, Shiner says, 'the market played a key role'.[29] Talking of the transition from patronage to the art market is perhaps useful as shorthand (to designate the transformation of art's mode of production from handicraft workshop production within the guild and the court to individual studio production within the gallery system), but it gives the false impression of a systemic change brought about by changes within the organisation of art's circulation.

Western Marxist theories of commodification, reification, spectacle and real subsumption all subscribe to the principle that changes in circulation, either of artworks specifically or commodities generally, are decisive in the formation of the social character of art as distinct from the arts. When the inquiry focuses

28 Rancière 2013, p. ix.
29 Shiner 2001, p. 89.

on circulation, classification and so on it is possible to ascertain discourses of the artist, the romance of the studio, the academicisation of the art school and so on as corresponding to the patterns and structures of capitalism. However, such correlations typically exaggerate either the complicity or autonomy of art in capitalism. Such accounts can be persuasive, complex, insightful, sophisticated and highly mediated, of course. What has been left obscure, however, is the relationship between them. When the difference between the artisan and the artist is discussed, for instance, the change is ascribed either to a false distinction (the myth of the artist-genius and the like) or to the effects of the commodification of artworks or to the individualism of bourgeois society more generally.

Notwithstanding theoretical problems with accounting for changes in the mode of production by tracing changes in circulation and consumption, the view that art emerges from the arts as a result of the transition from patronage to the art market blocks the analysis of changes in the social relations of the artist's studio and its supply chains, the division of labour between artists and their assistants, the division of labour between the artist, the art dealer and the art tutor, and so on and so forth. While it has certainly not gone unnoticed that painters and sculptors in the Middle Ages and the Renaissance worked collectively in artisan studios, art historians have tended to focus their attention on certain exemplary individuals and often exaggerated the degree to which they operated outside the artisan workshop system, abjured the use of assistants and apprentices, etc.

Typical of the tendency to overstate the modernity of the Renaissance, Geraldine Johnson claims it was with 'the influence of Vasari and the artist he most admired, Michelangelo, that many of our most fondly held assumptions about artists, art, and art history first emerged'.[30] There is, of course, ample anecdotal evidence to support the claim that the Renaissance constitutes the inaugural episode of art's separation from handicraft but what is decisive on this point is the social relations of production of the Renaissance workshop which remained artisanal, reproduced itself through the master-apprentice relationship, and continued to regulated within the dual system of guild and court.

Retrospectively, it appears as if an elite of practitioners in the Renaissance who won certain exemptions from the guild by squeezing privileges from the court anticipate what was to become the standard by which all artists were to be measured from the great artisan to the artist cannot take place without

30 Johnson 2005, p. 120.

an artistic division of labour that was not present during the Renaissance. If a minority of guild master artisans in the Renaissance and in the seventeenth- and eighteenth-century academy system who obtained exemptions from guild regulations came to appear as paragons of artistic individualism and were cited as vivid precedents for the modern myth of the artist, this is no basis for neg- lecting the difference between the mode of production for the arts, the Fine Arts and art in general.

While the social form of artistic labour in the Renaissance remains artis- anal, the aspiration for painters and sculptors to attain the scholarly status of the liberal arts is expedited through what we might call *techniques of elevation* including the biography of eminent painters and sculptors, the founding of the first academy, the grouping of painting, sculpture and architecture into the arts of design, and the opening skirmishes against artisan painters and sculptors. The desire for painting, sculpture and architecture to be accorded the status of the liberal arts, or at least to rise above the level of the mechanical arts, was not a demand to break with the feudal mode of production but expressed its highest wish. The Fine Arts is a category formed within the rivalry between court and guild and according to the norms of feudal society.

Among the techniques of elevation deployed by painters and sculptors in the Renaissance is the demarcation between the liberal and mechanical within the workshop. Originally, the workshop was not merely a place of work but also a shop that had an opening onto the street and a space behind for producing 'works of art'. The workshop would also typically be attached to living quarters for the apprentices and artisan day-labourers as well as the home of the 'master'. Some Renaissance workshops also contained a small private room for the mas- ter called a 'scrittoio' or a 'studiolo' and therefore a partition emerged within the workshop establishing two distinct spaces, the *bottega* and the *studiolo*. The *bottega* was a workroom occupied by apprentices and artisan day-labourers, whereas the *studiolo* was a separate space in the same building – perhaps noth- ing more than a desk, or a small space separated by a curtain – occupied by the master. As such, the desired elevation of the arts of painting, sculpture and architecture above the mechanical arts takes place within the artisanal work- shop itself in the form of a partition within it.

The *studiolo* had some of the qualities of a study and is depicted in the his- tory of art as a small room resembling 'the miser's counting room'[31] and the gentleman-scholar's study. Michael Cole and Mary Pardo say, 'the labors of the workshop ... were very different from the liberal exercises undertaken in the

31 Wood 2005, p. 94.

studiolo'.[32] More cautiously, we might say, the *studiolo* does not complete the elevation of painting and sculpture from the mechanical arts to the liberal arts but insofar as it *represents* scholarship, management and commerce, the demarcation of the *studiolo* from the *bottega* provided a space for the 'master' artisan to mark himself off from the manual labour of apprentices and journeymen. Hence, the spatial division between the *studiolo* and the *bottega* replicated in miniature the division between mechanical work and liberal contemplation that was integral to the hierarchy of the arts in the classical, medieval and Renaissance social order.

Technique was allocated a spatial characteristic that was socially coded. Martin Wackernagel's account of the various technical stages of making paintings and sculptures in the fifteenth century is a useful entry point for outlining a hierarchy of techniques in the Renaissance. The stages of making a painting, from the preparation of the panel, the drawing of the design, the cartoon, grinding colours, manufacturing brushes, preparing grounds and underpainting, transferring the cartoon to the panel, painting the modelled shadow areas, adding colour to each area of the tonal painting, background and clothes, painting hands and faces, to the finishing touches, can be rearranged according to who was assigned to perform certain tasks. The preparation of panels and the carving of frames were activities executed by carpenters outside the workshop. Grinding colours and making brushes were jobs for apprentices. Accomplished apprentices and adept assistants were trusted to execute a work planned and sketched by the master. Likewise, transcribing a drawing to full size or adding colour to an outlined painting, were skilled activities that could be assigned to apprentices and assistants. Designing the work and composing its elements was reserved exclusively for the master, as was the application of the finishing touches or retouches. In some cases, the master would do little more than signing off the work of others, but the decision could only be taken by him.

In the case of sculpture, sourcing the stone or marble, carving out the block and transporting it could be done by a group of artisans or assistants. Also, carving out the basic shape of a sculpture could be completed by apprentices or assistants. The preliminary drawing and the initial model for the sculpture in wax or clay would be made by the master. The full-size clay model would be made by assistants and apprentices with the master supervising and making final adjustments. Most of the 'laborious chiselwork'[33] would be assigned by

32 Cole and Pardo 2005, p. 19.
33 Wackernagel 1981 [1938], p. 314.

the master to members of his workshop. The social character of the division of labour and the hierarchy of practices within sculpture in the Renaissance is indicated negatively by Michelangelo's practice of deviating from his own drawings to such an extent that no assistant could take his place and his insistence on working the block from scratch, as well as his preference for visiting the quarry himself to select and cut out the block for a sculpture. All of this meant that Michelangelo could not delegate the mechanical aspects of the production of works of art because, in his improvisatory practice, nothing was entirely mechanical.

The absence of the demarcation between *bottega* and *studiolo* in Michelangelo's practice could be interpreted as risking the deadly association with the mechanical, but it was understood at the time as the most complete triumph of the liberal in the arts of design. Michelangelo was regarded as 'divine' because his technique exceeded his own plans. This was true, technically, insofar as Michelangelo would continue to invent, improvise and adjust his work at every stage, but it was also a legible statement to his peers. It was, in short, a technique of elevation. Michelangelo's unrelenting inventiveness was secured by and, in turn, necessitated, the exclusion of assistants from almost the entire process of artistic production because it replaced every mechanical operation with improvisatory techniques that constituted him as a special character: indispensable, unique, unsubstitutable.

Perhaps we can simply acknowledge that the basis of the recognition of Michelangelo as a supreme talent turned on his specific reconfiguration of the border between the master and the assistant which he pushed almost to infinity. The master, for Michelangelo, must do everything or almost everything; the assistant cannot act as the proxy of the master even in processes that for other sculptors and painters appear to be purely mechanical operations. His dismissal of assistants in the painting of the Sistine Chapel ceiling, for instance, which has become a prominent episode in the myth of the artist, testifies to his transposition of the border between master and assistant but the fact that a small number of assistants remained to grind colour and so on, also testifies to the impossibility during the Renaissance to completely eradicate the need for assistants. As such, Michelangelo represents an extreme position within the division of labour between master and assistant rather than representing the supersession of that relationship altogether.

For both painting and sculpture, drawing caps the hierarchy of practices. Drawing therefore came to carry the burden of their claim to be liberal. However, it was only insofar as drawing was identified with the technical manifestation of *design* and *invention* that it appeared to exemplify the liberal arts. Even as the process of observation in which the draughtsman came closest to the

natural philosopher, drawing was not sufficient to distinguish the proponent of the arts of design from the mechanic. Only a certain kind of drawing was meant to epitomise what Martin Kemp refers to as the three levels of ability necessary for painting and sculpture to be regarded as liberal in the Renaissance, namely 'innate brilliance of mind, acquired learning and executant skill'.[34] Chiefly, the elevation of painting, sculpture and architecture depended on the campaign to reconsider drawing as representing the Renaissance virtues of practice that Kemp described as activating 'connotations of learning and knowledge rather than ... associations with codes of routine to be followed with unquestioning diligence'.[35]

Drawing as a method of learning, which was essential for apprentices, is the highest form of education in painting and sculpture but is not, in itself, the most esteemed form of practice. Wackernagel identifies three stages[36] in the draw-ing process for a painting in the Quattrocento, which represent a hierarchy of practices. First, the master sketches a picture in the form of a composition, then would follow 'nature studies' and the like to clarify the features of the composi-tion, and finally, a 'precisely detailed sketch of the whole composition' would be completed. It is from this final drawing, often made the full size of the painting, that the artwork would be executed. Drawing could occupy any place within the hierarchy of practices from the most divine to the most menial. Drawing was liberal only insofar as it was recognised as an act of planning, thought and composition in which the individual's character was at stake. Execution is mechanical precisely because it could always be passed on to someone else. Such practices as working from a 'cartoon' could only edge towards the liberal arts by being executed in such a way as to add significantly to or deviate from what has been planned. Also, the technical development of drawing through the acquisition of the skills required to construct perspectival space was not the kind of drawing practice that garnered value within the hierarchy of tech-niques. As Kemp puts it, the 'humanists do not appear to have set much store by the painters' new science'.[37]

Typically, the *studiolo* marked off conception, design and management from the more manual and laborious phases of work, but the division between the *bottega* and *studiolo* occupied an indeterminate and unstable place between the mechanical and liberal arts because the *studiolo* makes a claim that cannot be accomplished or verified internally through the morphology of the activit-

34 Kemp 1977, p. 390.
35 Kemp 1977, p. 389.
36 Wackernagel 1981 [1938], p. 319.
37 Kemp 1977, p. 392.

ies that it houses. This spatial interval not only belonged to the hierarchy of the arts at large in which the liberal arts were connected to the mechanical arts through a system that also separated them, it also marked an interruption within a hierarchy of techniques within painting and sculpture. That is to say, the rise of scholarly texts on art by Alberti, Vasari and Da Vinci, and the founding of the first academies of design, do not *confirm* the success of the *studiolo* to break away from the *bottega* and establish painting and sculpture among the liberal arts; they are supplementary means for elevating painting and sculpture above the mechanical arts with which they had always been associated.

The *studiolo*, insofar as it transplanted the scholar's study into the artisan's workshop, was a kind of architectural manifesto for painting and sculpture as liberal arts. Renaissance academies had the same effect. Characteristically scholarly gatherings, academies discussed topics related to the liberal arts from which painting and sculpture had been excluded as mechanical arts. These events were the historical precedent for the lecture series of the seventeenth- and eighteenth-century academies of painting and sculpture and thereby stand as the origin of the abiding emphasis on theory in modern and contemporary art. The *studiolo* and the early academies were an attempt to stamp the arts of design as scholarly activities.

The *studiolo* and the reclassification of drawing elevated painting, sculpture and architecture by dividing the individual designer-draughtsman off from the mechanical arts. This was achieved by associating that part of the division of labour monopolised by the master with scholarship and the humanities, especially poetry. Hagiographies of eminent masters, therefore, underlined, exposed and exaggerated an already existing hierarchy within the social relations of the workshop in order to counter and reformulate a hierarchy that existed outside it. This demarcation built on the privileges of the dual system of guild and court the established hierarchy of master, journeyman and apprentice, within rather against this specific system. Hence, if there were normative pressures on individuals such as Raphael to distance himself from the manual labour of the *bottega* through drawing designs that were completed by his underlings, there were also material and economic counter-pressures that prevented the *studiolo* from being absolutely independent from the *bottega*.

Economically, the spatial division within the artisan workshop marked and masked relations of dependence and exploitation: the *studiolo* depended on the production of the *bottega* even though the apprentices and journeymen working in the *bottega* appeared to depend for their livelihood on the master in the *studiolo*. As such, the independence of the *studiolo* from the *bottega* is relative not absolute. It is an interval in space not an exodus from the workshop because it corresponds to the stretching of a real and symbolic social hierarchy

rather than a break between the artist and the artisan. That is to say, the division within the artisan workshop between the *studiolo* and the *bottega* does not do away with the artisanal mode of production.

There is a division of labour between what takes place in the *bottega* and what takes place in the *studiolo*, and this division marks a social distinction between the apprentices and day-labourers on the one hand and the master on the other, but there is no spatial dispersal of production (such as, later, between the art production in the studio and the manufacture of paints in factories), nor the intervention of market transactions between the various separate phases of production (such as, later, between artists and the fabricators who produce their works). If the relationship between the master artisan and the apprentices and journeymen now appears more remote than before, the workshop remains the economic unit of production.

Artists in the twentieth century as well as today also often worked collectively in ways that were suppressed by the myth of the individual author and therefore there is a remarkable sense of continuity between the attitude to assistants and apprentices expressed in the Renaissance and the systemic denial of assistants in the representation of artistic labour in modern and contemporary art. Henry Moore, for instance, employed a group of assistants to execute his work with various levels of control over the character of the final work, but they were very rarely depicted within images and films of the artist in the studio. The image of the painter or sculptor alone in the studio producing their own work without a social division of labour and without a boss or a buyer has come to represent not only the epitome of artistic production but also the paradigm of free labour, if not freedom full stop.

What this image of the unassisted producer signifies, however, differs in the arts, the Fine Arts and art in general. Each social form of artistic labour has its own distinctive normative economy through which the individualised producer is interpellated and enforced above and to the side of actual practices. For the arts, the separation is relative and conceals the distinctive social division of labour of the artisan workshop; for the Fine Arts it is an absolute break with handicraft that is based on the establishment of a two-tier system for the production of works of art; and for art in general it is internalised as a project of eliminating the remnants of handicraft from artistic production itself.

The artist's studio is not the final separation of the *studiolo* from the *bottega* but an historically unprecedented hybrid of them insofar as the artist has a studio to *make* works of art. The studio is the *bottega* under the domination of the *studiolo*. The relationship between the workshop and studio, which is not identical with the relationship between the *bottega* and the *studiolo*, and particularly the distinction between them, is obscured by the stubborn preference

of painters and sculptors since the Renaissance to stage their self-portraits in private rooms that resemble studios deliberately suppressing the representation of handicraft activities in various types of workshop.

Rembrandt, for instance, whose large three-storey house contained several distinct workshops, when he depicted himself at work, so to speak, did so in an image of himself alone with his easel and paints. This was a deliberate tactic, 'to promote himself and distinguish himself from his contemporaries or rivals'.[38] Even before the studio became the standard terrain of artistic labour, something very much like it already 'symbolised the act of creation, a space that embodies the arduous and fulfilling process of devising a world of illusion or significance',[39] as Giles Waterfield puts it. As such, although the studio, as a specific historical form of spatial organisation, cannot be considered merely 'as the normative concept applied to places of artistic production',[40] there are certainly normative, symbolic and semiotic features that contribute to the constitution of the studio and continue to activate it socially.

Private and individual in certain respects, the artist's studio belongs to and is one of the sources of a social imaginary of the artist and artistic production. In her book *Machine in the Studio* Caroline Jones narrates the passage from the Abstract Expressionist 'romance of the studio'[41] to the abandonment of the studio in site-specificity and Land Art via the anti-romantic embrace of semi-industrial techniques and the social production of art in Minimalism and Pop Art to construct a critique of the artist as a heroic individual. Warhol renamed his studio 'The Factory', that is to say, renaming the space (a Duchampian gesture of nomination, perhaps), as a site for the production of market goods and the place in which labour is social rather than individual.

Waterfield points out that until the nineteenth century British artists preferred the term 'Painting Room' to studio, and in France the word refers to a one room apartment.[42] And Daniel Buren, one of the pioneers of the critique of the studio as 'the first frame, the first limit, upon which all subsequent frames/limits will depend'[43] in the 1960s and 1970s, identified two types of artist's studio, the 'European Type' and the 'American Type'. The former, he claims, are modelled on high-ceilinged Parisian rooms and the latter are characteristically reclaimed lofts, barns and warehouses. 'The art of yesterday and today is not

38 Chapman 2005, p. 110.
39 Waterfield 2009, p. 3.
40 Adamson 2007, p. 14.
41 Jones 1996, pp. 1–59.
42 Waterfield 2009, p. 1.
43 Buren 1979 [1971], p. 51.

only marked by the studio as an essential, often unique, place of production; it proceeds from it', Buren wrote, adding: 'All my work proceeds from its extinction'.[44]

Jones represents not only the feminist critique of the modernist institutions and discourses of art but also a North American structural critique of humanism that discloses multiple forms of power located within the artist as a social actant. Feminist art history transformed not only how the representation of women was interpreted but also provided critical reinterpretations of the artist and its myths including how artistic labour is figured in art's discourses. Linda Nochlin's 1971 essay 'Why Have There Been No Great Women Artists?' is a major contribution to the critique of the Enlightenment, Romantic and modernist conceptions of the artist as a peculiarly masculine variant of freedom in labour that has subsequently been developed by the Guerrilla Girls, among others.

For the arts, the isolation of the painter and sculptor from assistants marks the elevation of painting and sculpture above the mechanical arts through the subordination of mechanical processes necessary for the production of works of art under the alleged liberal arts such as drawing undertaken in the *studiolo*. For the Fine Arts, however, the separation from handicraft is declared principally through an opposition between two types of painter or sculptor, exemplified by the division between the guild the academy that represent them. The differentiation is no longer internal to the technical processes required to produce works of art but distinguishes between a superior and inferior class of production and two distinct economies. In the case of art in general, though, a different type of discrepancy emerges in which the artist is differentiated from the artisan and the worker, as I will demonstrate later, through the double process of ejecting mechanical processes out of the studio and eliminating handicraft processes within it. In particular, the material basis for the isolation of the artist as an individual producer of art – and therefore the normative separation of the artist from the artisan and the worker – is the mechanisation and commodification of the artisanal processes that were previously necessary for the production of works of art.

The arts of design, as the name implies, remain arts and continue to operate within the hierarchy of the arts and according to the mode of production of the arts. Even if some individuals raised themselves by eliminating assistants and apprentices as far as possible, these arts continued to be passed on through the generations through an apprentice system regulated by the guild. While the apprenticeship came under question as an appropriate mode of acquisition for

44 Buren 1979 [1971], p. 58.

painting and sculpture as liberal arts, the alternative of the academies initially did not teach and functioned more like a seminar and social event for scholarly masters.

The Renaissance episode is not the historical origin of the modern condition of the heroic artist even if a gap begins to open up between a minority of master artisans and their own assistants and their artisanal peers, and a hagiographical literature exaggerates their independence and divinity in contrast with handicraft generally. The story of the differentiation of art in general from the manifold specific arts begins with the Renaissance demarcation of the *studiolo* and the *bottega* and with the hierarchy of practices that emphasised the difference between design (drawing) and handicraft, but painting and sculpture remain arts and continue to conform to the artisanal division of labour. Not only do the great masters of the Renaissance continue to occupy a place within the artisan workshop, they do not represent art in general but merely the attempt to elevate certain arts within the order of the mechanical and liberal arts. Subsequent historical events give the Renaissance painters and sculptors their appearance of modernity. We must turn, therefore, to the intensification of the battle between the guild and court in the seventeenth century through the development of the academies of painting and sculpture which consolidated the category of the Fine Arts.

Kristeller is right to identify the grouping of arts in Batteux's *The Beaux Arts* in 1746 as a landmark in the history of the antagonism between guild and academy or, as it comes to be understood, between art and handicraft, but events had preceded this theoretical construction in 1648, with the founding of the *Académie Royale de Peinture et de Sculpture* in Paris. Initially a fragile, small and vulnerable institution, in the century leading up to Batteux's formulation of the 'single principle' that distinguishes the 'Beaux Arts', the Académie had re-established itself as a prestigious institution that could secure privileges for its members and a prestigious reputation for bringing 'together the best French artists in a single body'.[45] It is to this episode in the history of the transformation of art's social form of labour that I will now turn.

45 Michel 2018, p. xiii.

Guild, Court and Academy

Art appears as an ahistorical and abstract category only in modernity. Prior to this the various arts that are eventually elevated as the Fine Arts and subsequently subsumed under the category of art in general do not appear as timeless and universal. In this chapter I want to examine the material conditions of art's abstraction within and against the dual system of guild and court during the passage from feudalism to capitalism. Art is abstracted from the various specific arts that had set themselves off from handicraft in a protracted process that begins in the Renaissance and culminates in modernist autonomy. In one sense, therefore, the historical reconstruction that I am attempting here follows the long historical passage from the arts to art in the previous chapter. However, since the arts from the Middle Ages to the establishment of the capitalist mode of production were divided into the liberal and mechanical arts, it is somewhat misleading to think of this struggle in terms of a linear history from guild to academy to autonomy. When art emerges out of the arts it does so through a struggle within the hierarchy of the arts.

The events in which the Fine Arts come to be associated with the liberal arts without fully attaining that status are not reflected in the convention of tracing the history of art from courtly patronage to the art market and leaving out the guild painters altogether. The linear history of the passage from court to market, which includes within it the development of the academy as a courtly institution, must be recast. The purpose is not to include a greater proportion of guild painters and sculptors within the canon, but to recognise that painters and sculptors in the court existed in a specific relation to painters and sculptors in the guild. The relationship between court and guild is expressed partly in the growing disparity perceived between great Renaissance individuals and their artisan counterparts, but it should be remembered at the same time that Da Vinci, Michelangelo and Raphael had served their apprenticeships, were members of the guild and had apprentices of their own.

In plotting the historical conditions for art's modern reformatting, Harrison and Cynthia White, in their pathbreaking book on the advent of the 'critic-dealer system', narrate the passage from the 'medieval painters' guilds' to the art market *via* the founding of the *Académie Royale de Peinture et de Sculpture* in France in 1648. At the beginning of the seventeenth century, they say, French painters can be divided into three groups: 'the Rome-educated *brevetaires* (both French and foreign) of the king and nobles, who were also in

demand by the *noblesse de robe*; the guild-trained artisan-painters; and, also within the guild, a dissident group of painters who enjoyed some commissions from the *noblesse de robe* and who chafed under guild restrictions'.[1] Note that these three groups belong to a dual system in which there are two escape routes from the guild to the court. As such, this classification of painters is not innocent but is couched specifically so that it can be cashed in as an episode in a simple tale of emancipation from feudal constraints.

The story of the liberation from feudalism is a bourgeois tale designed to justify imperial conquest, colonial settlement and ease the way for the violent imposition of *laissez faire* both home and abroad. Painters emancipating themselves from the guild by fleeing to Rome or belonging to a 'dissident' group at home conform precisely to the image of those individuals who appear to be always already bourgeois subjects within feudalism and therefore 'chafed under guild restrictions'. The romance of liberation is enhanced by the fact that a minority of individuals escape from institutional discipline, despite the fact that the guilds were the instruments of the self-organisation of the artisans. In the same vein, it is possible, also, to portray the king and the nobles as individuals who provide private support for dissidents against the prevailing system.

The campaign for the emancipation of individual painters from guild restrictions in the first half of the seventeenth century takes place at exactly the same time as the development, in philosophy, of the 'modern idea of a subject as an independent existent',[2] and of 'possessive individualism'[3] at large. What might initially seem to be a weakness in the account turns out to be both a core principle of the fable of liberation from the guilds and, at the same time, an emergent historical tendency within the revolutionary bourgeoisie. Not only was the emancipation from the guild expedited on an individual basis, this narrowness and weakness of the confrontation with the guild was conceived, within the political imaginary of the period, to be paradigmatic of liberation.

In eighteenth-century France, early advocates of economic liberalism such as Anne Robert Jacques Turgot, who was Louis XVI's Controller General, targeted the guilds for their restrictions on trade and restricting the workforce that entrepreneurs could hire, but also for preventing its members from working in a variety of techniques and extracting arbitrary charges from them. William Sewell chronicles how this attack on the guilds spawned a dispute

1 See White and White 1993 [1965], p. 5.
2 Taylor 1989, p. 188.
3 Macpherson 1962.

over the meaning of liberty.[4] Sheilagh Ogilvie, the mainstream economist, is perhaps the most prominent advocate today of Turgot's liberalism. She characterises the persistent controversy over the guilds by dividing the literature in two, with opinion split between 'economic historians criticizing the cartelistic provisions of guild charters, and social historians celebrating guilds' contribution to the solidarity of pre-modern society'.[5] Economic theory, she suggests, provides tools for correcting 'optimistic' views of the guilds and explains their longevity negatively by arguing that the 'costs of abolition'[6] were too high.

The interpretation of the abolition of the guilds as the emancipation of the worker or the liberation of capital from feudal constraints has been advocated across the full range of the social sciences and humanities. A sample might include the following: Henri Pirenne, the eminent late nineteenth-century scholar of the Middle Ages, claimed that craft guilds 'fulfilled the need of economic protection ... [t]he pressing necessity to stand by one another, so as to resist competition from newcomers',[7] and that they 'crush[ed] all scope for individual initiative';[8] Max Weber said 'the guilds were an instrument of the producers by which they protected themselves against surplus production and the fall in prices this entailed';[9] Rudolf Wittkower, the art historian, said the guilds for the arts of painting and sculpture 'exercised an equalizing influence'[10] and were typified by 'the regulated routine of a collective workshop' which he contrasted with the great individual of Renaissance Florence who, liberated from the guild, 'was now often on his own and developed habits compatible with his freedom';[11] Régis Debray argued that 'the educational project of socialism ... lifted its vision beyond that of unions and guilds';[12] and, finally, Hugh Trevor-Roper, the vigilantly anti-Marxist historian, noted 'the pressure of guild restrictions'[13] and their role in 'impeding technical change'.[14]

A recent tendency within the historical study of the guilds, led by S.R. Epstein, James Farr, Steven Kaplan, Catharina Lis, Hugo Soly and others, chal-

4 Sewell 1980, pp. 72–7.
5 Ogilvie 2008, p. 330.
6 See Ogilvie 2008.
7 Pirenne 1937, p. 79.
8 Pirenne 1937, p. 206.
9 Weber 2003 [1904–05], p. 38.
10 Wittkower 1961, p. 297.
11 Wittkower 1961, p. 293.
12 Debray 2007, p. 14.
13 Trevor-Roper 1967, p. 20.
14 Trevor-Roper 1967, p. 28.

lenges the caricature of the guilds which Epstein calls 'a generalized eighteenth-century debunking of the guilds'.[15] This has led to a complexification of the description and assessment of the guilds rather than merely an inversion of the vilification of them. This tendency pays attention to the geographical and organisational specificity of different guilds rather than focusing on a small number of case studies to form a generic theory of the guilds, insists on a greater variety of occupations and activities within the guilds and emphasises the multiple functions that they performed.

In the same spirit, the general narrative of the emancipation from the guilds can be confronted with an acknowledgement of the multiple specific actual freedoms secured by the guilds against the abstract freedom obtained by escaping from them or abolishing them. Guild members, both masters and journeymen, were obliged to become Freemen of the city, which was constitutive of becoming a citizen. Freedom, in this context, consisted principally of being at liberty to engage in trade, to have the privilege to participate in the administration of the city and the right to vote in parliamentary elections. Freemen were individuals who had been granted Freedom papers for a given city. A Freeman was free insofar as he was not bound into feudal servitude but also Freedom papers granted artisan guild members the privilege to market, trade, or conduct business. The guilds and the livery companies successfully secured a monopoly on this modality of freedom during the Middle Ages as the towns and cities were built. It is both this monopoly and this modality that is challenged in seventeenth- and eighteenth-century conceptions of freedom.

A specific iteration of this confrontation is captured in Marx's summary of the problem of regarding the abolition of the guilds solely in terms of the emancipatory narrative of attaining freedom from them.

> The immediate producer, the labourer, could only dispose of his own person after he had ceased to be attached to the soil and ceased to be the slave, serf, or bondsman of another. To become a free seller of labour power, who carries his commodity wherever he finds a market, he must further have escaped from the regime of the guilds, their rules for apprentices and journeymen, and the impediments of their labour regulations. Hence, the historical movement which changes the producers into wage-workers, appears, on the one hand, as their emancipation from serfdom and from the fetters of the guilds, and this side alone exists for our bour-

15 Epstein 2008, p. 155.

geois historians. But, on the other hand, these new freedmen became sellers of themselves only after they had been robbed of all their own means of production, and of all the guarantees of existence afforded by the old feudal arrangements.[16]

Hence, what E.P. Thompson called the 'rhetoric of liberty', was not restricted to the specific freedoms obtained by the guilds. Freedom, especially either side of the French Revolution, could also mean freedom from foreign domination, freedom from Absolutism, freedom from arbitrary arrest, freedom of the home from arbitrary search, 'some limited liberty of thought, of speech, and of conscience ... as well as freedom to travel, trade, and sell one's own labour'.[17] We might even go so far as to say the flowering of freedoms in the eighteenth century was itself a factor in the erosion of the legitimacy of the guilds insofar as their specific freedoms were confronted with rival modalities of freedom, especially those that were, at least formally, universal or general.

In the specific case of artisan-painters and artisan-sculptors in the seventeenth and eighteenth century, however, these two frameworks of freedom are insufficient in the hostilities between the guilds and academies. When a privileged minority of painters, sculptors and architects petitioned to be exempted from guild regulations, however, they did not turn themselves into wage labourers or the bearers of nothing but labour power stripped of the means of production.

Peter Wollen turns the table on the narrative of liberation from the guilds in the case of painters and sculptors in the seventeenth century by assigning agency not to the painters and sculptors themselves but to the crown. 'The establishment of the Academies became a keystone of Louis' regime', Wollen says, explaining that it recast 'the arts as a form of luxury good', subsumed the arts under the state, improved the manners of his court, and so on, including 'limiting and replacing the authority of the old independent craft guilds'.[18]

Michael Newman, in an otherwise excellent argument, telescopes the historical confrontation between guild and academy and overstates the philosophical contribution to it when he says, Kant

> distinguishes 'fine art', characterised as the 'art of genius', from the mechanical and other arts. Thus, instead of different arts, inspired by their

16 Marx 1990 [1867], p. 875.
17 Thompson 1991 [1963], p. 86.
18 Wollen 2000, p. 94.

respective muses, and with their distinct guild traditions, we have an over-arching category of 'fine art', characterised according to its beauty, its sublimity and the 'aesthetic ideas' that it generates. In practice it was not until the early twentieth century that Duchamp threw into question the organisation of art in terms of its particular mediums.[19]

Newman attributes to Kant a more emphatic conception of the abstraction of art in general from the Fine Arts than is evident in the text. Kant refers throughout to *schöne Kunst* and plays on the association with beauty that the term inherits from the French *Beaux Arts*. Kant uses the word 'art' in a number of ways simultaneously. Art refers to a skill but is also distinguished from it through the division between the liberal arts and the mechanical arts, which he redescribes through an opposition between 'freedom' and 'remunerative art'. And yet, within the interchange of terms and phrases that Kant deploys in order to discover freedom within a certain category of the arts, it is possible to detect a tendency that has its origins in the conflict between the guilds and the academies in the seventeenth century.

While individual painters in seventeenth-century France certainly peti-tioned for their freedom from the guild, these manoeuvres took place not simply to circumvent the tyranny of the guild but against the guild system's monopoly of freedoms of the city. The guilds secured various monopolies of trade within a particular locality through which they regulated the quality of products and trading practices both through internal controls (such as inspec-tion visits) and their participation in the political administration of the town or city. It is not the case, therefore, that the artisan-painters did not enjoy the freedoms that court-painters sought, but rather that court-painters jealously desired the multiple specific freedoms which were secured as privileges by the guilds for its members. In effect, the freedoms accorded to the guilds were being claimed on behalf of an elite group of individuals with aristocratic and royal patrons since the emancipation from guild regulations, in France as elsewhere, was conducted on an individual basis.

The Académie Royale, however, instituted the emancipation from the guild on a social scale even if its recruitment of members continued to be structured on an individual basis with the submission of a 'reception piece' and other pro-cedures designed expressly to associate the Académie with the highest quality of painting and sculpture. In the words of Christian Michel, whose study of the Académie is the most thorough to date, the purpose of the Académie was

19 Newman 2007, p. 87.

to bring 'together the best French artists in a single body'.[20] This is partly true insofar as the Académie was an institution of distinction but partly false insofar as the category of the artist was not yet formed in the modern sense and also questionable insofar as guild painters continued to be commissioned by the most prestigious patrons.

Michel follows the convention of art historical scholarship when he claims, '[a]dmission to the Académie became the principal means by which an artist was distinguished from a craftsman'.[21] The differentiation was real, but the terminology is anachronistic. Both artist and craftsman are of later coinage. What the Académie did was to underscore the existing differentiation between artisan-painters and -sculptors and scholar-painters and -sculptors that had operated across the dual-system of guild and court. The transition which the Académie did so much to realise was not from craft to art but from the mechanical art to the Fine Arts as a partial completion of the elevation of painting and sculpture to the liberal arts. Michel charts the disputes within the dual system of guild and academy as contingent events mapped onto the inevitable transition from the arts to art. He acknowledges the precarity of the Académie in its early years and the strength of the guilds but does not accurately assess the stakes of their rivalry because he overstates the modernity of the academy system. Michel's historical reconstruction is empirically rich but lacks a clear sense of the political conjuncture in which the elevation of the Fine Arts functioned within the aristocratic regime of the mechanical and liberal arts.

In 1648, the primary objective of the Académie was 'to raise the status of painting and sculpture to the rank of liberal arts ... [and] to escape the clutches of the guild'[22] but it did not entirely replace the guild system until its restoration after the French Revolution. Existing uneasily alongside one another, the Académie and guild were sometimes at loggerheads and sometimes in implicit or explicit partnership, such as the union with the guild in 1651. There was also traffic between them. In particular, the Académie appeared for the most part to draw the best of the painters and sculptors from the guild. As such, the Académie continued to rely on a type of formal or informal apprenticeship as a preliminary stage of education for their students. Academies did not teach painting or sculpture in any technical sense but restricted admission to candidates who could demonstrate facility in one of the Fine Arts through the presentation of a 'reception piece'. 'An apprenticeship in handling a pencil and

20 Michel 2018, p. xiii.
21 Michel 2018, p. 134.
22 Michel 2018, p. 131.

acquiring a good eye, first by copying drawings and engravings and then by drawing from three-dimensional forms, was a condition of admission to the Académie, but drawing was not taught there'.[23]

Students were only required to spend three years in the academy compared with the typical seven year apprenticeship, in part as an acknowledgement of the years already spent in the workshop or *atelier* of a 'master'. The Academy, therefore, was not a self-sufficient system but relied on the apprentice system that preceded it and the atelier system that developed within and around the academy. The atelier system was needed both to supplement the academy's own limited scope of education and to provide academic painters and sculptors with their 'principal source of income'.[24] In contrast with the apprentice system, in which, after an initial payment on behalf of the apprentice, the 'master' was obliged to provide food and lodging for the apprentice, the academicians drew 'the bulk of their income'[25] from their students. As such, only the wealthiest of academicians 'could afford to dispense with teaching'.[26] So, whereas artisan painters and sculptors operated within an apprentice system in which the practitioner was also, typically, a teacher, in the academy system the painter and sculptor would combine these two activities *as if* they were separate and specialised. Certainly, making works of art and teaching students had now become two distinct revenue streams.

Michel is right to point out that the first academicians were 'particularly anxious to defend the distinction [between the academy and the guild] ... because what was asked of them [by their patrons] was no different from what was asked of the guild painters and sculptors'.[27] As such, the absolute distinctions regulated by the guilds (the difference between an individual who had served an apprenticeship and another who has not, for instance) were replaced by the academy with relative differentiations. The perception of the difference in the quality of their work was of considerable importance to the academicians, hence they continued a discursive campaign against artisan painters and sculptors by associating them with nothing more than mechanical techniques and menial preparatory tasks.

André Félibien des Avaux's famous elaboration of the hierarchy of genres, delivered in a lecture at the Académie in 1669, constructs an elaborate scale of works of art based on a binary distinction between two forms of artistic labour

23 Michel 2018, p. 243.
24 Michel 2018, p. 295.
25 Michel 2018, p. 297.
26 Michel 2018, p. 295.
27 Michel 2018, p. 132.

that serve as the farthest poles of an incremental measure of the distance
between the academic painter and the artisan. 'That part of the representation
of a natural form which consists simply of drawing lines and mixing colours is
considered to be work of a mechanical kind',[28] he said, providing a baseline for
the various levels of difficulty and nobility (also referred to through the syn-
onyms perfection and grandeur). As such, the hierarchy of genres, whatever
else it signified,[29] was initially developed in the absence of an absolute distinc-
tion of legitimacy and illegitimacy between two rival factions of painters as a
method for differentiating between their relative legitimacy. It is the percep-
tion of an incremental distance 'from the artisan's manual skill and physical
material'[30] that prompts the rhetoric of 'superior to', 'more respect than', 'more
outstanding by far than', and cognate terms.

The quarrel over whether to privilege colour or drawing in the early years
of the Académie, since 'colour was associated with the manual task of grind-
ing pigments and staining cloths',[31] was both a struggle over the principles that
turned on philosophical questions about truth and beauty and also, in some
measure, a coded discourse on the relationship between the Fine Arts and han-
dicraft. Colour, as a substance, was the province of the artisan and therefore
the academician appeared to have two methods available for marking a separa-
tion from handicraft with regard to colour. Either colour could be relegated to
a low status below drawing and line, or colour could be assigned a new intel-
lectual significance that it did not have for the guilds. Both sides of the quarrel
built their arguments on the need to elevate the Académie above the artisan
practices of the colour grinders and dyers. Despite the differences within the
academy, therefore, the quarrel at no point crossed the line between the Fine
Arts and handicraft as this was reflected in the Académie's recently obtained
monopoly on drawing and the guild's longstanding monopoly on colour. In
effect, the debate on colour is best understood as an instance of the discurs-
ive construction of the divide between the academy and the guild as a contrast
between the liberal and the mechanical arts in which guild artisans were cast
as only capable of producing works by rote and reliant on copy books.

This association of the artisan painter with purely mechanical facility was
extended in the next century through the concept of polish and lick which
Richard Wrigley, in his study of the use of the term 'bourgeois' in art criticism

28 Félibien 1999 [1669], p. 35.
29 For a reading of the hierarchy of genres as prioritising the effects of 'drama', see Fried 1980,
 pp. 71–105.
30 Félibien 1999 [1669], p. 35.
31 Harrison, Wood and Gaiger 2000, p. 17.

in the late eighteenth century, describes as symptomatic of an ostensive 'bour-geois sensibility' that took its pleasures from paintings that displayed 'merely physical craft, lacking the inventive dignity of true art'.[32] These perceptions of the artisan (and the socially distinct 'author') are at the root of what became the law of copyright. Copying, which was now conceived as a mechanical pro-cess not because it could be done by machines but because it could be done by an artisan skilled in the mechanical arts, was at the heart of the confrontation between the Académie and the guilds. Katie Scott recounts the allegations of an apparently widespread practice of the 'unauthorized production of casts by sculptors of the guild after works by sculptors of the Academie'.[33] Whether or not this was exaggerated to confirm the distinction between artisans and Fine Artists, 'the king's council issued an act on the 21st June 1676 which prohib-ited all "bourgeois" sculptors (that is sculptors of the city of Paris) and others from making and selling casts after works by members of the Academie without permission of the author, on pain of a fine of 1000 livres, plus damages and costs'.[34] Such measures may have responded to actual cases of copying, or even a spate of them, but these real events were seized on to perpetuate and exag-gerate a differentiation that conceived the dual system of guild and academy from the point of view of the academy. This bias becomes all the more difficult to recognise once the academy's perception of guilds and artisans is incorpor-ated as part of the standard modernist argument for what distinguishes art from craft and is the foil for the avant-gardist critique of art's apartness from life, the everyday and social utility. As a result, one of the missing elements of the historical and conceptual analysis of art's autonomy has been the legacy of the academic differentiation of the Fine Arts from guild artisan painting and sculpture.

'In consolidating its monopoly of privilege', White and White argue, 'the Academy also emphasized a new conception of the artist: no longer an artisan or a low-caste hawker of wares, he was instead a learned man, a teacher of the high principles of beauty and taste'.[35] It is the academy's view of the guild that underpins Arvatov's conviction that the guilds 'killed talented inventors, des-troyed technical innovations'.[36] This rift established by the academy remains operative today in the sociological privileging of the artist in social movements on the basis that 'artistic expression has a special quality of expressing feel-

32 Wrigley 1998a, p. 137.
33 Scott 1998, p. 34.
34 Ibid.
35 White and White 1993 [1965], p. 6.
36 Arvatov 2017 [1926], p. 18.

ings that are at the roots of civil action'.[37] It is inscribed into the contrast between the 'expressive cultures developed in slavery ... where relations of cultural production and reception operate that are wholly different from those which define the public sphere of the slaveholders'.[38] It lurks in the background of the assumption that 'the volatile relationship between high art and mass culture'[39] is constituted in part by 'the quality differences between a successful work of art and cultural trash (Kitsch)'.[40] It can be traced, also, in the sociological critique of the rhetorics of creativity in cultural work 'in situations where managers assume the mantle of creativity ... to ensure that creative work is divested of its privileged status [and] recast as ordinary labour'.[41]

Peter Bürger credits the avant-garde with the perception of art as a system. A superficial reading of this seizes on the word 'institution', but for Bürger the *institution of art* refers specifically to 'the epochal framework within which the production and reception of literature occurs' or 'the definitions of the function of art in its social contingency and the changes in that function from period to period'.[42] What Bürger calls art as an institution is also known as the art system. Bürger is correct that the avant-garde instigated the negation of *art as a whole* and therefore, in a dialectical sense, understood *art as an institution* in an entirely new way, or even that with the avant-garde the ontology shifts from a category of objects to a social system of cultural production and reception. However, the very existence of an art system as a separate social grouping of institutions and arrangements is inaugurated by the academy when it split from the guilds and set up a social infrastructure specific to painting and sculpture rather than the generic arrangements of artisanal manufacturing at large.

It is vitally important to stress the conflict between the early academies and the guild workshops; however, the passage from the workshop to the studio *via* the academy does not seem to progress through a process of replacement but a sequence of conflicts and confrontations. What's more, this process of supersession was not complete until the eighteenth century and existed for 200 years only as a privileged exemption from guild regulations for a minority. James Ayres, the craft historian, has charted the pre-history of the Royal Academy in London as a series of itinerant members' clubs. Rooms were rented

37 Gielen and Lijster 2017, p. 45.
38 Gilroy 1999 [1993], p. 57.
39 Huyssen 1986, p. vii.
40 Huyssen 1986, p. ix.
41 Banks 2007, p. 80.
42 Bürger 1985–86 [1974–75], p. 7.

or donated, such as in St. Martins Lane or in the Duke of Richmond's establishments, for weekly congregations, but the desire for a permanent purpose-built residence was inscribed into the pattern of the independent academies. They served a variety of functions at the same time. They resembled the clubs and salons of polite society inasmuch as they were convivial social events with the marked difference of supplementing genteel discussion of *amateurs* with the purpose of instructing its members in drawing from antique casts and studying the nude.

At the same time, they were used by painters, sculptors and apprentices as an extension of the collective organisation of the arts that had always characterised handicraft. Given the expense of hiring a model, painters and sculptors would gladly pay the fee to attend the academies to 'spread the cost of employing models'.[43] Apprentices appear on the roster of members for the same reason. Such academies may, in retrospect, signal the death knell of the guilds and workshops, but they were constituted according to the principles of corporate self-organisation that remained the ethos of artisans. When the Royal Academy was founded in 1768 'an officer class was established amongst painters, sculptors and architects',[44] and when it inaugurated its annual exhibition in 1769, a new purpose of the academy to mediate between artists and the public was instituted. As a result, the academy took on a new meaning as the arbiter of quality. Nevertheless, clubs and societies continued to sprout up into the next century, such as the Norwich Society of Artists which held 'evening meetings, exhibitions, and sketching parties'.[45]

The Académie Royale, according to White and White, 'was at first merely independent of the guild, but soon dominated and then replaced it in power and prestige'.[46] To frame the relationship between guild and academy in terms of the victory of the academy system is to rotate a rivalry within a dual system into a supersession of one system by another. In some sense, this rotation actually took place over a relatively long period of time, but the apparent victory of the academy was incomplete until the French Revolution which, among other things, dissolved the guild system. The thesis of the supersession of the guild by the academy, however, must be moderated by the fact the revolutionary assembly decreed to close the Académie on the principle that 'all state-run art schools ... should be closed'.[47] It was not immediately clear whether the

43 Ayres 2014, p. 422.
44 Ayres 2014, p. 20.
45 Hemingway 1987 [1979], p. 8.
46 White and White 1993 [1965], p. 6.
47 Michel 2018, p. 200.

guild system would be maintained, reformed or abolished, partly because it was
the force of the 'petty producers, craftsmen or peasants that dealt the gravest
blows against the old order of society'.[48]

The *Sans Culottes*, consisting largely of craftsmen operating within the guild
system in the old regime, did not imagine that the revolution would wash away
all of their institutional modes of collective organisation. 'During the first two
years of the Revolution, many eminently revolutionary workers and masters
felt that corporate loyalties of one sort or another were perfectly compatible
with the new revolutionary ideology and state'.[49] Nevertheless, the National
Assembly dissolved the guilds in March 1791 within a political project that
demanded, in Sewell's terms, 'the annihilation of any sense of common interest
intermediate between the individual and the nation'.[50] The destruction of the
guild system in France was pitched by the Jacobin leadership as an expression
of the revolutionary abolition of privilege, tradition, hierarchy and regulation,
and replaced the hierarchical ordering of master, journeyman and apprentice,
as well as the distinction between members of the guilds and the various levels
of unskilled workers excluded from them. In place of this baroque order of
the arts within the guilds the new modern regime of labour installed a single
distinction between employer and employee. As a result, 'work evolved increas-
ingly from a skill developed and ratified by artisans ... into a commodity offered
by independent individuals'.[51]

Michel argues that the revolutionary critique of the academy 'strongly
resembled the critiques levelled by the Académie against the guild'.[52] It is true
that certain tropes that were deployed within the academic assault on handi-
craft recur in the revolutionary period within arguments against academicism,
specifically the pejorative reference to producing works of art by rote or stand-
ard formulas. However, the revolutionary critique of the academy does not
replay the discursive contrast between the vulgar and liberal arts. What is objec-
tionable about the academy at the end of the eighteenth century is not that it is
menial, manual and mechanical but that its hierarchical structures and schol-
arly techniques stifled talent, genius, imagination, invention and taste. Despite
the fact that the Académie was founded with the purpose of establishing 'free-
dom for the arts' and the Jacobins and modernists accused the Académie of
killing freedom, but this sequence of events does not correspond to the mythic

48 Soboul 1977, p. 155.
49 Sewell 1980, p. 92.
50 Sewell 1980, p. 89.
51 Fitzsimmons 2010, p. 262.
52 Michel 2018, p. 200.

narrative of the liberator turned tyrant. For the Académie, the freedom for the arts was understood specifically in terms of the freedoms that were the privilege of the guilds, whereas for the revolutionaries, the modernists and the avant-gardists, freedom was more abstract, individualist, subjective and universal.

The political dismantling of the guilds did not proceed unchallenged or without symbolic confrontation and corporal violence. As Hobsbawm puts it, the economic policies of the Constituent Assembly were consistently liberal: 'its policy for the peasantry was the enclosure of common lands ... for the working-class the banning of trade unions and, for the small crafts, the abolition of guilds and corporations'.[53] Hence, the destruction of the guild system in France appeared to belong to the revolution insofar as it was officially couched as an expression of the abolition of privilege, tradition, hierarchy and regulation, and replaced the hierarchical ordering of master, journeyman and apprentice, as well as the distinction between members of the guilds and the various levels of unskilled workers excluded from them. It is only after the success of abolishing the guilds that the academies are brought back from the dead. With the aristocratic collections of works of art in France either scattered around Europe or gathered within the Louvre galleries available to all for free, the academy system had lost its original social basis.

The supersession of the guild does not manifest itself until 1795 when the Académie de peinture et de sculpture merged with the Académie de musique and the Académie d'architecture in the Académie des Beaux Arts. Despite ongoing debates about the advantages of guilds versus industrialisation and *laissez faire* at the end of the eighteenth century, the guild system was not revived at the same time. While for the majority of jobbing artisan painters and sculptors nothing much changed in the structuring of the institutions of the guild and the workshop between the Renaissance and the Industrial Revolution, there is, for a minority, a dramatic reconfiguration of painting and sculpture during this period. There is, therefore, a new division that cuts through the arts of painting and sculpture in which the privileges of the few are denied to the many. And the social distinctions that are constructed between, for instance, court painters and guild painters, are inscribed in the built environment and the protocols of skills acquisition as much as in texts describing the qualities of 'the most eminent painters, sculptors and architects'. This situation is changed decisively not with the establishment of the Académie Royale but with the founding of the Académie des Beaux Arts alongside the abolition of

53 Hobsbawm 2010 [1962], p. 85.

the guilds. Even so, the agenda of the Académie Royale is, in many significant respects, preserved within the Académie des Beaux Arts, hence the rupture is simultaneously a consolidation of the opposition to artisanal production which is now understood as an historically obsolete feudal system.

Eventually, the passage from the arts to art concludes with the transition from the artisan to the artist, but this does not occur in an instant on the model of a revolutionary seizure of power. The hostility to the artisan and handicraft that has become a cliché of art theory had a sickening edge to it at the time. Peter Linebaugh has uncovered the fact that 40 percent of the 1,242 men and women 'hanged in Tyburn during the first half of the eighteenth century for whom we have biographies had been apprenticed to a trade'.[54] Linebaugh argues that 'the social history of Tyburn must also be an economic history of the trades and working conditions of its victims'.[55] That is to say, 'the hangings were functional to the transformation of the wage'.[56] The highwayman, Linbaugh says, 'aspired in part to the independence of the master artisan'[57] whereas the 'pedagogy of the gallows' attempted to persuade him to join 'a tractable, obedient labour force'.[58] Similarly, the bandit (guerrilla, 'noble robber', terrorist, 'resistance fighter', etc.), according to Hobsbawm, is typically drawn from 'peasants who refuse to submit'[59] during the hostile process of being 'absorbed into larger economies resting on class conflict'.[60]

One result of the supersession of the guild by the academy is that the modernists and avant-gardists who eventually pitted themselves against the academy did so, unwittingly, in normative terms that the Académie Royale had introduced in order to distinguish itself from the guild. The discursive and institutional elevation of art above mere skill, craft, industry, second-rate goods, bad taste, popular culture, standardisation, commodity production and so on and so forth, which pervades modernism and is not entirely absent from avant-gardism, does not begin from nothing in the seventeenth century but it took on its most emphatic form with the establishment of the academies of Fine Arts. When art in general is developed as a category out of the triumphs and disappointments of the categorisation of the Fine Arts and their institutionalisation in the academies, the ontology of art is not determined exclusively

54 Linebaugh 2006, p. 101.
55 Linebaugh 2006, p. 111.
56 Linebaugh 2006, p. 450.
57 Linebaugh 2006, p. 189.
58 Linebaugh 2006, p. 213.
59 Hobsbawm 2001 [1969], p. 28.
60 Hobsbawm 2001 [1969], p. 21.

by the new conditions of the art market, the art school, the studio and the
gallery but also by the legacy of the regime constructed to exalt the Fine Arts
above artisanal painting and sculpture. Before the break that is signalled by the
abstract category of the artist, there is a lingering historical process of disen-
tanglement, disaggregation and dissolution. Initially, the social reorganisation
of painters and sculptors outside the guilds and parallel with them does not
require a revolution, only a repositioning within the established system of the
arts. However, the repositioning was not even-handed.

However, the academicians went further than designating artisans as 'mech-
anicks', they also reconstituted the Fine Arts economically, socially and politic-
ally. The academies obtained certain privileges from the state but also imposed
on themselves a battery of prohibitions. Together these privileges and pro-
hibitions delineated the Fine Arts principally by elevating them above han-
dicraft, and in doing so defining the scholar-painter and scholar-sculptor in
terms that emphatically contrast with the artisan-painter and artisan-sculptor.
It is of lasting significance that the Académie Royale forbade its members 'to
open a shop for sale of his works or to exhibit them in the windows of his
house'.[61]

By establishing a social demarcation between the 'master' artisan and the
academically trained painter and sculptor that associated handicraft with sales,
on the one hand, and the Fine Arts with virtue, on the other, the Académie
inaugurated an antagonism to commercialism that resonates with subsequent
strands of the politics of art. There is some injustice to the accusation that
the guilds were institutions driven by commerce, which the academies fab-
ricated and Kant eventually adopted. Master artisans, for instance, 'used guild
regulations to thwart attempts by merchants to control production directly',[62]
confirming the point made by Marx that the guilds 'tried to prevent by force
the transformation of the master of a trade into a capitalist, by limiting the
number of labourers that could be employed by one master within a very small
maximum'. Indeed, Marx went so far as to say that the 'guilds zealously repelled
every encroachment by the capital of merchants, the only form of free capital
with which they came in contact'.

Since the Freemen of the guilds held the exclusive right to own a shop, the
statute forbidding academicians from opening a shop can be read as a vic-
tory of the guilds and the admission that the academy could not award such
a right to its members. In fact, the historical transition from the workshop to

61 White and White 1993 [1965], p. 13n6.
62 Harreld 2008, p. 134.

the academy, which recast the Fine Artist as a scholarly individual, blocked the breadth of activities that continued to be practised by artisans. In some sense, then, it constituted a palpable reduction of freedom and agency for the painter and sculptor. Nevertheless, the academy's narrow but elevated conception of freedom that modelled itself on the court has fared far better within art's modern institutions than the guild's regulation of freedom embedded in the governance of the city. Although the founding members of the Académie might have had to sacrifice privileges that they had obtained as 'master' artisans who had served an apprenticeship, the Académie had privileges of its own. The Académie obtained a monopoly on life drawing in France and enjoyed priority in securing royal commissions, the prohibition on copies of works by academicians, and later, the exemption of its students from joining the militia.

Although the Académie Royale followed the protocols of the guilds insofar as it sought to establish rights, privileges and freedoms for its members, more importantly it was a machine for producing and regulating distinctions within a specific conjuncture of the politics of work. The Academy distinguished itself from the guild in order to secure the distinction of members of the academy from artisans and the distinction of its students from apprentices. It is this highly charged politics of labour that is codified in the severing of the Académie from commerce in 1648 and reiterated in 1777 with a statute proclaiming those who 'wish to open a shop and trade in pictures, drawings, and sculptures by other hands, sell colors, gilding, and other accessories of the arts of painting and sculpture ... shall be required to seek admission to the Community [Guild] of Painter-Sculptors'.[63] The statute prohibiting commerce was the precondition for the emergence of two important developments. First, it prompted the inauguration of the Salons – opportunities for its members to exhibit, sell and advertise themselves to patrons and collectors – in which the commercial transactions between artists and patrons were mediated by the academy itself. And second, the rise of art dealers which sealed off the scholarly practitioner of the Fine Arts from direct economic transactions.

Tucked inside the transition from the workshop to the studio, the passage from the apprentice to the art student (which consists initially of a transition or transfer from the workshop to the academy), recast the painter and sculptor as the product of scholarship rather than handicraft. One of the keys to the supersession of guild by the academy, therefore, was the specific formation of the differentiation between the pupil of the academy and the apprentice of

63 Quoted in Michel 2018, p. 112.

the guild workshop. Indeed, the 'shift from an apprenticeship to a pupilage'[64] was an essential ingredient in the transition from the workshop to the studio, which itself is a vital element in the protracted transition from the arts to art in general *via* the Fine Arts.

Both transitions (from apprenticeship to pupillage and from workshop to studio) can be narrated in terms of transitions from a feudal to a modern condition, but they must also be understood as upward movements within the regime of the mechanical and liberal arts rather than as attempts to flee that system or undermine it. If the transition from the arts to art in general is understood as an anomalous trajectory within the historical process by which the guild system was dissolved to make way for the wage system, then the passage from patronage to the art market, which is a kind of shorthand for the transition from the arts to art in general, cannot be merely a modification of art's forms of consumption. There can be no displacement of patronage by the art market without a thorough reconfiguration of the social basis of artisanal production.

Painters and sculptors sought to establish institutions that confirmed that their activities belonged to the liberal arts. Hence, the academy inaugurated a new social division of labour for art in which teaching, at least for an elite, was provided outside the workshop by professors – originally, in the Académie, called the *elders* and later known as the *officers* – who gave lectures as well as posing the model and supervising the life class. Neither student nor professor make paintings or sculptures in a workshop but in a studio. This marks a turning point because all previous examples of artists working privately without assistants or taking on apprentices the painter or sculptor working in the studio had been apprenticed in a workshop whereas students in the academy may never occupy a workshop.

For some time, therefore, there existed a two-tier system in which workshops with apprentices persisted alongside the elite studios. However, the studio remained in many instances a social space rather than the private place of production which became dominant after the advent of the bohemian garret. The academies, therefore, initiated the turn from the artisan to the artist insofar as they introduced a new social division of labour between the production of paintings and sculptures and the instruction of painters and sculptors, and insofar as they were the first institutions that presupposed the private studio as sufficient for the production of works of art. However, insofar as the academies were academies of painting and sculpture, they were also institu-

64 Ayres 2014, p. 16.

tions that operated within the regime of the arts in which the several specific
Fine Arts were associated with the liberal rather than the mechanical arts. The
transition from the arts to art in general, therefore, was not completed by the
transition from the apprentice system to the academy system and the transition
from the workshop to the studio.

Conventional associations of the apprentice need to be addressed. Appren-
ticeships had always taken various forms. In North Carolina, for instance, in the
first half of the eighteenth century, as James Sidbury has chronicled, 'slaveown-
ers began to have their bondsmen trained to work in crafts'.[65] In England, from
1731, Freemen were forbidden to take on black apprentices.[66] Slave artisans do
not correspond to the 'myth of the artisan' that Rancière unpacks.[67] Nor are
those seafaring artisans who, although not slaveowners themselves, would be
sent groups of black female slaves from plantation owners on arrival in West
Indian ports.[68] And the women who dressed as men in order to serve appren-
ticeships also testify to the diversity of lived experience within the system of
artisanal production. The famous case of Mary Lacy (aka William Chandler),
who served her apprenticeship dressed as a boy on the HMS Sandwich in the
middle of the eighteenth century and went on to become a house builder in
Deptford, provides a vivid example of the systemic exclusion of women from
the apprentice system as well as the kind of exceptions that could be won in
and against it.

Apprenticeships in various skilled occupations still exist in one form or
another today, but they are a faint copy of the apprentice system regulated
by the guilds in which, on average in the colonial centres of Europe, 14-year-
old boys would be indentured to a 'master' for seven years to learn the secrets
of a craft, serve as an assistant within the workshop and live as a member of
the 'master's' household. The master-apprentice relationship combined what,
in the capitalist mode of production, would be the relationship between the
teacher and pupil (insofar as the apprentice learns a craft from the 'master'), the
employer and employee (insofar as the apprentice receives a livelihood from
the 'master'), the manager and worker (insofar as the apprentice does the 'mas-
ter's' bidding), and the capitalist and wage labourer (insofar as the apprentice
provides surplus labour for the 'master').

Painters and sculptors had not typically been apprentices in painting and
sculpture but had been indentured to a silver engraver, stainer, a house painter,

65 Sidbury 1995, p. 48.
66 See Ayres 2014, p. 3.
67 See Rancière 1986.
68 See Stark 1998.

ornamental plasterer, decorative carver, mason or a plumber.[69] The Académie was organised around a misperception of the apprenticeship as a merely technical acquisition of skills, referring to artisans pejoratively as 'colour grinders'[70] and 'hewers of stone',[71] whereas the guilds regarded the arts not as skills in the limited sense but mysteries. Hence, neither the guilds nor the academies believed that the arts could be taught. An apprenticeship with an artisan was not principally a process of being taught how to paint and sculpt but was an initiation into the mysteries of the craft such as the ingredients and techniques of grinding paint, making brushes and pencils, etc.; and the pupil of the academy was not taught how to paint or sculpt either.

Rather than serving an apprenticeship in the skills and secrets required to make works of art, study in the Académie was largely theoretical ('courses were confined to the study of optics and perspective and to the study of mankind through anatomy and the living model'[72]). The study of drawing followed a strict programme beginning with drawing from engravings of canonical works of art, then from plaster casts of antique statues and finally progressing to drawing the nude. This was not a programme of lessons but a sequence of increasingly difficult tests. Early modernists formulated a third version of the antagonism between art and technical instruction that rejected both handicraft and the imitation of classical precedent. Courbet reiterated the academic rejection of the apprenticeship as well as speaking up for a generation of anti-academic artists when he said art could not be taught. Courbet, in the nineteenth century, famously refused to take on any students of his own. For him, the would-be painter should neither immerse themselves in the tradition of handicraft nor submit themselves to the sterile protocols of the Fine Arts. Courbet and the early modernists advocated that the young painter be neither an apprentice nor a student and should turn to neither the academy nor the guild.

The Jacobins were the first to hold this position. It is the revolutionary critique of the Académie, which borrows tropes from the academic critique of the guild, that is reflected in White and White's description of what they call the 'Academic system' as a disciplinary institution. It consists, they say, of

> a persistent network of beliefs, customs, and formal procedures which together form a more-or-less articulated social organization with an acknowledged central purpose ... realised through recruitment, training,

69 For a fuller list see Ayres 2014, p. 421.
70 See Walsh 2017, p. 40.
71 Duro 2007, p. 96.
72 Michel 2018, p. 243.

continuous indoctrination, a sequential process of appraisal and graded
recognition, regularized appropriation of economic support ... a graded
system of discipline and punishment, acknowledged machinery for legit-
imation of adaptation and change, and controlled communication with
the social environment.[73]

This Foucauldian depiction reflects the specific situation of the French acad-
emies which were more thoroughly 'embedded in the wider structures of the
absolutist state'[74] than their counterparts elsewhere. More than this, though, it
reflects or sublimates the victory of the academy's critique of the guild and,
in particular, the transition from apprenticeship to pupillage, which recasts
the would-be painter or sculptor as a scholar and noble intellect rather than
a trained mechanic or skilled worker. Drawing, life studies, lectures and the-
oretical principles take precedence over the trade secrets passed on to the
apprentice.

Whereas apprentices worked alongside the artisan insofar as they both occu-
pied the same workshop and produced different aspects of the same works of
art, the relationship between the 'elder' and the pupil in the academy estab-
lished a firewall between their practices. This is essential to the transition from
workshop to studio. The studio preserves the social esteem of scholarship and
contemplation of the *studiolo* without abandoning completely the handicraft
production that went on in the *bottega*. The economic relations marked and
masked by the division between the *bottega* and the *studiolo* did not dissolve
when, in the nineteenth century, the studio was reconfigured as a space gov-
erned by the values of the *studiolo* but incorporating the activities of the *bot-
tega*. Although the artist subsequently would not always work independently,
the presence of assistants in the studio never attained the legitimacy that the
presence of apprentices and journeymen had in the *bottega*. What the studio
takes from the *studiolo* is not only its association with study but also the con-
notation of a private place or an individual's personal room as a retreat from
the world. Pupils were individualised by the academy in contrast to the ethos
of cooperation and incorporation of the guild apprenticeships.

Insofar as the *studiolo* was a space of withdrawal both from handicraft pro-
duction and the corporate or collective enterprise of the workshop, what is lost
or repressed in the studio is the *social* production of art. What gives this illusion
of individual production its material basis is, first, in the middle of the seven-

73 White and White 1993 [1965], p. 2.
74 Harrison, Wood and Gaiger 2000, p. 630.

teenth century, for example, the recoding of noble genres of works of art as remote from mechanical production, and second, in the first half of the eighteenth century, principally, the expansion of commercial suppliers of paint, brushes, pencils, paper and canvases. Artisans such as Alexander Emerton, who had served an apprenticeship and was operating as a House Painter when he advertised the sale of colours in 1725 in London, supplied other artisans with paint. As Marx noted, 'manufacture, in its strict meaning, is hardly to be distinguished, in its earliest stages, from the handicraft trades of the guilds, otherwise than by the greater number of workmen simultaneously employed by one and the same individual capital'. In the manufacture of supplies for painters and sculptors, the 'workshop of the medieval master handicraftsman is simply enlarged'.

With the manual and menial tasks previously allocated to apprentices in the workshop now taking place in remote places, painters in particular appeared to be more removed from handicraft than at any previous time. It is significant, too, that the first generation of painters and sculptors to benefit from the widespread supply of materials by commercial artisans were the founders of the Royal Academy in London. Importantly, the provision of paint by Colourmen allows Sir Joshua Reynolds and his peers to 'distance themselves from the craft of their art',[75] as Ayres puts it, but the distinction between painters and artisans that this implies should not be interpreted as outright hostility – as the bud that will blossom only with the eradication of artisanal production – since it is based on a hierarchical separation of the liberal and mechanical arts in which the normative elevation of painting and sculpture depends upon the preservation of the artisanal production of supplies. If the *studiolo* had underlined the division of labour within the artisan's workshop between the manual and the intellectual labour of the production of works of art, the purchasing of supplies from commercial artisans converted the technical division of labour into a social division of labour. Now, materials that had been produced within the workshop were purchased as commodities and therefore the production of paintings and sculptures was social in a new way.

The result was that the discursive and institutional distinction between the Fine Arts and the handicraft was underlined by an economic relationship. Though not quite converting the relative distinction of the Fine Arts from handicraft into an absolute difference, this development certainly gave it an objective dimension. The relationship between artists and their assistants, fabricators, technicians and interns which has been raised recently within a politics

75 Ayres 2014, p. 5.

of artistic labour testifies to the continuation of the economic and normative division between *bottega* and *studiolo* within the studio itself. In other words, the withdrawal from handicraft that was the founding gesture of the academy system survives in the both the perennial anxiety about the presence of handicraft in art and the persistent question mark over the relationship between the artist and a supporting cast of direct and indirect assistants.

These transformations of the social relations of artistic production during the Industrial Revolution have been veiled by inquiries into the act of painting itself such as deskilling because the crucial changes are not evident in the labour process but the isolation of the painter or sculptor as an individual producer who purchases tools and materials from suppliers that is the first sign of the effect of industrialisation on artistic production. Art in the eighteenth and nineteenth centuries defied mechanisation and industrialisation, partly because the Fine Arts had relegated everything mechanical in the production of works of art to the artisanal, but only by ejecting the mechanised and industrialised aspects of artistic production from the studio. We might even say that the Industrial Revolution is the precondition for the studio even as the studio is constituted as the spatial exception to everything mechanical and industrial. However, this historical understanding of the relationship between art or the Fine Arts and handicraft is best understood not as a process of deskilling but of the displacement of skill.

Marx noted that the division of labour under the guild system always took place through the multiplication of workshops and guilds rather than within workshops themselves.

> If circumstances called for a further division of labour, the existing guilds split themselves up into varieties, or founded new guilds by the side of the old ones; all this, however, without concentrating various handicrafts in a single workshop. Hence, the guild organisation, however much it may have contributed by separating, isolating, and perfecting the handicrafts, to create the material conditions for the existence of manufacture, excluded division of labour in the workshop.[76]

Artisan suppliers sold canvases, brushes, paper, pencils and other materials to painters and sculptors in the period. This breaking up into separate jobs of the tasks that had previously been integrated within the workshop or were realised through subcontracting between workshops, begins to appear, in retrospect, to

76 Marx 1990 [1867], p. 479.

be a clear sign of the transition from the artisan to the artist but its contemporary significance was vertical not horizontal (elevating above extant practices not superseding them).

Commercial suppliers diminished the need for apprentices to complete this work for the 'master' and therefore consolidated the academic system of education for painting and sculpture which consists of a social division of labour between the artist and the art teacher, thereby separating the studio from the art school.

Salon, Museum and Exhibition

In this chapter I will revisit the transition from the arts to art and the transformation of labour required for this transition by reconstructing the historical formation of a normative framework for the production and consumption of paintings and sculptures produced by a noble and scholarly practitioner of the Fine Arts and appreciated by a cultivated public. This imagined community of the Fine Arts was modelled on an idealised relationship between the scholar-painter or scholar-sculptor and the patron. The academies preserved the existing relations between royal and aristocratic patrons and court painters and sculptors (and, certainly, the academies recognised themselves within a continuous line of courtly patronage), and yet, the academy system put the relationship between patron and client on a new footing. If patronage had previously operated on an individual basis, the academies, by issuing statutes and petitioning the state for collective privileges, resituated patronage within a specific organisation of the Fine Arts. Also, in 1737, the academy system supplemented the existing patronage relationship with a new mechanism. The Salon exhibitions enabled academy members to showcase their work on an unprecedented scale.

A significant percentage of works exhibited at the Salons were, initially at least, not for sale because they had been commissioned by patrons. Economically, the Salon was not a satisfactory mechanism for securing the incomes and livelihoods of academic painters and sculptors, but it gave them hope of combining the virtue of not running a shop and the necessity of sales. What is significant about the Salons, therefore, is not only that they acted as shop windows for painters and sculptors but also that they were the first examples of the public exhibition of works of art. There were no public exhibitions of works of art within the guild system. Indeed, we might go so far as to say that what the Salons achieved, with mixed results, is to inflate the distinction between artisan-painting and -sculpture and scholarly-painting and -sculpture by presenting the latter to a public that did not exist for the former.

Disputes about the constitution of the public and the proper behaviour of the spectator of the Fine Arts in the eighteenth century have been read as the discursive formation of a coherent community for painting or the elaboration of a specifically aesthetic mode of attention or, in the case of the museum public in the nineteenth century, of the production of citizenship within the governmental manufacture of consent. Without refuting these accounts, I want

to propose another narrative. The elevation of the Fine Arts above handicraft can be understood by highlighting three major principles first established by the academy: (1) the disapproval of manual skill, (2) the prohibition on commerce, and (3) the establishment of a public. I am not concerned, here, with the question of whether the actual crowds that attended the Salons corresponded with the discursive construction of the public at the time, nor do I intend to settle the question of what constitutes a public as opposed to an audience, mass, mob or people.[1] The term is vague and was necessarily so within the disputes over the Salon crowd and the public for the Fine Arts throughout the eighteenth century.

The politics of the public cannot be fully comprehended by imposing a false clarity to it. One of the ways in which the public has been given a retrospective clarity has been to read discourses on the public as a veiled debate about the onset of market relations. While the analysis of the specific economic conditions of the production and circulation of the Fine Arts – and later art in general – is vital to understanding the historical emergence of the public for works of art, the two are not indistinguishable and the former is not merely an episode in the historical formation of the latter. In particular, I will examine the development of a public for works of art through the founding of the Salons, experimental modes of exhibition and the national public museums of the Fine Arts in order to dispute the prevailing theory of the passage from patronage to the art market.

There is a tendency within the historical accounts of the seventeenth- and eighteenth-century market for paintings and sculpture to switch in a binary fashion between patronage and the market. Partly this is due to forms of interpretation that depend on processes of extrapolation in which the smallest trace of a market transaction is taken to be the sign of an avalanche to come. Today's enormous global market for artworks is detected in embryo, therefore, in the entrepreneurial activities of painters and printmakers in the eighteenth century or in the marketing ploys of nineteenth-century art dealers or in the discourse of the author and genius that predates them, or in other events.

Since my purpose is not to trace the history or pre-history of the art market and art's alleged commodification, but to reconstruct the formation of artistic labour as distinct from handicraft and wage labour, I will re-examine the conditions under which a public for the Fine Arts developed as an episode in the history of labour. Instead of thinking of the public as a synonym for or symptom of the market, I will reflect on how the real and fictive publics for works of

1 For some notes on the differentiation of these categories of assembly, see Beech 2017.

art marked out a set of principles for a form of production that claimed, and in some ways realised, an antipathy to the commercial, the mechanical and the industrial.

The narrative of the passage from patronage to the art market is well established and is often deployed within politically resonant critiques of the colonisation of art by capitalism. Despite my sympathy for the project, I cannot subscribe to the interpretation of the history of art that such critiques expound. Pierre Bourdieu, whose account of the trajectory from patronage to the market is integral to his critical sociology of culture, is a case in point. Bourdieu's principal aim is to disclose the class character of the literary field and to identify the class position of the writer at the threshold of modernity. The passage from patronage to the market, in Bourdieu's telling of the story, is complete when writers and artists join the labour market to self-subsidise their artistic practice not when there is a labour market for writers and artists nor when there is a market for literature or artworks.

Art, here, we might say, is dependent on the wage materially insofar as the wage of the writer or artist derived from their 'second job' provides an objective bond between art and the capitalist form of labour, but art, as Bourdieu describes it, can only be said to be contiguous with wage labour and the labour market, not fully immersed in it. This is in fact a vital element in Bourdieu's political analysis of the growing independence and indignation of the writer in the late-nineteenth century, but it is not adequately theorised within his analysis of the drift from patronage to the market. The narrative of the shift from patronage to the art market is consistent with the Western Marxist thesis of commodification if it is understood as a transformation of cultural production brought about by changes to the social organisation of circulation. Adorno and Horkheimer tell the same tale in a more abstract tone, asserting that 'Art as a separate sphere was always possible only in a bourgeois society' and 'its freedom remains essentially bound up with the premise of a commodity economy'.[2] Art and the artist, in this conception, are characterised by the unity and opposition of 'market and independence'.[3]

The implication is that artists adjust to changing modes of consumption and therefore that the agents of art's social history are collectors, dealers and gallerists. For this insular argument, the difference between the arts and art is determined by how its objects are circulated and therefore leaves questions about the character of art's mode of production unanswered. Whereas previ-

2 Adorno and Horkheimer 1973 [1944], p. 157.
3 Ibid.

ously painters, sculptors and others produce bespoke works of art for individuals that are known to them, artists come to produce their works speculatively for a market of collectors who purchase works ready-made. More will need to be said about the fact that the patron supports the artist whereas the employer does not. And more needs to be said about the difference between the patron and the purchaser of art.

Some artists and writers in modernity, of course, operate through publishers and other merchant capitalists and a proportion of them find a market, but examples of artists and writers taking second jobs might be better summarised by the passage from patronage to the absence of a market. More will need to be said about this, too, and I will return to these questions in the next chapter and throughout the book. I will argue that the transition from the arts to art is best understood in conjunction with the related but separate transitions of the artisan to the artist, from the workshop to the studio and the guild system to the gallery system[4] via the academy system. This particular sequence is evident in France, the Netherlands, Austria, Germany, Denmark and England, and variations on it were found elsewhere, but regional and global asymmetries are played out in the peculiarities of specific social formations of artistic labour in different places and different periods.

Painters and sculptors within the academy system continued to accept patronage of the familiar type in which he 'was in fact treated as a member of the prince's "famiglia", along with couriers and officials of all kinds'.[5] Sébastien Bourdon, a founding member of the Académie Royale, for instance, left Paris for Sweden under the patronage of Queen Christina the year after her coronation. This form of patronage did not disappear but a new mediated system of patronage was being developed alongside it. With the Salon exhibitions, which were 'the first regularly repeated, open, and free display of contemporary art in Europe to be offered in a completely secular setting and for the purpose of encouraging a primarily aesthetic response in large numbers of people',[6] the academies constructed for the Fine Arts a public beyond their patrons. For painting and sculpture, the public is constituted as an assembly of people specific to the order of the Fine Arts within the academy system.

4 I have preferred the term 'gallery system' to the more conventional 'dealer system' or 'dealer-critic system' because highlighting the dealer is a way of prioritising art's commodification and the dominance of the art market whereas the gallery system has always included a significant proportion of exhibitions not oriented towards sale but public display.

5 Haskell 1963, p. 6.

6 Crow 1991, p. 3.

In England in the eighteenth century, the public appears, at least within the public itself, to be an exemplary community. It is, in a phrase highlighted by John Barrell in his ground-breaking study of the political theory of painting within the academy system in England, a 'republic of taste'. The public in this sense is constituted by a rhetoric of 'civic humanism' with its lexicon of 'common sense', 'public good' and the like. For those in and around the academy, the word public came to signify 'public man', a civic identity quite distinct from the aggregate of national life captured by the term 'public opinion'. For the academy, which forbade its members from setting up a shop, the public simultaneously acted as an idealised substitute for the marketplace and a convenient alibi for commerce.

The public can act as camouflage for the market for those who, following the lead of the Académie's classical aristocratic ethos, assume that art's social and cultural elevation depends on its rejection not only of handicraft but also of commerce. The public is not the market, or at least it is not reducible to the exchange of commodities insofar as all markets are also, to one extent or another, displays of goods to those who do not purchase them. If the concept of a market plays down the existence of non-purchasing bystanders, the concept of a public plays down the economic transactions that take place in public exchanges.

Collectors and patrons make up only a small proportion of the public, hence the public can be a virtuous ideal through which the market is both conceived and concealed. More broadly, too, Richard Wrigley has detected in eighteenth-century France a 'censorious discourse on money',[7] within the condemnation of the *nouveau riche* generally, and the relationship between art and money specifically which prompted 'a kind of nostalgia for the *ancien regime*'[8] and its forms of patronage. Indeed, what Wrigley discovers is that 'art and money were, within the dominant discourse of art and its value, categorically distinct'.[9]

In his highly acclaimed study of the Paris Salons, *Painters and Public Life*, Thomas Crow brilliantly combined art history and social history in an account of the simultaneous emergence of the public exhibition, art criticism and the politics of the public in eighteenth-century Paris. Crow vividly describes the sudden rise of the public as a real and fictive agent for art in the first half of the eighteenth century. 'Painters found themselves being exhorted in the press

7 Wrigley 1998a, p. 140.
8 Ibid.
9 Ibid.

and in art-critical tracts to address the needs and desires of the exhibition "public"; journalists and critics … claimed to speak with the backing of the public; state officials … assert[ed] that their decisions had been taken in the public's interest'.[10]

This rise of a public for art is consonant with a tendency that included the introduction of coffee houses (Habermas says their 'golden age' was between 1680 and 1730[11]), letter writing, the novel, reading societies, clubs, the publication of journals such as the *Tatler* and the *Spectator* in England, the birth of the restaurant in Paris which, for the first time, placed diners in a public arena,[12] and the 'instruments of institutionalized art criticism',[13] as Habermas calls them. Criticism and culture were prominent in the social processes of formation of the public in the eighteenth century. 'What will help to unify the English ruling bloc', for Terry Eagleton, 'is culture; and the critic is the chief bearer of this historic task'.[14] The public becomes a social force for the Fine Arts with the advent of the Salons and the emergence of the literature of reviews that accompanied them.

What counted as the public was always contested. 'Once the public sphere is defined as a horizon for the organization of social experience, it follows that there are multiple and competing counterpublics, each marked by specific terms of exclusion (class, race, gender, sexual preference) in relation to dominant publicity, yet each understanding itself as a nucleus for an alternative organization of society'.[15] Joan Landes has demonstrated that the bourgeois public sphere that Habermas chronicled 'was essentially, not just contingently, masculinist'.[16] This is why Seyla Benhabib argues that 'the struggle to make something public is a struggle for justice',[17] explaining that the boundaries of the public were drawn up specifically to 'confine women and typically female spheres of activity like housework … to the "private" domain',[18] and 'relegated certain types of activity like work and labor, and by extension all issues of economics and technology, to the private realm alone'.[19]

10 Crow 1991, pp. 1–2.
11 Habermas 1989 [1962], p. 32.
12 See Spang 2000.
13 Habermas 1989 [1962], p. 41.
14 Eagleton 1984, p. 9.
15 Hansen 1991, p. xxxvi.
16 Landes 1988, p. 7.
17 Benhabib 1992, p. 79.
18 Benhabib 1992, pp. 89–90.
19 Benhabib 1992, p. 80.

Negt and Kluge have theorised the 'proletarian public sphere'[20] both as proof of the limited horizons of the conception of the bourgeois public sphere and as the ongoing basis, alongside other counterpublics, of a more complete but less universalistic topography of the public. In retrospect, therefore, E.P. Thompson's *The Making of the English Working Class* charts the emergence of such a proletarian public sphere that constantly confronts the bourgeois universal public with what Eagleton called 'a whole oppositional network of journals, clubs, pamphlets, debates and institutions'.[21] Even so, within the public discourses and debates on the public of the Fine Arts in the eighteenth century, Eagleton is right to say that the 'interests of the properted classes are in a real sense all that politically exists'.[22] John Barrell confirms this, noting that the eighteenth-century gentleman 'was believed to be the only member of society who spoke a language universally intelligible; his usage was 'common''.[23]

The Coffee Houses, like many of the institutions of the public sphere, were spaces of exclusion but the Salons were not. For this reason, the crowd that attended the Salons did not correspond with the emergent normative category of the public. In Crow's terms, the 'Salon brought together a broad mix of classes and social types, many of whom were unused to sharing the same leisure-time diversions'[24] and therefore the eighteenth-century Salon 'marked a removal of art from the ritual hierarchies of earlier communal life'.[25] The Salon crowd was not a homogeneous public of white, properted men. A commentator in 1777 described its members: 'the fishwife trades her perfumes with those of a lady of quality ... the rough artisan, guided only by natural feeling, comes out with a just observation, at which an inept wit nearby bursts out laughing only because of the comical accent in which it is expressed'.[26] Crow characterises the Salon crowd as 'a new social body ... mined with insidious hazards',[27] and describes it as a spectacle that made 'artists and authorities uneasy' because it was 'noisy, sweaty, as much an urban festival as occasion for considered aesthetic experience'.[28] He takes his direction, in part, from Charles

20 Negt and Kluge 1993 [1972], pp. 54–95.
21 Eagleton 1984, p. 36.
22 Eagleton 1984, p. 35.
23 Barrell 1983, p. 34.
24 Crow 1991, p. 1.
25 Crow 1991, p. 3.
26 Pidansat de Mairobert quoted in Crow 1991, p. 4.
27 Crow 1991, p. 4.
28 Crow 1991, p. 13.

Coypel who, at the time, complained that the Salon crowd was 'not a true public, but only the mob'.[29]

George Rudé has exposed how the preoccupation with the mob in the seventeenth and eighteenth century, especially in France and England, was not primarily the distress felt at the new visibility of vulgar taste but the rise of a new agent in political history. Officially, the mob consisted of 'social dregs, pimps, prostitutes, thieves and receivers'[30] but arrest records show that the most numerous members of the mob were 'small workshop masters, shopkeepers, apprentices, independent craftsmen, journeymen, labourers, and city poor'.[31] Generally speaking, therefore, the dividing line between the public and the mob that is explicitly deployed by Coypel and implied by others, corresponds to the distinction between the scholarly and the artisanal that had been the founding act of the Académie. My point is not that disputes around the public for the Fine Arts are best read allegorically as cryptic discourses of labour but that the elevation of the Fine Arts above handicraft had to be instantiated over and over again at every perceivable point of conflict.

Apart from registering the discomfort of the presence of the artisanal mob within the Salon through the corporeal vicinity of the 'lower orders', it was criticism that was the most conspicuous feature of the new public for the Fine Arts. Crow points out that in the middle of the eighteenth century, art criticism had not yet established itself and was resented by many painters and sculptors since it 'promised them no material advantage and seemed indeed to threaten the opposite'.[32] What's more, it is feasible to imagine that the academicians regarded the mob-public as consisting largely of those guild artisans from whom they had emancipated themselves. It would have been maddening to set up the Académie Royale only to have the mob make the final judgement on the quality of works of art. Although artisans themselves were not the authors of Salon criticism, they were literate and could afford the pamphlets sold at the bottom of the stairs leading to the great biannual exhibition. Crow's central question is 'whether the actual audience in the Salon could be said to represent this community'[33] rather than inquiring into the hegemonic process by which the normative public of a legitimate minority, what Louis-Guillaume Baillet de Saint-Julien called 'that estimable portion of the public, the connoisseurs: persons apprised of the principles of art, and able to justify the praise that they

29 Coypel quoted in Crow 1991, p. 10.
30 Rudé 2005 [1964], p. 198.
31 Rudé 2005 [1964], p. 205.
32 Crow 1991, p. 11.
33 Crow 1991, p. 4.

award, in whom feeling is refined and justified by intellect',[34] was imposed on the heterogeneity of the Salon crowd.

In other words, the more fundamental question is how the normative conception of the public charged the actual crowd with a social purpose that confirmed the nobility of the Fine Arts despite the overwhelming evidence that it did not actually fulfil this function. Indeed, the normative conception of the public as 'a coherent, engaged, and demanding public',[35] becomes more urgent and socially resonant with the influx of the mob into the realm of the Fine Arts. In fact, both images, the trope of the 'true public' and the trope of 'the mob', both cheek by jowl attending the Salon exhibition, are best understood as fictions propagated by the ideologues of the Fine Arts. Indeed, anxieties about the Salon public allowed academicians to reconfirm their nobility. Being independent of commerce was now joined by the independence that one could demonstrate from popular opinion.

Critics, naturally, made the same point from the opposite vantage point, so to speak. Etienne La Font de Saint-Yenne, who in Adrian Rifkin's words 'belonged to a dissident fragment of a defined élite',[36] argued that only the public without links to the artists can be trusted to speak about works of art. Despite claiming that 'everyone has the right to make his own judgement'[37] La Font presented his 'reflections' on French painting as the result of gathering together 'the judgements of the public ... not at all our own judgement'.[38] The public of the Salon is initially conceived as both aggregate and ideal, empirical and abstract, and therefore it could connote the legitimate society of the aristocracy or the ideal form of the market or the mob rule of popular opinion. The public of the Fine Arts is not reducible to one of its social constituents nor does it correspond to a reconciliation of them or some abstract, ideal or ideological supplement of the actual crowd; nor is the public merely the empty signifier over which real social actors struggle.

Neither captured by enumerating the actual individuals and types that assembled nor the homogeneous community portrayed in its discourses, the public resembled the fable of the free market advocated by the theorists of *laissez faire*. It is known by its effects. The public was not a veiled image of the market, but they could pass for one another. For instance, in a parallel development

34 Baillet de Saint-Julien 2000 [1748], p. 565.
35 Crow 1991, p. 10.
36 Rifkin 1994, p. 31.
37 La Font 1979 [1747], p. 58.
38 Ibid.

in the German-speaking world, by the end of the eighteenth century Schiller characterised the event of breaking from his patron and trying to make his way as a professional writer by saying '[t]he public is now everything to me – my preoccupation, my sovereign and my friend'.

Abbé Jean-Bernard Le Blanc, countering La Font and in defence of French painting in general and the academy in particular, said '[a]ny writer seeking credit for his views lays claim to the authority of the public; but as there is more than one society, so there is more than one public, and everyone cites their own'.[39] Nonetheless Le Blanc did not reject La Font's confidence in the public outright. Defending what he called 'the enlightened public',[40] Le Blanc claims La Font's judgements do not represent the public: 'it is the way in which he distributes praise and blame that sets him furthest from public opinion'.[41] Whereas La Font claimed to be reporting the agreed judgements of the public, Le Blanc accuses La Font of guessing. The enlightened public, he said,

> exercises its rights as a sovereign judge, and bestows its votes on those who merit them. Implacable or indulgent, it judges equitably. It may, in a work where beauty prevails, pardon certain weaknesses; where talent is lacking, on the other hand, it has no regard for rules coldly observed. In short, where no praise is deserved, it bestows none.[42]

Le Blanc renovates the public invoked by La Font in the form of a specific public that allowed him to resituate the relationship between painting and the public. 'The author of the Reflections', he says, 'seems, as yet, unaware of the many talents needed to paint a fine portrait, which seems to him a negligible genre'.[43] In this respect, Le Blanc aims to restore the nobility of portrait painting by shifting the focus of scrutiny from the economic incentives of producing portraits to the qualities of the pictures themselves.

What the critics demanded of painters and sculptors in the Salons may have often conflicted with their commercial interests but it was often consonant with the discourses and principles that had been established by the academy. The hierarchy of genres is reinforced by Salon criticism. 'Of all the genres of painting, history is without question the most important. The history painter

39 Le Blanc 2000 [1747], p. 563.
40 Le Blanc 2000 [1747], p. 561.
41 Le Blanc 2000 [1747], p. 564.
42 Le Blanc 2000 [1747], p. 563.
43 Le Blanc 2000 [1747], p. 564.

alone is the painter of the soul, the others only paint for the eye',[44] La Font states categorically. This tendency, which is inherent to the bourgeois concept of the public, acted as a social buffer against the commodification of the Fine Arts despite the actual momentum of the market and despite the growing popular demand for cheap prints of the famous works exhibited at the Salon.

La Font complains that French painters 'abjure[d] their talent and abandon[ed] themselves, like our writers have done to works of wit, to the futile subjects of fashion and of the day; or else to the most lucrative genre of this art, which is, and has been for several years, the portrait'.[45] If the statute against opening a shop is the inaugural gesture in what came to be called art's autonomy and art's economic exceptionalism, then the social pressure imposed on scholarly painters and sculptors by the real and fictive public turns this noble arrangement into an abstract ethics of anti-commercialism that demands sacrifice:

> A painter today, obstinately attached to history painting through the elevation of his thoughts and the nobility of his expressions, will see himself reduced to a few works for churches ... not in a position to feed his family on more solid fare than glory ... in contrast to the rapid financial gains made by his colleagues the portrait painters.[46]

Hence, the critics of the Salons extended the principal of the academy's injunction on opening a shop to a critique of the most commercial genres and styles.

Economically, the Fine Arts depended on the fluctuating tastes of a very wealthy elite and the critics 'singled out for disapproval all of the most lucrative forms of painting',[47] while the kind of painting admired by the 'irrepressible clandestine press'[48] had no market among the existing clientele. By pointing out the economic interests of painters and sculptors and citing remarks that support this, Crow plays down the importance for the Fine Arts of appearing to be above commercial incentives. In his account, therefore, the advent of a public for works of art was incidental to the academy and provided 'a third party' and a 'disinterested community' that 'represents something different from the

44 La Font 1979 [1747], p. 58.
45 La Font 1979 [1747], p. 61.
46 Ibid.
47 Crow 1991, p. 11.
48 Crow 1991, p. 14.

prince's humanist advisers or the artist's self-protective guild'.[49] Crow traces the emergence of art criticism through this lens, but my concern is to link the rise of the public, published criticism and the public exhibition with the development of an ethos of production for which the public-mindedness of the critic – what La Font characterised as 'a disinterested and enlightened spectator'[50] – may or may not be justified but always serves as an ethical demand on the production of painting and sculpture to be guided by the highest social principles rather than individual self-interest. The critique of the most commercial forms of the Fine Arts, therefore, went hand in hand with a critique of consumerist modes of attention.

Michael Fried's enormously important study of Salon painting in the eighteenth century, *Absorption and Theatricality*, enters the debates on the public through its individual exemplar, the beholder. Strikingly, what Fried highlights in the rhetoric of the beholder, particularly as evidenced in Diderot's art criticism, is the necessity of its fictive disappearance. 'In a dramatic representation, the beholder is no more to be taken into account than if he did not exist',[51] Diderot said. Like the absent commercial transactions that set the scholar-painter and -sculptor off from the artisanal tradesman, the public attains its ideal state for the Fine Arts when it is wholly disregarded.

Fried comments that 'Diderot was repelled by every form of exaggeration in painting and drama that seemed to him to indicate a desire to play to the crowd'.[52] When Wrigley refers to the 'collision between the Salon, as a receptacle for elite culture, and the street, as the rightful territory of the independent and the popular',[53] two different modalities of the public are invoked. Entry to the Salon was not free, as a deliberate attempt to exclude the mob, and yet the ideologues of the Fine Arts remained anxious that the public of the Salon exhibition could not be adequately differentiated from the crowd of the street.

Here, therefore, we witness a significant metamorphosis of the public that Wrigley has also noted: 'early revolutionary rhetoric and imagery that had evoked a brave, consensual, patriotic crowd gave way to anxieties that the public was dangerously vulnerable to malevolent *agents provocateurs*'.[54] The public could not always be reliably distinguished from the crowd and this meant

49 Crow 1991, p. 22.
50 La Font 1979 [1747], p. 58.
51 Fried 1980, p. 94.
52 Fried 1980, p. 98.
53 Wrigley 1998b, p. 54.
54 Wrigley 1998a, p. 142.

that the Fine Arts could not safely embrace the public unconditionally. This, I would argue, makes sense of Fried's 'paradox' that 'it was only by negating the beholder's presence that ... his actual placement before and enthrallment by the painting [could] be secured'.[55] Fried provides an erudite endorsement of Diderot underlying preference for drama over theatre which was, in part, structured by a conflation of 'le public' with 'la multitude'.

For Diderot, 'the crowd is not capable'[56] of occupying the place of the non-existent beholder. In reconstructing this episode in the history of painting, Fried supplements Clement Greenberg's arguments about the superiority of the avant-garde over kitsch, occasionally figured in terms of good and bad taste, which doubles as a coded critique of the theatricality of Minimalism, Pop, Land Art, Conceptualism, Body Art and much else besides. From the vantage point of the history of the confrontation between the Fine Arts and handicraft, I want to suggest, it is possible to reinterpret Diderot's anxieties about 'the desire to play to the crowd'[57] as akin to a geometrical rotation of the elevation of the scholar-painter above the artisan in which it is the public that must now be elevated in the direction of the educated, liberal aristocrat. When Diderot speaks of the specific kind of attentiveness of the beholder he extends the rhetoric of the *studiolo* to the individual member of a public who perhaps momentarily detaches herself from the crowd and enters a fictive space of studious contemplation.

Modelling the viewer on the student has, since the introduction of public exhibitions for works of art, been a permanent feature not only of the discourses of painting and drama but also, later, of photography, film, contemporary art and curatorial practice. Bertolt Brecht's critique of commercial culture's production of passivity in the audience for theatre, film and photography advocated the construction of a critical subject through such techniques as the *Verfremdungseffekt*, commonly translated as the 'alienating effect', which refers to the processes of making the familiar strange. The purpose of *Verfremdungseffekt* is to distance the audience from the Aristotelian effects of theatre (exemplified by a cathartic experience or resolution of tension) and to prompt them to take an intellectual, critical or actively engaged response to the drama, film or photograph.

Studiousness in art, as a critique of the passive, ideological, aesthetic or pleasure-seeking attitude to art, is prominent within what Silvia Harvey has

55 Fried 1980, p. 103.
56 Fried 1980, p. 117.
57 Fried 1980, p. 98.

called 'political modernism', which consisted of a 'return to Brecht' in exper-
imental cinema exemplified by Luc Godard. Peter Wollen, who was one of
the major film-makers and film-theorists of political modernism, described a
kind of mimetic relationship between the critical author, critical artwork and
critical viewer, saying just as counter-cinema 'by introducing its own decod-
ing procedures, interrogates itself, so the reader too must interrogate himself,
puncture the bubble of his consciousness'. Suggestively, in a special issue of
October magazine in 1981 on 'a theoretically directed cinema' in the 1970s, the
editors state that the texts included 'issue from the entrance of cinema into the
academy', which by this time means some combination of the university, the
publishing industry and the commercial gallery system.

There is an echo of Diderot's critical project in Adorno's negative philosophy
of aesthetic pleasure when he says '[r]adical art today is the same as dark art:
its background colour is black. Much of contemporary art is irrelevant because
it does not take note of this fact, continuing instead to take a childish delight in
bright colours'.[58] Chantal Mouffe insists that art and artists 'can play an import-
ant role in subverting the dominant hegemony'. Peter Osborne's confrontation
between taste and critical judgement and the concomitant opposition of the
critical viewer and the aesthetic consumer of art is a prime example of the tend-
ency that I am highlighting here. Richard Noble's four categories of political art
are also structured around the same anxieties.[59]

Claire Bishop's complaints against the celebration of 'conviviality' in Nicolas
Bourriaud's 'relational aesthetics' and her advocacy, instead, of antagonism
can be re-read in terms of the concerns raised by the early history of public
exhibitions of works of art. Bishop highlights projects 'marked by sensations
of unease and discomfort rather than belonging'. Only art that 'sustains a ten-
sion among viewers, participants, and context'[60] is adequate 'to challenge con-
temporary art's self-perception as a domain that embraces other social and
political structures'.[61] Recent debates on participatory art and the pedagogical
turn in curating allow Diderot's fears of the crowd to bubble up to the sur-
face once again. I have to admit, also, to the fact that my own practice as an
artist and writer is deeply mortgaged to the privileging of the studious spec-
tator and the scholarly model of the artist that was promoted by Conceptual

58 Adorno 1984 [1970], p. 58.
59 See Noble 2005. His four categories are: 1. Art as political criticism; 2. Art as subject pos-
 ition; 3. Art as utopian experimentation; 4. Art as an investigation of its own political
 condition.
60 Bishop 2004, p. 70.
61 Ibid.

art. In fact, we might say that contemporary socially engaged art is the elim-
ination of everything in art other than the politics of publics which was first
prompted by the Salon exhibitions.

This critical tradition can be regarded as the dominant force within art the-
ory, a tradition that Jacques Rancière's book *The Emancipated Spectator* con-
fronts. Rancière argues against critical art, including political modernism, on
the basis that it presupposes an uncritical viewer that it purports to 'wake up'.
Rancière turns the screw on two related 'errors of critical thought': socially
engaged art and the critique of the spectator. The former follows from the latter,
which has a long pedigree in the work of Brecht, Debord, Artaud and God-
ard. For Rancière the problem is fully articulated by Plato. 'According to the
accusers', in Rancière's polemic, 'being a spectator is a bad thing for two reasons.
First, viewing is the opposite of knowing: the spectator is held before an appear-
ance in a state of ignorance about the process of production of this appearance
and about the reality it conceals. Second, it is the opposite of acting: the spec-
tator remains immobile in her seat, passive. To be a spectator is to be separated
from both the capacity to know and the power to act.' Rancière is on the side
of the unlearned against the expert, the pupil against the teacher, of the poten-
tially disruptive knowledge of the untrained intelligence. Instead of seeing the
spectator as the repository of established ideologies and cultural practices – as
the specific body adapted to art's institutionalisation – he takes sides with the
spectator against all the critical methods we have developed to counteract the
spectator's supposed incapacities. Against this, Rancière insists that 'the incap-
able are capable'.

The outcome is the same. For Rancière the critique of the spectator is self-
defeating because the spectator already 'observes, selects, compares, inter-
prets'. This is a diluted portrait of a studious and critical spectator of art, but
it is a very familiar character nonetheless. Where Rancière disagrees with the
critics of the spectator is that, for him, the spectator is naturally and ines-
capably already the kind of thoughtful, discriminating, judging subject that
Diderot thought was only possible by eradicating theatrical effects from paint-
ings and Brecht thought was threatened by a naturalistic theatre which invites
the audience to 'hang up their brains with their hats in the cloakroom'. Rancière
proceeds not only on the assumption that anyone is capable of making observa-
tions, selections and so forth, but also, by implication, that this form of attent-
iveness can be deployed in the encounter with any kind of art at all. In doing
so, therefore, he shifts the focus of political modernism from the qualities of
the artwork to the problems of dividing the public into the capable and the
incapable. Given that he argues that everyone and anyone has the capacity for
the kind of alertness that is exemplified by the enthralled beholder or critical

subject, all that is disputed here is the means by which the scholar-spectator comes to encounter the artwork.

Debates about the constitution of art's public and the capacity of the viewer, I want to suggest, bear directly on questions regarding the character of artistic labour that are rooted in the separation of the Fine Arts from handicraft in the seventeenth century. Conventionally, the study of publics and spectators is taken to signal a shift from attending to the production to the reception of works of art. This culminates today in the history of exhibitions which confronts the modernist metaphysics of the artist and the artwork with an empirical study of assemblage and institutions. At the same time, however, exhibition practices and their discourses from the Salons onwards are also mechanisms and ciphers for the construction and reconstruction of artistic labour as a distinct mode of production. Anxieties about the public and the viewer codify and crystallise concerns about the differentiation of the Fine Arts and art in general from handicraft, commerce, commodity production and so on. The adequate spectator is not a euphemism for the consumer but is primarily a counterpart of the figure of the scholar in the studio. The public, as normatively distinct from the crowd or the mob, contrasts with the market only insofar as it acts as a fictive guarantor of the nobility of the work of art.

Carol Duncan and Tony Bennett are prominent among those who have tracked the passage from the courtly collections of art to the formation of the national public museum of art through an analysis of institutions that are as discursive as they are material. The formation of the national public art museum is also the formation of a nation and a public, and these accounts foreground the ways in which individuals are transformed into an art public by the museum. Art museums are characterised as systems through which individuals who participate in them do so by following a 'script or score' that is inscribed into them.[62] While Duncan states explicitly that 'art museums are elements in a large social and cultural world'[63] and Bennett recognises that the art museum belongs to 'an array of governmental agencies',[64] and both therefore stitch art to modern society *politically*, others have narrated the genesis of art's specific institutions and discourses within an episode of *economic* history. As important as it was that the inquiry into the category of art as a specific concrete institutional formation was subjected to the same historical and social scrutiny as the prison, asylum and other institutions of biopower, and to locate the art museum among the instruments that constitute the state rather than in some

62 Duncan 1995, p. 1.
63 Duncan 1995, p. 133.
64 Bennett 1995, p. 87.

rarefied space outside it, the analysis of the changes that take place in the late eighteenth and early nineteenth century from which art emerges cannot be drawn from institutional and legislative transformations alone.

The relationship of a visitor to a princely collection 'was essentially an extension of his social relationship to the palace and its lord'[65] whereas for a visitor to a national public art museum 'the state, as an abstract entity, replaces the king as host' which 'redefines the visitor ... as a citizen and therefore a shareholder in the state'.[66] Since, 'by 1825, almost every western capital, monarchical or republican, had [a public museum of art]',[67] the transition from the concept of the several arts to the abstract concept of a singular and general art is widely institutionalised in a short space of time. A visitor to the Louvre in 1799, therefore, according to Sewell, participated in the 'concrete history of social abstraction'.[68] As well as changing the status of the visitor, the new institution of art transposed the status of its contents. Paintings and sculptures are signalled as art rather than arts by becoming universally available and of universal interest. Art, as a singular and general category of labour and products, is abstract in a material sense and its abstraction is confirmed and amplified by having its history assembled publicly in great museums.

The history of ideas and the Foucauldian ambition 'to trace the formation of those spaces and institutions in which works of art are so assembled, arranged, named and classified',[69] tends towards the analysis of the social formation of the subject of art, whether this manifests itself in art's discursive literature on in its framing of the visitor or public. This is why Bennett's study of the birth of the museum aims to disclose the historical processes through which Pierre Bourdieu's narrative of the historical genesis of the 'pure gaze' is constituted. Claiming that the history of the museum and the history of the pure gaze are two sides of the same coin, Bennett gives the impression that the pure gaze is the subjective correlate of the material formation of the art through its own distinctive institutions.

I am tracing the historical formation of a normative framework for the production of paintings and sculptures that circulated in eighteenth-century Salon criticism as a fiction of a noble and scholarly practitioner of the Fine Arts. The equivalent fiction of the disinterested spectator who is also the voice of the public acts not only as an alibi for the critic but also as a supplementary stimu-

65 Duncan and Wallach 1980, p. 456.
66 Ibid.
67 Duncan 1995, p. 32.
68 Sewell 2014, p. 16.
69 Bennett 1995, p. 163.

lus for painters and sculptors to remain faithful to the highest principles of the academy. In effect, both endorsed and underlined the growing gap between the Fine Arts and handicraft. However, this division could also show itself in ways that palpably dented the livelihoods of academicians. Katie Scott argues that the introduction of the Salons in 1737 'created new opportunities for concern'[70] regarding the copying of works by members of the Académie. Scott refers to a case in which the copyright of a print-publisher, Louis Bance, to reproduce two paintings, were contested by a wallpaper manufacturer, Pierre Simon, in stark political terms: 'the position of the "author" ... was portrayed as of the party of hierarchy, privilege, monopoly, private interest, in short, of the Ancien Regime, while the position of the "counterfeiter" and the system of limited protective measures was ranged on the side of equality, liberty, the public good and the Revolution'.[71] Martha Woodmansee, who focuses mainly on the author of the literary text, characterises the author prior to the eighteenth century as an unstable combination of craftsmanship and inspiration, after which 'theorists departed from this compound model' insofar as they 'minimized [or discarded] the element of craftsmanship'.[72]

Assuming that 'inspiration' is nothing but a metaphysical veil for something more material, Woodmansee attaches the concept of the author to a claim that the product is a form of property. I would not disagree that property and ownership are significant components of authorship, but the social distinction that plays out in the separation of inspiration and handicraft cannot be boiled down to the social context for the implementation of copyright laws. As I have tried to argue, here, the elevation of the painting and sculpture, which could be expressed in all manner of esoteric, normative and speculative tropes, is not adequately characterised either by plotting a course from patronage to the art market, or by revealing the social processes of the commodification of works of art behind the discursive construction of the nobility of the Fine Arts. If, therefore, 'inspiration' is a metaphysical mask for something more material, it is the real social differentiation of artistic labour from handicraft and drudgery that opens up in the early years of the Industrial Revolution. However, the historical passage from the guild to the individual producer of works of art, via the academies of Fine Arts, was far more contested, complex, and experimental than this narrative suggests.

In the final years of the eighteenth century, the most prominent painter of the French revolution, Jacques-Louis David, experimented with a new format

70 Scott 1998, p. 37.
71 Scott 1998, p. 39.
72 Woodmansee 1994, p. 37.

of circulation and display of his paintings in which the public would gain access through the payment of a small fee. In the accompanying pamphlet – another technique of publishing that presupposes a public – David explained his decision. 'The painter's practice of exhibiting his works to the eyes of his fellow citizens, in return for individual remunerations, is not a new one', he wrote: 'the practice of public exhibitions was accepted by the Greeks; and we can hardly doubt that, in the realm of the arts, we need not fear of losing our way by following in their footsteps'.[73] He goes on: 'In our day this practice is observed in England, where it is called *exhibition*'.[74]

David spent four years on the painting *The Intervention of the Sabine Women* and then hired a venue in which it would be on public display for a further five years. His pamphlet is as much a plea for the public to overlook the commercial aspect of the fee-paying exhibition. Using the same tactic as Le Blanc, David redirects public attention away from commercial transactions to the painting itself. Unlike Le Blanc, however, he follows La Font in distinguishing between the nobility of history painting and the corruption of more commercially successful genres. He speaks of the great sacrifices involved in producing such works. '[H]ow many honest and virtuous painters', he says, 'who would never have taken up their brushes to paint anything but noble and moral subjects, have been forced to degrade and debase them through sheer need! They have prostituted their works for the money of the Phryncs and the Lais'.[75]

The public exhibition of fee-paying visitors is described by Luiz Renato Martins, not without justification, as hinging on 'the painter as a private entrepreneur and the market as judge'.[76] Indeed, David was criticised by his contemporaries for venality and the fee-paying exhibition had a bad reputation in France. However, David's entrepreneurialism is atypical both of the role assigned to the artist within the art market that ultimately becomes dominant in capitalism and of the enterprising capitalist insofar as David's activity consists primarily of the production of a handicrafted object rather than the advancement of capital or the setting up of a new capitalist enterprise (a new firm or a new invention, for instance). David takes on the task of generating an income from his paintings without the help of a dealer and without selling his product as a commodity.

For David the patron is not replaced with the dealer or collector but the public who do not purchase the work but pay an entrance fee to see the paint-

73 David 2000 [1794], p. 1120.
74 Ibid, emphasis in original.
75 Ibid.
76 Martins 2017, p. 81.

ing. Renato Martins is correct insofar as the fee-paying exhibition form has an entrepreneurial aspect to it, but its mode of production remained exceptional to the capitalist mode of production. From an economic point of view, the Fine Arts remain artisanal insofar as the independent producer-owner is first and foremost a specialist kind of maker rather than a bearer of capital or a seller of labour power. Unlike the typical artisan-painter, however, David does not sell his product but charges a form of rent on the use of his painting by the public. Economically, therefore, David was more like a busker, an itinerant actor or a circus performer than an artisan-painter insofar as he receives money directly from the public.

Hence, David in this instance is neither capitalist, worker nor artisan; he is instead something of an economic hybrid: an entrepreneurial producer. And while the onset of capitalism eventually splits these two activities along a class divide, they were long combined in the guild system in which the master artisan was skilled worker, shopkeeper, teacher, employer, trade official, bearer of privileges, etc. Where the fee-paying exhibition form differs from the combination of commerce and skilled production in guild handicraft, however, is through the invocation of the public. Although David flatters the public by implying that the reader is concerned primarily with the noble and virtuous in painting, he does not stress the distinction between the true public and the mere crowd or the mob.

This possibly expresses a radical political conviction, not entirely without justification at the time, that the old social hierarchies that separated the connoisseurs from the amateurs was a thing of the past. At the same time, of course, he was also hoping for a popular success and therefore he held on to the widest possible definition of a public for the Fine Arts. These two positions are not mutually exclusive and we certainly should not read the former as nothing but a euphemism for the latter. One of the reasons for resisting this kind of critical debunking of the high ideals of experiments in recomposing the relationship between painting and its public is that it derives, at least in part, from the elevation of the Fine Arts. In some sense, my reconstruction of the elevation of the Fine Arts above handicraft attempts to issue a caution not to conflate the critique of capitalism's colonisation of culture with the righteous condemnation of commerce within the aristocratic order of the Fine Arts.

Other experimental blends of commerce and the public were developed for the Fine Arts at the same time. Prints, when authorised, were a very lucrative income stream for painters. William Hogarth exploited a range of markets for prints. His 'Harlot's Progress' print cycle sold for a guinea each and the 'Rake's Progress' series sold for two, whereas 'Beer Street/Gin Lane' sold for 3 shillings, 'Four Stages of Cruelty' went for 6 shillings and 'Industry and Idle-

ness' could be purchased for 12 shillings. Hogarth placed advertisements in popular newspapers, designed subscription tickets which he signed as limited edition prints and published a sales list for prints 'to be had at his house in Leicester Fields'. In the case of the 'March to Finchley' in 1746, the subscription of 7s 6d followed by half-a-guinea on delivery, was supplemented by paying an extra 3 shillings to enter a lottery for the original painting. Having sold close to 2,000 'chances', Hogarth pocketed a considerable sum but explained 'it was disposed of by lottery (the only way a living painter has any chance of being paid for his time)'. Subscription and lottery, therefore, allowed Hogarth to earn a better than average living without depending on the traditional mode of patronage.

Subscription was not an unusual financial instrument in the eighteenth century. Throughout the eighteenth century it is estimated that the rate of books published on subscription tripled.[77] Hogarth borrowed it from the publishing practices of literature but it was more widespread than that. As well as subscription libraries and subscription charity-schools, a church was rebuilt in the 1720s on subscription and a coffee-room was built in Glasgow in 1781 from 107 subscriptions. Subscriptions were not restricted to the middle classes. In 1699 the keelmen of Newcastle opened up a subscription (agreeing a penny per tide for each crew member) to build The Keelman's Hospital. Nevertheless, Hogarth's use of subscription was innovative for the Fine Arts. Hogarth did not experiment with what would later become the gallery-dealer system of the art market. Hogarth has been given credit for his entrepreneurship, marketing and shrewd commercial transactions but the use of subscriptions and other experimental financial strategies were not only the means to obtain an income. The economic relations set in play by Hogarth were also mechanisms for constructing a public. Just as the publication of literature, especially the novel, turned reading into a private activity in the home and yet the discussion of literature in journals, coffee houses and reading societies gave that private experience a public dimension, Hogarth's subscription method of obtaining funds for painting and prints corresponded precisely to the social processes of the bourgeois public sphere. Although the Salons combined the experience of being in a crowd and being an individual spectator or beholder of works of art, the sale of prints to 2,000 subscribers was simultaneously public and private without assembling a crowd and therefore, in the terms of the debates on the public in the eighteenth century, could be seen as eliminating some of the difficulties raised by the threat of the mob.

77 Raven 2001, p. 105.

Given the innovation of the fee-paying exhibition and the prepayment of prints by public subscriptions, the passage from artisan to artist was not co-terminous with the passage from the guild system to the dealer system. Experiments in the circulation and display of works of art in the eighteenth century do not bear out the theory of the smooth passage from patronage to the art market but there are many examples that appear to verify it. William Blake's annotations on Joshua Reynolds's 'Discourses', for instance, seem to reject patronage and embrace the sale of works of art as commodities almost in the same breath. Against Reynolds's hope in liberal patronage, Blake wrote: 'Liberality! we want not liberality. We want a Fair Price & Proportionate Value & a General Demand for Art'.[78] As with David, the cure for servitude to a patron appears to include the elements of commerce that had existed within the guild system but had been forbidden within the academy system of the Fine Arts. For neither David nor Blake, however, does this negation of the negation of artisanal commerce require either the establishment of the collective practices of the workshop or the elimination of the divide between the Fine Arts and handicraft.

If we acknowledge that the range of tasks performed by the guild artisan came to be distributed among a variety of new specialists (the art dealer, the academy professor, the art critic and the art historian, as well as the artist), then it is no longer acceptable to chart the transition in art history as a history of works of art which are produced originally by artisans and then by artists. David, Hogarth, Blake and others do not conform to the model of the artisan turned artist promoted by the academies of Fine Arts since they do not reject commerce. Like the artisans of the guild, these entrepreneur practitioners do not cut themselves off from the range of activities of the artisan who was a shopkeeper and salesman. They foster a market and a public without accepting the division of labour imposed by the economic distinction between the artist and the dealer. What's more, all three write and publish pamphlets and other written material for the exhibition and distribution of their works rather than accepting the emerging distinction between the artist and art critic. Hogarth was instrumental in establishing the academies in London that preceded the Royal Academy and David was a committed teacher. As such, we might say that David, Hogarth and Blake, amongst many others, preserved or revived a significant portion of the range of the activities of the artisan that had been prohibited by the academy albeit according to a spatial division of labour[79] that was foreign to it.

78 Eitner 1971, p. 108.
79 I take the idea of the spatial division of labour from Doreen Massey. See Massey 1984.

For these and other individuals to secure a measure of the freedoms and agency once monopolised by the guilds and sacrificed by the academy, it is necessary not only for guild restrictions on trade to be abolished or for the academic regime to lose its social basis in courtly culture, both of which are mythic representations of historical processes seen from the vantage point of what at the time was an unknown and unpredictable future. To interpret these commercial and entrepreneurial experiments as early variants of the art market is to neglect the extent to which they were revivals of artisanal practices. It is possible to interpret these attempts to make a living by constructing a paying public for works of art as an intermediary stage between patronage and the art market insofar as the absence of a market for artworks is compensated for by sharing the costs among a larger aggregate of purchasers, but it can also be interpreted as a counter-tendency to the insertion of the art dealer or gallerist between the artist and the public. Similarly, the national public art museum was certainly deployed by the state as part of the nineteenth-century biopolitics of the citizen and it also tended to align itself with the art market by granting survey exhibitions to major collectors and commercially successful artists and so on, but it was also a mechanism by which the Fine Arts solidified their shift of orientation from the market to the public. My point is not to view these episodes in art history with rose-tinted spectacles but to attempt to understand how such developments altered the activity and self-image of the producers of works of art.

Mechanic, Genius and Artist

I have reconstructed a history of the mode of production for works of art from the artisanal workshop of the mechanical arts to the *studiolo* of scholarly painting and sculpture to the *atelier* of the Fine Arts and the studio of art in general. This is not proposed as a linear history of singular homogeneous stages but a sequence of contested conditions that are sites of struggle partly because they run parallel, overlap and mimic one another. Although the historical disputes about the status and nature of the production of works of art that I have been tracing in this book have often been posed as confrontations between types of producer, I have focused on the distinction between the mechanical and liberal arts, the guild and the academy and so on rather than studying the differences between 'mechanicks', artisan-painters, scholars, Fine Artists and so on. I have plotted a history of the transition from the arts to art *via* the Fine Arts but I have only referred in passing to the skirmishes between artisans, would-be scholars and artists. I have also mentioned the worker, slave, master, apprentice and journeyman as well as the Freeman, the noble savage and the genius. My aim, in this chapter, is not to follow the passage from artisan to artist, as if the historical rise of the artist as a distinctive kind of producer is captured by a transmutation that takes place within individuals or in the adaptation of individuals to new normative, technical and social conditions. Instead I will reconstruct the historical emergence of the artist as an effect of changes to the social relations of artistic production.

The term 'artist' predates the category of the artist insofar as it designates someone proficient at one or more of the arts. It is common in the seventeenth century, for instance, for writers to refer to artists either as an accomplished painter, sculptor, poet, composer or architect, but equally the term might be used without denoting specifically a practitioner in one of the Fine Arts. To the modern reader it can appear as if the concept of the artist emerges in the Renaissance when, as Pevsner puts it, 'the art of painting [claimed] a place amongst the *artes liberales* ... separating it from craftsmanship and the well-defined social system by which it had flourished in the Middle Ages'.[1] Pevsner uses the word 'artist' for those painters and sculptors in the Renaissance who distanced themselves from the guild by turning to the court and setting

1 Pevsner 1973 [1940], p. 30.

up informal academies and denies it to the guild painters and sculptors who remain on the wrong side of the distinction between handicraft 'as a despicable toil [and] painting as a science'.[2]

We can agree that the artist emerges through hostility to handicraft and that this process begins in the Renaissance but, if we focus on the transformation of the social form of artistic labour rather than on the first fissures of the divide between court and guild, then there is reason to be cautious about ascribing the historical advent of the artist to the Renaissance. The distance between these quattrocento masters and the modern category of the artist is intimated in the details of Pevsner's account, specifically his acknowledgement that the court painters of the Renaissance aimed to establish themselves within the liberal arts and that they did so by associating painting with science. When the word artist takes on a new meaning in the eighteenth century, it is a category of practitioner that includes the great painters and sculptors of art history but not on their own terms.

In my own historical schema, while it is possible to regard the concept of the artist to be in operation within both the dual system of guild and court as well as the academic system of the Fine Arts, an historically unprecedented level of abstraction is attached to the term with the emergence of the category of art in general. When an artist is someone proficient in one or several of the arts, then there is little or no difference between being a painter and being an artist and only a relative difference to the artisan who is also a legitimate practitioner of the arts. But when the category of art in general subsumes the Fine Arts under it, then the artist becomes irreducible to the painter, sculptor, printmaker, musician, dancer, poet and so on. The abstraction of the category of art comes to install itself within the concept of the artist itself, inflating it and depositing an element of mystery in it insofar as the difference between the artist and the painter, poet, sculptor, etc. is never adequately explained but the difference between the artist and the artisan becomes absolute.

Although, retrospectively, the Renaissance painters and sculptors who withdrew from the milieu of handicraft appear as predecessors of the eighteenth- and nineteenth-century artists, it is not until the bourgeois revolution's undermining of the institutional and economic power of artisans and the abolition of courtly institutions of patronage, I want to argue, that the artist is finally differentiated in absolute terms from the artisan. The artist is a category of producer that emerges historically with the disintegration of the social basis of the arts.

2 Pevsner 1973 [1940], p. 31.

However, the artist is not merely the result of the individual's liberation from the guilds and the academy. What brings about the dissolution of the guilds and academy is the onset of the capitalist mode of production, hence the artist is formed as an anomalous effect of the period in which the Industrial Revolution introduced a new mode of paid work that appeared to contemporary commentators as inhumane repetitive toil. In this regard, the artist occupies a new place of anomaly, as neither artisan nor worker, but it differentiates itself this way partly by presenting itself as an ancient category rather than a specifically modern one.

The artist is an anomalous development that cannot be explained simply by applying to art the generic theory of the transition from feudalism to capitalism or the standard narrative of the passage from artisan to worker. The artist is not what is left when the medieval institutions of painting and sculpture are brushed aside by modernity, Enlightenment, industrialisation and the hegemony of the capitalist mode of production or when aristocratic academies and salons are swept away by the free market and the bourgeois state. The artist is a modern category of producer, not the result of a resistance to modernisation. Although the kinds of practices typical of the artist in the eighteenth century are not distinctively modern – drawing, painting, carving, modelling, and so on – the social relations of artistic production are, indeed, modern. As such, the historical advent of the artist in its modern sense must be attached to changes in the social form of artistic production in the eighteenth and nineteenth centuries.

When the aristocratic institutions of the Fine Arts were dismantled or refitted as bourgeois institutions, the dual system of guild and academy gave way to a highly charged division between art and industry conceived normatively through the distinction between the artist and the worker that developed seamlessly out of seventeenth-century discourses on the difference between the scholar-painter or -sculptor and the artisan-painter or -sculptor. The establishment of the academy of Fine Arts was brokered through an exaggeration of the mechanical and menial character of guild production. The Fine Arts were elevated above handicraft through the double action of remodelling academic painters and sculptors after scholars and quashing everything but the mechanical from their counterparts in the guild.

The classical argument, from Plato and Aristotle, that slaves and mechanics are incapable of reason and unfit for citizenship is deployed in seventeenth- and eighteenth-century arguments for the painter and sculptor to be elevated above the artisan. In France, in the middle of the seventeenth century, the hostility to handicraft which is the historical basis for the introduction of the category of the artist is inverted in order to justify the establishment of the

Académie Royale. Martin de Charmois's petition to the King in 1648 begins with the claim that the group of painters and sculptors within the course are 'weary of the persecution that it has suffered these long years through the hostility of certain master craftsmen, who take the name of painters or sculptors only to oppress those who have spent their youth toiling at the study of beautiful things in order to merit this title'.[3]

André Félibien, who played a significant role in the academic redescription of painting in France, writes in his 'Preface to Seven Conferences', for instance: 'we must not imagine it ought to be considered as purely mechanical, because in painting, the Hand does nothing without being conducted by the Imagination'.[4] The Spanish humanist Antonio Palomino de Castro y Velasco, in his argument that painting must be elevated into the liberal arts, put the same argument more emphatically, saying 'in liberal art there is more contemplation than toil, and in mechanical art there is more toil than contemplation'.[5] When an art is completely mechanical without any contemplation at all, then, for Palomino, it consists of nothing but 'the repetition of simple material practice and bodily exercise in humble, lowly and rather unworthy operations. It is regarded as contemptible or sordid because it stains, lowers and defiles the excellence of an individual's rank and person, although it is quite fitting for those who don the clothes of labour'.[6]

One of the most respected artists of the middle of the eighteenth century, the Dresden-born A.R. Mengs, wrote perhaps the most thoroughgoing and influential text of his epoch on the distinction between the liberal and mechanical arts. The difference, for Mengs, turns on the activity of the soul which for him is synonymous with reason. Invention is preferable to imitation, he argues, because the 'soul, or reason, ought to choose of all the spectacle of nature, those parts, which according to the human idea are most beautiful'.[7] Hence, he said, 'Thought is the essential thing to our soul; that is, to employ it in thinking, since the genius cannot have any other occupation'.[8] Comparing the 'ideal' with the soul and the mechanical part of the production of paintings with the

3 Charmois 2000 [1648], p. 81.
4 Felibien 2000 [1667], p. 112.
5 Palomino 2000 [1724], p. 318.
6 Palomino 2000 [1724], p. 319. The 'sordid arts' for Palomino are arts that should not properly be called arts at all. This allows him to develop a three-tiered system of liberal, mechanical, and sordid arts. My observation of the discursive conflation of handicraft with the purely mechanical does not preserve his unstable distinction between the mechanical and sordid arts.
7 Mengs 1796, p. 30.
8 Mengs 1796, p. 101.

body, Mengs argues that the imitation of nature is a purely mechanical process that can be expedited by slaves[9] and others 'incapable of thinking'.[10]

Tracing the development of a civic humanist political theory of painting from Reynolds to Hazlitt, John Barrell explains that 'the use of the words "mechanical" and "servile" carry so heavy a charge in eighteenth-century writings on art' and comments that the word mechanical, in particular, 'continually occurs in contexts which are concerned with the process by which the theory of painting is reduced to a rule of thumb, a practical method'.[11] In addition to this classical distinction, Reynolds attempts to separate painting as a liberal profession from painting as a 'mechanical trade' insofar as the former 'works under direction of principle' while the latter requires nothing but a 'narrow comprehension and mechanical performance' according to 'vulgar and trite rules'.[12]

Barrell draws attention to a symptomatic episode in the history of painting conceived within the order of the mechanical and liberal arts: 'When Shaftesbury required a painting to be produced which would exemplify his theory of painting, he felt himself obliged to invent and compose the picture himself, engaging a "workman" for its mere execution, for the merely manual part of the task'.[13] In this way, Barrell argues, 'the civic humanist theory of painting distinguishes the liberal man from the mechanic in terms which emphasise that its value-language is a political language'.[14] He detects an attempt, particularly in the writings of the portrait painter Jonathan Richardson, 'to extend the definition of a gentleman to those men of liberal education who pursued private careers and not aspire to public service',[15] which Barrell interprets as 'a compromise between the civic virtues of "traditional" humanism and the mercantile virtues of its alternative, "bourgeois" form'.[16]

9 Mengs elaborates: 'A free man with inclination does all that he can, more or less according to his capacity, but a slave does only that which he is commanded to do, and his natural will is destroyed, by the violence it causes it to obey. The habit of obeying, at last oppresses his capacity, and his race will become worse and worse, so as no longer to desire that which they despair of obtaining' (Mengs 1796, p. 21).

10 Mengs 1796, p. 120.

11 Barrell 1986, p. 15.

12 Reynolds quoted in Barrell 1986, p. 15.

13 Barrell 1986, p. 18.

14 Ibid.

15 Barrell 1986, p. 20.

16 Barrell 1986, p. 21. Barrell contrasts the public good advocated by the aristocracy with the public effects of private interest as described by Adam Smith who said 'it is not from the benevolence of the butcher, the brewer, or the baker, that we expect our dinner, but from their regard to their own interest' (Barrell 1986, p. 47).

There is another political vocabulary operating within the changing form of the philosophy of painting that relates directly to labour. Within the academic discourses of painting and sculpture in the second half of the seventeenth century and the first half of the eighteenth, the artisan or mechanic, often seen through the lens of the slave, comes to be described in terms that anticipate descriptions of the worker. In this sense, it is already the case that the difference between the artisan and the worker is almost completely dissolved before the worker emerges fully on the historical stage with the dominance of the industrial mode of production. By the end of the eighteenth century, a minority of painters, sculptors and poets already regarded themselves as neither artisans nor workers and called themselves artists.

These norms of painting as workless work were not merely ideas but were instantiated in the establishment of the specifically bourgeois infrastructure of art: museums, galleries, art schools, auction houses, studios, art magazines and the discursive formations specific to them, namely art history, art criticism and aesthetic philosophy. The grain of truth in the institutional theory of art is that art comes to dislodge itself from the Fine Arts only when the institutions of the Fine Arts are replaced with the institutions of art in general, even if the new institutions are initially called institutions of Fine Arts, and in many cases still are. What has to be detected, therefore, is not a shift in language – although the use of the terms 'art' and 'artist' become more frequent – or the development of the theory of art – even though this development has been well documented in the history of ideas and aesthetic philosophy – but a new social condition for artistic production.

The artist belongs to the same conjuncture as the invention of the public art museum, art history, aesthetic philosophy and the category of art, all of which were developed through social processes of annexation. Both art history and the art museum appropriated aristocratic collections of the Fine Arts but recoded them through the establishment of a new institution, a new scientific hang and a new relationship to the public. The continuity between the aristocratic order of the Fine Arts and the bourgeois category of art in general is based on these acts of arrogation but also serves to conceal the battery of cultural innovations ushered in during the long bourgeois revolution.

Part of what Michael Moriarty calls the 'polymorphous proliferation of discursive elements'[17] including the *esprit de finesse, gôut, sentiment*, the sublime, *urbanité, galanterie* and *honnêteté*, the *je ne sais quoi* – a term which singles out a moment of ecstatic rupture in which the self is affirmed through the

17 Moriarty 1988, p. 61.

inexplicable acknowledgement of 'something' – is symptomatic of the contested hopes and anxieties of an uncertain social and cultural confrontation in which 'a circle of minor nobles and bourgeois' *parvenus* seek to legitimate themselves socially through a culture 'which emphasises cultural distinction over noble origins'.[18] 'The je-ne-sais-quoi', explains Richard Scholar, 'is no more than a detail, but it happens to distinguish the tasteful few from the tasteless many'.[19] Although the phrase circulates within polite society between 1580 and 1680, the *classicus locus* of the use of the term was published as late as 1701 when Nicolas Boileau wrote 'if I am asked to say what that charm or salt is, my reply will be that is a *je-ne-sais-quoi* that one is able to feel much better than to express'. The phrase is used to designate 'powerful experiences that unsettle habitual ways of thinking and talking'.[20] Hence, as Jean Starobinski puts it, the *je ne sais quoi* 'constitutes a kind of mysterious residue that resists all analysis'.

The *je ne sais quoi* is formed within the realm of the passions, a category that it both exemplifies and threatens. Susan James characterises the dominant perception of the passions at the point at which the *je ne sais quoi* disrupts its operation: 'the passions were regarded as an overbearing and inescapable element of human nature, liable to disrupt any civilised order, philosophy included, unless they were tamed, outwitted, overruled, or seduced'.[21] Richard Scholar, who traces its shifting modalities from referring to occult properties or errors of reasoning to the inexplicable sign of quality or the transparent code of social exclusion, argues that the *je ne sais quoi* 'is not one passion, but the pathos of all passion, and not one emotion, but the motion of all emotion'.[22] Used as shorthand for a broader and more diverse field, the *je ne sais quoi* traverses a history of transition, opposition and indeterminacy from the sixteenth century to the middle of the eighteenth century. Established as a staple of polite conversation by the 1670s, the spread of the term *je ne sais quoi* into wider – and lower – social circles reduces its impact within elite circles and the term takes a slide until it becomes a sign of preposterous social climbing. In 1749, the *je ne sais quoi* is still limping along prominently enough in the English cultural lexicon for it to be targeted for satirical treatment by Henry Fielding in *Tom Jones*. A French periodical in 1726 could still draw on its normative charge: 'We are far from wanting to criticize what the fair sex does to increase its allure. But we will not pretend that their natural beauty is improved; indeed, it suffers a great

18 Scholar 2005, p. 185.
19 Scholar 2005, p. 203.
20 Scholar 2005, p. 279.
21 James 1997, p. 1.
22 Scholar 2005, p. 154.

deal when they try to charm through an outrageous artifice that always lacks grace and the *je ne sais quoi* of simplicity and *naivete* that earns them love and respect'.[23] And, in the middle of the eighteenth century, David Hume continues to speak of 'that certain *je-ne-sais-quoi*, of which 'tis impossible to give any definition or description'.[24]

It is a feeling that combines impenetrability with sensitivity, or at least a certain delicacy, because it can be felt only by suspending what is known and prescribed. Opaque and spontaneous in equal measure, the 'indefinable' *je ne sais quoi* is opposed to artifice, affectation and convention. It appears to have the form of a riddle only because it cannot be determined, fixed or predicted. It does not have any laws. And so, in the seventeenth century, it is associated with simplicity, nature and truth. If we acknowledge that the *je ne sais quoi* does not simply release the extant individual from the generic responses of cultural convention but establishes novel conditions in which such an unprecedented subjective experience can form itself, then we might say that it is an invitation to experiment with freedom at the level of affect. Paradoxically, the subject exemplifies itself in the absence of its own knowledge. Scholar captures what is at stake in the noun – the *je ne sais quoi* – when he observes that it is 'a phrase which requires its subject to say "I"'.[25] At the same time, the phrase requires the subject to be marked by a lack. If the subject can be rehoused in feeling rather than knowledge, however, then the lack of knowledge can be recoded as a gain. Ironically, extending the phrase to 'a certain *je ne sais quoi*' highlights its lack of certainty. If the *je ne sais quoi* is a precursor of the concept of aesthetic labour then it is, first of all, framed within a cultural formation in which labour counts for very little or nothing at all. In the intervening decades between the advent of the discursive power of the *je ne sais quoi* and the formulation of the new theory of aesthetic labour another concept emerges that like the *je ne sais quoi* has become almost unutterable today without laughter or suspicion or irony. Genius, however, contributed to the reconfiguration of the concept of labour in the revolutionary period of the bourgeoisie. This is because the *je ne sais quoi* operates in the absence of rules.

Indeed, the '*je ne sais quoi* attitude [is] defined by an antipathy to rules, consciously flouting the code of etiquette developed carefully over the course of the civilizing process'.[26] What it originally evoked was a suspension of established modes of justification which called on the individual to make a judge-

23 Quoted in Benhamou 1997, p. 33.
24 Hume 1740, Book I, Part III, Section VIII.
25 Scholar 2005, p. 273.
26 Gigante 2005, p. 163.

ment of their own and therefore also a transfer of authority from the canons of knowledge to the individual subject. Despite the perception that the *je ne sais quoi* was nothing but a mask for power and privilege or a retreat into irrationalism, therefore, it is important to acknowledge, with Rémy G. Saisselin, that it is also one of a number of 'non-abstract forms of intelligence'.[27]

Among the milestones of aesthetic thinking in the period of the apparent demise of the *je ne sais quoi* were Joseph Addison's 'The Elevation of Man through Art' published in 1709, Francis Hutcheson's 'An Essay on the Nature and Conduct of the Passions and Affections' published in 1728, Alexander Baumgarten's *Reflections on Poetry* published in 1735, Hume's 'Of the Standard of Taste' published in 1757, and Edward Young's 'Conjectures on Original Composition' which was published in 1759. That is to say, in the wake of the *je ne sais quoi* came the concepts of aesthetics, taste, and the genius, all of which reaffirm some version of an inexplicable but undeniable experience beyond conventional knowledge. Indeed, in the era that coins the concept of art in general in the immediate aftermath of the transformation of the passions by the power of the experience of 'a certain something', it is understandable that it becomes possible to say that 'the *je-ne-sais-quoi* belongs to art as much as it does to nature. Art possesses qualities that are irreducible to the underlying rules: its possession of such qualities may indeed be, in a normative sense, what makes it art'.[28] Art is differentiated from the arts first in the middle of the eighteenth century, just as the force of the *je ne sais quoi* is diminishing and new terms are taking on most of its tasks. 'The *ancien régime* of taste based on the aristocratic *je ne sais quoi* of French neoclassicism, and adapted to the British discourse of taste by way of the connoisseur, transforms into its antithetical horizon: the benighted don't-know-don't-care philistinism of Victorian England'.[29] Ernest Gellner completes this development when, in the middle of the twentieth century, he deployed the phrase to name and shame any and every attempt to obfuscate through the 'suggestion or implication that there is a difference but it cannot be located or stated'.[30]

It is unsatisfactory to narrate the history of the *je ne sais quoi* linearly as a rise and fall or as suffering a process of degeneration or dilution. While the term itself loses its semantic charge, or perhaps metamorphoses from being charged with feeling to being pretentious and unserious, its conceptual con-

27 Saisselin 1961, p. 149.
28 Scholar 2005, p. 182.
29 Gigante 2005, p. 180.
30 Gellner 1956, p. 101.

tent does not disappear along with the phrase but is transferred to other forms, terms, phrases and concepts. The evident passage from the *parvenu* concept of the *je ne sais quoi* to the bourgeois concept of taste (and the fading power of the concept of taste in the face of utilitarian, consumerist and relativist logics of calculation, preference, choice and identity), can also be narrated as the decline in the need to assert and justify the *je ne sais quoi* which had obtained general acceptance in a variety of new forms. Despite being unutterable today, the *je ne sais quoi* is alive and well in most if not all of its historical usages. At its worst, the *je ne sais pas* indicates a pale mystery that surrounds a fortunate surplus to requirements such as survives today when journalists talk about a celebrity having 'the x factor', and yet a trace of it remains in what Roland Barthes called the *punctum*, that effect of culture, in contrast with the *stadium*, that 'pricks' the individual. The *je ne sais quoi* survives in the affirmation of 'not knowing' in contemporary art, the resistance to theory, the reliance on feeling or intuition and so on. Various aesthetic, ethical and affective claims to 'just know' something also carry 'the double semantic charge of the *je-ne-sais-quoi*', which Scholar identifies as 'affirming both the inexplicable nature of the force and the sheer fact of its presence'.[31]

Dubos, who is 'the greatest eighteenth century theoretician of the aesthetics of feeling',[32] said, 'a person must be born with a genius'.[33] Anecdotes in which painters, sculptors and poets showed enormous talent at an early age, outshone their masters, worked in a frenzied manner when inspired, and so on, are present in ancient literature but Dubos's theory of genius is modern for three reasons. First, he characterises the genius in contrast with practices of imitation. Second, he assembles his anecdotes about geniuses, not sporadically to testify to the specific traits of an individual, but intensively in order to identify a type or species of character. Third, he locates the genius within a differentiated field of labour in which, for instance, he addresses the modern question of whether many geniuses 'who would have distinguished themselves'[34] are stifled by the 'greatest part of mankind being put out from their infancy to low mechanic trades'.[35] His method is scientific in the Enlightened sense (it subsumes facts under categories), and his social framework is secular, disembedded, dehierarchised and impersonal. In this respect, Dubos hooks the new British conceptualisation of the genius onto the kind of objectifying social

31 Scholar 2005, p. 284.
32 Ferry 1993, p. 43.
33 Dubos 1748, p. 4.
34 Dubos 1748 [1740], p. 26.
35 Ibid.

science pioneered by William Petty and the moral conception of the individual spearheaded by Jean-Jacques Rousseau. His concept of genius operates within a social imaginary structured by what individuals do and their capacities. While his characterisation of the genius is not the most emphatic of the first half of the eighteenth century, Dubos's theory, which I will return to below, was the most ambitious to date as a social category of labour.

Herbert Dieckmann claims that Diderot gave the concept of genius 'a definitively new turn',[36] which he explains thus:

> The transition from the conception of genius as mere talent to the conception of the genius as an individual was accomplished through a specific act of thought. The following discussion will show that Diderot accomplished this act of thought and thereby became conscious of the problem of 'the genius' as a type of person.[37]

Dieckmann underestimates the contribution of Dubos and exaggerates the novelty and gravity of Diderot's conceptualisation of genius because Diderot did not build on Dubos's enquiry into the genius. Diderot's characterisation of the genius is closer to the English accounts of Addison and Young, that is to say, limited to descriptions of technical proficiencies and personality traits required for the power of invention to be imposed freely. Like Dubos, Diderot's genius is moved by enthusiasm, but unlike Dubos or their English predecessors, Diderot characterises the genius as cool and calm rather than frenzied. 'It is in the moments of calm and composure, Diderot tells us, that the most important insights are given to the genius'.[38] He visits the studio of La Tour and describes the painter as 'never breathless' and observes that 'he remains collected',[39] reporting this episode in the manner of providing evidence to correct a common error. Diderot's concept of the genius is novel, then, in its sobriety and in the absence of any pathological or melodramatic traits. The genius is not characterised by his impetuosity or absolute independence; rather 'the genius observes more precisely, accurately, exactly and deeply than the ordinary man'.[40] Despite this difference of tone, Diderot credits the genius with the power of originality, saying that, in the case of literature, 'all new words and word-combinations are exclusively the work of the genius'.[41] The genius is an

36 Dieckmann 1941, p. 151.
37 Dieckmann 1941, p. 152.
38 Dieckmann 1941, p. 171.
39 Diderot 2011, p. 26.
40 Dieckmann 1941, p. 171.
41 Dieckmann 1941, p. 177.

exceptional individual who does not produce work through acts of copying. And yet, the works of the genius not only can be replicated by others but, in a sense, are confirmed as the work of genius by the mimicry of others. Originality appears to be possible in isolation unless it is conceived of as the origin of something else. 'The fundamental feature of Diderot's reflections is the acknowledgment of the creative power of genius',[42] which means that other producers can copy what the genius has originated but 'the genius, and only the genius, creates the prototype'.[43]

Although the genius was seen as unteachable and producing works that are technically unfathomable, the concept 'came to be applied to a particular kind of inventive human being',[44] that is to say, an active individual, which dovetailed with the politically charged norms of freedom and liberty that were attached to the Enlightenment within the long bourgeois revolution. These freedoms were more often evident in consumption than production but there was traffic between the two in which the artistic labour of the genius took on some of the qualities of the freedom of the consumer and the consumer was inflated by obtaining some of the qualities of the genius. In a contrast that anticipates some aspects of the theory of aesthetic judgement, Dubos argues that the number of jewels you bring home 'will be in proportion to the money you took with you for the purchase',[45] whereas what you derive from the great masterpieces of Rome, he argued, depends on the genius 'by the light of which'[46] you study the ancients. This opposition between taste and purchasing, or the internal capacity of the individual and the external capacity to buy, will be reiterated not only throughout successive phases in the history of the concept of genius but within the burgeoning discourses of art and aesthetics too. Dubos highlights this opposition within a theory of the genius partly because he is systematically surveying the structure of differentiation within which the genius is located (the 'natural price' of things is simply one of a long list of forces to which the genius cannot submit), and partly because the normative economy of the genius must be opposed specifically to the political economy of exchangeable goods.

While the labour of unskilled labourers continued to be perceived to be almost exclusively deleterious and detestable, the emergent emphasis on the value of individual and collective human productive capacity was represented

42 Dieckmann 1941, p. 176.
43 Ibid.
44 Mason 1993, p. 210.
45 Dubos 1748, p. 48.
46 Ibid.

ideally in the hallowed hyperbole of the genius. It is worth noting, for instance, that the genius, insofar as he was unteachable and independent of authority and rules, is the exact counterpart of the apprentice within a context in which work was being revalued through scientific study. Moreover, the contrast with the worker is evident in Batteux's account of 'periods of inactivity', 'uneven inspiration' and 'periods of languor and weakness' that the genius suffers as a result of their need for 'enthusiasm'.[47] In the eighteenth century the concept of genius helped to articulate the 'firm belief in the value of human making'.[48] Evidently, the modern concept of the genius preserves the ancient aristocratic opposition towards manual labour but it replaces the noble values of education, decorum, rules and divine hierarchies, with a metaphysics of the autonomous individual derived in part from the discourse of the passions and the rhetorical power of the *je ne sais quoi*. Dieckmann does not exaggerate when he says 'at the end of the eighteenth century, the artistic "genius" comes to be thought of as the highest human type, and thus replaces such earlier ideal types as the hero, the "sage", the Saint, the *uomo universale*, the *cortigiano*, the *honnête homme*'.[49]

The genius, we might say, was the embodiment of the *je ne sais quoi* or the translation of the inexplicable and destabilising judgement of quality not only into a personality or character but a type of activity or a modality of labour. For the Jena Romantics, a small group of poets and philosophers in Germany between 1798 and 1804, the genius was not only the basis of a new kind of cultural writing – criticism – but also the basis of a Romantic conception of society as the community of free individuals. Whereas the previous theorists of the genius did so within debates that were shaped by the institutions of art or the arts, the Jena Romantics inserted questions of art and aesthetics at the heart of philosophy, politics, ethics and truth. It was within this particular intellectual programme that the concept of genius is deployed within a fully articulated concept of aesthetic labour. Philip Kain reads the aesthetic episode in German philosophy through the lens of the early Marx as animated by 'a particular humanistic ideal for social and political institutions'[50] using 'modern aesthetic concepts'[51] in opposition to the modern division of labour. Kain identifies the common thread as a desire to rekindle the Greek ideal of unity in which aes-

47 Batteux 2015 [1746], p. 15.
48 Mason 1993, p. 230.
49 Dieckmann 1941, p. 151.
50 Kain 1982, p. 6.
51 Kain 1982, p. 7.

thetic activity develops the personality, an ideal that appears lost in a world only recently torn into shreds by specialisation and fragmentation within the capitalist division of labour. Each in different ways turns to art – principally poetry – as a form of activity that has not been subjected to the division of labour and therefore retains the (Greek) ideal relationship between activity (as an end in itself) and self-development.

Although the genius is the purest form of the inner force of the self, it belongs to a spectrum of specifically modern forms of subjectivity. The era after Descartes is the epoch of the subject but also, and because of this, the age of the taxonomical mapping of subjectivities. The latter includes the calculating positivist[52] and the 'man of feeling',[53] the ironist and the nationalist,[54] the class warrior and the private citizen, the workaholic and the pursuer of wealth, the classicist and the avant-gardist, the family man and the libertine, the domestic goddess and the fallen woman,[55] the aesthete and the philistine.[56] In other words, the genius is a figure without equal only insofar as it is figured differentially within a modern matrix of subjectivities. In its modern form, therefore, it belongs to a specific historical moment in which the subject emerged as a prime political, philosophical and cultural vector of freedom, reason, feeling and agency.

What is lost in the critique of the genius is the recognition that it was one of the earliest attempts to extrapolate the concept of freedom from its legal meaning. Genius was formulated as a figure of freedom in which freedom, no longer restricted to political freedom, is rearticulated as an undetermined mode of activity. As well as being a picture of freedom, therefore, the genius is a picture of work emancipated from itself.

Batteux lent his considerable weight to the concept of the genius but for him it had to be tethered to imitation and ultimately to nature and its laws. It is not for the genius 'to imagine what cannot be but to discover what is',[57] he said, reiterating the concept of 'invention' established at least since the Renaissance. Just as an economy of copying was the condition for Addison's concept of the original genius, so imitation is at the heart of not only Batteux's

52 See Force 2003.
53 'The Man of Feeling' is the title of a book by Henry Mackenzie first published in 1771 that figures prominently within the historical study of the preconditions for Romanticism in literature.
54 See Bruno 2010.
55 For a fuller survey of modern conceptions of female gender roles, see Abrams 2002.
56 See Beech and Roberts (eds) 2002.
57 Batteux 2015 [1746], p. 5.

concept of the genius but also his concept of the Fine Arts, which he thinks are synonymous with the imitative arts. 'Genius can only follow and imitate nature', he says, and therefore 'everything that it produces can only be an imitation'.[58] What Dubos wanted to rule out, by stressing that the capacities of the genius were innate, was the possibility of the genius being a product of education or training. 'Education', he argued, 'is incapable of giving a particular genius or inclination to children', or even 'to strip them of this inclination'.[59] Hence great painters, for instance, can be apprenticed to mediocre masters since there is nothing in their apprenticeship that decides whether or not they will reach the level of the genius. 'Such a disposition of mind', he said, 'cannot be acquired by art'.[60]

Painters and poets are not formed pedagogically or compelled by external causation; they are impelled by forces within. The genius is driven by 'enthusiasm',[61] or a 'poetic fire',[62] which cannot be controlled. Or again, the genius is 'a plant which shoots up, as it were, of itself'.[63] 'Genius is the fire which elevates painters above themselves',[64] Dubos said. These tropes of inner propulsion serve the purpose of distinguishing the works of genius from the works of standard labourers, skilled and unskilled, manual and intellectual. As well as being independent of origins, the genius is also independent from the opinions and tastes of the public or the market, and is certainly not driven by the taste of patrons. 'He is not discouraged' by a lack of success, as a jobbing purveyor of goods might be, but 'pushes on with perseverance'.[65] Genius, for Dubos, is original, singular and creates something new. Titian's use of colour, Dubos says, 'requires invention'.[66] Dubos also expresses this point negatively when he says we 'meet nothing new in the compositions of painters of no genius, nothing singular in their expressions'.[67] By contrast with the mediocre painter (here an instantiation of the artisan or apprentice or more generally the 'mechanic'), who is first an imitator of others and then an imitator of his own work in the routinisation of technique, the genius is perpetually impelled to renew and

58 Batteux 2015 [1746], p. 6.
59 Dubos 1748, p. 25.
60 Dubos 1748, p. 6.
61 Dubos 1748, p. 11.
62 Dubos 1748, p. 12.
63 Dubos 1748, p. 32.
64 Dubos 1748, p. 13.
65 Dubos 1748, p. 18.
66 Dubos 1748, p. 51.
67 Dubos 1748, p. 46.

refresh his work. The former is condemned 'to follow a beaten track',[68] whereas the genius is able 'to open a new road'.[69]

The young writers of the *Sturm und Drang* movement gave the strongest emphasis to the genius that it has ever enjoyed. '*Genius* is the programmatic term of the German *Sturm und Drang* movement' with its emphasis on intuition, fantasy, emotion, subjectivity and individualism. More emphatically, '[u]ntamed, spontaneous authenticity was everything'.[70] Gotthold Ephraim Lessing argued that 'the prerequisites of genius were originality, passion and enthusiasm'.[71] His student, Johann Gottfried Herder, along with Goethe, spearheaded a new intellectual movement in Germany by pushing the idea of genius to its eighteenth-century limits. Herder provided a new model of the genius, despite not using the word, in his enormously influential reassessment of the work of Shakespeare. Arguing that classical literature is determined by its relationship to the 'folk' rather than through perfection of its form, Herder freed the ambitious artist from imitating the classics in order to match them. Herder, who took the idea of genius from Young, even borrowing his analogy of how crutches help the lame and hinder the healthy, placed the individual personality at the centre of art and aesthetics. Goethe's Werther, for whom inner necessity must always take priority over rules, argued in a letter that both art and love ought to be free of external constraints. This is the agenda that the concept of genius amplifies for the *Sturm und Drang*: 'man constitutes himself'.

In particular, the artist is an embodiment of the bourgeois translation of the aristocratic ideas of the *je ne sais quoi* and the genius which models free human activity on the aesthetic experience of the consumption of beautiful things. In the eighteenth century, the concept of the genius took a distinctive turn towards originality and against training and mechanical work within a political context in which the spectrum of human activity, from unskilled labour to the amateur natural philosopher, was being radically reconfigured. Both, I want to argue, are initially construed as antagonists of work and therefore belong to a politics of labour that is ultimately internalised within the category of the artist. As such, unpacking the politics of labour built into the concept of genius permits a more precise analysis of the politics of labour embodied in the figure of the artist and in the discourse of artistic labour. This historical reconstruction will also allow us to reinterpret the politics of labour crystallised in the cur-

68 Dubos 1748, p. 47.
69 Ibid.
70 Blanning 2010, p. 34.
71 Ibid.

rent political discourses of automation and the emancipation from work that juxtaposes the robot and the idler.

New attitudes towards work and the elevation of subjective experience are combined in the concept of genius as an unproductive producer located differentially in contrast to the artisan and the wage labourer. Genius, in the eighteenth century, is introduced specifically insofar as it 'derogates the craftsman's manipulation of inherited techniques and materials as capable of producing nothing but imitations'.[72] The genius is the individual who produces originals rather than copies, and therefore produces artefacts not by following established procedures but through unorthodox methods. 'Original works are the product of a more organic process: they are vital, grow spontaneously from a root, and by implication, unfold their original form from within'.[73] Before the genius is associated with absolute originality or the waywardness of an asocial idiosyncrasy, it is a figure within an economy of copies. What consecrates the producer as a genius is that others copy what he – rarely she – has done. There is no original without copies. Indeed, it is the subsequent act of copying from the works of the genius that such works obtain their status as originals – they are the origin of the copy. This is evident in the earliest comments on genius by Addison and Young.

Joseph Addison appears to be the first to use the concept of genius in the modern sense, which is to say as an individual with talent beyond skill, originality beyond imitation and proficiency beyond training. In a short essay on genius in the *Spectator* on 3 September 1711, Addison declared that the 'imitation of the best Authors is not to be compared with a good Original'.[74] Since he conceived of the genius as the originator of subsequent copies, he spoke of a 'great natural genius', which refers to the ancient and medieval sources of eighteenth-century architecture, literature and the visual arts. The genius, therefore, is not initially conceived of as a peculiarly modern individual liberated from tradition and the institutions of social and cultural orthodoxy but as a remote (foreign and ancient) precedent. The genius, Addison said, is 'found among the Ancients, and in particular among those of the more Eastern Parts of the World',[75] who excel in 'unbounded Flights of Nature'[76] without rules and without imitation. He compares the two types of genius with the analogy of a wilderness and a garden.

72 Woodmansee 1984, p. 446.
73 Ibid.
74 Addison 1970, p. 328.
75 Addison 1970, p. 326.
76 Addison 1970, p. 327.

While rules and imitation do not preclude genius, for Addison, the 'great Danger in these latter kind of Genius's is, least they cramp their own Abilities too much by Imitation, and form themselves altogether upon Models, without giving full Play to their own natural Parts'.[77] Addison attempted to pinpoint 'what is properly a great genius'.[78] Geniuses are, he wrote, 'the Prodigies of Mankind, who by mere Strength of Natural Parts, and without any Assistance of Art or Learning, have produced Works that were the delight of their own Times and the Wonder of Posterity'.[79] Characterising the genius in terms of natural, wild and extravagant powers, Addison argues that the products of genius are more beautiful than the more polished works of fine handicraft. The contrast between works of genius and works of skill is based on opposed attitudes to skilled manufacture expressed through the distinction between copying and inventiveness.

Although Addison wrote about genius as an ancient capacity for the production of originality, Edward Young's 'Conjectures on Original Composition' in 1759 is the principal English text on genius that was taken up by the German Romantics, translated twice into German within two years of its appearance in English. Herder allegedly said that Young's ideas had an 'electrical effect and kindled a blaze of fire in German hearts'.[80] Young characterises the genius precisely as 'the Power of accomplishing great things without the means generally reputed necessary to that end'.[81] It is the absence of the usual preconditions for such production that suggests that geniuses 'partake of the divine' and that their works are miraculous.

'Young's man of genius can bear no stimulus or motive for his work; any commerce with tradition, like conscious thought itself, stands in the way of discovery'.[82] Young's concept of genius 'is a declaration of freedom'[83] articulated around tropes of learning or training presented as forms of dependence and restriction. 'Learning is borrowed knowledge', Young says, whereas genius 'is knowledge innate, and quite our own'.[84] Rules are like crutches, Young suggests provocatively, meaning that they are useful to the 'Lame' but 'an Impediment to the Strong'.[85] For Young, the genius is distinct from handicraft and manufac-

77 Addison 1970, p. 328.
78 Addison 1970, p. 325.
79 Ibid.
80 Pearsall Smith 1925.
81 Young 1971 [1759], p. 341.
82 Bromwich 1985, pp. 143–4.
83 Buelow 1990, p. 123.
84 Young 1971 [1759], p. 343.
85 Young 1971 [1759], p. 342.

turing insofar as 'it grows, it is not made',[86] which draws a sharp line between the genius and the apprentice painter's practice of 'learning by doing'.[87]

Genius is a key notion for Kant and Schiller's aesthetic philosophy. Not only the embodiment of freedom insofar as the genius is undetermined, the genius is the emblem of a new conception of labour and at the same time an effect of the new weight attached to the subject insofar as the genius is the purest form of the inner force of the self.

For Schiller, genius is naive insofar as it is natural, childlike, feminine, innocent, ancient, or in Deleuze's terms *minor*. Unaware of the rules or independent of rules, the genius diverts from the known 'without ceasing to be at home'.[88] The genius 'does not proceed according to known principles, but by feelings and inspiration', and, what's more, 'its feelings are laws for all time, for all human generations'.[89] 'Naive art', assuming the traditional definition of art, is a contradiction in terms, as Kant pointed out,[90] hence, for Schiller, the genius reconciles two opposing forces. While the genius is a figure endowed with natural abilities, there is no determination by natural forces in the production of originality.

Genius is a figure of freedom understood as a mode of activity undertaken freely to such a degree that one's independence overcomes all social and historical determinations. 'You are a genius to the extent that you are able to challenge the sociohistorical conditions of your identity',[91] as Julia Kristeva accurately puts it. Despite often being credited in the eighteenth century to either nature or God or both, the genius represents a power that is peculiarly human, albeit the human reduced understood not as species being but individual person. Through the concept of the genius 'art had advanced [from meaning skill] to become the supreme form of human activity'.[92] Bettina von Arnim's comment about Beethoven, that he 'treated God as an equal', testifies to the elevation of art in the trope of genius. This is unprecedented. Previously art had been understood either in terms of the properties of works of art or in terms of technique, but the genius represents a new perspective on art as human vitality. 'Therein lies genius, which is quite simply creativity'.[93] Genius took hold 'where there was a marked shift from focusing upon a work itself to

86 Young 1971 [1759], p. 17.
87 Ames-Lewis 2013, p. 37.
88 Schiller 1875 [1795], p. 272.
89 Ibid.
90 See Kant 1987 [1790], p. 206.
91 Kristeva 2004, p. 504.
92 Blanning 2010, p. 37.
93 Kristeva 2004, p. 503.

looking at how the writer creatively interacts with his work'.[94] As well as being a picture of freedom, therefore, the genius is a picture of work, albeit of a very unusual kind. Genius is both freedom from determination and freedom to produce works according to one's own personality. Insofar as the unprecedented type of work characteristic of the genius is unlike work as it has previously been conceived or practised, the freedom of the genius is based in part on an alleged freedom from work inscribed into a mode of work itself.

Genius is deployed in the third *Critique* as a minor but integral part of the analysis of 'the central problem of the irreducibility of the conditions that fashion knowledge'.[95] Genius instantiates 'the limits and possibilities of the judging subject'[96] in general by focusing on the exceptional judgements of 'the artistically creative subject'.[97] In the creative activity of the genius, '[w]hat occurs is an illumination',[98] which is hyperbolised freedom. 'Genius implicitly becomes (the) Enlightenment'.[99] Genius requires freedom from all rules and therefore negates or opposes art in the ancient sense, namely a skilled activity that can be taught. 'Kant's concept of genius opens up the approach to art as an exemplary activity that creates its own autonomous legislation'.[100] Kant's detachment of the genius from imitation and teachability, commenting for instance that 'one cannot learn to write inspired poetry',[101] points in the same direction.

This is why imagination takes on such importance in the early literature on the genius. 'Imagination was once a reproductive power that enabled us to recreate and remember what was absent'.[102] 'The mimetic paradigm of imagining is replaced by the productive paradigm'.[103] Ultimately, 'the imagination becomes ... the immediate source of its own truth'[104] and 'the designation of genius emerges from the recognition that human beings make things after their own imagination rather than imitating something already given'.[105] 'The imagination was introduced to try and overcome the separation of subject and object ... The imagination takes on an increasingly important role ... [T]he ima-

94 Bruno 2010.
95 Goetschel 2000, p. 149.
96 Wang 2000, p. 16.
97 Ibid.
98 Wang 2000, p. 21.
99 Ibid.
100 Goetschel 2000, p. 150.
101 Kant 1987 [1790], p. 176.
102 Bruno 2010.
103 Kearney 1988, p. 155.
104 Ibid.
105 Bruno 2010.

gination can dissolve what had seemed to Descartes and his successors the insoluble problem of the relation between the inner and the outer, the mental and the corporeal'.[106] Mary Warnock, in her *Imagination and Time*, says Descartes set up a problem for Western philosophy for many years. 'What most distinguishes the modern philosophies of imagination from their various antecedents is a marked affirmation of the creative power of man'.[107] Imagination is a concept deployed as a cipher of production that dwarfs or bypasses manual production, anticipating the idea of immaterial labour.

If the bourgeois public sphere is constructed on the basis of a merely formal equality of its participants, an 'as if' equality that is best interpreted as a mechanism for preserving inequality (of bracketing and obstructing the demand for full equality), bourgeois political theory is predicated on a concretely limited freedom expressed abstractly as a universal and unlimited freedom. If the eighteenth century is characterised by 'concerns with sentiments, passions, morals, and manners on the one hand and with habits, customs, institutions, and philosophical histories of political societies on the other',[108] then the genius must be placed within only one side of this normative division and decidedly against the other.

'Placing the genius at the central interface between imagination and understanding emancipates the discourse on aesthetics while it keeps it free from normative rules'.[109] This results in 'imagination [being] conceived of as a "lamp" rather than a "mirror"'.[110] Production, here, is an element of freedom on condition that it is not merely manual or, as it was said at the time, 'mechanical' (in a conflation that deliberately associates manual workers with machines). Imagination is celebrated not simply for being intellectual but for being active and productive, unlike the old regime's celebration of contemplation which was based on inactivity.

Genius comes to be constituted as impervious to habits, customs, institutions and social systems. Rather than merely arguing that the genius is a divisive myth, it is vital to understand that the genius is a species of the author. Clearly, the author is conceived in proximity to issues around intellectual property, in which ownership and production are united in a Lockean pact. 'The notion that property can be ideal as well as real, that under certain circumstances a person's ideas are no less his property than his hogs and horses, is of course a modern

106 Bruno 2010.
107 Kearney 1988, p. 155.
108 Sonenscher 1998, p. 377.
109 Goetschel 2000, pp. 149–50.
110 Bruno 2010.

one'.[111] As such, a paradigm of labour is substituted by a paradigm of property. No longer assigned on a case by case basis, writers during the long bourgeois revolution argued that art as such and artists in general were characterised by authorship. In fact, we might even detect the transferral of authorship to the artist as the inflation of authorship to its most abstract and absolute form. The genius is the infinite author. But the politics of authorship, which turns on questions of property, does not set the horizon for the politics of the artist-genius, which cannot be fully understood outside of the politics of work.

Genius from the outset is both a personification of freedom (i.e. that which is not determined by external forces) and a denial of labour within labour. The absence of causation for the genius (the self-caused individual) spreads to an absence of causation by the genius (the creative individual who cannot explain their own processes of production) so that labour is extracted from the processes of creation. Genius is labour in denial because the poet is unable 'to show how his ideas, rich in fancy and yet also in thought, arise and meet in his mind; ... he himself does not know, and hence cannot teach it to anyone else'.[112] In short, 'genius always remains a mystery to itself'.[113] It is its mystery that brings disrepute to the idea of genius in the years following the dissolution of romanticism. It goes without saying that the concept of genius is a falsification of sorts. Clearly, 'authors do not work in isolation'[114] for instance, despite romantic myths of absolute self-reliance, heroic isolation and rugged independence but the 'demystification of Romanticism'[115] or 'dismissed as one idol of [the romantic] subject's ideological mystification'[116] is not an adequate response to the 'provocative hyperbole of the term *genius*'.[117]

The concept of the genius naturalises the social chasm felt by the artist in hostile social conditions, but the ideological critique of the genius addresses neither those feelings nor the social conditions in which art remains economically, socially, and technically anomalous to capitalist production. We can read the concept of the genius as both a utopian image of dynamic individualism elevated above the mechanical arts and freed from feudal constraints, as well as a marker of social distinction that preserved social rank in the absence of the old regime's mechanisms for reproducing social hierarchy. However, it also

111 Woodmansee 1984, p. 434.
112 Kant 1987 [1790], p. 177.
113 Schiller 1993 [1900], p. 189.
114 Wu 2015, p. 41.
115 Wang 2000, p. 18.
116 Wang 2000, p. 21.
117 Kristeva 2004, p. 493.

figures prominently within a broader discursive remodelling of social relations under the sign of universalised freedom in different modalities either side of the French Revolution. Before the revolution, genius belonged to an ensemble of concepts including taste, the aesthetic, imagination, passion and beauty that were reconstituting the individual as the basis of the social order. Based on but outstripping the individual presumed by political economy, the aesthetic subject in the second half of the eighteenth century can be understood as an attempt to extrapolate a radical figure of absolute freedom from the liberties and pleasures of the bourgeois consumer or 'the so-called Man of Taste had to navigate an increasing tide of consumables, seeking distinction through the exercise of discrimination'.[118] The artist, as a figure distinct from the artisan, was modelled on the pleasures and freedom of the consumer sublimated in the subject of taste.

Despite the limits placed on aesthetic conceptions of the individual by the material conditions of commodity consumption and the display of taste, the theoretical articulation of the genius and other aesthetic figures did not merely describe or express this state of affairs, it extrapolated from it in a utopian, radical and emancipatory discourse of freedom. Of course, absolute freedom belongs to a metaphysics that has a material basis in the campaign for free trade, a free press, free labour, freedom of contract and the freeing of slaves, and it is vitally important that bourgeois ideology is indexed to these realities. Nevertheless, it is by taking the literature on freedom literally and building on the promise rather than the predicament, that the bourgeois revolution lit up the political imaginations of others. Insofar as bourgeois ideas necessarily exceed the social formation from which they are formed (since ideology can only appear to justify a given social condition by abstracting and exaggerating its central values not by revealing them directly), ideology always has a utopian moment and always therefore provides fuel for resistance. The genius, therefore, is simultaneously an alibi for power and privilege and, at the same time, an image of an as yet unheard of extension of freedom.

In his study of Bohemianism, César Graña asks how it was possible in the middle of the nineteenth century that 'one section of the bourgeoisie was efficiently gathering profits with unbending matter-of-factness, [while] another was giving itself over to philosophical despair, the cult of sensitivity, and the enthronement of the nonutilitarian virtues?'[119] This not entirely unfounded cliché goes like this: the artist is the impoverished progeny of the *nouveau riche*

118 Gigante 2005, p. 3.
119 Graña 1964, p. 17.

or the respectable 'middling type' after being drawn away from studying the law or something equally promising of a steady career in order to join up with café society and become devoted to Art with a capital A. His answer, in one sense, is exemplary insofar as it acknowledges that Bohemianism is overdetermined by geographical, sociological, economic, psychological, historical, political, philosophical and aesthetic conditions. His study focuses on literature, and therefore he traces how the social position of the writer passes from the beneficiary of patronage to the hero and victim of the commercial publishing industry. He attempts to explain the alienation of the writer and artist from 'society' and particularly the bourgeoisie, but he does this without any historical explanation of the normative framework of the antipathy to commerce and the virtues attendant to this or the hostility to handicraft and the opposition to labour that gave art in general its distinctive shape.

In addition to identifying the various social causes for the individual artist or writer to feel 'the tension between the heroic self-image of the creative person and the impersonal commercialization of the market',[120] it is essential to identify the counter-tendencies to commodification and the social forces that are played out within the social relations of artistic labour. While it is well established that the artist sprouts up in the wake of the bourgeois revolution, it is too often assumed that this is the result of art's commodification through the rise of the art market in the wake of the aristocratic system of patronage. What I am reconstructing here, however, is an alternative narrative in which the artist emerges as the result of the social division of labour and the industrialisation of those aspects of artistic production that can be taken over by commercial firms. This requires two developments. First, the Fine Arts have already split off from handicraft, and second, the social enterprise of elevating the Fine Arts loses its social basis as the hierarchy of the liberal arts over the mechanical arts becomes irrelevant to the organisation of labour under capital. The modern category of the artist is neither a remnant of the pre-capitalist world of the arts nor simply an obfuscation of the conversion of the artisan into a producer of commodities for the market.

Bourdieu's version explains the social position[121] of intellectuals and artists by claiming they owe their 'dispositions towards the social world ... to their status as poor relations'[122] and differentiates the tastes of two fractions of the

120 Graña 1964, p. 57.
121 Bourdieu's method is to outline the positions available in a given social milieu and the activity of position-taking within it in order to classify individual writers and artists. See Bourdieu 1995 [1992], p. 85.
122 Bourdieu 1984 [1979], p. 176.

bourgeoisie on this basis, saying 'the dominant fractions of the dominant class (the "bourgeoisie") demand of art a high degree of denial of the social world and incline towards a hedonistic aesthetic of ease and facility',[123] whereas 'the dominated fractions (the "intellectuals" and "artists") have affinities with the ascetic aspect of aesthetics and are inclined to support all artistic revolutions conducted in the name of purity and purification, refusal of ostentation and the bourgeois taste for ornament'.[124] Bourdieu is right to emphasise that art is characterised by an inversion of the economic,[125] but he is too suspicious of art and aesthetics to treat the institutions and discourses of art and literature as counter-tendencies. He allows only a 'symbolic revolution'[126] that results in the 'antinomy of modern art',[127] which he explains as a 'temporal gap between demand and supply'.[128] That is to say, what differentiates the artist from the hawker of wares is largely an illusion or delusion or myth.

Recognising that the discursive construction of the artist is in key respects a fantasy of origin and authenticity, however, does not leave us with nothing. For one thing, the fictional character of the artist has been deployed within the actual history of art and now has an entire infrastructure built around it, as well as an 'infrastructure of dissent' built around the disclosure of the myth of the artist (including counter-myths of critical thinking). As such, the dissolution of the myth of the artist must be practical as well as intellectual so it cannot be realised entirely by social science. More importantly, though, the myth of the artist is not entirely false. It is mythic only in the sense that it is character-ised by exaggeration, abstraction, hyperbole, romance and euphemism. What is required is an historical account that explains the social changes that are codified in the myth of the artist. Moreover, I would say, we need to provide an explanation of the perceived need for the myth of the artist within the his-torical processes that attempted to secure artistic labour as an anomalous and subordinate mode of production under threat from the capitalist mode of pro-duction.

Bohemia was one of the names for the sociality of hyberbolically liberated individuals on the edges of the imperial centres of the capitalist mode of pro-duction. The fiction of Bohemia allowed artists to establish cultural, social, political and professional solidarities commensurate with the modern divi-

123 Ibid.
124 Ibid.
125 Bourdieu 1995 [1992], pp. 81–4.
126 Bourdieu 1995 [1992], p. 81.
127 Bourdieu 1995 [1992], p. 82.
128 Ibid.

sion of artistic labour in which the artist now appeared to be self-sufficient because the artisanal elements of artistic production were provided by firms external to the studio and the commercial and pedagogic components of art were assigned to specialist dealers and teachers in other places. It is this social and geographical partition of artistic labour that is the material basis for the normative discourse of the artist as an independent producer whose subjective values and tastes must always take priority over orthodoxy, convention, public acclaim and material rewards.

The myth of the Bohemian artist was diametrically opposed to the bourgeois myth of industriousness and restraint. In the early nineteenth century, the artist both preserves and represses the content of the genius. 'Genius was unleashed as an all-powerful, radical, and unequalled event, a gift of nature which must be allowed to take its course no matter how disruptive to common perceptions'.[129] Artistic labour was conceived of as an extension of the independence of the artisan no longer subject to the rules of the guild and less and less in unison with apprentices and journeymen but also as an expression of the 'pained abhorrence of the bourgeoisie'.[130] Since there is no legitimate place left for the arts and their corporate idiom or for the Fine Arts and the feudal hierarchy of the arts in a society dominated by the accumulation of capital, the artist must be conceived of in tropes of anomaly, independence, madness, individuality, license and mystery. Whereas the guild Freeman obtained certain privileges, the artist enjoyed a precarious independence, absolute in principle yet perpetually at risk by circumstance because the precondition of its independence was the absence of any social mechanisms that might secure and maintain the artist's actual autonomy from the market. It is independence that becomes key to distinguishing the artist from both the artisan and the worker in industrial capitalism.

When the Romantic image of the artist faded, its historical hybridity tended to be settled, for critical thought, as a privileged idler, a defunct courtier or a deluded luxury supplier. Which is to say, the exemplar of individual freedom in self-expressive labour was cast as a worker or a capitalist, or both, but not under any circumstances neither. My aim is not to refute the feminist, Marxist, posthuman and postcolonial critique of the artist-genius in defence of the cherished image of the creative sovereign individual. It is evident that the discourses and institutions of the artist deserve to be criticised as elitist, masculinist and colonial. The concept of genius, taken in isolation as a trope

129 Graña 1964, p. 52.
130 Graña 1964, p. 11.

of elite individuals capable of originality, warrants all the criticism it receives. It is also true that the myth of the artist as genius misrepresents the social production of art that gave rise to it.

Janet Wolff, for instance, is right to point out that 'the concept of creativity is used in a metaphysical and non-historical way'[131] and also that the 'concept of the artist/author as some kind of asocial being, blessed with genius, waiting for divine inspiration and exempt from all normal rules of social intercourse is therefore very much an ahistorical and limited one',[132] but there are at least two methods with which to provide a social account of the artist, however: either to reconcile the artist with the world of work or to explain the gap between them socially. What I have attempted to do in reconstructing the historical circumstances of the advent of the social form of artistic labour is to show that the myth of the artist as an isolated producer of artworks is at once the result of a spatial division of labour brought about by industrialisation and a discursive and institutional bunker for the protection of an anomalous mode of production.

Within the historical schema that I have outlined so far, the redescription of the artist as a cultural worker, commodity producer, entrepreneur or bearer of (cultural) capital is as much a misrepresentation of the social relations of artistic production as the genius. The degree to which this cynical deflation of the artist appears to be more realistic than the myth is, I want to suggest, a measure of the waning of a particular politics of labour.

To reject the mystifications integral to the idea of genius would be in vain if the hope is to reveal some form of standard labour that the concept shielded from view. As if the splitting of labour could be reconciled in thought simply by ridding it of abstraction and overstatement. Rather than concluding that the genius is nothing but a mythic figure of falsity, an ideological construction and metaphysical trope, in the hope of discovering the truth of artistic labour in the mundane processes and exchanges, as if these conceptual enhancements of artistic labour did not exist, were not rooted in real perceptible developments and had no transformative impact on practice. Genius is an abstraction that corresponds, exactly or approximately, to the abstract condition of art and the artist, as well as artistic labour, which establishes itself in art's institutions and values from the middle of the eighteenth century onwards.

Kant said 'genius is the exemplary originality of a subject's natural endowment in the *free* use of his cognitive powers'.[133] The traditional understanding

131 Wolff 1981, p. 118.
132 Wolff 1981, p. 12.
133 Kant 1987 [1790], p. 186.

of the artist as imitative was superseded by an understanding of the artist as originary. Hence, 'there seems to have been a separation between an artisan, with its connotations of craftsmanship, and the "artist" ... understood as a self-expressive creator of original works'.[134] Genius does without handicraft or at least is irreducible to it. In other words, the concept of genius marks a separation between two modalities of labour. Insofar as 'genius is from heaven, learning from man',[135] or, as Kant put it, 'the artist's skill cannot be communicated but must be conferred directly on each person by the hand of nature',[136] genius is a form of labour that is distinctly not laboured. Technique is emphatically diminished, if not entirely extinguished, by the short-circuiting of imagination and the works that flow from it. Genius is the absent origin of works that seem to generate themselves or to be generated by unknown forces. The emphasis on poetry rather than, say, painting does not entirely explain the absence of labour in the romantic conception of the genius. For one thing, it is not empirically verifiable, hence such real differences cannot render its properties intelligible.

The genius is the figure of a kind of labour that is not labour at all. Not only does the genius signify a form of labour that is intellectual, it is also seen as pleasurable. As such, I want to argue, the genius and the artist are formulated through a type of labour modelled on consumption rather than production. Genius is always a discourse on labour as containing a moment of absolute freedom, but in different stages of the concept's development this free activity or activity of freedom cannot be thought except as the opposite of physical work or skilled labour, or in contrast with toil or the body.

Genius, in my reading, marks art's location on the outskirts of the capitalist mode of production and the social division of labour. The artist appeared to be a hybrid and an anomaly: an owner-producer in an era of the historical divide between non-owner workers and non-worker owners, a skilled handicraft worker in the age of mechanisation and deskilling, a lone studio occupant in the days of factory production, and a producer of unique goods at the birth of standardised mass production. However, if we understand the development of the artist as a type within the emergent schema of labour after the guild system was replaced by the wage system, then the lone producer in the studio, while atypical of the socialisation of labour generally, is consonant with the individualisation of the free labourer after the abolition of the guilds and the smashing of the corporatist vision of workers' self-organisation. Rather than becoming a

134 Bruno 2010.
135 Young 1971 [1759], p. 29.
136 Kant 1987 [1790], p. 177.

fully-fledged capitalist entrepreneur or submitting to the new regime of work as a wage labourer, the artist was first formed as an unprecedented category of producer, in the style of a bohemian – a free spirit, a genius, an expressive personality, an unbiddable and incalculable pleasure seeker.

Even if the myth of the Romantic artist cannot be resuscitated, it is necessary and valid to recognise that in the passage from the artisan to the romantic genius (or the autonomous modernist hero or the postmodern critical intellectual), the producer of art undergoes a radical transformation that does not follow the same pattern as the transformation of artisan to the wage labourer. The rise of the artist is rooted in – and explained by – the historical metamorphosis of work during the long bourgeois revolution but only if the exceptions and anomalies are included within the process. Artistic labour is one of the largely unheralded forms of labour, like the unpaid portion of wage labour and unwaged domestic labour, that were introduced by the capitalist mode of production but did not conform to the core economic purpose of the self-accumulation of value.

In its modern form, the genius is a lightning rod for a specific historical moment in which the subject emerged as a main political, philosophical, and cultural vector of freedom, agency, reason and feeling. While art is an abstraction of the arts, it is not a form of abstract labour, and while the artist is an abstraction of the artisan, it is not an expression of the capitalist conversion of the artisan into a worker according to the abstract concept of labour. Prior to the eighteenth century there was no artistic labour in the modern sense, only certain specific craft skills such as painting, drawing, carving and printmaking. During the period of transition from one regime of work to another, the artisans who previously practised painting, sculpture, music and literature did not become workers or wage labourers but began instead to call themselves artists. As such, the artist resuscitated the independence of the Master craftsman in a social system that had dispensed with that category of labour along with its institutional lifeworld.

To revisit the concept of genius as it develops in the eighteenth century is to reconstruct the place assigned to art and human activity within modernity as an expression of the freedom anticipated by the bourgeois revolution. Artistic labour assumed a new universal status as soon as the highest principles of self-expressive freedom and self-determination were given their emblematic form in the notion of the artistic genius. The demarcation which the concept of genius delineates, albeit in hyperbolic terms, continues to operate in a somewhat muted, universalised discourse of creativity, individuality, originality and talent. With the genius, and still in some current conceptions of the artist as well as comparable individual agents, the personality of the producer is extern-

alised, realised and augmented by the work she or he produces. As such, despite the numerous difficulties associated with the concept of genius it must be read, in the eighteenth century and perhaps also today, as the archetype not only of artistic labour but also of the emancipation of the individual's labour and the labour of the self.

Aesthetic Labour

In the first half of this book I have focused on the historical separation of the social form of artistic labour from handicraft and the normative and institutional basis of the differentiation of the artist from the artisan and the worker. Having done this, I am now ready to revisit the philosophical and utopian project to reverse the tendency of the industrial mode of production to reduce labour to drudgery, toil and monotony. First, I will reconstruct the philosophical ideal of what I will call *aesthetic labour* in German Idealism, and then, in the next chapter, I will turn my attention to the utopian vision of labour merged with pleasure in Utopian Socialism.

Aesthetic labour could be taken to mean the incorporation of the aesthetic into the desiccated system of the workplace.[1] Aesthetic labour has recently come to refer in the sociology of work to the post-Fordist extension of the regime of work to include the personal characteristics of workers (the appearance, voice and style of the service and hospitality worker, for instance). This category fuses the two traditions of aesthetic thought and the politics of work in a dystopian image of the commodification of the aesthetic. On this reading, aesthetic labour represents, on the one hand, the ultimate degeneration, recuperation and reification of the aesthetic and, on the other, the complete reduction of labour to work understood as an activity undertaken for the principal purpose of obtaining a wage. There is, however, another reading of the term 'aesthetic labour' which stresses the irreducibility of labour to work insofar as labour is or could be an aesthetic experience in itself. This, too, has been subjected to intense critique of late. My aim is neither to rehabilitate aesthetic labour as the epitome of the broader politics of the emancipation through labour nor to endorse the one-sided campaign for the emancipation from work.

In this chapter I will reconsider the politics of aesthetics and work through a re-reading of the philosophical tradition concerned with the ideal of aesthetic labour. Aesthetic labour is an ideal in the double sense that it is (1) a theoretical rather than an empirical development, and (2) conceived as a barely attainable model of human activity. Aesthetic labour is also ideal, we might say, because it was produced by *Idealists* in the German philosophical tradition as the aesthetic theory of the production of art and the proposal of the aesthetic transformation of labour. Strictly speaking, however, there is no philo-

1 See Nickson et al. 2003, Dean 2005.

sophy of aesthetic labour in the writings of that tradition of thought from Kant to Feuerbach. It is only in retrospect that we can speak of German Idealism as theorising labour aesthetically because, in the absence of the self-organisation of labour in the labour movement, the conditions were not ripe for a theory of labour at all. As such, aesthetic labour was conceived originally as a theory of activity distinct from labour. What justifies the term 'aesthetic labour' is that later conceptions of labour modelled on art were indebted to this aesthetic conception of activity.

Most philosophical expositions of the German Idealists do not mention a distinctive new turn in the philosophy of labour but the activity of the subject understood as 'the mind' or thought or consciousness in the world and in relation to nature. Even commentaries on Schiller's theory of play often stress the ethical dimension of beauty rather than the distinction between different kinds of activity. It is primarily within Marxian scholarship that German Idealism has been re-read as providing materials for an ontology of labour.[2]

It is true, within the discourse of aesthetics in German philosophy after the 1790s – amongst questions of taste and the aesthetic experience of the consumer – there are fragments of thought on artistic production that go beyond the proposal of genius to describe the unity between production and the producer. I will assemble the splinters of an argument in German philosophy for a politics of work in art (as the activity of freedom, a form of self-realisation, spiritual production, etc.) not in order to conclude that the history of human emancipation leads to the convergence of art and labour, but in order to acknowledge a major milestone in the history of thinking about art and labour.

Empirically, work was being subsumed under capital, divided into mindless repetitive tasks and subjected to the tyranny of the machine, but theoretically, work – conceived within the more expansive notion of human productive activity – took on the qualities previously reserved for the contemplative occupations of the elite. Hence, as the category of abstract labour emerges, there is nothing resembling an aestheticisation of labour, no social transformation of working conditions to introduce aesthetic principles into the experience of work, but philosophers and poets begin to adumbrate the criteria of aesthetic labour as an ideal.

Beginning as the study of knowledge derived from the senses and the interest in bodily and sensuous experience, later turning into the inquiry into the judgement form and the analysis of taste, German philosophers at the end

2 See Gould 1978, Kain 1982, Gullì 2005, Sayers 2011.

of the eighteenth century began to apply aesthetic concepts of taste, judgement and experience that were initially formulated to account for the consumption of art and nature to the activity of producing art and composing poetry. Drawing on theories of the Fine Arts and genius as well as the philosophy of aesthetics established by Baumgarten and the transmutation of art history by Winckelmann, Kant initiated the German philosophical reflection on labour by rethinking the artist as a special kind of producer exemplary of freedom rather than coercion and remuneration.

Aesthetic labour is not a concept constructed out of earlier theories of labour but modelled on recently formulated modes of contemplation, judgement, experience and consumption. Notions such as the 'je ne sais quoi', genius and taste are harvested for a new concept of artistic labour as the epitome of the activities of taking pleasure from the consumption of works of art and other luxuries. Exercising one's power of judgement through delicate discriminations between the almost imperceptible qualities of things is an exemplification of the subject rooted in perception, appreciation, affect and the purchase of luxuries.

Cultural tropes such as the *je ne sais quoi* and the genius form part of a chain of concepts that first emancipate the 'man of taste' from rules and tradition, and then later are converted into a theory of the embodiment of freedom in human activity exemplified by the artist. Labour, or some special modality of it, came to be theorised in sharp contrast with toil by philosophers in the second half of the eighteenth and the first half of the nineteenth century, as one of a series of powerful oppositions, within which the genius signified both the potential value of labour and the evident disgust with actually existing dominant forms of labour. Labour was reconceived by linking it to the hostility to handicraft in the Fine Arts and the recent development of aesthetics, art history and art criticism.

Aesthetics is born as a philosophical discipline in the vacuum created by the fading rhetorical charge of those tropes of mystery and taste exemplified by but not limited to the *je ne sais quoi*. As we have seen, though, the *je ne sais quoi* did not characterise a process of aesthetic production but the aestheticisation of evaluation and yet it is transposed and translated as a key component of a new theory of labour at the end of the eighteenth century. Referring to the *je ne sais quoi*, Luc Ferry says that 'the term acquires pertinence in the designation of a new faculty, capable of distinguishing the beautiful from the ugly and of apprehending through immediate sentiment',[3] which acknowledges the prom-

3 Ferry 1993, p. 14.

inence of processes of consumption in the contestation of culture during the early modern period. This tendency is upheld by subsequent theories of aesthetics and taste in the eighteenth century.

It is this theoretical reformulation of human activity modelled on the artist as distinguished from the artisan, as a genius not a 'mechanic' and a free individual not a wage labourer, that constitutes aesthetic labour. It is an aesthetics of human activity that remains theoretical – an *ideal* rather than a social condition – and which is therefore never fully realised as a theory of labour. As such, art and artistic labour became central to the modern philosophy of society, freedom and human fulfilment. Not only were these philosophers persuaded that there could be no good life without art, they developed a theory of artistic labour that was integral to the formulation of ethics and their perception of an ideal society.

While aesthetic theory itself emphasised the consumption of art in acts of judgement, perception, reflection and critique or states of pleasure and displeasure or the exercise of taste, moral philosophy and social theory were constructed around a new concept of artistic labour. Freedom, both the freedom of economic liberty, which loads the dice in favour of the wealthy, and the universal freedom of political liberty (e.g. freedom of speech, freedom of movement, sexual freedom, and so on), insofar as these two freedoms can be disentangled, transforms the concept of labour (first, by contrasting 'free labour' from slavery, and then by either defining labour as the absolute opposite of freedom or imagining a form of labour that corresponds to the radical concept of freedom). Freedom is politically limited, but it is nonetheless politically provocative during the eighteenth and nineteenth century's development of a politics of labour and its utopian or revolutionary transformation.

Although the epistemological question of the relationship between nature and self-consciousness is paramount in Kant's aesthetic philosophy as the critique of the power of judgement, and this puts a strong emphasis on the experience of consuming art rather than producing it, Kant builds his analysis of art and aesthetics on a conception of art as labour. Kant does not develop a theory of aesthetic labour but distinguishes the artist from the artisan in terms of the former's freedom. Hence, Kant articulated key elements of the Romantic conception of aesthetic labour by formulating the contrast between art and handicraft in terms of two types of labour. 'Art is ... distinguished from handicraft', he said, insofar as 'the first is called liberal, and the second can also be called remunerative art'.[4] Since it is not the aesthete who is remunerated, it

4 Kant 1987 [1790], p. 171.

is clearly the producers of art and handicraft that Kant has in mind here. He allows his distinction to carry a trace of the old aristocratic ordering of the liberal and mechanical arts but he does not replicate the terms of that hierarchical system.

Kant implies that the artist is an amateur of some kind, but it is perhaps more accurate to distinguish the artist from the artisan through the former's semi-detachment from the consumer. That is to say, the artisan tends to work to commission whereas the artist, by the end of the eighteenth century, had begun to work 'speculatively', that is to say, producing works independently of any commission and in advance of any sales. Even if an artist gains more income from sales than an artisan does from commission, therefore, it appears that the artist works independently of remunerative rewards, as if their income always has a haphazard relationship to their production. And it is on this basis that Kant begins to lay out the scaffolding of a theory of aesthetic labour.

'By right, only production through freedom, i.e., through a capacity for choice that grounds its actions in reason, should be called art',[5] Kant writes in the section on 'Art in general' in the third critique. Since handicraft is 'an occupation that is disagreeable (burdensome) in itself and is attractive only because of its effect (e.g., the remuneration)',[6] it is not free and it is not freely produced. Art, by contrast, for Kant, 'is agreeable in itself',[7] which is to say, is not produced under duress or for any extraneous purpose. Art contrasts with wage labour not only insofar as it is empirically independent of pay but that it is not produced by a worker whose prime motive is to receive a wage. Art is free from the disciplines of the workplace because the artist is not an employee under the command of an employer.

More than this, the production of art is 'agreeable on its own account'.[8] Kant's point here is not the weak argument that making art is enjoyable – a form of pleasurable activity akin to a hobby – but that art is an occupation that the artist chooses for itself not as a disagreeable means to obtain some other agreeable reward. This is why Kant characterises art in terms of freedom. Kant said:

> fine art[9] must be free in a double sense: it must be free in the sense of not being a mercenary occupation and hence a kind of labor, whose mag-

5 Kant 2000 [1790], p. 182.
6 Kant 2000 [1790], p. 183.
7 Ibid.
8 Kant 1987 [1790], p. 171.
9 Guyer translates this phrase as 'beautiful art must be free art in a double sense' (Kant 2000 [1790], p. 198).

nitude can be judged, exacted, or paid for according to a determinate standard; but fine art must also be free in the sense that ... it feels satisfied and aroused ... without looking to some other purpose.[10]

Guyer translates the last part of the passage with more emphasis on the precon-ditions for artistic activity as a form of freedom: artistic production 'must feel itself to be satisfied and stimulated (independently of remuneration) without looking beyond to another end'.[11]

Art, for Kant, insofar as it is understood as produced through human activity, is the labour of freedom and the exemplar of the freedom embodied in labour. Freedom in artistic production for Kant is not theorised aesthetically as a cer-tain pleasurable mode of activity but as an activity chosen freely not as a means to another end but as an end in itself. The contrast he draws with labour as pain and trouble is vivid. Wage labour is the epitome of the mercenary but Kant does not merely contrast the two types of activity in terms of their pleasure and pain; he indexes this to their purpose and therefore treats the aesthetics of activity as secondary to the question of whether the individual chooses an occupation for itself or for some extraneous purpose. Wage labour is not agreeable on its own account even when the worker enjoys her job because it is taken up for the purpose of earning a living. Insofar as Kant regards art as non-remunerative, therefore, he defines it as free.

Agreeableness – which does not refer to pleasure in Kant but to something closer to choice – is coupled with freedom in a conception of activity – a spe-cific form of labour – that is the antithesis of work in the capitalist division of labour but not synonymous with its alleged opposites, leisure, non-work, inactivity, idleness. Although artistic labour for Kant is non-mercenary, agree-able and free, it is not reduced to the spontaneous activity of the individual pleasure-seeker, to a naive interpretation of play or leisure. 'Only that which one does not immediately have the skill to do even if one knows it completely belongs to that extent to art'.[12] Art is conceived by Kant, therefore, not as a form of rest or pleasure but as an activity that requires practice. This descrip-tion aligns art to the highly skilled sector of handicraft which requires an apprenticeship because its mysteries can be disclosed only through an exten-ded period of activity.

However, Kant also allows his formulation of the distinctive activity of art to resemble the older definition of the liberal arts as those skills that cannot

10 Kant 1987 [1790], p. 190.
11 Kant 2000 [1790], p. 199.
12 Kant 2000 [1790], p. 183.

be learned by rote. Art, for Kant, we might say, is taxing on the individual insofar as it requires skills and judgements that need to be tested or stretched rather than merely relied upon and executed routinely or mechanically. Kant therefore divided artistic production off from labour proper, from work, by ascribing characteristics to it that belong to a specific idiolect of activity: it is non-remunerative and therefore agreeable, practical and yet non-mechanical. What this group of characteristics share is that they suggest the inverse of various kinds of 'determinations', that is to say, external forces. In fact, Kant's brief account of artistic labour is a coherent depiction of freedom as a mode of activity. Rather than art being free from labour and all its costs, as leisure might be understood, the production of art, for Kant, is freedom embodied as a precisely articulated mode of activity.

Schiller expands on Kant's suggestive theory of aesthetic labour. Despite his enormous debt to Kant, it is Schiller's lacing together of art and play as exemplary of freedom that has been consistently taken to be the origin of the philosophical reformulation of art and labour. For him, poetry and the aesthetic occupy a utopian third place between 'on the one hand intensive and exhausting labor, on the other enervating indulgence',[13] that is to say, between toil and idleness, or again between 'painful labor' and the 'repugnant spectacle of indolence'.[14] Hegel said,

> Schiller must be credited with the great merit of having broken through the Kantian subjectivity and abstractness of thought, and having dared to transcend these limits by intellectually grasping the principles of unity and reconciliation as the truth, and realizing them in art.[15]

Schiller studiously built his aesthetic theory from extrapolations of Kant's thinking on artistic activity. Kant's remark about art being a form of play is magnified by Schiller and elaborated through an extended and clear articulation of art's relationship to labour and leisure.

Schiller's methodology turns on a dialectical reconciliation of 'two contrary forces'.[16] He typically understands each single force or element to be one-sided, determining and constraining, and time and again he opposes a negative force with another negative force in order to bring about a synthesis in which the faults of each are neutralised in a third state of combination. Play is the third

13 Schiller 1966 [1795], p. 170.
14 Schiller 1954, p. 35.
15 Hegel 1993 [1820–29], p. 67.
16 Schiller 1954, p. 64.

term that reconciles toil and idleness. Play is the activity of freedom. If Kant's conceptual formulation of artistic activity can be recast in the vocabulary of the politics of labour as neither leisure nor work, Schiller's concept of play is an attempt to think through the possibility of extending the specific modality of artistic activity beyond art. As Lukács points out, Schiller is the first to weaponise aesthetics in the critique of existing society by 'extending the aesthetic principle far beyond the confines of aesthetics, by seeing it as the key to the solution of the question of the meaning of man's existence in society'.[17] If Schiller confronts the social systems and structures of his day, he does so, I think we have to admit, principally by attacking both work and the privileged exemption from work in propertied idleness.

Schiller's letters contain an attempt to legitimise the aesthetic morally and socially, but it could do this only by locating art critically within and against the modern social division of labour which he saw as dividing manual and intellectual labour, fragmenting the labour process into skilled and unskilled activities, and splitting the social body according to the apartheid of enjoyment and toil. However, this critique is mortgaged to the normative framework of the academy system of the Fine Arts. Schiller's assertion that '[m]an is only completely human when he plays' is an emphatic expression of the humanising power of aesthetic labour conditional on the discrete separation of this kind of activity from work understood as toil, hardship, drudgery, slavery and wage labour. Play, conceived by Schiller as neither work nor idleness, retains the hostility to handicraft characteristic of the academy system of the Fine Arts. It could also be said that Schiller converts the elevation of the Fine Arts – their proximity to nobility – into a quality of civilisation which appears to adhere to everything properly aesthetic. Play, for Schiller, conceived as being 'active without working', is the unity of the modern bifurcation of work and pleasure. If it is the aesthetic that serves as Schiller's model for a fully realised human life, it is the aesthetic as it shaped by the academy system.

'The whole burden of the argument in [Schiller's] *Letters* is, in a single sentence, that Man must pass through the aesthetic condition, from the merely physical, in order to reach the rational and moral',[18] according to Friedrich Snell. Kain argues that 'Kant described a historical development from the natural state to the rational state [whereas] Schiller now wants society to move beyond the rational to the aesthetic state'.[19] Schiller distinguished art and play from leisure as carefully as he distinguished them from work. The purpose of

17 Lukács 1971 [1923], p. 139.
18 Snell 1954, p. 12.
19 Kain 1982, p. 27.

the distinction is universal, abstract freedom (as distinct from the manifold specific freedoms of the *ancien regime*). In Schiller's own words: 'Art is a daughter of Freedom'[20] and we must 'follow the path of aesthetics, since it is through Beauty that we arrive at Freedom'.[21]

Kain argues that Schiller diverges from Kant insofar as 'For Kant art and play are directly opposed to work'[22] whereas 'Schiller's goal is to transform labor and to make it more like play'.[23] Kain, who reads Schiller as a spontaneous Marxist *avant la lettre*, implies that Schiller's elaboration of the aesthetic entails a theory of labour. It is true that Schiller opposes activity to contemplation, leisure and toil, but for Schiller activity is not understood simply as a form of labour. His model is the life activity of the slave-owning aristocracy of Classical Greece. It is possible to read certain passages in the Letters as suggesting a radical reorganisation of labour in order to bring about the universal reign of aesthetic activity but Schiller was ultimately incapable of formulating a concept of aesthetic labour because, for him, this conjunction would be a contradiction in terms. It was not labour, but a specific kind of activity independent of labour, that held the promise of freedom for Schiller.

Hegel goes further than Schiller in drawing out an ideal of aesthetic labour from the practice of producing art as much as contemplating it, specifically in the case of poetry and painting. The necessity of thinking of the work of art as 'a product of human activity'[24] is indicated, for Hegel, by acknowledging that the work of art 'regarded as an external object, is dead'[25] and 'has not in itself movement and life'[26] insofar as it is nothing but stone, wood, canvas, paper and print. This 'external existence', Hegel argues, 'is not what makes a work into a production of fine art'.[27] Works of art, on the contrary, are 'moulded in harmony with mind'.[28] Works of art are 'the *conscious* production of an external object'.[29]

Hegel's philosophy of aesthetic labour depends on a differentiation derived from the academic hostility to handicraft. Although Hegel recognises that 'the work of art has a purely technical side, which extends into the region of han-

20 Schiller 1954, p. 26.
21 Schiller 1954, p. 27.
22 Kain 1982, p. 19n.
23 Kain 1982, p. 19.
24 Hegel 1993 [1820–29], p. 30.
25 Hegel 1993 [1820–29], p. 33.
26 Ibid.
27 Ibid.
28 Ibid.
29 Hegel 1993 [1820–29], p. 30.

dicraft',[30] he contrasts that which can be executed mechanically according to rules with 'the meaning-laden spiritual activity of true art'.[31] Following the academy system, Hegel stresses the importance of scholarship within the distinction between 'true art' and handicraft, saying 'the higher an artist ranks, the more profoundly ought he to represent the depths of heart and mind, and these are not known without learning them'.[32] Hence, 'study is the means whereby the artist brings this content into his consciousness'.[33]

Hegel confronts the idea that natural objects are superior to works of art by arguing against the assumption that the former are works of God whereas the latter are not. 'In this antithesis between natural production as a divine creation and human activity as a merely finite creation, we at once come upon the misconception that God does not work in man and through man'.[34] It is only by recognising the work of God through human activity that it is possible 'to penetrate the true conception of art'.[35] Indeed, Hegel claims that art, as the product of human activity, is superior to nature because the divine element in art is 'the form of conscious spirit'.[36] Hegel generalises the case of the work of art by arguing that 'man is realized for himself by practical activity',[37] not only in theoretical activity. Through practice, he argues, man 'produces himself' by the 'modification of external things upon which he impresses the seal of his inner being, and then finds repeated in them his own characteristics'.[38]

In retrospect, armed with Marx's concept of labour, it is possible to discern references to work in Hegel's examination of the production of works of art and the rational activity or conscious activity of knowing subjects. The 'outstanding achievement' of Hegel, Marx wrote in 1844, was that 'he grasps the essence of labour and comprehends objective man – true, because real man – as the outcome of man's own labour'. Having said this, Marx also pointed out at the same time that the 'only labour which Hegel knows and recognises is abstractly mental labour'. Hence, Marx's acknowledgement of Hegel's commentary on

30 Hegel 1993 [1820–29], p. 32. Hegel sketches a gradient of the relationship between art and handicraft with architecture and sculpture closest to handicraft while painting, music and poetry are more remote from it.
31 Hegel 1993 [1820–29], p. 30.
32 Hegel 1993 [1820–29], p. 32.
33 Ibid.
34 Hegel 1993 [1820–29], p. 33.
35 Ibid.
36 Ibid.
37 Hegel 1993 [1820–29], p. 36.
38 Ibid.

labour should not be taken as proof that Marx derived his concept of alienated labour from Hegel. Chris Arthur, for instance, points out that Hegel's references to labour

> are superficially comparable to Marx's in that both Hegel and Marx see work not merely in its utilitarian aspect but as a vehicle of self-realisation ... [but] whereas Marx holds that only a change in the mode of production recovers for the worker his sense of self and its fulfilment, Hegel thinks that the educative effect of work, even within an exploitative relation of production, is sufficient for the worker to manifest to himself his own 'meaning' in his product.[39]

Hegel is concerned with the activity by which the human being is able, as 'a free subject, to strip the outer world of its stubborn foreignness and to enjoy in the shape and fashion of things a mere external reality of himself'.[40]

Ludwig Feuerbach provided a materialist twist to the Hegelian dialectic of the inner and outer world. The externalisation of the inner world through human activity is characterised by Feuerbach not only in terms of knowledge and spirit but alienation, which is a mixture of objectification and veiled self-knowledge. 'We know the man by the object, by his conception of what is external to himself; in it his nature becomes evident',[41] by which he means that human activity not only realises self-knowledge but also concretises alienation. 'Religion is the disuniting of man from himself: he sets God before him as the antithesis of himself'.[42] Instead of seeing human activity as the work of God through man, Feuerbach interpreted God as the production of humanity divided from itself: 'in God man has only his own activity as his object'. Therefore, '[w]here man inhabits houses', Feuerbach remarked, 'he also encloses gods in temples'.[43]

Against Hegel's optimistic dialectic of progressive self-consciousness, Feuerbach is struck by a pessimistic dialectic of concretised alienation which anticipates Adorno and Horkheimer's dialectic of Enlightenment and is central to Debord's theory of the society of the Spectacle. For instance, Feuerbach argues that humanity 'projects his being into objectivity, and then again makes himself an object to this projected image of himself thus converted into a subject; he thinks of himself as an object to himself, but as the object of an object,

39 Arthur 1983, p. 70.
40 Hegel 1993 [1820–29], p. 36.
41 Feuerbach 2008, p. 4.
42 Feuerbach 2008, p. 29.
43 Feuerbach 2008, p. 17.

of another being than himself'.[44] Hence, Feuerbach argues, '[t]he more sub-
jective God is, the more completely does man divest himself of his subjectivity,
because God is, *per se*, his relinquished self'.[45]

'In activity', Feuerbach says, 'man feels himself free, unlimited, happy';[46]
however, this is only true for 'what we do willingly',[47] since all constraint and
limitation makes activity passive. Hence, Feuerbach inverts the privileging of
aesthetic contemplation over aesthetic production which is foundational to
philosophical aesthetics and the discourses of the Fine Arts. 'To read is delight-
ful, reading is passive activity; but to produce what is worthy to be read is more
delightful still'.[48] István Mészáros describes what was at stake in this process
from Marx's point of view:

> Feuerbach wanted to tackle the problems of alienation in terms of real life
> (this programmatic affinity explains Marx's attachment to Feuerbach in
> a certain period of his development), in opposition to the Hegelian solu-
> tion, but because of the abstractness of his viewpoint: idealized 'man'
> ('human essence' taken generically, and not as 'the ensemble of social
> relations'), his position remained basically dualistic, offering no real solu-
> tion to the analysed problems.[49]

Feuerbach thus inherits Hegel's conception of activity as abstract mental activ-
ity which Marx rejects. For Marx, on the contrary, with his concept of activity
as practice or productive activity or labour, 'a non-externalized, non-objectified
activity is a non-activity'.[50]

According to Chris Arthur: 'The idea of production as a "species activity" is
developed by Feuerbach and by Hess. However, in the works of the "Young
Hegelians" such views have no fundamental significance. They lie alongside
remarks about other human functions. Only with Marx does the social and
historical theory of man as his own product emerge'.[51] Kain, similarly, recon-
structs the 'aesthetic ideal' present in Schiller and Hegel as a prelude to Marx's
theory of labour. He reads the Idealist episode in German philosophy as anim-

44 Feuerbach 2008, p. 25.
45 Feuerbach 2008, p. 26.
46 Feuerbach 2008, p. 179.
47 Ibid.
48 Ibid.
49 Mészáros 1986 [1970], p. 85.
50 Mészáros 1986 [1970], p. 91.
51 Arthur 1986, p. 106.

ated by 'a particular humanistic ideal for social and political institutions'[52] using 'modern aesthetic concepts'[53] in opposition to the modern division of labour.

Kain redescribes the aim of communism as the realisation of German Romanticism[54] and argues that the young Marx modifies Schiller, Hegel, and Feuerbach to formulate a radical utopian hope that labour in post-capitalism could 'become the highest form of human activity'.[55] Kain builds an interpretation of Marx's ontology of labour out of a reading of Schiller and Hegel. Schiller's assertion that 'Man is only completely human when he plays' was an attempt to legitimise the aesthetic morally and socially as opposed to labour understood as nothing but toil. Hence, the aesthetic could perform this task only by locating art and the aesthetic within and against the modern social division of labour. The aesthetic is not an ideal variant of labour, for Schiller, since it is differentiated from work on two counts, first that it is a form of play, and secondly that the aesthetic of the Aesthetic Education is principally a form of consumption.

Kain builds a Schillerian reading of Marx's theory of labour which results in a vision of the ideal of aesthetic labour. Rather than trace how Marx converted the ideal of aesthetic activity into a class struggle against the capitalist mode of production, Kain reads Marx's philosophy of labour as a vindication of the aesthetic ideal in 'unalienated labor'.[56] This argument assumes an aesthetic model of unalienated labour that Kain formulates as follows: 'With man in control of his object and of his own activity, he can be related to these as ends in themselves. He can begin to appreciate the beauty of the object. This is an aesthetic model, aesthetic freedom of the Schillerian sort'.[57] It is remarkable that Kain identifies the moment when the product of labour is seen as beautiful that a state of non-alienated labour is achieved since non-alienated labour is therefore understood as an experience of the consumer. This is certainly more Schillerian than Marxian.

Kain admits that 'Marx does not naively think that the aesthetic condition is enough to overcome estranged labor. Practical activity is required; the world must actually be changed'.[58] And in wrestling with this question, Kain

52 Kain 1982, p. 6.
53 Kain 1982, p. 7.
54 The aesthetic ideal, he argues, 'was designed to overcome alienation and estrangement in the modern world, brought about by the division of labour' (Kain 1982, p. 7).
55 Kain 1982, p. 117.
56 Kain 1982, p. 100.
57 Kain 1982, p. 100.
58 Kain 1982, p. 91.

comes to argue that the aesthetic model of non-alienated labour corresponds only to the young Marx's theory of labour but that Marx later rejected the possibility of a convergence of work and self-realising human transformative activity as he came to understand that it was impossible to reconcile it with the most advanced industrial forces of production. According to Kain, young Marx, modifying German Idealism, hoped that labour in post-capitalism could 'become the highest form of human activity'.[59] Kain argues that Marx later rejected the possibility of a convergence of work and human activity that is an end in itself. Marx eventually proposes a combinatory model of work and aesthetic labour and a social organisation of work and free time to reduce the harm of the former and enhance the benefits of the latter. 'Marx has not given up on the aesthetic model of freedom, but he has transferred its realization to the realm of free time'.[60]

Bruno Gullì is stringently optimistic about labour as 'an ontology of liberation'.[61] Labour, for him, is exemplified by artistic production and correspondingly labour becomes the foundation of 'a new and total social being'.[62] His philosophical re-examination of labour against economic theory is justified. This is because, for him, labour is best understood at the highest level of abstraction as an ontological category. Gullì dissolves the blockages of an immanent political and economic theory of labour with the abstractions of a philosophy calibrated to construct a 'notion of labor as a univocal and common concept ... necessary to a new political ontology'.[63] As such, Gullì's concept of labour, meaning human self-realising transformative activity, is as generic as anything that appeared within the German Idealist tradition from Kant to Feuerbach.

Labour, for Gullì, corresponds to 'sensuous, practical activity'.[64] It is, therefore, an example of aesthetic labour in its late eighteenth- and early nineteenth-century form despite being articulated through the writing of Agamben, Negri, and Virno. Gullì consistently contrasts labour in its ontological sense with labour as it appears subsumed under capital as work and productive capacity, or labour power. His vision of revolution, therefore, is a campaign for the liberation of labour from its capitalist fetters and therefore to liberate the human force of liberation itself. Labour, he says, is that which 'tears itself away

59 Kain 1982, p. 117.
60 Kain 1982, p. 124.
61 Gullì 2005, p. 27.
62 Gullì 2005, p. 32.
63 Gullì 2005, p. 191n.
64 Gullì 2005, p. 41.

from the opacity of nature thereby starting the development of history, the constitution of cultures: an act of freedom'.[65]

Like Kant, Hegel, and Schiller, Gullì does not affirm labour in all its forms, but only labour of a specific type. If the ideal labour conceived of by German Idealism corresponded largely with the discourses of the Fine Arts and the hostility to handicraft, his corresponds to the category of art in general. No longer distinguished from mere copying or working by rote, Gullì's aesthetic labour is distinguished, instead, from 'labor as a curse' and 'labor as wage labor'.[66] It is not clear whether handicraft has been absorbed into work or is to be accorded the status of aesthetic labour, but the opposition of the Fine Arts and handicraft has been replaced with the opposition of art and work. So rather than regard aesthetic labour as an elite exception or privileged realm of human activity, Gullì argues that 'the esthetic dimension of labor is labor's fundamental and univocal disposition'.[67]

In another contemporary re-reading of German Idealist aesthetic philosophy Rancière calls Schiller's Letters 'the "original scene" of aesthetics'.[68] In so doing, Rancière tilts Schiller's politics of play (as neither work nor idleness) into a more conventional focus on the aesthetic experience of the consumer of works of art. Rancière says Schiller's aesthetic letters 'constitute a sort of new region of being – the region of free play and appearance – that makes it possible to conceive of the equality whose direct materialization ... was shown to be impossible by the French Revolution'.[69] Schiller's statement that mankind is only completely human when at play is extracted by Rancière from debates on labour. 'We could reformulate this thought as follows: there exists a specific sensory experience – the aesthetic – that holds the promise of both a new world of Art and a new life for individuals and the community'.[70] This particular promise constitutes what Rancière calls the 'aesthetic regime of art'.[71] The trick to reconciling the promise of art as an aesthetic experience and the promise of a new life to come, in Rancière's argument, is to recognise that the autonomy under consideration is not the autonomy of art as a minority culture, but 'the autonomy of the experience'.[72]

65 Gullì 2005, p. 49.
66 Gullì 2005, p. 147.
67 Gullì 2005, p. 148.
68 Rancière 2002, p. 135.
69 Rancière 2004, p. 27.
70 Rancière 2002, p. 133.
71 Rancière 2002, p. 134.
72 Ibid.

It is this reorientation of Schiller's emphasis on aesthetic labour (in the production of works of art) to the sensory experience of engaging with completed works of art that leads Rancière into a theoretical impasse. 'How can the notion of "aesthetics" as a specific experience lead at once to the idea of a pure world of art and of the self-suppression of art in life, to the tradition of avant-garde radicalism and to aestheticization of common existence?',[73] he asks. Rancière turns to both the 'permeability of art and life'[74] in Romanticism and to the rejection of the aestheticisation of everything by anti-art, and advocates an undecidable shuttling between aesthetic art and the abolition of art. So, whereas for Schiller play was posited as the synthesis of the dichotomy of work and idleness, for Rancière the opposition is recast between aesthetics and anti-art which is resolved through a gesture of suspension.

Perhaps the reason for Rancière's blindness to the affirmation of aesthetic labour within Schiller's theory of play is that he had already rejected the defence of handicraft in the workers' movement as corresponding to the myth of the happy worker. Rancière argues in 'The Myth of the Artisan' that 'the men who sing the glory of "work" the most loudly are those who have most intensely experienced its degradation'.[75] Saint-Simonian workers and the worker-poets who published in *L'Atelier* proclaiming their 'love of work', he argues, should not be taken at their word. Inversely, he points out, 'it is precisely those who are satisfied with their work who have no need to sing hymns to it'.[76] Rancière also rejects the temptation 'to turn the standard interpretation upside down',[77] like a camera obscura, projecting the image of the love of work on its head as the hatred of work. In some sense, then, the interpretation of the theory of aesthetic labour in German Idealism depends on the fate of the workers' movement in the nineteenth and twentieth century.

Since the affirmation of work by the workers' movement would not be clearly formulated until the middle of the nineteenth century, the concept of aesthetic labour in German Idealism remained merely theoretical, vague and was hesitantly formulated. It is only with hindsight that we can characterise human activity as it is theorised from Kant to Feuerbach as experimenting with the idea of aesthetic labour. It is legitimate to speak of the concept of aesthetic labour emerging among this small group of German philosophers not because they used the term or formulated the concept with any clarity but because the

73 Ibid.
74 Rancière 2002, p. 145.
75 Rancière 1986, p. 324.
76 Ibid.
77 Ibid.

radical reconceptualisation of labour, which hits a peak in the early writings of Marx, is profoundly indebted to the reformulation of the concept of activity based on an aesthetic theory of art in the works of Kant, Schiller, Hegel and Feuerbach.

One of the developments which separate later theorists of the aesthetic dimension of labour from their German-speaking predecessors are the processes of industrialisation, Fordism and the post-Fordism which have transformed the landscape of work in the interim. Also, the theoretical scene of work has been redirected by Max Weber's sociological study of the so-called 'work ethic'. Labour was not seen as pleasurable or fulfilling in itself for the Protestant Reformation. The Calvinist notion of the calling, derived from the vocation of monks, nuns and priests, provided a new narrative for an individual's identification with labour which is a valuable component of the Romantic conception of the artist and attendant forms of artistic labour, but the norms of labour established by the Reformation are constructed around sacrifice and hardship, frugality and discipline, not pleasure, fulfilment, freedom and play. Hence, the genealogy of the Protestant ethic of work fails to account for the historical emergence of the eighteenth-century theory of aesthetic labour as that which Adorno contrasts with the Reformation concept of labour by saying 'the extent to which art makes a mockery of honest, socially useful labour, there is something to be said in its favour'.[78]

Insofar as the Protestant work ethic is consonant with 'the ideological foundation of discipline and obedience in the factories'[79] it is incongruous with labour coded aesthetically as rewarding in itself. Two distinct conceptions of work, one in which labour is normatively prescribed as part of the worthy life and one in which labour is satisfying, are often conflated in accounts of the Protestant work ethic. The difference is between 'hard work as a virtue'[80] and the inverse relationship between work and ethics, namely a specific kind of artistic labour that facilitates what Schiller called the 'aesthetic education of man'.[81]

Charles Wright Mills applied the kind of affirmation of aesthetic labour found in German Idealism to middle-class work patterns that were under threat in the middle of the twentieth century. Stuart Hall included Mills in a trio of American analysts who the New Left relied on to understand the 'new forms of property, corporate organisation and the dynamics of modern accumulation

78 Adorno 1984 [1970], p. 359.
79 Anthony 1977, p. 64.
80 Beder 2000, p. 10.
81 Schiller 1954.

and consumption'.[82] Mills's most important contribution, *White Collar*, was written as a testament to 'a new ethic that endows work with more than an economic incentive'[83] after the replacement of the old middle class and its work ethic with the new middle class and the 'morale of the cheerful robots'. The new spirit is one in which the appearance of satisfaction in work has become good business and a result of good management but this is counterposed by his conviction that 'the model of craftsmanship lies, however vaguely, back of most serious studies of worker dissatisfaction today'.[84] Craftsmanship,[85] for Mills, is a normative model of how work can be organised in opposition to alienation, one that is derived from the likes of John Ruskin and William Morris. It is an 'ideal', he says, that does not correspond to any historical activities of artisans but which signifies a kind of work in which there 'is no ulterior motive'.[86] 'Human society', he argues, 'ought to be built around craftsmanship as the central experience of the unalienated human being and the very root of free human development'.[87] What must be overcome, according to Mills, is bureaucratisation and centralised administration, which roots his account of the virtues of handicraft in Weberian sociology.

Mills can be read as translating the vindication of aesthetic labour into a defence of the relatively humane professions of white-collar workers insofar as he detects a certain amount of freedom from administration, mechanisation, instruction and routine. Poets, novelists and artists exemplify this autonomy but other creatives and others who have control over their own work also qualify. 'As ideal', Mills argues, 'craftsmanship stands for the creative nature of work, and for the central place of such work in human development as a whole'.[88] Expressing his doubt as to whether Ruskin and Morris were justified in regarding the work of the medieval artisan as exemplifying this set of attributes, he considers their account of handicraft to be 'an anachronism' that nonetheless

82 Hall 2010, p. 186.
83 Mills 1972 [1951], p. 234.
84 Mills 1972 [1951], p. 220.
85 Craftsmanship, he argues, 'is central to all intellectual and artistic gratification' (p. 296) and comprises six features: (1) 'pleasure in work itself' (p. 220); (2) the craftsman 'understands the meaning of his exertion in terms of [the] whole' (p. 221); (3) 'the workman is free to begin his work according to his own plan' (p. 222); (4) that work is for the worker 'a means of developing himself as a man' (p. 222); (5) 'there is no split of work and play' (p. 222); and (6) the worker 'does not flee from work into a separate sphere of leisure' (p. 223).
86 Mills 1972 [1951], p. 220.
87 Mills 1963, p. 386.
88 Mills 1963, p. 383.

can be used sociologically as a model or ideal 'in terms of which we can sum-
marize the working conditions and the personal meaning work has in modern
work-worlds, and especially to white-collar people'.[89]

Richard Sennett's *The Craftsman*, Andrew Ross's *No Collar: The Humane
Workplace and its Hidden Costs*, and Andy Merrifield's *The Amateur* extend the
reach of Mills's affirmation of handicraft. Sennett defines craftmanship as 'an
enduring, basic human impulse, the desire to do a job well for its own sake',
which follows William Morris and John Ruskin in defining handicraft in terms
of the morphology of production rather than its social relations. Skill is central
to this tradition of thinking about the artisanal but skill is defined in isolation
from the social apparatuses of exclusion, monopoly, regulation and reproduc-
tion that characterised the handicraft mode of production within the guild
system. Sennett argues that skill confers authority on the one who possesses
it rather than recognising that skill, in the history of artisanal labour, was inex-
tricable from the privileges, freedoms and authority of the social regulation of
handicraft.

Doctors and nurses are necessarily craftsmanlike, Sennett argues, insofar
as they are driven by curiosity, required to 'learn from ambiguity', but the
craft skills of medical professionals 'have been eroded by the introduction of
health care targets that are entirely quantitative. No place for the craftsman's
subtle and practised "interplay between tacit knowledge and self-conscious
awareness" in the brutal Fordism of the modern NHS'. Also, Harry Braverman's
Labor and Monopoly Capital defends Mills's use of the concept of alienation
against the 'feeble results achieved by questionnaire-sociology',[90] which con-
cerns itself only with 'the delineation of various layers of stratification by
means of questionnaires which enable respondents to choose their own class,
thereby relieving sociologists of the obligation'.[91] Braverman's account of the
degradation of work is structured around an opposition between actual and
ideal work practices that can be read as a politically radical reinterpretation
of Mills's vindication of handicraft by foregrounding questions of worker con-
trol.

Roger Scruton puts the blame for the waning of craft skills not on the own-
ers, managers, bosses and bureaucrats of Fordism and Taylorism but on free-
thinkers and radicals. He observes snidely: 'Originality and "doing your own
thing" have replaced obedience and perfection as the standards to live up to,
and this is everywhere to be observed in the deskilling of modern societies

89 Mills 1972 [1951], p. 224.
90 Braverman 1998 [1974], p. 20.
91 Braverman 1998 [1974], p. 19.

and in the marginalisation of those who truly know their job, and know it as something more interesting than themselves'.[92] Tellingly, Scruton takes his distance from Sennett's argument at the point where craft is threatened by art, in the example of Frank Gehry's Guggenheim Museum in Bilbao: 'a residual sympathy for modernism leads him to praise Gehry's costly extravaganza. He is entitled to his taste; but he should be clear that Gehry's building is not an exercise in craft but an attempt at art, and exemplifies the same kind of "look at me expressing myself" that has led everywhere to the death of those virtues – humility, piety, obedience – without which no tradition of craftsmanship can really survive'.[93]

In 1957 the art historian Meyer Schapiro argued that artistic production resisted the capitalist mode of production by virtue of its distinctive sensitivity to hand, eye, tool and object. 'Paintings and sculptures', he said, 'are the last handmade, personal objects within our culture. Almost everything else is produced industrially, in mass, and through a high division of labor'.[94] He was aware that artists after the First World War embraced technology, manufacturing and the division of labour with works that 'assumed the qualities of the machinemade',[95] but underestimated the persistence of this facet of anti-art because he believed that it depended on an 'optimistic' attitude towards industry and science. In his account, it was when this optimism proved to be unfounded that a progressive defence of the handmade became possible in art. And when he mounted this defence, he did so using the terminology of non-alienated labour: 'Few people are fortunate enough to make something that represents themselves, that issues entirely from their hands and mind, and to which they can affix their names', Schapiro said. And he describes industrial production in a way that corresponds to the concept of alienated labour: 'the practical activity by which we live is not satisfying: we cannot give it full loyalty, and its rewards do not compensate enough for the frustrations and emptiness that arise from the lack of spontaneity and personal identifications in work: the individual is deformed by it, only rarely does it permit him to grow'.[96] Schapiro affirms the practices of painting and sculpture by stressing the value of the 'devices of handling, processing, surfacing'[97] which, he said, 'confer to the utmost degree the aspect of the freely made. Hence the great importance in painting of the

<hr>

92 Scruton 2008, np.
93 Scruton 2008, np.
94 Schapiro 1979, p. 217.
95 Schapiro 1979, p. 219.
96 Schapiro 1979, p. 218.
97 Ibid.

mark, the stroke, the brush, the drip, the quality of the substance of the paint itself, and the surface of the canvas as a texture and field of operation-all signs of the artist's active presence'.[98]

Schapiro's observations about the relationship between artistic production and industrial production was the result of a sustained attempt to develop a Marxist theory of culture from 1931 onwards with 'the leitmotiv of history as humanity's self-emancipation that Schapiro took from the early Marx'.[99] The 'individualism[100] of modern art, far from being a denial of social relationship', he said in 1948, was the 'fruit of a certain mode of social relationship'.[101] He argued that painting is 'opposed to our actual world and yet is related to it' and bases the contrast between art and industrial labour not on the heroic actions of the individual but on the absence and presence, respectively, of the division of labour. He does not stress that artistic labour is satisfying or enjoyable or rewarding, only that it is structured differently.[102] Often the antagonism

98 Ibid.
99 Hemingway 2006, p. 133. As early as 1936, in his essay 'The Social Bases of Art', an essay which presents the historical and social emergence of the individualism of the artist as a material condition that obstructs the development of socially engaged content in modern art, Schapiro had understood clearly that the 'the discrepancy between [the artist's] archaic, individual handicraft and the collective, mechanical character of most modern production' was not proof of the artist's separation from society but was in fact the basis of art's specific mode of integration in 'modern society'.
100 Contemporary scholarship assumes Schapiro's complicity in the construction of the artist as exemplary of 'heroic individualism' (Jones 1996, p. 10) but the caricature is undeserved and can be sustained only by pressing Schapiro's historical and critical analysis of the emergence of the artist as an individual producer into a one-dimensional and uncritical celebration.
101 Schapiro quoted in Hemingway 2006, p. 141.
102 Thomas Crow argues that Schapiro and Greenberg draw different conclusions from an 'almost identical' (Crow 1985, p. 242) social analysis. Both, he argues, base their analysis of the antagonism between the avant-garde and popular culture on 'the commodification of culture' (ibid.), the replacement of 'the rich and coherent symbolic dimension of collective life' with spectacle, and both regard the avant-garde as a critical response to the capitalist transformation of culture. However, this account is biased towards Greenberg's opposition of the avant-garde and kitsch, since Crow is concerned, above all, with questions around the relationship between art and popular culture. If Schapiro's analysis overlaps such questions it is not because he is or becomes 'a renowned and powerful defender of the American avant-garde' (Crow 1985, p. 241) against popular culture, but that he builds a Marxist theory of culture on the basis of a social and historical understanding of labour. This is why his critical account of art's confrontation with capitalism is more emphatic and more far-reaching than Greenberg's opposition of the avant-garde and kitsch. Schapiro contrasts artistic labour to the labour that produces commodities in capitalism, not specifically opposing it to the labour that produces kitsch.

between art and society is expressed at the time in exaggerated and fantastical forms,[103] but Schapiro's analysis was determinedly material, social and historical. The American avant-garde drew on Surrealism and Expressionism to develop a concept of aesthetic production that appeared to support the case for considering art as a paradigm of non-alienated labour.

Art was theoretically reconciled with handicraft by Marxist art critics in the USA in the middle of the twentieth century. Harold Rosenberg and Meyer Schapiro were the two leading exponents of the argument that artistic labour itself was quite distinct from capitalist production. Rosenberg, for instance, described painting as 'an activity that would be an alternative to both utility and idleness',[104] and Schapiro declared that paintings and sculptures 'are the last hand-made, personal objects within our culture'.[105] Rosenberg argued in his essay 'The American Action Painters', published in *Art News* in 1952, that modern painting was a spontaneous act that confirmed rather than denied the subjectivity of the producer.

It was not a foregone conclusion that artists would be given credit for the kind of refined judgements that were being ascribed to the patrons and consumers of art. And the transfer of these capacities from the realm of consumption to the realm of production is not to be understood mechanically as simply the mirrored presence of taste in the production of works that were consumed by refined customers. Since these philosophical steps were taken in the absence of the transformation of the concept of work by the nascent workers movement following the French Revolution, their proposals for the conjoining of activity and freedom falls a long way short of the social reorganisation of labour and therefore is more accurately understood as the proposal for aesthetic labour (i.e. a philosophical reconception of human activity) rather than in terms of the later concepts of attractive labour or non-alienated labour.

Aesthetic labour and the aestheticisation of labour take on a new political charge from the workers' struggle after the French Revolution but artistic labour and its cognates should not therefore be taken as the ideology of the work ethic writ large nor as the epitome of what labour would be like under a workers' administration. While the works of Kant and Schiller are marked by

103 Barnett Newman spoke of the artist living 'the life of a creator' despite 'the fall of man' (Newman 2005 [1947], p. 577) and Mark Rothko spoke of the 'unknown adventure' of making paintings that 'must be miraculous' (Rothko 2005 [1947], p. 572) for instance.
104 Rosenberg 1952, p. 43.
105 Schapiro 1978, p. 217.

the proximity of revolution, neither were clear enough or went far enough in formulating the conceptual grounds for the reorganisation or abolition of work in the light of aesthetic labour. It is to the transformation of the politics of work within the workers' movement, therefore, that I now turn.

Attractive Labour

Not long after the ideal of aesthetic labour was developed in German philosophical thought, the concept of attractive work was formulated in France and Britain by the social reformers Henri de Saint-Simon, Charles Fourier and Robert Owen. Prior to the organisation of workers themselves and their political maturation, the vision of a reconciled society in which attractive work prevails was first formulated in the period between the French Revolution and the revolutions of 1848 by the first wave of Socialist thinkers who were later dubbed Utopian Socialists by Marx and Engels. Socialism began, therefore, not as a politics that expressed the urgent demands of the workers' movement but as a planned exodus from industrialisation and modernity.

Saint-Simon and the Saint-Simonians gave Socialism its first theoretical and institutional form. Saint-Simonism became a prominent social movement from Egypt to the Americas in the decade after Saint-Simon's death in 1825 and was an important force within the workers' movement between 1830 and 1848. For Saint-Simon, who proposed a new society in which women and workers would play a full part in social life, 'a clerical elite was deemed necessary to lead the masses'.[1] He advocated 'a new, peaceful relationship between the classes should replace social conflict; that the work of the industrialist and the proletariat should be equally valued, even if not equally remunerated; and that inheritance of wealth, although not the private ownership of property, should be abolished'.[2] Charles Fourier's utopian schema, advocating the establishment of a well-regulated social system including a version of a universal basic income and an equivalent sexual allowance, was widely circulated in Europe and North America in the 1830s and '40s. Around the same time, Robert Owen in Britain was arguing 'that the Co-operative Commonwealth was the ideal framework for the moral regeneration of mankind'.[3]

Harmony was the structuring principle of all socialist utopias in the first half of the nineteenth century and it served as a trope that linked Newtonian physics with the beauty of the human body, aesthetics, the elimination of social conflict and the economic theories of Adam Smith.[4] Alongside har-

1 Moses 1982, p. 242 n. 5.
2 Moses 1982, p. 242.
3 Miliband 1954, p. 234.
4 For a discussion of the concept of harmony in utopian socialism see Taylor 1982, pp. 3–4.

mony, the utopian socialists stressed the value of association and cooperation, preferred agriculture and handicraft to industrialisation, and, for the most part, advocated peaceful transition rather than violent revolution. Not all could be described as democratic and equality was not built into any of their social systems, although some sort of justice or moral code was. And while the question of work was raised in all of them, albeit in ways that were insufficient, 'none of them appealed to the newly emergent factory workers'.[5]

Harmony would be easier to achieve, of course, if the unskilled landless poor had no place in it. More pointedly, we can say, utopian socialism was an attempt to exclude the new type of workers from society altogether. These socialist utopias were not proletarian fantasies but the dreams of capitalists, lapsed minor aristocrats and bureaucrats. Although none of the first wave of socialists theorised work to any great extent or planned social production on a wholly new basis, work haunted their projects precisely by virtue of their strict absence: no machinery, no factories, no wages and no toil.

Although William Sewell characterises the early decades of the nineteenth century as consisting of a 'general fascination with labor – a fascination that arose out of fear as much as sympathy',[6] work was not one of the major concerns of any of them, but as one of the conspicuous sources of unhappiness and of wealth, work could not be ignored by any of them either. Nevertheless, Saint-Simon, Fourier and Owen represent a turning point in the history of labour. The utopian patriarchs provided vindications of the labourer without challenging the established concept of labour as pain and trouble. The immediate conceptual result of the critical revulsion to the degradation of labour in the factories and the critique of industrialism was a reinforcement of the ancient idea that work is abhorrent rather than the development of the idea of labour as a reward in itself.

The utopia of attractive labour is not reducible to the ideal of aesthetic labour partly because one is utopian and the other is ideal. Of course, there were always utopian details within the ideal of aesthetic labour and the utopia of attractive labour contains its ideals. To some extent the difference can be traced to the fact that the ideal of aesthetic labour was formulated by philosophers and poets, whereas the utopia of attractive work was developed by social reformers. Nevertheless, the ideal of aesthetic labour was a normative force within the society whereas the utopia of attractive labour had to be constructed outside the existing society. James Burgh, in 1764, described the uto-

5 Taylor 1982, p. 19.
6 Sewell 1980, p. 222.

pian impulse as 'what a good man would wish a nation to be, than the true account of the state of one really existing'.[7] This wish, however, tended to be fulfilled only through geographical detachment.

Utopianism is initiated in literature as a colonial narrative in which the native culture of a foreign land is praised as a model for modern, European society. Utopian Socialism, however, did not imagine that Socialism already existed within indigenous cultures. Socialism would have to be built. By and large, Socialism in the first third of the nineteenth century was to be formed by setting up a colony, that is to say, by securing a piece of land and occupying it with a group of like-minded citizens. It was possible for a Socialist colony to bed down in Europe but the trend was for them to proliferate in the colonies in the New World. Indeed, Utopian Socialism might also be dubbed Settler Socialism insofar as it placed its hopes in an exodus from Europe to establish colonies along the routes plotted by imperial conquest and colonial trade. That is to say, Socialism was not initially a reformist politics that aimed to change the existing society but a negation of the existing society conceived of geographically as an exodus rather than temporally as a revolution.

Utopianism is distinct from the ideal also insofar as it is primarily concerned with organisational, governmental and regulatory matters. Before Socialism could be built, it had to be designed. Actually, Socialism in its earliest incarnation, as a planned colony, had to be formed as a colony because it was planned. The Socialism of Saint-Simon, Fourier and Owen all begin as texts, visions, ideas, proposals. And what this means is that they all begin with an author who is imagined as a founder of a new society. All three attempted to draw up the blueprints for a society that would no longer suffer from the conflicts and irrationalities that plagued modern society. Socialism begins as a loosely affiliated cluster of theoretical and practical proposals for the perfection of social harmony. All proceeded on the basis of that society could be cured of its worst ailments through the proper forms of social organisation, either through managerial techniques or governmental ones and for this reason all at one time or another cherished the idea that some enlightened monarch or state would recognise the benefit of implementing such a social system and either sign off the requisite legislation or fund an experimental colony.

Attractive labour is utopian in both the sense of being bound up with a vision of administered harmony and in being, from the start, a colonial enterprise. The phrase 'attractive work' appeared for the first time in Fourier's Utopian Socialist tome, *The Theory of the Four Movements*, published in 1808. While it is true

7 Burgh 1994 [1764], p. 73.

that 'the total transformation of the nature of labour that was the centrepoint of Fourier's utopian vision',[8] Fourier did not articulate a total transformation of the meaning of labour. Fourier continued to subscribe strictly to the concept of labour as an unpleasant hindrance. Although Marcuse claims, the 'transformation of labor into pleasure is the central idea in Fourier's giant socialist utopia',[9] a close analysis of Fourier's argument does not bear this out. Fourier coined the idea of 'attractive labour' within a utopian schema of social organisation in which the members of an ideal community would work voluntarily, not that work itself would be transformed into a pleasurable activity.

Fourier's utopian prophecy of a new society paid far more attention to the beneficial effect of the social organisation of labour rather than to any pleasure to be derived directly from labouring as an activity. Despite asserting that the new kind of labour 'will have to differ in every particular from the repulsive conditions which render it so odious in the existing state of things',[10] the seven conditions (cited below) he outlines in order that labour 'become attractive' specify only that workers are associated, share the proceeds of labour in a rational manner, and have a variety of tasks to perform. While 'Fourier's basic premise is that work is to be transformed from something repulsive, to something positively attractive',[11] labour as an activity does not become attractive in Fourier's utopia. 'The radical evil of our industrial system is the employment of the laborer in a single occupation'.[12]

Work becomes attractive, therefore, he argues, when the worker is no longer 'obliged to spend twelve, and frequently fifteen, consecutive hours in some tedious labor'.[13] Work does not undergo any morphological transposition in Fourier's account, it is merely distributed in such a way that individuals are not condemned to repeat the same work throughout the working day, day in and day out, for the duration of a working life. When Fourier speaks of 'attractive work', the word 'attractive' is used in accordance with Newton's theory of gravitational pull, not to connote the aesthetic experience of an activity that is a reward in itself. Fourier begins his account of 'attractive labour' by pointing out that labour 'forms the delight of various creatures such as beavers, bees, wasps, ants' since God has provided a mechanism by which such animals are attracted to their given tasks.

8 Granter 2009, p. 54.
9 Marcuse 1955, p. 217.
10 Fourier 1901, p. 164.
11 Granter 2009, p. 56.
12 Fourier 1901, p. 169.
13 Fourier 1901, p. 166.

Attraction, in the concept of attractive labour, operates as an instinct and it functions mechanically or automatically. Fourier enumerates its operations as follows:

> Associative labour, in order to exert a strong attraction upon people, will have to differ in every particular from the repulsive conditions which render it so odious in the existing state of things.
>
> It is necessary, in order that it become attractive, that associative labour fulfil the following seven conditions:
>
> 1° That every labourer be a partner, remunerated by dividends and not by wages.
>
> 2° That every one, man, woman, or child, be remunerated in proportion to the three faculties, capital, labour, and talent.
>
> 3° That the industrial sessions be varied about eight times a day, it being impossible to sustain enthusiasm longer than an hour and a half or two hours in the exercise of agricultural or manufacturing labour.
>
> 4° That they be carried on by bands of friends, united spontaneously, interested and stimulated by very active rivalries.
>
> 5° That the workshops and husbandry offer the labourer the allurements of elegance and cleanliness.
>
> 6° That the division of labour be carried to the last degree, so that each sex and age may devote itself to duties that are suited to it.
>
> 7° That in this distribution, each one, man, woman, or child, be in full enjoyment of the right to labour or the right to engage in such branch of labour as they may please to select, provided they give proof of integrity and ability.
>
> X[1] Finally, that, in this new order, people possess a guarantee of well-being, of a minimum sufficient for the present and the future, and that this guarantee free them from all uneasiness concerning themselves and their families.[14]

For Fourier, the variety enjoyed throughout the working day depended on wealth. He illustrates this with a comparison between the days of a poor and wealthy inhabitant of his utopian society, Lugas and Mondor. Lugas works in the stables, does some gardening, reaps the fields, grows vegetables, participates in manufacturing and ends his day with amusement,[15] whereas Mondor's

14 Fourier 1901, p. 164.
15 Fourier 1901, p. 167.

day includes 'hunting and fishing in the morning, perusing newspapers over lunch and art exhibitions and concerts after supper'.[16] Marx and Engels later universalised Fourier's utopian perception of Mondor's day when they argued in the *German Ideology* that in communist society specialisation would be abolished, allowing each individual 'to hunt in the morning, fish in the afternoon, rear cattle in the evening, criticise after dinner ... without ever becoming hunter, fisherman, herdsman or critic'.[17]

An analysis of Fourier's utopian scheme of work must divide the concept of attractive work into strong and weak variants. The strong variant, which he does not subscribe to but which has become attached to his account, is the idea that work might itself become an attractive experience. This reading appears to be informed by the philosophy of aesthetic labour. The weak variant, which Fourier subscribes to and does not deviate from, is simply that it is possible for workers to be attracted to work despite its persistently unattractive forms. Fourier does not adequately distinguish attractive work from the attraction to work and thereby perhaps presents the latter under the heading of the former, perhaps on the assumption that the former is too far-fetched even for a Socialist. Work is not made any more attractive in his harmonious system, but the workers will be more attracted to existing tasks, he imagines, when they are not compelled by starvation and have more variety. This limit of thinking about attractive labour was shared by William Godwin who argued that injustice is suffered by workers, not in the actual labour but in its quantity. 'What is misnamed wealth', he said, 'is merely a power vested in certain individuals by the institutions of society, to compel others to labour for their benefit'.[18]

Owen, like Saint-Simon and Fourier, appealed to artisans, petty producers, shopkeepers and small business owners while he was actively and consistently antagonistic towards the industrial layer of the working class, rejecting the trade unions and opposing Chartism. In the words of Ralph Miliband, Owen

> denied that a society could be called civilized which left the vast majority of its members helpless victims of ignorance and destitution, and the denial went in hand with the assertion that it was the positive duty of society to provide the means whereby men might freely develop their faculties.[19]

16 Granter 2009, p. 62. See Fourier 1901, pp. 167–8.
17 Marx and Engels 1996 [1845–46].
18 Godwin 1823, p. 158.
19 Miliband 1954, p. 234.

Utopian socialism responded to the emergence of industrial capitalism around it by imagining a world in which the Enlightenment did not lead to the application of science to the production of wealth but to the administration of agreeable social relations. Attractive work appears in the early nineteenth century as an oxymoron that might be partly reconciled by the implementation of administrative checks on the worst aspects of industrial wage labour. For the Utopian Socialists, though, work can never become a reward in itself, as the aesthetic labour appeared to be.

After the unprecedented but limited conception of attractive labour in utopian socialism, the concept of labour is taken up by Thomas Carlyle, exemplar of Romantic anti-capitalism, whose 'Sign of the Times' published in 1829 was a scorching critique of industrialism. Since the machine has come to dominate production, products and their producers, Carlyle deploys the concept of the machine and mechanisation in countless variations, literal and metaphoric, to characterise industrial processes, industrial society and the subjectivities and experiences of individuals marked by and adapted to mechanisation. Anticipating Deleuze by over a century, Carlyle speaks about 'religious machines', 'machines for education', 'the machine of society', 'a taxing machine', a 'machine for securing property' and so on. It is in this context that Carlyle describes the new subjectivity of the industrial age: 'Men are grown mechanical in head and in heart, as well as in hand'.[20]

His complaints against industrialisation are at once general, about the metamorphosis of culture, ideas, religion and feeling, and at the same time about production and labour in particular. 'Nothing is now done directly, or by hand', he wrote, '[o]ur old modes of exertion are all discredited and thrown aside ... the living artisan is driven from his workshop, to make room for a speedier, inanimate one'.[21] It is possible to detect, within Carlyle's rhetoric, the hostility to the mechanical fostered within the academy system of the Fine Arts but here it is opposed to handicraft now subsumed under the broader category of handiwork. The machine appears to have infiltrated every pore of society and has replicated itself within the actions and feelings of human beings themselves. In a sense, therefore, Carlyle inverts the shift from denigrating the mechanical arts to rejecting mechanisation by perceiving the machine within the activity of the labourer.

In *Past and Present* Carlyle provides the first formulation of the Romantic affirmation of the worker: 'Awake, ye noble Workers, warriors in the true war. It

20 Carlyle 1986, p. 67.
21 Carlyle 1986, p. 64.

is you who are already half-alive-whom I will conjure in God's name, to shake off your enchanted Sleep, and live wholly!' Romantic anti-capitalism constructs a vivid opposition between industrialism and 'living wholly'. Carlyle supplied a florid justification of work that mixed the new perception of the dignity of work with a religious rhetoric of saintliness that is not reducible to the Protestant concept of the 'calling':

> All true Work is sacred; in all true Work, were it but true hand-labour, there is something of divineness. Labour, wide as the Earth, has its summit in Heaven. Sweat of the brow; and up from that to sweat of the brain, sweat of the heart; which includes all Kepler calculations, Newton meditations, all Sciences, all spoken Epics, all acted Heroisms, Martyrdoms, – up to that 'Agony of bloody sweat,' which all men have called divine! O brother, if this is not 'worship,' then I say, the more pity for worship; for this is the noblest thing yet discovered under God's sky. Who art thou that complainest of thy life of toil? Complain not. Look up, my wearied brother; see thy fellow Workmen there, in God's Eternity; surviving there, they alone surviving: sacred Band of the Immortals, celestial Bodyguard of the Empire of Mankind.[22]

Drawing on classical philosophy, in which the good life is one without work, Carlyle does not see work as dehumanising. It is only modern industrial work, in which the worker becomes an adjunct to a machine, or even a mechanised animal, that is spurned. As well as montaging the worker with the saint, Carlyle flattens the hierarchy of human activity and places the previously dominant and higher forms of activity under the heading of labour, as if 'the sweat of the brain' is seen as more divine by being understood as a variant of manual work.

In his 1840 book *Chartism*, Carlyle characterised the radical organised working-class movement as proof of the 'diseased condition of England', meaning that the old social relations were eroding. Ruskin, likewise, responded to the Chartists by describing them as 'vociferous, terrified and mischievous', and he held out hope for a more enlightened bourgeois solution to the problems of modern industrial capitalist society. Politically, their lack of affiliation with the workers' movement and their nostalgic, conservative endorsement of a golden age of preindustrial social relations of exploitation, but their conception of labour neither reiterated that of an earlier age, nor was it representative of the conservative attitude to labour[23] in the nineteenth century.

22 Carlyle 1986, p. 249.
23 The conservative attitude to work is exemplified in the nineteenth century, I would argue,

Romanticism is one of the principal registers through which labour (of a certain type) is reconceived as consonant with the well-being of the free individual. Usually the anti-capitalism characteristic of Romanticism, which is the base of its revaluation of labour, is presented as a nostalgia for premodern social forms of labour. For instance, Löwy and Sayre argue that the 'deeply antagonistic relationship of Romanticism to industrial society'[24] typically takes the form of an 'opposition to capitalism in the name of pre-capitalist values'.[25] However, the nostalgia for earlier forms of labour was new. Hence, it is a mistake to read the defence of handicraft and skilled labour by Romantics (and radical artisans) as nothing but a protest against change and modernisation.

Even so, while a broad spectrum of positive connotations of labour arose in the face of industrialisation, coinciding with the birth of the workers movement led by radical artisans, the most emphatic statements of labour as exemplifying the human were not developed by workers themselves but bourgeois critics. Certainly there were plenty of 'sentimental Tories' and 'utopian visionaries' who, according to Engels, responded to the inhumanity of industrial capitalism by 'wallowing in reminiscences of the extinct patriarchal cottage-industry exploitation and its concomitant piety, homeliness, hidebound worthiness and its set patterns handed down from generation to generation'. And indeed, even those bourgeois radicals, romantics and revolutionaries who aligned themselves more directly with the workers often did so through the lens of this and similar Tory sentiments.

Such bourgeois advocates for an aesthetically inflected concept of labour should neither be taken as the mouthpieces of the values and interests of the working class, nor as the adherents of a philosophical tradition completely independent of the incipient working class, as evidenced in the sans culottes, the worker poets and the Chartists. And yet it is precisely during the period of Chartism's prominence, between 1838 and 1857, that John Ruskin 'was the first to declare that men's "pleasure in the work by which they made their bread"',[26] in the *Stones of Venice* published in 1849. What is the relationship between these bourgeois reflections on labour and the workers movement to which they often expressed serious reservations? To what extent do the likes of Carlyle and

by the exponents of *laissez faire* who argued that the working day should not be reduced to 10 hours and that wages should not be increased as higher wages would lead to higher prices, lower profits and an idler workforce which would consequently fall into drunkenness, crime and violence against the state.

24 Löwy and Sayre 1984, p. 46.
25 Ibid.
26 Thompson 2011 [1976], p. 36.

Ruskin write about labour as a result of the conspicuous presence of politicised workers and, even if their aestheticisation of labour is effectively a bourgeois colonisation of work, to what extent has their agenda been set by the working-class politicisation of labour? When radical artisans defended handicraft as preferable for the worker to the industrial processes of the factory, a gap was opened up in which it was possible for the first time to speak of labour as either mindless toil or a reward in itself for the skilled producer. Workers themselves did not always lay great stress on this differentiation as they attempted, instead, to bring all workers together through their shared interest in universal suffrage and parliamentary reform. However, from this point onwards the defence of handicraft became a standard method for criticising modernity, industrialisation and capitalism by bourgeois critics but also a section of the radical artisans who were active within the early communist movement. There developed, therefore, a twofold conception of labour in which the long-established tropes of labour as pain, toil and trouble were assigned only to the most recent forms of labour while a new set of positive connotations of labour as a reward in itself and so on were ascribed to more traditional processes of handicraft production. This double anachronism is the conceptual framework through which Ruskin articulated his politics of labour. This is summarised clearly in his statement: 'It would be well if all of us were good handicraftsmen in some kind, and the dishonour of manual labour done away with altogether'.[27]

Some indication of the class dimension of Ruskin's politics of labour can be found in his proposal to address the horrors of industrial labour. Taking the example of the manufacture of glass beads, he describes the process of production, the effects on the workers and then, finally, the social mechanism through which such industrial labour can be eliminated. Glass beads, he says, 'are formed by first drawing out glass into rods; these rods are chopped up into fragments of the size of beads by the human hand, and the fragments are then rounded in the furnace'.[28] Ruskin describes the physical and mental costs of workers who are required to repeatedly execute processes that do not require 'the use of any single human faculty'.[29] He explains: 'The men who chop up the rods sit at their work all day, their hands vibrating with a perpetual and exquisitely timed palsy, and the beads dropping beneath their vibration like hail'.[30] Rather than addressing his concerns to the industrialists and legislators and calling for reforms, or to the workers themselves who produce such glass beads

27 Ruskin 1985, p. 90.
28 Ruskin 1985, p. 88.
29 Ibid.
30 Ibid.

to smash the furnaces, join together to improve their working conditions or
calling on a more general workers' movement to abolish both the wage system
and the capitalist mode of commodity production that sacrifices workers for
the sake of profit, Ruskin appeals to 'every young lady'[31] who perpetuates this
system by purchasing glass beads. As well as neglecting the politics of domestic
labour in which young ladies were excluded from the wage system, Ruskin here
supplies an early formulation of what is later termed 'ethical consumerism',
Ruskin puts his hope in the elimination of demand through the transforma-
tion of consumer behaviour. As such, the agents of social change, for Ruskin,
are enlightened members of the bourgeoisie, not the working class who they
pity and make small personal sacrifices to help.

As Raymond Williams put it, 'the idea of "wholeness", as a distinguishing
quality of the mind of the artist, led Ruskin into a criticism of society'.[32] Echo-
ing Schiller's notion of an unalienated wholeness of personality, Ruskin was
not content to provide the conditions under which workers might be willing to
work, like Fourier. His aim was the realisation of the full potential of each and
all. Like Oscar Wilde more emphatically after him, Ruskin took his bearings
on the question of labour and its erosion of the full personality of the worker
under the industrial condition, from the artist as an exemplar of an individual
who, in producing things produces himself or herself as a more whole person-
ality. The division of labour, he said, is in fact the division of men, '[d]ivided
into mere segments of men – broken into small fragments and crumbs of life'.[33]
Thus, Ruskin declared, 'we manufacture everything ... but men',[34] or rather: 'we
blanch cotton, and strengthen steel, and refine sugar, and shape pottery; but to
brighten, to strengthen, to refine, or to form a single living spirit, never enters
into our estimate of advantages'.[35]

Taking his point of departure from Diderot's and Adam Smith's example
of the division of labour in the industrial manufacture of pins, Ruskin com-
plained 'all the little piece of intelligence that is left in a man is not enough to
make a pin, or a nail, but exhausts itself in making the point of a pin or the
head of a nail'.[36] Against this, he asked, 'what kinds of labour are good for men,
raising them, and making them happy'?[37] His answer to this question, though

31 Ibid.
32 Williams 2013 [1958], p. 139.
33 Ruskin 1985, p. 87.
34 Ibid.
35 Ibid.
36 Ibid.
37 Ibid.

partially given through the advocacy of specific qualities (variation, invention, unity of design and execution, and so on), is provided more generally through the concept of 'Vital Beauty' which refers to 'the joyful and right exertion of perfect life in man'. Vital beauty, for Ruskin, was an extension of the idea of human perfectibility, but, as Williams points out, with the difference that for him, 'it is the exertion, rather than the discovery, of "perfect life in man"'.[38] That is to say, labour is an indispensable component of human happiness.

Despite his lack of confidence in the working class itself, Ruskin presents the most radical conception of labour of anyone before him. William Morris is justifiably acknowledged as politically more progressive than Ruskin, with an undoubtedly stronger relationship to the working class and its political self-organisation, but his vision of labour owes more to Fourier than to his erstwhile mentor. Indeed, in the mid-1880s 'Morris had become one of the two or three acknowledged leaders of the Socialist movement in England'.[39] However, Engels described him as a 'very rich artist-enthusiast but untalented politician',[40] and, when it was suggested that his business might introduce profit-sharing he rejected it as 'feeding the dog with its own tail'.[41] Nevertheless, Morris was a genuine supporter of the political agency of the working class: 'What we want is real leaders themselves working men'.[42]

Putting aside his work in political leadership and his record as a propagandist for socialist reform and revolution, however, Morris's statement that 'art is the expression of man's joy in labour' combines the radical reconstruction of labour as human self-activity with a specifically bourgeois conception of art and the aesthetic. Although Morris does not subscribe to the modern view of art as referring strictly to the abstract legacy of the Fine Arts, preferring instead to revive and remodel a category of the arts in which art and handicraft exist in a continuum with each other, his conception of art and the arts is somewhat deceptive. Superficially moulding art on handicraft and using the arts to orient art and manufacturing (as well as society), his concept of handicraft does not resemble any premodern model. The arts, he declares, generate two types of pleasure, the first is derived from their use, principally in the beautiful decoration of well-made things, while the second consists in 'giving us pleasure in our work'.[43] Combining the emphasis on beauty and pleasure in the eighteenth-

38 Williams 2013 [1958], p. 139.
39 Thompson 2011 [1976], p. 302.
40 Morris quoted in Thompson 2011 [1976], p. 342.
41 Morris quoted in Thompson 2011 [1976], p. 319.
42 Morris quoted in Thompson 2011 [1976], p. 344.
43 Morris 2008, p. 59.

century idea of the *beaux arts* with the nineteenth-century idea of attractive work, Morris's concept of the arts is closer to the Romantic theory of aesthetic activity than it is to medieval notions of handicraft.

During a speech on 'The Decorative Arts' delivered the Trades Guild of Learning in London in 1877 Morris declared that his conception of pleasure in work derives from Ruskin's writing on the subject,[44] and E.P. Thompson was right to stress that 'it was from John Ruskin that Morris gained a new outlook on the role of creative satisfaction in labour'.[45] And yet, despite this, when Morris came to elaborate his proposals for work in 'Useful Work Versus Useless Toil', in 1884, he did so not in the terms laid out by Ruskin but through the language and rationale of Fourier's theory of attractive work. Morris's proposals for the introduction of variety,[46] the short duration of labour,[47] pleasant surroundings,[48] the day's work divided between agriculture, handicraft and science,[49] and so on, are precisely the kind of measures that characterised Utopian Socialism. Where Morris diverges from Fourier is not in his conception of how the conditions of work can make it more pleasant, but in his argument that the 'first step towards making labour more attractive is to get the means of making labour fruitful, the Capital, including the land, machinery, factories, etc., into the hands of the community'.[50] In 1892, however, Morris had to admit that '[e]xcept with a small part of the more artistic side of the work ... I could not do anything (or at least but little) to give this pleasure to the workman'.[51]

Morris's 'discontent and hope'[52] was expressed, in large part, as a formula for the convergence of art, handicraft and work that both rejected the capitalist mode of production and anticipated the Socialist emancipation of labour from capital and the capitalist class. Morris also understood this tradition as it had formed throughout the nineteenth century: 'St. Simon, Proudhon, Fourier and his followers kept up the traditions of hope in the midst of a *bourgeois* world', he said, adding that Fourier stands out amongst them 'since his doctrine of the necessity and possibility of making labour attractive is one which Socialism can by no means do without'.[53] Taken generally, therefore, Morris's critique

44 Ibid.
45 Thompson 2011 [1976], p. 32.
46 Morris 2008, p. 20.
47 Morris 2008, p. 21.
48 Morris 2008, p. 22.
49 Morris 2008, p. 23.
50 Morris 2008, p. 17.
51 Morris quoted in Thompson 2011 [1976], p. 105.
52 Morris quoted in Thompson 2011 [1976], p. 310.
53 Morris 1993, p. 322.

of industrialisation and his preference for handicraft together express solidarity with the working class. More specifically, though, his politics has a different cast. Morris's 'revolt against capitalism stemmed from a moral revulsion rather than direct experience of poverty and oppression',[54] as E.P. Thompson put it, and yet he understood that it was '[c]apitalism, not machinery, [that had] reduced the worker to an "appendage of profit-grinding"'.[55] His politics of work perfectly crystallised the complex social relationship between the classes in which the bourgeoisie sees itself reflected back in a mirror which it places between itself and the workers. Artistic labour, here, stands at the pinnacle of handicraft and is removed even further from the processes of industrial production from which handicraft was differentiated. And, as such, this enlightened fraction of the cultivated bourgeoisie represents itself as the pinnacle of a society in which handicraft and the values of aesthetic humanism are threatened by philistine capitalists and ignorant wage labourers alike. Morris modelled himself on the image of a certain kind of worker, albeit one that was abstracted from an obsolete mode of production.

Oscar Wilde is the true heir of Ruskin's conception of pleasure in labour after Morris. In 1891 he published *The Soul of Man Under Socialism* in which he presented the most lucid and coherent formulation of the utopia of attractive labour that had ever been written: 'Every man must be left quite free to choose his own work. No form of compulsion must be exercised over him. If there is, his work will not be good for him, will not be good in itself, and will not be good for others. And by work I simply mean activity of any kind'.[56] Although building his conception of post-capitalist labour around the liberal principle of freedom of choice, Wilde's advocacy of the benefit of work to the 'soul' of the individual is unambiguous, absolute and undaunted by practicalities. If some have argued that 'Wilde brought the [Aestheticist] movement to its inevitable sterile conclusion',[57] the focus on the politics of labour and its relationship to art demands a different assessment.

Wilde expresses the negative case in a more or less standard way, saying: 'One's regret is that society should be constructed on such a basis that man has been forced into a groove in which he cannot freely develop what is wonderful, and fascinating, and delightful in him – in which, in fact, he misses the true pleasure and joy of living'. But his formulation of the positive case is new or at least has a new emphasis. Wilde avoids the medieval nostalgia of Ruskin and

54 Thompson 2011 [1976], p. 307.
55 Thompson 2011 [1976], p. 649.
56 Wilde 1990 [1895], p. 6.
57 Mulhern 1974, p. 50.

Morris not only by giving emphasis to freedom of choice but also by rejecting the model of handicraft 'in which a workman individually carried his piece of work all through its various stages from the first to the last',[58] in favour of the model of the artist. These elements combine seamlessly in his statement that 'Thackeray's "Esmond" is a beautiful work of art because he wrote it to please himself'.[59] Wilde's point was more general, more social and more revolutionary than this suggests. 'It is a question whether we have ever seen the full expression of a personality, except on the imaginative plane of art',[60] he speculated. 'Byron, Shelley, Browning, Victor Hugo, Baudelaire, and others, have been able to real-ise their personality more or less completely',[61] he wrote, acknowledging that their wealth allowed them to do so ('Not one of these men ever did a single day's work for hire. They were relieved from poverty. They had an immense advant-age'[62]), but arguing that it was their artistic labour rather than their wealth that brought about this result, namely to realise themselves.

Sven Lütticken proposes to divide the defence of art within Romantic anti-capitalism in the nineteenth century into 'two distinct forms of aestheticism': 'The first was the more familiar phenomenon of *l'art pour l'art* from Gautier and Whistler to Huysmans, Wilde and beyond; the second, which could be termed utilitarian aestheticism, was embodied in Ruskin's or Morris's attempts to reintegrate art into daily life and the realm of "useful" labour and artefacts'.[63] The division does not hold, partly because figures like Wilde belong on both sides of the divide, and partly because the concept of 'utilitarian aestheticism' is an inept attempt to grasp the anti-aestheticist and anti-utilitarian politics of art and labour by the defenders of handicraft against industrialisation and commercially driven commodity production.

As far as questions of labour are concerned, the radical tradition that links Utopian Socialism, Victorian medievalism and Aestheticism puts no stress on the 'useful'. What runs through this tradition of critical and utopian thinking against capitalism and the malign effects of wage labour is not what is useful, and no adoption of utilitarianism or even the utilitarian theory of happiness, but a cluster of tropes that, when combined with the notion of work or labour, turn the world upside down. It is not useful labour that is vindicated but attract-ive work, pleasure in work, work as an end in itself, work that is good for the

58 Morris 1993, p. 316.
59 Wilde 1990 [1895], pp. 27–8.
60 Wilde 1990 [1895], p. 8.
61 Wilde 1990 [1895], p. 6.
62 Ibid.
63 Lütticken 2016, p. 112.

worker, a vital beauty. What this tradition affirms, to use the rhetoric of the time, is the manufacture of humanity through the humanisation of manufacture.

Socialist patriarchs such as Saint-Simon, Fourier and Owen could no longer speak for the working class when 'organization in trade unions, co-operative societies and political associations began to replace the blind and purposeless manifestations of the anger of the working poor, as instanced by the Luddite riots of 1813–4'.[64] Regarding the organisers of labour and the owners of industrial enterprises as the basis of a new society, Saint-Simon 'was clearly not the herald of a proletarian revolution',[65] but his ideas were reinterpreted by the incipient workers' movement in order to fashion a radically new valorisation of labour as exemplary of human being. When artisans themselves came later to defend their customs, practices and values against the threat of industrialism, however, they often did so in solidarity with factory workers, agricultural wage labourers and so on. Artisans became the leaders of the working-class movement rather than merely representing their own narrow and conservative interests against them. 'Painfully aware that the new methods of production threatened to reduce them from skilled, respected participants in their workshops to mere "hands", the socialist worker-poets regarded producers' cooperative associations as their best line of defence against the Industrial Revolution'.[66]

It would be false to suggest that a period in which the redefinition of labour was driven by upper and middle classes was superseded by a period in which the workers themselves, led by artisans, took the initiative. Not only do the two contributions from above and below, so to speak, overlap on a timeline of events but the classes intersect on this question, although it is often difficult to discern clearly between instances of convergence and conflict, solidarity and aggression or managerialism and autonomy. No clear distinction opened up in the new social imaginary of work according to class. Instead, class divisions that were not yet fully articulated operated as distorting mirrors: capitalists saw themselves, for instance, as hard working and fretted at the idleness of the working class, while the workers began to see themselves as the only indispensable class insofar as they produced all the necessities, luxuries, instruments and infrastructure that, to use a Brechtian phrase, 'keeps mankind alive'. At various stages between the middle of the eighteenth century and the end of the nineteenth, a range of competing definitions of work, some recycled from tradition and some invented anew in response to the changing condi-

64 Miliband 1954, p. 239.
65 Manuel 1956, p. 255.
66 Newman 1979, p. D-1221.

tion, formed an expanding and contradictory terrain on which labour could be thought and, more pointedly, rethought. It is possible to identify a specific trajectory within this differential field, which begins with the utopian concept of 'attractive labour' and culminates in the concept of labour as a reward in itself (exemplified by the Pre-Raphaelites), that Marx, at one point, subscribed to as a picture of labour in communism.

Strikingly, though, it is at this time that the concept of exploitation undergoes a pointed transposition. Previously signifying 'the productive utilisation of some resource',[67] the word had had no normative connotation, but when workers began to speak of the exploitation of labour, of the use of one human being by another, 'was to speak ironically, to imply that the labor of a human was being treated as if it were a nonhuman resource',[68] treating labourers like inanimate objects, beasts or merely as a cost to be calculated. In short, exploitation in 1830 'has a very specific meaning: treating labourers as dehumanized "factors of production"'.[69] The perception of the dehumanisation of workers by mechanisation prompted a new revolutionary rhetoric of exploitation and extended the struggle against the dehumanisation of labour. While the Enlightened bourgeoisie carried out investigations of the moral and physical degradation of the poor, the solution to the exploitation of labour for the revolutionary workers of France in the early part of the nineteenth century was the reorganisation of society according to the principle of the humanity of the labourer. Exploitation, understood as the dehumanisation of the labourer, is therefore the conceptual counterpart and confirmation of the meaning of labour as an activity that is no longer considered to be inhumane but instead as integral to both social and individual flourishing.

Workers themselves began to reconceive labour as intrinsic to social life and human fulfilment. 'Labor is a treasure; labor, which in appearance is only affliction, is on the contrary an inexhaustible source of prosperity and happiness',[70] as the Lyonnais Mutualists said in 1831. Hence, the source of the affirmation of labour, of labour as a reward in itself rather than a punishment or pain was the radical artisans and skilled labourers of the early nineteenth century. Arguably, it was only when artisans aligned themselves with workers generally as belonging to the working class that they began to advocate the cause of labour rather than the cause of handicraft. Something changed. Whereas the utopian socialists appealed to artisans and rejected the industrial workers, the working-

67 Sewell 1980, p. 200.
68 Ibid.
69 Sewell 1980, p. 201.
70 Sewell 1980, p. 214.

class movement – the trade unions, Chartism, working-class publishing, etc. – provided a new condition under which the artisans took on a different role in the class struggle which was signalled, in part, by their development of a new normative framework for labour.

It was not independence but syndicalism that characterised handicraft under the guilds. Artisans did not talk about independence within the guild system, they talked about corporatism, quality and shared interests. Independence is a result of the abolition of the guilds in contrast with the unskilled industrial worker. According to Edgar Leon Newman, 'the socialist worker-poets were fundamentally conservative. They wanted to change the political system and the economic system so that their daily routine, their sense of pride in their status as artisans and in their work, and their hierarchy of values could stay the same'.[71] This is true for those artisans who gave their support to Fourier and Owen, but not the whole story for those who participated in or became leaders of the workers' movement.

Saint-Simonian artisans began to affirm the value of labour in poems and articles published in *L'Atelier*, *La Ruche populaire* and the *Union* during the July Monarchy between 1830 and 1848. 'The key was pride: the worker-poets, like most skilled artisans, were proud of their work and of their place in society'.[72] Such pride in their work spilled over into a pride in work and workers generally. 'The most striking trait of the worker-poet – a trait common to all of them – was their class-consciousness and class pride'.[73] Radical artisans built their politics on labour as 'the chief touchstone of full political rights',[74] on the criticism of idleness and the praise of industriousness, and initially their interests appeared to depend on distinguishing themselves from unskilled wage labourers as much as the idle rich. However, they also became poets and novelists. There is more to the appearance of worker-poets in the late 1830s than the demonstration that 'manual laborers were capable of poetry'[75] or that they confirmed the 'vision of the creativity of labor [that] underlay all the socialist writings of the era'.[76] The worker-poet not only conjoins two seemingly incongruous individuals – the worker and the poet – who are perhaps from different classes. The worker-poet is also a tense unity of two portions of time, in which a person divides her or his day into earning a wage and writing verse. Since conflict existed between waged

71 Newman 1979, p. D-1221.
72 Newman 1979, p. D-1204.
73 Newman 1979, p. D-1205.
74 Prothero 1979, p. 86.
75 Sewell 1980, p. 236.
76 Ibid.

work and time spent engaged in activities without recompense, the worker-poet is a vivid embodiment of the disparity between the subjective component of labour within a single person and a single day.

'Whenever workers speak in the name of work, affirm its rights or glorify its greatness', Rancière says, 'we run the risk of inferring a false picture of the collectivity they represent or of the realities that underlie their speech'.[77] Rancière unnecessarily presupposes a mimetic relationship here. The worker who writes a hymn to work does not have to enjoy his job in order to subscribe to the new radical image of work as a worthwhile and potentially fulfilling human activity. Rather than doing away with such discrepancies through the critical revelation of 'the myth of the artisan', the task is to give an account of the emergence of such myths and to trace their effect on practices, social organisation and identities. In a certain sense to speak of work is always to speak of myth, not in the sense of something false and arbitrary – Rancière refers to 'distortions'[78] – but in the sense of a normative regime that shapes the world and our experience of it. As the regime of the arts lost ground to the regime of labour an alien constellation of new tropes of work were coined, some stuck and some didn't, but those that stuck did not do so only because they corresponded to reality; some tropes of work persisted precisely because they represented nostalgic losses or utopian longings or both.

Rancière is justified in being suspicious of the 'hymns to labour'[79] by Saint-Simonian workers in the first half of the nineteenth century but he does not adequately distinguish between the sentimental depictions of happy labourers, which John Barrell says increased towards the end of the eighteenth century 'to reassure us that they do not resent their condition',[80] and the reconceptualisation of labour as human activity that is simultaneously essential to the supply of necessities, the production of wealth, the reproduction of society and the formation of subjectivity. This distinction was first drawn by the early Communists who differentiated themselves from their Socialist forebears by rejecting their sentimental advocacy of love and brotherhood in favour of a politics oriented around class struggle.

Rancière similarly fails to distinguish between the celebration of labour as the source of all goods, wealth and utility, and the celebration of labour as an end in itself. It was possible, for instance, for labour to be regarded as the foundation of every social order as well as the acknowledged source of life and value,

77 Rancière 1986, p. 327.
78 Ibid.
79 Rancière 1986, p. 324.
80 Barrell 2009 [1980], p. 21.

and therefore for labour to be seen for the first time as 'synonymous with creativity',[81] without endorsing the actual work patterns and labour processes of the day. The significance of this is captured by Iorwerth Prothero who points out that 'their ideal of independence through labour',

> could provide a basis for criticising those landowners, financiers, merchants or speculators who did not labour. These men were parasitic, living off the rest of the community, and the key to their position was political power. Radical reform would sweep this system away and destroy the aristocracy by removing their power.[82]

So, although the radical movement was dominated by the campaign for the extension of suffrage, the legal status of trade unions, wages, working conditions and the regulation of employment and the use of machinery, the perception of labour and its value was an integral part of their struggle. At the same time that the founders of Socialism 'were discovering and anatomizing the moral and physical degradation resulting from modern conditions of labor, labor was also being praised as the height of human creativity'.[83]

Moses Hess, who in the 1840s was a Young Hegelian living in Paris and one of the leading inheritors of utopian socialism who converted its principles into a fully-fledged communism, was among the first to conceive of socialism as the transformation of existing society in a future reconciled condition. He said in 1843 that within 'free human society ... free human occupations ... ceases to be "labour" and becomes totally identical with "pleasure"'.[84] At first, the blending of work and pleasure is only one element of his political vision but by 1846 it had become the leading principle of his communist ethos. His *Communist Credo* begins with the question 'What is the meaning of working?' and he answers: 'Every transformation of matter for the life of mankind means working'.[85] Beginning with such an ontological definition of work,[86] Hess's vindication of labour is not reducible to a myth of the happy labourer. Indeed, it is based on the critique of the existing system of work: 'Only under the conditions of alienated property is pleasure divorced from work',[87] he said in his important publication, 'Twenty One Sheets from Switzerland'.

81 Sewell 1980, p. 237.
82 Prothero 1979, p. 331.
83 Sewell 1980, p. 236.
84 Hess 2004, p. 111.
85 Hess 2004, p. 116.
86 For a philosophical account of labour as an ontological category see Gullì 2005.
87 Hess 2004, p. 107.

For Hess, the difference between unpleasant work and work that is identical with pleasure is not morphological (he does not base it on the difference between work conducted in the factory and the skilled labour of the artisan's workshop, for instance) but on its social relations, specifically whether it is free or forced. 'Free activity is all that grows out of an inner drive', he says, whereas a worker 'who looks for the wages of his work outside himself is a slave'.[88] Hess goes on to ask: 'Can we nowadays act according to our true human nature or truly enjoy our human life?', to which he answers, 'Absolutely not'. This is because, he says, '[a]lmost every activity in our society comes not from an inner drive of our human nature, not out of passion and love of labour, but out of external pressure, usually because of need or money'[89] and 'those life activities which are caused by inner drives, which we call pleasure or virtue, are perverted in such a way that they hurt the living enjoyment of human nature even more than this occurs through coercive labour'.[90] Among his descriptions of the 'hurt' that is characteristic of pleasure under existing conditions, he says, 'drinking turns into boozing' and 'taking a rest from strenuous work into laziness, scholarship into pedantry' and 'virtue into self-torture'.[91]

Although the politics of labour in Hess is quite different from the organisation of attractive labour by the Utopian Socialists, it is nevertheless the case that the Utopian Socialist principle of attractive labour was often a vision of how labour *could* be organised, not a vindication or celebration of actually existing work practices. Rather than acting as an ideological support for work – as the 'work ethic' is said to function – the vision of work as a joy eroded the condition under which work was a burden forced on the propertyless in exchange for wages. Before we explain the predicament of the workers on their persistent affirmation of labour rather than rejection of it, let's remember that the failure of the nineteenth-century workers' movement to bring about an abolition of their condition was not predetermined by their acceptance of the 'work ethic' or their hegemonic subjugation by the bourgeois ideology of work but by brutal state violence.

E.P. Thompson sums up the fate of the English workers' movement in the 1840s as the decade in which the Duke of Wellington led a middle-class mob against a Chartist demonstration, and the imprisonment, transportation and colonial emigration of radical workers as well as 'millions starved out of [their homes] in Ireland – and with the first great working-class party in Europe in

88 Hess 2004, p. 117.
89 Ibid.
90 Ibid.
91 Hess 2004, pp. 117–18.

total defeat'.[92] It was during this period that the Chartists wrote poetry and prose and sang hymns to the rights of the worker and lamented their lack of freedom and equality without venturing into statements about the human value of labour, the joy of labour or the identity of labour and pleasure.

Chartists recognised that the workers were the source of all life and wealth but they did not write about the experience of work itself except to complain about the endurance of toil. Labour, for the Chartists and the new Unions of workers, had another positive meaning, understood clearly by their class enemies. Elliot York M P for Cambridgeshire acknowledged this in a piece published in the Cambridge Chronicle in 1846, fearfully noting: 'I do not believe there is any village in my neighbourhood that would not be ready to assert by *brute force* their right (as they say) to eat fully the fruit arising from their own labour'.[93] And when the Chartists themselves spoke about labour and the labourers, they did not speak of pleasure but virtue and the production of wealth, as when John Thom characterised the workers as 'this class from which all blessings flow to those above them' and explained that it is 'the poor labourers and working mechanic, who are the real riches of a country, and never more so than when virtue and morality are the companions of their daily toil'.[94]

However, the transformation of work was not a major element of early Socialist proposals for utopian colonies. Of the three principal thinkers in the first wave of Socialist thought, only Fourier wrote about the transformation of work in the new society. When the idea of pleasure in work is retrospectively assigned to the utopian vision of attractive labour, this is better attributed to the revival of their ideas towards the end of the nineteenth century by artists committed to Socialism and a second revival of utopianism in the 1950s and 1970s by social theorists and philosophers. Before turning to these, however, I will take a fresh look at Marx's own response to German Idealism and Utopian Socialism in his concept of alienated labour.

92 Thompson 1961, p. 29.
93 Thompson 1984, p. 175.
94 Thompson 1984, p. 176.

CHAPTER 8

Alienated Labour

Marx enters the history of debates on the concept of labour in 1844. Marx's intervention has two prongs. In the *1844 Manuscripts* Marx comments on two separate discourses on labour, one philosophical and one economic. Marx brings the philosophical idea of alienation into proximity with the economic idea of labour but rather than developing an alienation theory of labour or a labour theory of alienation Marx critiques both alienation and labour simultaneously in the concept of alienated labour. None of the ingredients of Marx's theory of alienated labour are original but the combination of elements forms an unprecedented amalgam of the history of work, theories of free and unfree activity, the emergent politics of labour and the German Idealist philosophy of freedom.

Whatever else it is, Marx's concept of alienated labour is a significant intervention in the theory of labour as this was developing in philosophy, politics and economics in the first half of the nineteenth century since it performs a double rupture, simultaneously altering the course of the theory of labour and the philosophy of alienation. The proper names that signify the two components of Marx's thinking on labour are Hegel and Smith. Marx's concept of alienated labour sits at the intersection of these two schools of thought. Marx's first engagement with the labour theory of value in Smith and Ricardo occurred at the same time as his turn to labour to overcome the binary of materialism and idealism within his philosophical critique of Young Hegelianism. Hegel had drawn on Adam Smith and combined this with a theory of alienation but without giving any emphasis to labour.[1]

On the one hand, the economic conception of labour as the source of value is challenged by viewing labour from the perspective of the worker, and on the other hand, the Hegelian conception of alienation, which resolved all its negative moments in a positive conception of self-realisation, is critically reconfigured around the idea of the alien product appearing to the worker as a hostile thing, of the process of production being alienated from the worker who is no longer in control of work, and of the alienation of labour power as a saleable commodity.

1 What Hegel took from Smith was an ideal relationship between the individual and the universal via civil society, not the labour theory of value. And Hegel's theory of alienation served a contemplative philosophical system in which the subject came to full self-consciousness by recognising herself in the world that she has made.

Rousseau was the first to formulate a modern theory of alienation by extending and repurposing the legal-political conception of the distinction between the alienable and the unalienable as this was used by Steuart, for instance. Rousseau stands on the threshold of alienation as a technical term and the dialectical, historical, political and psychological conceptions of alienation that were to be developed by Hegel, Feuerbach and, later, the existentialists and the social scientists of the early twentieth century.[2] Rousseau's concept of alienation extrapolates from Steuart to address questions of political association. Rousseau understands the social contract as a metamorphosis of the natural rights of the individual into the guarantees of the state enjoyed by a citizen. He characterises this transfer of rights as an *aliénation totale*. The social contract is morally acceptable, in Rousseau's argument, if, instead of the renunciation of the individual will, there is a total alienation which is simultaneously an integral recovery of liberty, property, power and security. So, 'rather than an alienation, they have made an advantageous exchange'.[3] Rousseau's concept of alienation, therefore, is double-edged, based as it is on the loss of natural individual rights and the formation of the social relations that constitute the individual in its full sense. As Ludwig Siep notes,

> In Rousseau's *Discourse on Inequality*, alienation is the loss of identity, autonomy, and happiness on the part of the individual. The development of culture, of cohabitation, and of the distribution of labor disrupts the original equilibrium between needs and their fulfillment, between self-understanding and action. Modern man in the urban cultures of the eighteenth century does not live on his own terms, in harmony with his nature and his authentic experiences and aims. His very self-consciousness has become completely dependent on comparison with others, on fashions and expectations, on contrasts and artificial distinctions.[4]

Significantly, then, alienation is a central component of Rousseau's concept of emancipation.[5] Alienation is not the problem which emancipation dissolves. On the contrary, alienation is the historical process by which purely private interests are superseded by social and civic or communal interests. For Rousseau the only way to conceive of the conditions under which individuals

2 See Campbell 2012.
3 Rousseau 2012 (1762), p. 36.
4 Siep 2014, p. 178.
5 See Horowitz 1986, p. 79. Hence: 'The contract is thus a compounding of alienation and not its solution' (Horowitz 1986, p. 78).

or households give up their natural rights is under the state and the sovereign who heads it, hence for him, in Horowitz's words, the 'answer to the state of alienation is the state as the alienated expression of communal life'.[6]

Rousseau supplies the prototype for the concept of alienation developed by Hegel. Hegel extends and cascades Rousseau's notion of alienation (that the social contract is the outcome of the alienation of the individual in the community), to characterise not only the relationship between the citizen and the state but the human being and nature. And like Rousseau's vindication of the social contract, alienation is not characterised only by loss insofar as the individual's 'true original nature and substance is the alienation of himself as spirit from his natural being'.

Hegel refers to various kinds of activity including work and even art, but he neither develops a concept of alienated labour nor does he put labour at the heart of his conception of alienation. This reference to activity, labour and art is at its most emphatic when Hegel writes, 'a child's first impulse involves this practical alteration of external things; a boy throws stones into the river and now marvels at the circles drawn in the water as an effect in which he gains an intuition of something that is his own doing' and also, he says, this same dialogue with the world 'runs through the most diversiform phenomena up to that mode of self-production in external things which is present in the work of art'. Hence, for Hegel, 'the externalization [alienation] of self-consciousness that posits thinghood ... has not merely a negative but a positive meaning ... for in this externalization [alienation] it posits *itself* as object, or the object as itself'.[7]

It is possible to interpret the concept of alienated labour as nothing but the preservation of the Hegelian concept of alienation within the materialism of Feuerbach pressed into the labour theory of value. Such a reading can proceed by recognising the various debts of Marx. In this reading, the concept of alienation within alienated labour is assumed to be a survival from Hegel, Marx's 'new materialism' is not adequately distinguished from Feuerbach's 'old materialism' and Marx's labour theory of value is seen as borrowed from the classical political economists. The result of such studies tends to draw Marx's *1844 Manuscripts* into the orbit of the Young Hegelians or even casts Marx as a Feuerbachian pure and simple. However, the concept of alienation undergoes a profound transformation with the theory of alienated labour and the concept of labour found in political economy is given its first radical critique in Marx's elaboration of the theory of alienated labour.

6 Horowitz 1986, p. 78.
7 Hegel 1977 [1807], p. 479.

Hegel never used the term 'alienated labour' and it is only in retrospect that references to alienation in Hegel's writing can be interpreted in terms of the alienations of labour. Chris Arthur is right to warn that, 'it is one thing to read Marxism back into Hegel, it is another to generate it out of Hegel'.[8] In fact, it is Marx not Hegel who is the origin of the spread of the concept of alienation, albeit through the overemphasis of alienation in the concept of alienated labour by generations of writers who have neglected the specific concept of alienated labour. A linear inheritance of the concept of alienation in Rousseau, Hegel and Feuerbach can be detected in Marx's concept of alienated labour only by minimising the concept of labour in it. However, it is Marx who is the source of the exaggeration of the presence of Hegel in the concept of alienated labour.

Marx's notebooks of 1844 (and in his published work after that date) have been widely read as providing a theory of labour combined with a philosophy of alienation. In my reading, however, Marx's theory of alienated labour in 1844 is a twin critique of existing theories of labour and alienation. I want to make two claims about this. First, alienated labour was the first critical theory of labour. And second, Marx's concept of alienated labour was as much a critique of the concept of alienation as it was a critique of the concept of labour. I will critically revisit the Hegelian Marxist tradition of thinking about alienation and labour in Marx before outlining my alternative reading.

Lukács set the pattern for thinking about alienation in Marx even before the *1844 Manuscripts* were rediscovered in the 1930s. His *History and Class Consciousness*, originally published in 1922, manages to assemble a coherent account of alienation in Marx's writings from fragments in *Capital* Volumes I and III, *A Contribution to the Critique of Political Economy*, *The German Ideology*, and other texts, without the benefit of the section on Estranged Labour in the *1844 Manuscripts*. What is striking about Lukács's account of alienation, from the perspective of the concept of alienated labour, is that textual evidence from Marx which repeatedly characterises alienation in terms of labour is interpreted by Lukács in terms of 'the reified structure of consciousness'.[9] The principal axis of Lukács's analysis is plotted between the commodity-form and ideology, with the consciousness shaped by commodity relations characterised as *reification* (relations between people taking on the character of relations between things), and the consciousness of the proletariat in its confrontation with capitalism as the negation of reification. Lukács roots his concept of reific-

8 Arthur 1983, p. 67.
9 Lukács 1971, p. 99.

ation in Marx's concept of commodity fetishism: 'Marx describes the basic phenomenon of reification as follows: "A commodity is therefore a mysterious thing, simply because in it the social character of men's labour appears to them as an objective character stamped upon the product of that labour"'.[10] And while this passage triggers a few pages of discussion of labour, some of it showing an expert grasp of the concept of alienated labour,[11] for Lukács the lesson to be drawn from these observations is the 'split between the worker's labour-power and his personality, its metamorphosis into a thing, an object that he sells on the market ... a commodity'.[12] Labour is understood, here, under the theory of the commodity-form rather than the commodity being understood as the alienation of the product of labour. While it is important to note that, 'after reading Marx's *1844 Manuscripts* in Moscow in the 1930s, he was to substitute the more optimistic concept of "labour" for that of the "commodity" as his starting point for historical materialism',[13] it is equally important to recognise that at no point does *alienated* labour (or, a critical rather than optimistic concept of labour) become the basis for Lukács's social ontology.

Alienated labour plays a very minor role in Lukács's work. When he refers to the conditions for 'the commodity structure to penetrate society in all its aspects and to remould it in its image',[14] he does not acknowledge the sale of labour for a wage as one of the principal forms in which commodification is experienced. Even in his later work, such as the chapter on labour in his ontology of social being, there is no mention of alienated labour and hardly any reference to the labour as estrangement rather than objectification, even less to the product of labour becoming a hostile power against the labourer. Lukács's persistent neglect of the critical potential of the concept of alienated labour in Marx, despite referring to it on several occasions, might be attributed to his filtering of Marx through Weber. Weber characterises the difference between the artisan and the worker in terms close to those of Marx's concept of alienated

10 Lukács 1971, p. 96.
11 Lukács writes: 'a man's own activity, his own labour becomes something objective and independent of him, something that controls him by virtue of an autonomy alien to man' (1971, p. 87); and: 'a man's activity becomes estranged from himself, it turns into a commodity which, subject to the non-human objectivity of the natural laws of society, must go its own way independently of man just like any other consumer article' (ibid.); 'the process of labour is progressively broken down into abstract, rational, specialised operations so that the worker loses contact with the finished product and his work is reduced to the mechanical repetition of a specialised set of actions' (Lukács 1971, p. 88).
12 Lukács 1971, p. 99.
13 Stedman-Jones 1971, p. 60.
14 Lukács 1971, p. 85.

labour,[15] but his conclusion is that '[w]hat is specific to modern capitalism' is 'the strictly rational organisation of work', and this leads Lukács to place the emphasis on bureaucracy and reification rather than alienated labour. In his 1967 *Preface* to Volume 2 of his writings, which later appeared in the English translation of *History and Class Consciousness* in 1971, Lukács explained that he had followed Hegel's definition of alienation as objectification and criticises his own early work on this account, and defends himself by saying 'when I identified alienation with objectification I meant this as a societal category – socialism would after all abolish alienation'.[16] He also conceded that 'the phenomenon of reification is closely related to that of alienation but is neither socially nor conceptually identical with it. Here [in *History and Class Consciousness*] the two words were used synonymously'.[17] It is vital to note, here, the persistent reference to alienation and the complete absence of alienated labour from his conceptual apparatus. Lukács sketches the context in which alienation was used by him in the 1920s:

> This is the question of alienation, which, for the first time since Marx, is treated as central to the revolutionary critique of capitalism and which has its theoretical and methodological roots in the Hegelian dialectic. Of course the problem was in the air at the time. Some years later, following the publication of Heidegger's *Being and Time* (1927), it moved into the centre of philosophical debate. Even today it has not lost this position, largely because of the influence of Sartre, his followers and opponents.[18]

Clearly, therefore, Lukács's concept of alienation is detached from the concept of alienated labour. This is partly because Lukács takes Hegel as his point of departure for a Marxian concept of alienation in general, and partly because Lukács built his theory of alienation around the commodity-form.

When alienation is privileged over the concept of alienated labour, Marx's concept of alienated labour is seen as nothing more than a contribution to the

15 Weber writes: 'The relative independence of the artisan (or cottage craftsman), of the landowning peasant, the owner of a benefice, the knight and vassal was based on the fact that he himself owned the tools, supplies, financial resources or weapons with the aid of which he fulfilled his economic, political or military function ... [whereas in modern capitalism] the tools, supplies and financial resources essential both for the business-concern and for economic survival are in the hands, in the one case, of the entrepreneur and, in the other case, of the political master' (quoted in Lukács 1971, p. 95).
16 Lukács 1971, p. xxiv.
17 Lukács 1971, pp. xxiv–xxv.
18 Lukács 1971, p. xxii.

concept of alienation. In the words of Gerald Sykes (in the introduction to the two-volume anthology on Alienation published in 1964), Marx seems to differ from Rousseau ('we live alienated from nature') and Kierkegaard ('we live alienated from ourselves') as follows: Marx claims that 'we live alienated from society'.[19] Likewise, Erich Fromm conceives of alienated labour as a particular form of alienation, saying '[f]or Marx the process of alienation is expressed in work and in the division of labor'.[20] Instead of thinking of alienated labour, therefore, as either an alienation theory of labour or a labour theory of alienation, that is to say, of viewing alienated labour only through the lens of alienation theory, I hope to disentangle alienated labour from the philosophy of alienation by acknowledging that Marx's adoption of the concept of alienation in the *1844 Manuscripts* and beyond is one half of an act of splicing together two distinct concepts, two intellectual traditions, and two methodologies. Marx montages alienation and labour together. The clash of opposites transforms the significance of each of the component parts. When writers read Marx's chapter on Estranged Labour as a redeployment of the Hegelian and Feuerbachian idea of alienation (sometimes completely failing to refer to the concept of alienated labour altogether), or when thinkers interpret the concept of alienated labour as a lamentable or revolutionary revitalisation of the concept of alienation, the whole concept of alienated labour is fractured and diminished and its specificity is sacrificed. It is true that Marx occasionally refers to the 'alienation of life' and the 'abolition of all alienation', rather than to the abolition of alienated labour specifically, but he does so through a theory of alienation that is oriented around the concept of alienated labour. For Marx, I want to insist, the root of all alienation is alienated labour.

Marcello Musto traces three rival interpretations of the *1844 Manuscripts* that competed within the Marxist tradition between the 1930s and the 1960s. The first group, which consists of heterodox Marxists, theologians and existentialists, 'stress the theoretical pre-eminence of the former work', and this position survives in the various claims that the *1844 Manuscripts* or the *Grundrisse* ought to be taken as superior to *Capital* and the alleged economic determinism of orthodox Marxism. The second argue for a break between the early and mature work in which only the later work is considered to represent Marxism proper, and this position, both the official line of Marxism-Leninism and elaborated by Althusser and the Althusserians, continues to be asserted in which the Marx of the *1844 Manuscripts* is seen as 'the Marx most distant from Marx-

19 Sykes 1964, p. xiiv.
20 Fromm 2003 [1961], p. 39.

ism'. And 'a third tends toward the thesis that there is a theoretical continuum between them and *Capital*', which is epitomised by Western Marxism generally and is the position, specifically, of Marcuse and Lukács as well as Henri Lefebvre and Ernest Mandel, amongst many others. Each position on the early notebooks of Marx, we can say, has its own implications for the concept of alienated and non-alienated labour. The first and third groups have generated theories of alienated labour whereas the second group has opposed this concept as part of their more general rejection of the humanist theory of alienation. Alfred Schmidt, for instance, 'opposed the widespread Western European, often neo-Existentialist, tendency of the 1950s to reduce Marx's thought to an unhistorical "anthropology" centred on the alienation problematic of the early writings'.[21]

Whereas in Hegel and Feuerbach various forms of activity are written into the concept of alienation, in Marx alienation is inscribed into labour and the worker. However, Marx does not merely introduce labour as a positive and active counterpart to contemplation. Labour is conceived by Marx not as the embodied equivalent of Aristotle's activity as an end in itself but as the embodiment of estrangement, objectification and alienation. When, in the *Grundrisse*, for instance, Marx refers to 'objectified labour', he does so to characterise the metamorphosis of labour into capital. Compared directly with Hegel's version of the objectification of the subject in the world, Marx's theory of objectified labour appears as a cruel joke played on German Idealism by the capitalist mode of production. When time rather than the subject of the producer is objectified in the product, the Hegelian and Feuerbachian concept of alienation/objectification is dissolved into the analysis of labour subsumed under capital.

Acknowledging that '[t]he objectification of the general, social character of labour (and hence of the labour time contained in exchange value) is precisely what makes the product of labour time into exchange value', meant that, for Marx, alienation had to be understood through labour and, therefore, labour had to be understood as alienated. For Marx, this meant not only assembling anecdotes about boys throwing stones into lakes but taking as his point of departure the actual productive activity of modern industrial capitalism. The concept of alienated labour in Marx is the result of what Althusser called the 'double rupture', that it to say the phased critique first of Hegel in a Feuerbachian vain, and then of Feuerbach through an emphasis on labour. This is why 'Marx's intense study of political economy sharpened his criticism of Feuerbach'.[22]

21 Schmidt 1971 [1962], p. 9.
22 Mészáros 1986 [1970], p. 85.

Feuerbach is not merely the bridge between Marx and Hegel but the pivot by which Marx lifts Hegel off his perch. However, it is not Feuerbach but the concept of alienated labour that finally divides Marx from Hegel. David Fernbach, arguing in the wake of May '68 (when the *1844 Manuscripts* were under sustained and charged political analysis), adds a vital dimension to the philosophical drama. It is 'historical fact that Marx in 1843 and 1844 criticized Hegel and political economy from a philosophical standpoint very close to that of Feuerbach, and it is also historical fact that he was heavily involved both in 1844–50 and 1864–72 in the work of proletarian organization'.[23] That is to say, Marx's double critique of Hegel and Feuerbach coincides with his political engagement with labour as a category.

The concept of alienation that Marx deploys in the *1844 Manuscripts* and in all his subsequent writing is based on the concept of alienated labour not only as a philosophical critique of the Hegelian and Feuerbachian concepts of alienation as the alienation of spirit or of spiritual alienation, but also as a critical theory of labour as it was found in classical political economy, utopian socialism and 'materialist communism'. Rather than providing a philosophical account of the persistence of the concept of alienation within the concept of alienated labour, therefore, it is enlightening to regard the transition from the philosophy of alienation in general to the theory of alienated labour specifically not as an application of the concept of alienation to labour (or the embroidering of the intersection of alienation and labour already patchily present in Hegel and Feuerbach), but as an act of montage in which the philosophy of alienation is transformed by being sutured to the politics of labour, which is itself transformed by its contact with the philosophy of alienation.

Questions about the philosophical pedigree of the concept of alienation within the theory of alienated labour must be set alongside and not ahead of the question of how this idea inserted Marx's embattled philosophical inquiries into a political project that retained its fidelity to the ontological and political centrality of labour and the labourer that had been claimed by the Socialists and the workers' movement. Marx does not confirm one tradition of thinking by lining it up isomorphically with another. He stages a confrontation between them. In the concept of alienated labour Marx preserves neither the German Idealist theory of alienation nor the theory of labour in classical political economy. Alienated labour is not reducible to either objectification or the source of value and it is not an instance of alienation but reformulates the usable elements of the existing philosophy of alienation as a critical theory of labour.

23 Fernbach 1969, p. 63.

Alienated labour is not an alienation theory of labour (i.e. a German Idealist interpretation of political economy), nor is it a naïve attempt at a labour theory of value. Alienated labour is a labour theory of alienation. With the concept of alienated labour, alienation is no longer theorised in terms of rights (Rousseau), mental activity (Hegel) or religious loss (Feuerbach). Labour is no longer understood as work in the narrow and pejorative sense nor in the optimistic sense of 'transformative human activity' (that is, the active principal by which human beings act on the world and therefore act on themselves), but as the alienable activity through which alien products confront the producer as a hostile force.

'What, then, constitutes the alienation of labor?', Marx asks. His immediate answer bears quoting in full.

> First, the fact that labor is external to the worker, i.e., it does not belong to his intrinsic nature; that in his work, therefore, he does not affirm himself but denies himself, does not feel content but unhappy, does not develop freely his physical and mental energy but mortifies his body and ruins his mind. The worker therefore only feels himself outside his work, and in his work feels outside himself. He feels at home when he is not working, and when he is working he does not feel at home. His labor is therefore not voluntary, but coerced; it is forced labor. It is therefore not the satisfaction of a need; it is merely a means to satisfy needs external to it. Its alien character emerges clearly in the fact that as soon as no physical or other compulsion exists, labor is shunned like the plague. External labor, labor in which man alienates himself, is a labor of self-sacrifice, of mortification. Lastly, the external character of labor for the worker appears in the fact that it is not his own, but someone else's, that it does not belong to him, that in it he belongs, not to himself, but to another.[24]

No writer on labour had formulated a concept of labour like this before. There had been pejorative accounts of labour and utopian schemes for attractive labour, even sentimental poems to labour, but no critical theory of labour. In the *1844 Manuscripts* and the *Grundrisse*, written between 1857 and 1858, Marx formulated a concept of alienated labour that retains the legal meaning in Steuart, of property that is alienable and the Hegelian sense of the objectification of the subject in products, as well as combining the two in the formula of labour that 'objectifies itself in things not belonging to it'.[25] In addition, Marx

24 Marx 1959 [1844], pp. 72–3.
25 Marx 1973 [1857–58], p. 462.

refers to alienated labour as labour is not controlled by labourers themselves, the sale of labour to a hostile other and the product of labour acting as a hostile force against the producer.

The concept of alienated labour is the first critical theory of labour and the first labour theory of alienation. These two statements will need to be corroborated since they contradict a great deal of what has been written about Marx's concept of alienation, particularly the tradition of critical thinking that regards alienated labour as an alienation theory of labour and therefore falling short of the full, mature critical theory of labour that Marx developed in the three volumes of *Capital*. When I say that alienated labour is a critical theory of labour I mean that, in place of normative theories of labour (for example, pejorative theories of labour as drudgery or affirmative theories of labour as the activity of the self), and economic theories of labour (as the source of value), Marx reconceptualises labour not as the species-activity of human being in the abstract sense that philosophers have understood but as the specific activity of actual workers in various social conditions throughout history.

Whereas for Hegel, activity is the objectification of the subject in the external world, for Marx labour power is the alienable element of the 'free' labourer which results in 'the monstrous objective power which social labour itself erected opposite itself as one of its moments'.[26] This is not merely a difference of interpretation but is based on the fact that the product 'belongs not to the worker, but to the personified conditions of production, i.e. to capital'.[27] Marx, indeed, ascribes the difference between the two positions to a social division: 'objectification in fact appears as a process of dispossession from the standpoint of labour or as appropriation of alien labour from the standpoint of capital'.[28] In this sense, we could say that the Hegelian formula of the objectification of the subject in the product is not only passed through the filter of political economy but pressed into the class division that structures the capitalist mode of production.

Within the terms of Marx's concept of alienated labour, it is erroneous to separate self and society as two antithetical perspectives on questions of political conflict, subjective crisis and social reconciliation. Sean Sayers makes this mistake when he says:

> Marxism often presents itself as a purely social philosophy. The self is
> portrayed as a merely social creation. Marxists often seem to imply that

26 Marx 1973 [1857–58], p. 831.
27 Ibid.
28 Ibid.

social change alone will be sufficient to transform and realise the self –
as though 'after the revolution' all conflicts between self and society will
automatically be resolved without any action on the part of the individual
being required. This is untenable, as the existential account quite rightly
insists [he means Sartre].[29]

What such an argument fails to take into account is the philosophical signific-
ance of the concept of labour in Marx's confrontation with German Idealism.
Marx does not choose between Idealism and (the old) Materialism, self and
society or the subjective and the objective. He rejects the proposed resolu-
tion of philosophical and social contradictions within thought itself and, at
the same time, rejects what we would call the empiricist or positivist version of
materialism in which objects and facts are as inert as they are obdurate. Instead,
Marx reorients philosophy around the concept of labour which is reducible
neither to the objective world (since labour acts on the world subjectively) nor
to the subjective mind (since labour must exist within the world and respond
to it). What is untenable, therefore, is to think labour adequately through the
separate categories of self and society.

 Hegel and Marx differ insofar as the former articulates alienation as a prob-
lem of consciousness whereas the latter inscribes it in labour. Feuerbach played
an important role in Marx's reorientation of Hegel's theory of alienation but
Marx does not refer to the human being, as Hegel does. It is the worker not
'man' who executes human activity in Marx's discussion of alienated labour.
Marx not only draws attention to the perception of the self in the product but
stresses, instead, how the product is alienated from the producer and acts as a
hostile force. Hence, Marx writes:

> The alienation of the worker in his product means not only that his
> labor becomes an object, an external existence, but that it exists out-
> side him, independently, as something alien to him, and that it becomes
> a power on its own confronting him. It means that the life which he
> has conferred on the object confronts him as something hostile and
> alien.[30]

Alienated labour, for Marx, situates the worker within class relations that,
among other things, alienate the product from the producer and alienate the

29 Sayers 2011, p. 8.
30 Marx 1959 [1844], p. 70.

worker from work insofar as she sells her labour power to a hostile other and
therefore alienates the workers from a work process that is controlled by others.

There is a clear genealogical relationship to Feuerbach's theory of alienation
in Marx's concept of alienated labour, which Marx lays out frankly:

> Just as in religion the spontaneous activity of the human imagination, of
> the human brain and the human heart, operates on the individual inde-
> pendently of him – that is, operates as an alien, divine or diabolical activ-
> ity – so is the worker's activity not his spontaneous activity. It belongs to
> another; it is the loss of his self.[31]

And yet, this borrowing from Feuerbach is at the same time a transposition.
Marx, in effect, *replaces* Feuerbach's spiritual alienation (the externalisation of
human properties into a non-human divinity), with the non-spiritual and post-
humanist (no mention of human essence etc. but only of the worker) concept
of alienated labour. We get a clearer picture of the relationship between Marx
and Feuerbach by recognising the originality of the concept of alienated labour
rather than by crediting Feuerbach with the concept of alienation deployed in
the *1844 Manuscripts*.

Whereas in Hegel and Feuerbach various forms of activity are written into
the concept of alienation, in Marx alienation is first and foremost inscribed into
labour. All labour is alienated for Marx, and all alienation is expressed through
labour understood in its most capacious sense as human transformative activ-
ity. Marx does not formulate a theory of alienation in which individuals are
sundered from society in general and therefore live in a constant state of suf-
fering but he does refer to the 'increasing misery of the worker'[32] as a result
of the alienation of the product of labour and the alienation of labour power
within the wage system. In this respect, perhaps, we can say that in Hegel and
Feuerbach labour is marginal to the core issue of alienation, whereas for Marx
alienation in general is marginal to (and completely disappears in) the core
issue of alienated labour.

If Feuerbach can be credited with formulating the first critical or negative
conception of alienation that Hegel anticipated only in subordinate stages of a
dialectic that was ultimately positive and conservative, Marx's concept of alien-
ated labour pours the critical concept of spiritual alienation into the categories,
activities, structures and conflicts of modern society. Feuerbach's critical con-

31 Marx 1959 [1844], p. 73.
32 Marx 1959 [1844], p. 27.

ception of alienation was indirectly or implicitly critical of modern society in ways that were decipherable to his contemporaries but Marx's concept of alienated labour was formulated in such a way as to identify and critique the central problem of the advanced economies and the principle obstacle to the self-realisation of the human species as a whole in communism. As such, if Feuerbach's philosophy of alienation is the first critical theory of alienation, Marx's theory of alienated labour is the first revolutionary theory of alienation.

Marx does not merely write critically about labour but realises his critique of society through an analysis of labour as alienated and alienating. This means that he opens up the concept of labour to political critique. Where Hegel and Feuerbach might talk of the activity of man, Marx in 1844 talks about labour by referring to the worker. And, against the political economists, who regard the worker as both the source of value and the owner of a commodity (labour) which is sold for a wage, Marx shows that the labour of the worker produces not only commodities and wealth but also the conditions of the worker's material and spiritual impoverishment. Hence, in place of the philosophy of alienation, in which mankind is alienated from the world or god or essence, Marx refers to the alienation of workers and conceives of labour as the process of world-making in which the world acts as an alien force against the worker.

In the immediate wake of the publication of the *1844 Manuscripts* the concept of alienated labour was central to the thinking of a new generation of democrats, Christians and Romantic anti-capitalists as well as the first generation of Western Marxists, culminating in the debates on alienation, alienated labour and non-alienated labour in the 1950s, the structuralist and poststructuralist critique of humanism in general and Sartrean Marxism in particular. Effectively, the Marxist concept of alienated labour becomes misperceived by postmodernists as an iteration of the metaphysical concept of alienation because it is caught in the crossfire between structuralism and existentialism. The surge of structural models of analysis in the humanities and social sciences in the 1960s, in which 'Lévi-Strauss's pioneering importation of models from mathematics and linguistics',[33] specifically identified Sartre as the chief threat to 'extracting the formal conditions of social reality'.[34]

Jacques Lacan, Roland Barthes, Michel Foucault and Jacques Derrida would all take their point of departure from the philosophy of consciousness, as this was exemplified in the work of Sartre. Each, in different ways, pushed against the centred subject toward an account of codes, systems, orders, discourses,

33 Lizardo 2010, p. 652.
34 Lévi-Strauss 1966 [1962], p. 250.

and the like. In this assault on existentialism, understood as also a critique of Western philosophy generally, the metaphysics of the subject was indefinitely suspended through the vigilant labour of paying attention to its framings, formations, and regimes. The transfer of critical attention from the subject to the interrogation of structures became globally hegemonic when French theory was taken up by Anglophone writers and practitioners in the theoretical tendency of postmodernism. Jean-François Lyotard's *La Condition Postmoderne*, published in 1979, marks a threshold. Not a study of postmodern *society* or postmodern *culture* or the postmodern *era* (these terms belong to the lexicon of Enlightenment discourses of linear and stagist history that naturalise colonial asymmetry, gender regulation, and social stratification), Lyotard prefers the term 'condition' because it signifies a specific, contingent social system. Alienation theory appears to be rendered obsolete by the development of this kind of anti-humanism and post-humanism.

However, my aim here is not to reinstate the concept of alienation to the status it held prior to the structuralist assault on humanism. My focus is on alienated labour and my reading of Marx underlines the difference between speaking of alienation and the theory of alienated labour rather than interpreting alienated labour as an instantiation of the philosophy of alienation, that is to say as an alienation theory of labour or of the application of alienation theory to labour. I subscribe to the view, as expressed by Chris Arthur, that '[f]or Marx, from 1844, the problem of alienation in modern society is understood to gravitate around the estrangement of labour. All other spheres of estrangement are to be related to this'.[35] What will become clear, as I survey the literature on Marx's concept of alienated labour, is that the conceptual predominance of alienated labour in 'the problem of alienation' in Marx's writings is badly understood. What we find instead is the dominance of the concept of alienation in general over the concept of alienated labour, so much so in fact that alienated labour is often marginal or absent from great swathes of Marxist debates on alienation. Since my book is about art and labour I was bound to give more emphasis to the concept of alienated labour; however, in addition to this emphasis, I am convinced that Marx's concept of alienated labour is the key to understanding all instances of alienation in his writings. What's more, I am suspicious of those tidier philosophers who prefer to have one concept for the actual, concrete activity of labour under capitalism (presumably we can call this alienated labour) and another concept for the abstract, general idea of

35 Arthur 1986, p. 9.

labour ('universal ontological ground of social life',[36] as Arthur puts it), which we might call labour. The problem with such a distinction is that it acts as the preamble for a theory of labour that minimises or abandons Marx's critique of the philosophical and economic traditions of thinking about labour.

Philosophers have tended to reduce Marx's concept of alienated labour to the more general concept of alienation, or, to put the same point in a positive light, philosophers have refused to reduce Marx's concept of alienation to the specific concept of alienated labour. For philosophy, the concept of alienation within the concept of alienated labour must be addressed separately as part of any adequate interpretation of the concept of alienated labour. This is evident in the first phase of the Marxist discourse on alienation after the rediscovery of the *1844 Manuscripts* with Marcuse. In 1961 Robert Tucker claimed that Marx 'came to see alienation everywhere',[37] providing a list – 'religion, the state, law, the family, morality and, last but not least, the economic life'[38] – that did not specifically include alienated labour. Althusser's critique of Marx's concept of alienated labour, in fact, is thematised as a critique of the persistence of the concept of alienation within Marx's earliest writings on labour.

Carol Gould and Philip Kain bind Marx's concept of alienation directly to Hegel's, and Sean Sayers treats alienation as a 'Hegelian theme', only crediting Feuerbach for providing Marx with the concept 'species-being'.[39] More recently, Malcolm Bull and Marcello Musto have rejuvenated a 'fourfold form'[40] of alienation, drawing on Bertell Ollman's identification of four types of alienation in Marx. Whereas Ollman identified four ways in which the worker is alienated (1) in his productive activity, (2) in his product, (3) from other men, and (4) from his species, Bull does not include alienated labour or the alienation of the product of labour within his fourfold alienation.[41] He places the stress firmly

36 Arthur 1986, p. 17.
37 Tucker 1971, p. 102.
38 Ibid.
39 Sayers 2011, p. 145. Feuerbach draws the idea of species being – if not the term – from Goethe who said, '[o]nly men taken together ... live human nature'.
40 Bull 2010, p. 23.
41 Compare Siep's four concepts or four variants of the concept of alienation in Hegel: first, the alienation internalised by the 'unhappy consciousness', consisting of self-denial, which is connected with Rousseau's original conception of alienation; second, 'alienation as the work's mastery over its author'; third, alienation as 'a world split in two and of the transfiguration of the present into a better, but unreal, beyond'; and fourth, alienation as the dissolves of the spiritual order and the traditional moral order by secularisation and Enlightenment respectively (Siep 2014, pp. 176–7).

on the concept of alienation independent of labour. Bull says, 'both alienation and communism are defined within the same matrix, one axis of which locates man's simultaneous alienation from nature and from his own cultural production, the other his alienation from both public and private life'. Significantly, Bull quotes Marx directly: 'alienated labour tears man from the object of his production ... his own body, nature exterior to him, and his intellectual being, his human essence', but reads this as saying: 'Together they constitute alienation from species being, the life that man would have if he were fully socialized, and society was not merely the means but also the end'.[42] Labour appears to be systematically redacted from alienated labour in the philosophical reading of Marx in order to focus on the concept of alienation, as if to get to something more significant.

Bull is programmatic in turning away from alienated labour in order to focus on alienation in general, as is demonstrated in the following passage that I will quote in full.

> Communism involves 'the positive abolition of all alienation, thus the return of man out of religion, family, state, etc [he might have added, nature], into his human, i.e. social being'. It takes place both on the public–private axis, where 'human emancipation will only be complete when the real, individual man has absorbed into himself the abstract citizen; when as an individual man, in his everyday life, in his work, and in his relationships, he has become a species-being'; and on that of nature and culture: 'society completes the essential unity of man and nature ... the accomplished naturalism of man and the accomplished humanism of nature'.[43]

Where Bull says 'communism involves' Marx actually says: 'Communism as the *positive* transcendence of *private property*, as *human self-estrangement*, and therefore as the real *appropriation of the human essence* by and for man', and therefore Communism is the 'positive transcendence of private property as the appropriation of *human* life is, therefore, the positive transcendence of all estrangement – that is to say, the return of man from religion, family, state, etc., to his *human* i.e. social mode of existence'.[44] At every step Marx ties the concept of alienation to real social circumstances, or, more precisely, elaborates the concept of alienation only through specific social conditions.

42 Bull 2010, p. 23.
43 Bull 2010, p. 24.
44 Marx 1959 [1844], p. 103 (original emphasis).

Alienation, for Marx, is not articulated separately from theorising labour and the social relations through which labour is structured. The difference between stressing alienation in general and stressing alienated labour in particular is that the former fails to acknowledge that Marx provided a new basis for the philosophical idea of alienation with his own concept of alienated labour. Hence, even if Marx speaks more generally about the 'alienation of life' and the 'abolition of all alienation', he does so through a theory of alienation that is oriented around the concept of alienated labour. The abolition of all alienation is dependent upon the abolition of private property because all alienation in Marx is the root of all alienation is alienated labour and the alienation of the product from the labourer.

Crediting Hegel or Feuerbach with Marx's concept of alienation within alienated labour serves to limit the examination of the convergence of economics, philosophy and revolutionary politics that informed Marx formulation of a critical theory of labour. 'The political conjuncture which Marx and Engels faced in the late 1830s and early 1840s', Göran Therborn explains, 'combined three important moments'.[45] First, was the French Revolution and the July revolution of 1830 and the English parliamentary reform of 1832 which followed it. Second was the failure of the bourgeois revolution in Germany which cast a shadow over the programme of the Young Hegelian philosophers. And third was the 'decisive appearance'[46] during this period of the working class as an economic, social and political force.

At the same time, the young Marx was building a new life. In the words of Jonathan Rée,

> Karl Marx was certainly elated around the time of his twenty-sixth birthday in May 1844. He was living in Paris, newly married; his daughter, Jenny, was just a few days old; and he was filling page after page of his notebooks with hectic hopes for the dawning of a communist new age.[47]

In the August of the same year, Engels went to Paris to meet Marx and by April the next year they had written two major texts together, *The Holy Family* and *The German Ideology*, both of which drove a wedge between themselves and the Young Hegelians. At the same time, Engels was completing his book on the condition of the working class in England and Marx was writing notes in

45 Therborn 1973, p. 8.
46 Ibid.
47 Rée 2000, p. 163.

which his reading of political economy was woven into a rereading of Hegelian philosophy via the Christian materialism of Feuerbach both of which were subjected to immanent critique. Marx built on German philosophy, of course, but he did so by fusing it with the new theory of labour in general which he takes form classical political economy and emergent debates on working conditions and the conditions of the working class which were generating new meanings for labour and from which Marx formulated a new ontology of labour.

For Althusser, the decisive issue in Marx's critique of Hegel that separates it from Feuerbach's critique of the same work is 'the abandonment of the philosophical problematic'.[48] Étienne Balibar follows the same line, saying Marx's *Theses on Feuerbach*, written in March 1845, are characterised by 'a repeated exit from theory in the direction of *revolutionary activity (or practice)*'.[49] Marx differentiated himself from Feuerbach, in the first thesis, along the division between theory and practice: 'he regards the theoretical attitude as the only genuinely human attitude ... he does not grasp the significance of "revolutionary", of "practical-critical" activity'.[50] The third thesis also refers to 'the changing of circumstances' as 'self-changing' and 'revolutionary practice'.[51] In the fourth thesis, Marx describes Feuerbach's concept of 'self-alienation' in terms of the secular discovery that the holy family is modelled on the earthly family and complains, in the fifth thesis, that Feuerbach 'does not conceive sensuousness as *practical*, human-sensuous activity'.[52] This is why he characterises Feuerbach's philosophy as a 'contemplative materialism'[53] in thesis nine.

What separates the old contemplative materialism from the new materialism instigated by Marx, therefore, is that human-sensuous practice is conceived as 'the ensemble of social relations'.[54] As such, when Marx says, in the eleventh and final thesis that '[t]he philosophers have only interpreted the world, in various ways; the point is the *change* it',[55] he does so in the context of a joint emphasis on practice and revolution. As such, I will argue below, it is one-sided to interpret the reference to change the world only in terms of a transition from philosophical contemplation to revolutionary activity since it also refers to the

48 Althusser 2005 [1965], p. 48.
49 Balibar 2007 [1993], p. 13.
50 Marx 1996 [1845], p. 121.
51 Ibid.
52 Marx 1996 [1845], p. 122.
53 Marx 1996 [1845], p. 123.
54 Marx 1996 [1845], p. 122.
55 Marx 1996 [1845], p. 123.

contrast which Marx at this time was formulating for the first time between the resolution of contradiction through thought and the resolution of contradiction through (alienated) labour.

Althusser's timeline of Marx's 'epistemological break' categorises the *1844 Manuscripts* as among Marx's early humanist philosophy before the mature critique of political economy. Mandel follows this line of argument when he characterises the *1844 Manuscripts* as 'interpreting the socioeconomic passages [long quotations from Smith, Say and others] in a philosophical sense'.[56] For these writers, and others like them, the watershed, and what needs to be detected in the literature, is the shift from idealism to materialism or the transition from philosophy and contemplation to politics, practice and revolution. However, my inquiry demands a different optic. I am not claiming, as Chris Arthur does, that the 'turning point in Marx's intellectual development comes in 1844 with his discovery of *labour*, an event documented in his manuscripts composed in Paris that year under the impetus of his first encounter with political economy'.[57] Instead, I am interested in the possibility that the timing of the epistemological break is linked to the concept of alienated labour and might be affected by the interpretation of it.

The argument for the epistemological break in Marx's *oeuvre* is undermined by the persistence of the concept of alienated labour in Marx's mature writing. Musto explains: 'Whereas, for Althusser, it is a "philosophical category" that "Marx's scientific work tended to get rid of", the truth is that, not only in the [*Economic-Philosophic Manuscripts of 1844*], but also in the [*Grundrisse*], *Capital* and its preparatory manuscripts, it plays an important role in characterizing labour and social relations in the capitalist system of economy and production'.[58] More particularly, though, it is the persistence of the concept of alienated labour rather than alienation per se that is significant. Althusser's placement of the break between the *1844 Manuscripts* and the 1845 *Theses on Feuerbach* is tied up with the interpretation of Marx's concept of alienated labour as the persistence of Feuerbachian philosophy within Marx, as the preservation of the Young Hegelian idea of alienation. Althusser bases his analysis of the status of the *1844 Manuscripts* on the assumption that alienated labour is an alienation theory of labour (i.e. a philosophical and humanist view of labour), rather than a labour theory of alienation, which is to say a materialist critique of the metaphysics of alienation theory.

56 Mandel 1971, p. 62.
57 Arthur 1986, p. 105.
58 Musto 2015, p. 249.

Evidence that Marx was dismissive of the concept of alienation in *The German Ideology* is scant. Marx placed the term in quotation marks and qualified its use, saying: ' "Alienation" (to use a term which will be comprehensible to the philosophers)'. There is also a barbed remark by Marx and Engels in *The Communist Manifesto*, when they said: 'The German literati ... wrote their philosophical nonsense under the original French [socialist and communist literature]. For example, under the French critique of monetary relations they wrote "externalisation [Entäußerung] of the human essence" ... The literature of French socialism-communism was thus punctiliously emasculated'.[59] The phrase is from 'The Essence of Money' by Moses Hess, but what remains unclear is whether the error that is highlighted by Marx and Engels concerns the term 'externalisation' or the concept of 'human essence'. My point is not to defend the concept of alienation in its general form. I revisit these interpretations of Marx's apparent cooling attitude towards alienation only to point out that Marx's alleged rejection of the concept of alienation only a year after the *1844 Manuscripts* in *The German Ideology* did not include the rejection the concept of alienated labour. And if, as I argue, the concept of alienated labour is the principal form in which Marx both borrows and transforms the concept of alienation from German Idealism, then the test of any alleged *volte face* must turn not on his subsequent position on alienation in general but alienated labour in particular.

In the section of the *1844 Manuscripts* titled 'Estranged Labour' by its editors, Marx alloys German Idealist philosophy with classical political economy in the concept of alienated labour. This has been interpreted within the Althusserian tradition and elsewhere as a bridge from philosophy to politics in which the force of Hegel and Feuerbach remains potent and the critique of capital has not fully formed. If we interpret the opposition between interpreting the world and changing it as a call for philosophers to become revolutionaries, then the *1844 Manuscripts* fall some way short of the highest ambitions of Marxist thought. However, if we understand the reference to changing the world as pointing towards the importance of practice, activity and labour in the critique of the Young Hegelian emphasis on contemplation, then the *1844 Manuscripts*, and especially the section on estranged labour, do not represent the persistence of German Idealism in Marx but mark the first decisive step out of it. While Henri Lefebvre assesses the contribution of the *1844 Manuscripts* with the warning that 'historical and dialectical materialism *developed*. It did not come into being

59 Marx and Engels 2015 [1848], p. 255.

abruptly, with an absolute discontinuity, after a break', we can say, nonetheless, that these notebooks do in fact represent an abrupt introduction of a critical theory of labour.

What Marx writes in his notes on estranged labour in 1844 is consistent with his discussion of alienated labour in the *Grundrisse* and what he comes to say in *Capital*, which was published in 1867. There, alienated labour reappears as both the alienation of the labourer in the process of production and the aliena-tion of the product from the producer. First, he says: 'his own labour has already been alienated from him, appropriated by the capitalist, and incorporated with capital, it now, in the course of the process, constantly objectifies itself so that it becomes a product alien to him'.[60] Then he adds: 'the worker himself constantly produces objective wealth, in the form of capital, an alien power that domin-ates and exploits him'.[61] Wages are reconceived, accordingly, as the 'appropri-ation of alien labour' through 'the exchange of objectified labour as exchange value for living labour'.[62] Fixed capital is understood in the *Grundrisse* as cor-responding to the formula of alienated labour as follows: 'all powers of labour are transposed into powers of capital; the productive power of labour into fixed capital (posited as external to labour and as existing independently of it)'.[63] Money, he writes, 'functions as a means of circulation only because in it the value of commodities has taken on an independent shape',[64] like the qualities of human beings alienated in the shape of God. Labour-power, too, is formu-lated in *Capital* by Marx in terms derived from his theory of alienated labour. The worker, he says, 'must constantly treat his labour-power as his own prop-erty, his own commodity, and he can do this only by placing it at the disposal of the buyer'.[65] As such, labour power is that part of the labourer which is alien-able since the labourer is not the commodity for sale. 'In this way', Marx says, 'he manages to both alienate his labour-power and to avoid renouncing his rights to ownership over it'.[66]

When Marx argues in *Capital* that labour is an exclusively human activity, contrasting it with the constructions of spiders and bees, he does so by drawing on the concept of alienated labour. Initially he presents this in Hegelian terms but the formula is quickly subverted. Labour, he says, 'is, first of all, a process

60 Marx 1990 [1867], p. 716.
61 Ibid.
62 Marx 1973 [1857–58], p. 514.
63 Marx 1973 [1857–58], p. 701.
64 Marx 1990 [1867], p. 212.
65 Marx 1990 [1867], p. 271.
66 Ibid.

between man and nature ... [through which] he acts upon external nature and changes it, and in this way he simultaneously changes his own nature'.[67] That is to say, labour is the process by which human beings transform themselves by imposing themselves on the world. Hence, as he famously states, 'what distinguishes the worst architect from the best of bees is that the architect build the cell in his mind before he constructs it in wax'.[68] In other words, the architect is emblematic of the Hegelian objectification of the subject in products. 'Man not only effects a change of form in the materials of nature; he also realizes his own purpose in those materials'.[69] However, Marx adds, the producer must subordinate herself to the plan and therefore a conflict arises between subordination and pleasure.

> Apart from the exertion of the working organs, a purposeful will is required for the entire duration of the work. This means close attention. The less he is attracted by the nature of the work and the way in which it has to be accomplished, and the less, therefore, he enjoys it as the free play of his own physical and mental powers, the closer his attention is forced to be.[70]

As such, Marx immediately inverts the image of the human worker as a Hegelian subject whose products are an objectification of her own will: the intention or the plan in which the product 'already existed ideally'[71] in the mind of the builder, emerges as an alien power over the worker. Clearly, the subordination of the worker to the plan is more emphatic in the case of a labourer executing the plans of an employer or boss the more that the formal subsumption of labour under capital (i.e. as wage labour) is converted into the real subsumption of labour under capital (i.e. its transformation into the capitalist mode of production).

Typically, alienation is detected in the pages of *Capital* within the passages on commodity fetishism. And this is justified, at least up to a point. Echoing Feuerbach, Marx turns to the concept of fetishism as an analogy in the way that he did when, in the passage already quoted, he explained the alienation of labour through a comparison with religion: 'Just as in religion the spontaneous activity of the human imagination, of the human brain and the human heart,

67 Marx 1990 [1867], p. 283.
68 Marx 1990 [1867], p. 284.
69 Ibid.
70 Ibid.
71 Ibid.

operates on the individual independently of him'. In the discussion of fetish-
ism Marx says 'the products of the human brain appear as autonomous figures
endowed with a life of their own'.[72] The value of commodities in exchange,
which is 'nothing but the definite social relation between men themselves' non-
etheless appears as 'the fantastic form of a relation between things'.[73] While
recognising the validity of the interpretation of commodity fetishism as an ali-
enation theory of value that reprises steps that Marx took when transposing
Feuerbach's theory of spiritual alienation in the *1844 Manuscripts*, this inter-
pretation puts more stress on the perpetuation in Marx's mature writing of a
theory of alienation *per se* rather than a theory of alienated labour in partic-
ular. This concept survives in *Capital*, for instance, when Marx theorises the
'dialectical inversion'[74] through which 'within the capitalist system all meth-
ods for raising the social productivity of labour are put into effect at the cost of
the individual worker'.[75] Which is to say, labour alienated as surplus value and
fixed capital imposes itself as the personification of capital, that is, as an alien
and hostile force against labour, so that 'they become means of domination and
exploitation of the producers'.[76] What's more, Marx observes, such methods of
increasing productivity (mechanisation, technical division of labour, etc.) 'ali-
enate from him the intellectual potentialities of the labour process in the same
proportion as science is incorporated in it as an *independent power*'.[77]

The possessors of commodities, Marx says in *Capital*, engage in exchange by
becoming the bearers of commodities, that is to say, by existing for one other
as nothing but 'representatives'[78] of commodities. 'In order that these objects
may enter into relation with each other as commodities', Marx explains, 'their
guardians must place themselves in relation to one another as persons whose
will resides in those objects'.[79] Marx carefully holds a position, here, between
commodities as the objectification of their owners and their owners being
nothing but the personifications of an alien power. 'For the owner', Marx adds,
'his commodity possesses no direct use-value. Otherwise, he would not bring it
to market. It has use-value for others; but for himself its only direct use-value
is as a bearer of exchange-value, and, consequently, a means of exchange'.[80]

72 Marx 1990 [1867], p. 165.
73 Ibid.
74 Marx 1990 [1867], p. 799.
75 Ibid.
76 Ibid.
77 Marx 1990 [1867], p. 799 (emphasis added).
78 Marx 1990 [1867], p. 179.
79 Marx 1990 [1867], p. 178.
80 Ibid.

Marx thus characterises the owner of commodities, that is to say, the seller rather than the consumer, as alienated from their own possessions at least insofar as use is concerned. The owner, he says 'makes up his mind to sell it in return for commodities whose use-value is of service to him'.[81] Marx concludes: 'All commodities are non-use-values for their owners, and use-values for their non-owners'.[82] Here, I think, we can detect the operation of the dialectical logic of alienated labour rather than the variant of alienation that is expressed in the concept of commodity fetishism. Marx extends the familiar argument since Steuart that the producer is alienated from her own products, by arguing that the owner of commodities is also alienated from her own possessions insofar as she has no use for them.

Neither the capitalist nor the wage labourer produce for their own use or to satisfy their own needs and desires: both, in principle, subordinate themselves to the consumer, and neither therefore recognise themselves in the world that they help to produce. It is not the producers (split into capitalists and wage labourers) who are objectified in the world, but consumers (who represent disposable wealth). Since disposable wealth is spent on commodities through the mediation of market mechanisms, which use incentives to bring about 'trade-offs', the consumer, like the producers, does not typically encounter commodities as things of use but things of value (markets discipline consumers to purchase a commodity because it is affordable, rather than consuming something that is preferred over all others regardless of price). As such, none of the characters portrayed by classical political economy escape from the matrix of alienated labour that Marx develops from 1844 onwards. In capitalism the product as commodity is neither the objectification of the worker nor the objectification of the capitalist as subject or personality. If the commodity appears to be the objectification of the capitalist it is only insofar as the capitalist is already the personification of capital. Alienated labour theorises the product as the objectification of capital.

For Marx there are various kinds of alienated labour, not merely the two-way conception of objectification and estrangement. Labour is alienated from its product and labour alienates itself by being sold to a hostile other. These two linked but separate modes of alienated labour indicate the two prongs of Marx's theory of alienated labour which forks at the junction of the producer and the product. Both preserve and extend James Steuart's concept of the alienable. Marx does not reduce the concept of alienated labour to that which

81 Marx 1990 [1867], p. 179.
82 Ibid.

is alienable, however. He builds his theory of alienated labour on the recognition that the sale of the product and the sale of labour power require separate investigations. In pre-capitalist conditions the producer is alienated from her product either through the sale of surpluses and/or through the appropriation of a portion of the product by the landowner or master. In capitalist relations of production, in which wage labour is dominant, the act of selling labour power alienates the whole product from the producers insofar as it is already the property of the capitalist who pays wages to the worker. Labour power, as the alienable element of labour, presents the body and mind of the worker as a piece of property, a commodity, for sale. Labourers, therefore, can both relinquish the ownership of the product and relinquish control over the process of production. Marx extends this observation to acknowledge that all forms of dead labour (capital, surplus value, the means of production, and so on) are both the product of labour and exist objectively, as if independently of labour, in opposition to labour as an alien force.

In capitalism, the production of the means of production (e.g. making tools and machinery), and the planning of production (e.g. designing products and designing the work process itself), understood in isolation and in the abstract, can be reconciled with the idea of alienation as the objectification of the subject of the producer in products, the social division of labour in capitalism – in which one class plans work and another class executes it – casts the same sequence (or stages of production) in an antagonistic light. All production for exchange alienates the producer from ownership and use, but commodity production for exchange through the unregulated market subordinates (alienates) the producer (capitalist and wage labourer alike) to market demand and subjects the production process to the rigours of reducing costs and increasing productivity. As such, the rationalisation of production through the division of labour, mechanisation, automation, robotisation and the application of science and measurement generally leads to both the reduction of the time required to produce goods and the extension of the working day to increase the production of surplus value.

Workers lose control of the processes of production, which are increasingly designed and administered by managers and experts and their activity is converted into something measurable as so many portions of time or in terms of rates of return on expended wages. This loss of control is expressed in specialisation, deskilling, the division of labour and mechanisation, as well as the erosion of knowledge of the product and the fact that the worker no longer works up the product from the beginning to the end of its production. In this respect, the alienation of labour from its product is registered at the level of individual experience insofar as the worker adds a tiny proportion of the work

required to produce the product and experiences the product as an incomplete thing. The fragmentation of the production process results in the fragmentation of the workers who each now only perform one simple task over and over again. The product of labour, therefore, does not become the means by which the labourer recognises herself objectified in the world, or if she does she recognises herself not as the subject who produces the world in her own image but the means or the mechanism by which an external will (the capitalist as the personification of capital) objectifies itself for another external will (the consumer as the personification of revenue).

All wage labour is alienated labour insofar as it is sold as a commodity (to an alien other), but wage labour that is subjected to a division of labour established for the purposes of this alien other and subjected moreover to the means of production (e.g. machines) which are the products of labour standing in opposition to the producers, is labour alienated across several dimensions, so to speak. A generic theory of alienation cannot grasp these various dimensions or aspects of alienated labour. And what's more, understanding them requires a knowledge of the production process, the social relations of production and the class antagonisms involved. The chart below is a preliminary and incomplete summary of the various forms of alienated labour based on those found in Marx. It is introduced here to indicate the range and the coherence of labour's alienations primarily to refocus the debate of alienation in Marx's concept of alienated labour to the specific features of labour that are alienated.

Always, when Marx refers to a specific moment of alienated labour he understands this as part of a larger sequence which turns on itself reflexively, so that, for instance, the alienated product subsequently, as dead labour, acts as a hostile force against living labour. Also, although labourers produce machines, these machines when put to work, act as an objective condition for other workers who now become an appendage to the machine. Rather than seeing these reflexive practices as occurring within a single organic unit – for instance, as the activities through which human beings produce, reproduce and recognise themselves – Marx assigns these different practices to one side or the other of a class division. What might otherwise be seen as an act of objectification, in which human beings change the world and are recognised in its forms, Marx sees as the double alienation of one class who produce without ownership and control and another class who own and control production without producing.

The Western Marxist distinction between conceptions of alienation which, on the one hand, understand alienation to be specific to capitalism, and on the other hand, regard alienation as an eternal condition of human nature, must therefore be revisited. A complex and differentiated theory of alienated labour is neither reducible to one nor the other. While it is conceivable that

mechanisation might be devised under radically different social conditions in order to reduce the burden of the producers rather than further exploit labour, it is inconceivable that living labour might one day be emancipated from dead labour. Also, when wage labour is understood as nothing but the source of value then the activity of producers is self-estranging in the sense of doing something that is already an objective alien force outside of oneself. The optimistic, euphemistic and abstract view of labour as human transformative activity, of labour extracted from Marx's theory of alienated labour and cleared of every dimension of alienation except the Hegelian one that is synonymous with objectification and self-recognition in the produced world, is based on a narrow conception of alienation and implies a one-dimensional theory of alienated labour. This is also the case, as I will show in the next chapter, of theories of disalienation and of non-alienated labour.

Non-alienated Labour

Marx's concept of alienated labour is historical[1] and therefore always presupposes the historical supersession of the condition of alienated labour. This is not the case for the generic theory of labour which has been plucked out of Marx's writing on alienated labour nor is it the case for the various subcategories of labour within Marx's mature works (abstract, concrete, necessary, surplus, living, dead, and so on). Labour, as a category of social ontology, does not presuppose its own supersession. By contrast, we might go so far as to say that Marx's concept of alienated labour is devised precisely to signal its own historical abolition. Despite this, and despite the fact that there are traces of Marx's own theory of non-alienated labour in the *1844 Manuscripts* and elsewhere, Marx did not formulate a separate theory of non-alienated labour distinct from his conception of communism.

Chris Arthur identifies the passages in which Marx speaks of work after the 'abolition of labour' in communism. What's more, Arthur tracks down the corresponding passages in Moses Hess, who Marx was reading at the time, in which certain familiar ideas within the discourses of non-alienated labour are given their first form. Hess asserts, for instance, that in communism 'the opposition of enjoyment and labour disappears' and concludes his critique of Fourier and Saint-Simon with the argument that 'out of the multiplicity of free human inclinations and activities arises the free, living and ever-youthful organism of free, human society, free, human occupations that cease to be "work" and become identical with "pleasure"'. While it is true that 'in his 1844 Manuscripts Marx is writing under the immediate influence of such views',[2] it is equally true that Marx does not go as far as Hess in endorsing this positive conception of labour in which work and pleasure become identical.

Marx introduces the idea of 'the positive transcendence of all estrangement'[3] by pointing out that the first thinkers to conceive of the abolition of capitalism misconstrued the problem by opposing (1) capital instead of private property (Proudhon) and (2) a particular form of labour (e.g. industrial labour) instead of alienated labour (Fourier and Saint Simon). It is only then that

1 Musto confirms this, saying 'Marx always discussed alienation from a historical, not a natural, point of view' (2010, p. 82).
2 Arthur 1986, p. 19.
3 Marx 1959 [1844], p. 102.

Marx says that the 'transcendence of private property is therefore the complete *emancipation* of all human *senses* and qualities' and yet, '[n]eed or enjoyment have consequently lost their *egotistical* nature, and nature has lost its mere *utility* by use becoming *human* use'.[4] Marx goes on to say: 'in place of the *wealth and poverty* of political economy come the *rich human being* and the rich *human* need. The *rich* human being is simultaneously the human being *in need of* a totality of human manifestations of life – the man in whom his own realization exists as an inner necessity, as *need*'.[5] In this and in other passages, Marx aligns himself with Hess and other proponents of socialism and communism at the time, but does not propose the convergence of work and play or pleasure that is present in their texts.

Marx did not use the term 'non-alienated labour' nor did he theorise the supersession of alienated labour except as part of the supersession of capitalism and private property more generally. As such, it is more accurate to say that the discourse of non-alienated labour does not take shape in any substantial way with Marx but with the rediscovery of Marx's *1844 Manuscripts* in the 1930s. Non-alienated labour, therefore, is principally a twentieth-century concept. It does not become a staple of Marxist theory straight away but tends instead to drop out of use and return periodically. Even so, when writers breathe new life into the concept, they do so, typically, by assuming that it can be traced back through a continuum of Marxist (and other) scholarship, going back to Marx's writings. This is not achieved without tracing the lineage of the concept of alienated labour through a string of terms including reification, fetishism, anomie, bureaucratisation, and so on.

Musto acknowledges that although various 'concepts that were later associated with alienation'[6] emerged between the 1890s and the 1920s, 'Alienation subsequently disappeared from philosophical reflection, and none of the major thinkers of the second half of the nineteenth century paid it any great attention'.[7] However, while Musto is correct to say that the 'rediscovery' of the concept of alienation is justly credited to Lukács who brought the concept out of retirement in his *History and Class Consciousness*, published in 1923, the rediscovery of the concept of *alienated labour* and therefore *non-alienated labour* came later. One of the difficulties in reconstructing the history of the concept of non-alienated labour is that it is neglected within the elaboration of the concept of alienation. As such, what is an event in the history of the

4 Marx 1959 [1844], p. 106.
5 Marx 1959 [1844], p. 109.
6 Musto 2010, p. 79.
7 Ibid.

philosophy of alienation can be seen, in the context of my study of art and labour, as a factor in the suppression of the theory of alienated and non-alienated labour.

Three waves of the theory of non-alienated labour can be detected in response to the first publication of the *1844 Manuscripts* in 1932.[8] First, a hopeful but largely unheeded call from a tiny minority for the examination of non-alienated labour within Marxism in the 1930s in the immediate aftermath of the publication of the *1844 Manuscripts*; second, a small surge of interest in ideas strongly associated with non-alienated labour in the 1950s; and then, an unprecedented peak in the early 1970s which not only established the dominant theory of non-alienated labour but also precipitated the conditions for a widespread intellectual rejection of non-alienated labour for subsequent generations. Although it is true that various individuals have revisited the concept of alienation, alienated labour and non-alienated labour since the 1970s, there has been no tendency or movement for which alienated or non-alienated labour has been a consistent or prominent feature since the 1970s.

Two of the earliest reviews, both published in 1932, were written by Henri de Man in *Der Kampf*, and Marcuse in *Die Gesellschaft*. De Man argued that the manuscripts 'revealed the ethical-humanist motives informing [Marx's] socialist orientation' and only asked 'whether that humanist phase should be seen as a position he later overcame or, on the contrary, as an integral and lasting part of his theory'. Marcuse's review, entitled 'New Sources on the Foundation of Historical Materialism',[9] which he presented as a preliminary and incomplete reading, assigned a pivotal role to the early manuscripts in the 'foundation of historical materialism'. In so doing, Marcuse seized on the concept of alienated labour as the philosophical basis of Marx's critique of political economy and reads the concept of non-alienated labour, therefore, as the core element of Marx's theory of revolution and Communism.

Marcuse has been credited with 'anticipating the later tendency to revise interpretations of Marxism from the standpoint of the works of the early

8 The publication of the *1844 Manuscripts* in 1932 took place simultaneously in the USSR and Germany. Each edition was supplemented with an introduction. The Russian introduction stressed the orthodoxy of the early text, claiming it was nothing but an early study of key economic categories, whereas the German introduction, written by the Social Democrat Siegfried Landshut, claimed the *1844 Manuscripts* put Marxism on a new footing: communism was not 'the socialization of the means of production' and the overcoming of 'exploitation' through the 'expropriation of the expropriators', but rather the 'realization of man'.

9 When this essay was translated into English in 1972 the title was changed, reflecting the long delay between publications, to 'The Foundation of Historical Materialism' (Marcuse 1972).

NON-ALIENATED LABOUR 223

Marx'.[10] Marcuse himself prefaces his analysis by stressing that the *1844 Manuscripts* 'show the inadequacy of the familiar thesis that Marx developed from providing a philosophical to providing an economic basis for his theory',[11] and argues that Marx's critique of political economy begins, in these early notebooks, 'out of his emphatic confrontation with the philosophy of Hegel'.[12] The point, for Marcuse, is not only to emphasise the importance of philosophy in Marx's early works or the continuation of philosophical concerns in the later works, but to use Marx's engagement with German Idealism as a fulcrum for salvaging Marx from the political activists and Left parties that he had abandoned as a young man to turn to a philosophy 'committed to a dialectical rather than a mechanical understanding of Marxism',[13] as Martin Jay puts it.

Marcuse's intellectual agenda shows itself not only in the pleasure he displays in reporting Marx's critique of 'crude and thoughtless communism',[14] but also in his reading of Marx's theory of alienated labour, first, by focusing his comments on 'Marx's concept of labour'[15] and, second, by penetrating the concept of alienated labour to discover, within it, the concept of alienation. Hence: 'if we look more closely at the description of alienated labour we make a remarkable discovery: what is here described is not merely an economic matter. It is the alienation of man, the devaluation of life, the perversion and loss of human reality'.[16] Marcuse splits the concept of alienated labour into the twin philosophical inquiries into labour and alienation. This has the result, and not only in this text, of de-emphasising alienated labour as an analysis of work and the worker within specific historical circumstances in order to give emphasis to 'the activity of man'.[17] 'Marx grasps labour', he says, 'beyond all its economic significance, as the human "life-activity" and the genuine realization of man'.[18] Marcuse speaks of non-alienated labour as 'the transcendence of estrangement', more generally.[19] When he considers the labourer he remarks that the

10 Marcuse 2001, p. 3.
11 Marcuse 1972, p. 3.
12 Marcuse 1972, p. 4.
13 Jay 1973, p. 29.
14 Marcuse 1972, p. 9. Marcuse goes on to say that crude communism 'does not centre on the reality of the human essence but operates in the world of things and objects and thus itself remains in a state of estrangement' (ibid.).
15 Marcuse 1972, p. 7.
16 Marcuse 1972, pp. 7–8.
17 Marcuse 1972, p. 11.
18 Marcuse 1972, p. 22.
19 Marcuse 1972, p. 26. Marcuse puts an emphasis on the abolition of the relationship between 'master and servant' and the role of knowledge in this process, saying 'it is only in labour and in the objects of his labour that man can really come to understand himself,

worker 'is not a man in the totality of his life-expression, but a non-person' for whom the products of labour 'are not expressions and confirmations of the human reality of the worker, but alien things, belonging to someone other than the worker – "commodities"'.[20] Marcuse, therefore, inverts Marx's critique of German Idealism by treating alienated labour as secondary to labour as human activity just as the worker is secondary to 'man'.

Shortly after the appearance of Marcuse's essay, the American poet and art critic Harold Rosenberg translated a review of the *1844 Manuscripts* for *Partisan Review* by Max Braunschweig which resulted in what is probably the first reference to non-alienated labour in the English language.[21] Like Marcuse, Braunschweig welcomes the rediscovered manuscripts as proof that it is too narrow to read Marxism as a narrow economic theory. Also, like Marcuse, Braunschweig argues that the 'center of young Marx's reflections was neither economy nor social morality, but man'.[22] However, for Braunschweig it is more precise to say that 'the foundation of Marx's considerations' is not man but 'man "alienated from himself"'.[23] Braunschweig puts a stronger emphasis on alienation, therefore, arguing that, for Marx, 'all his reflections will radiate'[24] from the concept of alienation. The concept of alienation is immediately elaborated by Braunschweig through an account of various alienations of labour: 'the man who works is a stranger to his labor; he performs it only with disgust; likewise, he is a stranger to the product of his toil, since this product belongs to another'.[25] The proletarian revolution, therefore, according to Braunschweig, 'acquires a larger meaning',[26] namely that the suppression of private property 'will suppress the alienation of work and restore to man his true personality'.[27] By thinking through alienation through the concept of alienated labour, Braunschweig prepares the ground for conceiving the historical abolition of alienation as exemplified in non-alienated labour.

Non-alienated labour is presented by Braunschweig as the natural development of thinking about alienated labour. In it, he says, 'free labor incarnates

others and the objective world in their historical and social situation'. And yet, when he refers specifically to the labourer, Marcuse presumes that 'labour is not free activity' (1972, p. 39).

20 Marcuse 1972, p. 26.
21 I am grateful to Andrew Hemingway for drawing my attention to this text.
22 Braunschweig 1964, p. 503.
23 Braunschweig 1964, p. 504.
24 Ibid.
25 Ibid.
26 Braunschweig 1964, p. 506.
27 Ibid.

the personality of the man'[28] and, as a result, 'his work is a joy, since it is the expression of life'.[29] Work as non-alienated labour is also understood by Braunschweig as the basis of social life in which there is 'a tremendous enlarging of the human personality'[30] and in which, quoting Marx, 'our products are so many mirrors in which our being is reflected'. Unlike Marcuse, Braunschweig constructs the concept of 'the richness of man' around the concept of non-alienated labour, deliberately contrasting this with the conception of 'the ideal type of man' in the history of philosophy. 'In all pre-Marxist philosophy, the ideal type of man was the contemplative man', he observes, adding 'to this Marx opposed a new type of man. Man is man through his work'.[31] Braunschweig comments: 'Man is no longer static, but dynamic. He is no longer defined by his qualities, but by his activity. This is a tremendous revolution in the history of philosophy'.[32]

Braunschweig does not speak of labour in the abstract but only alienated labour and non-alienated labour or free labour. For the former, labour produces riches, but for the latter, labour produces the 'richness of the socialist individual and of socialist society'.[33] But by far the most remarkable thing about Braunschweig's reading of the *1844 Manuscripts* is the prominence that he gives to art. In this inaugural discussion of non-alienated labour in Anglophone publishing, non-alienated labour is unequivocally identified with art. He begins, without stressing the point, with the example of sculpture: 'Michelangelo fashions with his chisel an expression of his being'.[34] He goes on to make a more general and emphatic point: 'We all recognise it in the exceptional case of the artist, that is, the creative transformation of nature is, according to Marx, the attribute of every man who works, providing he has broken loose from the fetters of "alienation"'.[35]

This alliance of non-alienated labour and art was not formulated again, after Braunschweig in 1936, as far as I can tell, until the 1950s and would not be given its full theoretical expression until the 1960s. Some measure of how dislocated the emerging discourse on non-alienated labour was is indicated by the fact that Braunschweig is not referred to in any of the subsequent literature, not

28 Braunschweig 1964, p. 504.
29 Ibid.
30 Braunschweig 1964, p. 505.
31 Braunschweig 1964, p. 507.
32 Ibid.
33 Braunschweig 1964, p. 506.
34 Braunschweig 1964, p. 504.
35 Braunschweig 1964, pp. 504–5.

even in Rosenberg's subsequent writing despite conspicuous overlaps in approach. 'A painting that is an act is inseparable from the biography of the artist', Rosenberg argued, knowingly contrasting painting with the alienation of the worker from the labour process. Underscoring this point, he wrote, 'the act-painting is of the same metaphysical substance as the artist's existence. The new painting has broken down every distinction between art and life'.[36] Or even more ardently, he said, the test of action painting is 'the degree to which the act on the canvas is an extension of the artist's total effort to make over his experience'.[37] In all this Rosenberg appears to draw on Braunschweig but does not cite his work. Braunschweig does not entirely disappear from the literature on alienation and non-alienated labour. The essay that he originally published in *Partisan Review* reappears in the two-volume anthology on alienation published in 1964 edited by Gerald Sykes. However, this republication makes it all the more remarkable that Braunschweig continued to be absent from bibliographies and citations in the literature.

Although missing from Sykes's anthology on alienation, the writer who appears more than anyone else in the literature on alienation, alienated labour and non-alienated labour is Marcuse. His initial contribution, 'New Sources on the Foundation of Historical Materialism', which was not translated into English until 1972, does not figure prominently, though. *Reason and Revolution* (1941), *Eros and Civilisation* (1955), *One-Dimensional Man* (1964) and *The Aesthetic Dimension* (1978) are the key texts that appear and reappear in the literature on non-alienated labour. Marcuse wrote about alienated and non-alienated labour throughout his working life, speaking in his last book, *The Aesthetic Dimension*, of society 'under a new reality principle: existence would no longer be determined by the need for lifelong alienated labor and leisure, human beings would no longer be subjected to the instruments of their labor, no longer dominated by the performances imposed upon them'.[38]

Although he is perhaps acknowledged more for his theory of repressive desublimation, which bemoans art's subordination to the reality principle, Marcuse also associates art with non-alienated labour. Quoting Adorno, who argued that 'art opposes to institutionalized repression the image of a man as a free subject',[39] he differentiates art from work and alienation, although later in his career he will speak of the alienation of art within the culture industry.

36 Rosenberg 1952, p. 23.
37 Rosenberg 1952, p. 48.
38 Marcuse 1990 [1978], p. 54.
39 Adorno quoted in Marcuse 1955, p. 110.

Nevertheless, towards the end of his life he reaffirms the incommensurability of art and alienated labour, saying, 'Art is a productive force qualitatively different from labor; its essentially subjective qualities assert themselves against the hard objectivity of the class struggle'.[40]

As well as distinguishing between 'alienated and non-alienated labor (between labor and work)',[41] Marcuse draws on Fourier's concept of 'attractive labor' as 'the release of libidinal forces',[42] but justifiably rejects Fourier's managerial solution to the problem of work, arguing that 'work as free play cannot be subject to administration'.[43] He rejects administration for a 'change in the character of work by virtue of which the latter would be assimilated to play'.[44] 'Labor in its true form', he argues, 'is a medium for man's true self-fulfilment, for the full development of his potentialities',[45] but Marcuse reinterprets non-alienated labour on the basis of the individual's pleasure. This is the content of his idea of 'libidinal work'.[46] Marcuse, therefore, restricts his conception of the supersession of alienated labour to 'the moment of play, when people could attain a freedom denied them in productive activity', as Musto puts it.[47] However, he does not equate this moment of play with the practice of art, at least not in its current form, saying 'art cannot abolish the social division of labor which makes for its esoteric character, but neither can art "popularize" itself without weakening its emancipatory impact'.[48]

Despite his centrality to the literature, it would be misleading to represent Marcuse as someone who pays a great deal of attention to alienation or alienated labour. As the so-called guru of a new generation of radical thinkers in the 1960s, he popularised the critique of work and the reorganisation of society around libidinal satisfaction, but Marcuse tends to scout for more acceptable and up-to-date alternatives to the term alienation and, as a result, the concept

40 Marcuse 1990 [1978], p. 37.
41 Marcuse 1955, p. 151.
42 Marcuse 1955, p. 154.
43 Ibid. He extends this to a critique of Fordism and Soviet industrialism, advocating 'the protest against the definition of life as labor, in the struggle against the entire capitalist and state-socialist organization of work (the assembly line, Taylor system, hierarchy)' (Marcuse 1990 [1978], p. 28).
44 Marcuse 1955, p. 152.
45 Marcuse 1955, p. 277.
46 Marcuse 1955, p. 153. Marcuse goes as far as saying 'the true spirit of psychoanalytic theory lives in the uncompromising efforts to reveal the anti-humanistic forces behind the philosophy of productiveness' (1955, p. 156).
47 Musto 2010, p. 84.
48 Marcuse 1990 [1978], p. 21.

of non-alienated labour appears very infrequently in his work. In *Reason and Revolution*, Marcuse summarises the emergence of the concept of alienated labour as follows: 'Marx's writings between 1844 and 1846 treat the form of labor in modern society as constituting the total "alienation" of man. The employment of this category links Marx's economic analysis with a basic category of the Hegelian philosophy'. Here, then, Marcuse does not refer to alienated labour at all but joins the two together by associating labour with the alienation of man. This is the basis of an error, as explained by Peter Hudis: 'Marcuse is led to conclude that a new society, for Marx, entails the abolition of labour *per se*',[49] rather than the abolition of alienated labour specifically. He repeats the same mistake when he describes a socialist (or presumably communist) society as 'a society in which free time, not labour time is the social measure of wealth and the dimension of the individual existence'.[50]

Between the publication of *Reason and Revolution* and *Eros and Civilization*, C. Wright Mills published *White Collar* (1951) in which 'Marxism's projection' of a future society characterised by 'unalienated labor'[51] is simultaneously rejected (as outmoded) and preserved (in the form of a vindication of the romance of handicraft). Mills cannot subscribe to the concept of non-alienated labour because, amongst other things, he dismisses the 'cult of alienation',[52] which he describes as 'a form of collapse into self-indulgence',[53] although later he described the 'advent of alienated man' as 'a major theme of the human condition in the contemporary epoch and of all studies worthy of the name'.[54] He discusses alienation more than alienated labour and argues that the alienation of the white-collar worker is more extensive and more intensive than that of the industrial worker: 'the alienation of the wage-worker from the products of his work is carried one step nearer to its Kafka-like completion'.[55] And, in addition, he acknowledges that '[c]urrent managerial attempts to create job enthusiasm ... attempts to conquer work alienation within the bounds of alienation'.[56]

49 Hudis 2012, p. 203. See below my reiteration of Chris Arthur's discussion of the necessity of reading 'labour' as 'alienated labour' in Marx's writing on the supersession of capitalism and the 'abolition of labour'.
50 Marcuse 2000, p. xxiii. Quoted in Hudis 2012, p. 202.
51 Mills 1972 [1951], p. xix.
52 Mills 1972 [1951], p. 159.
53 Ibid.
54 Mills 1959, p. 171.
55 Mills 1972 [1951], p. xvi.
56 Mills 1972 [1951], p. 235.

Nevertheless, Mills tends to reduce the concept of alienated labour to feelings of dissatisfaction at work,[57] which means that instead of regarding non-alienated labour as a future condition for human activity, he assumes the concept is a category of actual experience, namely of 'joy as creative work ... limited to a small minority'.[58] This relativism of subjectively felt satisfaction in work is certainly no measure of labour being non-alienated in any serious sense. And Mills recognises this insofar as he acknowledges 'whatever satisfaction alienated men gain from work occurs within the framework of alienation'.[59] Mills remains sceptical about the presence of non-alienated labour in an era of personnel management. Clearly, Mills' account has little more than a superficial relationship to the Marxist concept of alienated labour and its historical supersession. In fact, Mills' vindication of handicraft does not belong in any historical survey of the Marxist discourse on non-alienated labour although *White Collar* is an agenda-setting book that has had an impact on Marxism.

Although the elements of a theory of non-alienated labour are in place in the middle of the twentieth century, no writer had yet formulated the theory in full. However, while a convergence was taking place between the theory of non-alienated labour and the burgeoning acknowledgement of the antagonism between artistic production and capitalist commodity production, Ernst Fischer, a leading cultural Stalinist who was a journalist and editor of *Arbeiter-Zeitung*, worked in Moscow during World War II and served in the provisional government in Austria,[60] outlined a counter-position in his book *The Necessity of Art*, published originally in East Germany in 1959 and translated into English in 1963. For Fischer, art is a symptom of the social division of labour and therefore is a manifestation of alienation. For Fischer, art and alienation go hand in hand:

> The artist and the arts entered the fully developed world of capitalist commodity production with its total alienation of the human being, the externalization and materialization of all human relationships, the divi-

57 Mills ascribes alienation to empirical factors such as the product being a commodity, the worker not following the product throughout the process of production, managerial decision making, etc.

58 Mills 1972 [1951], p. 219. Mills mixes up non-alienated labour with the feeling of satisfaction in work which he defines relatively: 'satisfaction from work is felt in comparison with the satisfaction of other jobs' (1972 [1951], p. 229).

59 Mills 1972 [1951], p. 235.

60 For a sketch of Fischer's life see Solomon 1979 [1973], pp. 270–1.

sion of labour, the fragmentation, the rigid specialization, the obscur-
ing of social connexions, the increasing isolation and denial of the indi-
vidual.[61]

Instead of identifying art as the prototype of non-alienated labour, as the exist-
ence of non-alienated labour within a social formation that runs on alienated
labour, Fischer theorises art fully within the dynamic of alienated labour and
saves the promise of a non-alienated art and non-alienated labour for a post-
capitalist condition. 'Just as magic corresponded to man's sense of unity with
nature ... so art became an expression of the beginnings of alienation',[62] which
is to say, for Fischer, the 'division of labour and property ownership'.[63] However,
although Fischer theorises art as a form of labour and understands its struc-
tural relationship to alienated labour, he does not refer to alienated labour
specifically and uses Marx as a springboard to speak of alienation in Baudelaire,
Cézanne, Kafka, and so on. He argues that art is both a mode of alienation and
a means to 'raise man up from a fragmented state into that of a whole, integ-
rated being',[64] but this is not a book that theorises art in terms of non-alienated
labour.[65]

61 Fischer 1971 [1959], p. 52.
62 Fischer 1971 [1959], p. 38.
63 Fischer 1971 [1959], p. 39. If the history of the emergence of the concept of art out of
 the ruins of handicraft force us to doubt Fischer's historical narrative of the twin birth
 of art and alienation, we can nevertheless acknowledge the importance of the attempt
 to fuse them at the root. And, of course, if we substitute the modern term art with the
 more appropriate terms of the various specific arts (painting, carving, poetry, etc.), then
 Fischer's theory that the division of labour is necessary for their development and is also
 the precondition of Marxian alienation (viz. alienated labour) does not seem implaus-
 ible.
64 Fischer 1971 [1959], p. 46.
65 Mészáros similarly steers clear of speculating about non-alienated labour and includes
 the concept of alienated labour within a broader philosophical recovery of the concept of
 alienation in Marx. Rather than theorise artistic labour as non-alienated labour, Mészáros
 adopts Fischer's position – without citing him – that Marx 'was the first to raise the alarm
 about artistic alienation' (Mészáros 1986 [1970], p. 190). Mészáros ascribes the belief in art
 and the aesthetic as resistant to alienation to Schiller, and rejects it. 'With the advance of
 alienation', he explains, 'the artist's isolation increases. He has been set free from all the
 bonds against which the Renaissance artists had to fight, but only at the price of submit-
 ting himself to the impersonal power of the art market' (Mészáros 1986 [1970], p. 204). This
 reference to the art market as the mechanism through which artists are brought under the
 power of capital is a ruse by which Marxists have attempted to bring art within the general
 field of alienation without claiming that artists have become wage labourers whose labour
 is alienated from them. Mészáros's case, then, is more anecdotal but possibly all the more
 persuasive as a result. Artists in pre-capitalist societies, he says, were socially integrated

The strongest candidate for the first full account of art as non-alienated labour is Adolfo Sánchez Vázquez's *Art and Society* published in 1965 (translated into English in 1973). Sánchez Vázquez was a humanist Marxist who studied with José Ortega y Gasset in Madrid. He wrote principally about ethics and art with a deep scholarly knowledge of Marx and Marxist philosophy. Reviews of Sánchez Vázquez's book claim that his position is almost identical to Marcuse's, but his argument for art as non-alienated labour is more developed than the fragments of a case discoverable in Marcuse. His book is structured around Marx's assertion of capitalism's hostility to art. He develops this by examining the relationship between art and labour. Despite the apparent chasm between the artist and the worker, Sánchez Vázquez draws out a politics of labour from the acknowledgement that 'there is no radical opposition between art and work'.[66] 'The similarity between art and labor', he says, is that 'they are both creative activities',[67] by which he means, '[a]ll work is objectification'.[68] Hence, a politics of art and labour cannot be based on their shared properties alone but must deal with the fact that 'labor loses its creative character while art becomes a distinct, substantive activity'.[69] It is by understanding the contradictory unity of art and labour in which art and labour come into conflict because 'not all work implies the alienation of the human being',[70] that art comes to be identified by Sánchez Vázquez as non-alienated labour.

Although he does not use the term non-alienated labour, Sánchez Vázquez argues that 'under capitalism the artist tries to escape alienation, for alienated art is the very negation of art',[71] and his vindication of artistic labour is situated precisely on the opposition between alienated labour and the supersession of alienated labour.[72] Art's resistance to alienation, for him, turns on a

whereas artists in capitalism are 'outsiders' and 'outcasts' and, even more graphically, 'the main effect of alienation [in art] is the appearance of a "public" which is barred from participating in the processes of artistic creation'. (Mészáros 1986 [1970], p. 205). Bertell Ollman also subscribes to a broad alienation theory in which alienated labour has a place amongst other things but which, at the same time, is tied specifically to capitalism. Hence, Ollman states categorically, 'unalienation is the life man leads in communism', (1971, p. 132), and he leaves it there. He does not speculate about non-alienated labour and says almost nothing about art in his book on alienation.

66 Sánchez Vázquez 1973 [1965], p. 63.
67 Ibid.
68 Sánchez Vázquez 1973 [1965], p. 55.
69 Sánchez Vázquez 1973 [1965], p. 67.
70 Sánchez Vázquez 1973 [1965], p. 55.
71 Sánchez Vázquez 1973 [1965], p. 85.
72 Fischer exaggerates the degree to which artistic labour has been incorporated into the capitalist wage system precisely in order to rule out the possibility of non-alienated labour

single material factor: 'The artist does not resign himself to becoming a salaried worker'.[73] So, although his language occasionally slips into a more general conception of alienation, his theory of art's relationship to alienation is firmly linked to the concept of alienated labour, specifically the relationship between the artist and capital. The artist, he says,

> searches for ways of escaping alienation, refusing to submit his work to the fate of all merchandise, winning his freedom at the price of terrible privations. But the source of this alienation lies outside of art; it is fundamentally a socioeconomic alienation. Therefore, according to Marx, only a change in social relations can enable labor to reclaim its true human sense and art to be a means of satisfying profound spiritual needs. That is why the salvation of art is not in art itself, but in the revolutionary transformation of the socioeconomic relations which permit the degradation of artistic work by placing it under the general law of capitalist commodity production.[74]

Having grasped, in rudimentary form, the economic exceptionalism of art,[75] Sánchez Vázquez hesitates or oscillates on the question of whether artistic labour is a form of non-alienated labour or whether it, like wage labour, can become non-alienated only after the revolutionary supersession of the capitalist mode of production. What needs to be acknowledged, however, is that this crucial question only arises when art is raised in relation to non-alienated labour rather than nonalienation more generally.

1975 is something of a turning point. The tone of the discourse becomes bolder and the concept itself crystallises. For instance, Hans Jauss and Peter Heath claim emphatically that art is an instance of non-alienated labour and claim, to boot, that Marx is the source of this idea: 'If there is a chance of becoming immediate possessor of one's work this will be most likely to be the case with the artist as the least alienated worker'.[76] They claim that this argu-

within capitalism whereas Sánchez Vázquez ties alienated labour to wage labour specifically in order to make room for artistic labour to be granted the status of non-alienated labour on account of not being wage labour.

73 Sánchez Vázquez 1973 [1965], p. 85. Note the opposition of art and alienated labour, for Sánchez Vázquez, is not based on some vaguely understood special case for art or by characterising the artist as a special kind of individual but on the political economy of artistic labour.

74 Sánchez Vásquez 1973 [1965], p. 85.

75 For a fuller account of art's economic exceptionalism see Beech 2015.

76 Jauss and Heath 1975, p. 206.

ment derives 'from Marx's correlative statement: "The individual produces a certain article and turns it into himself again by consuming it; but he returns as a productive and self-reproducing individual. Consumption thus appears as a factor of production"'.[77] Jauss and Heath cite the *1844 Manuscripts* as a whole to show that 'the work of art could become a paradigm for non-alienated labor which could uphold the idea of free productivity and sense-changing receptivity in periods of alienated material labor'.[78] In the same year, Andreas Huyssen referred to art and 'non-alienated labor' in a critical assessment of the German SDS group (Socialist German Student Association) article, 'Kunst als Ware der Bewußtseinsindustrie' published in 1968, which attacked 'Hollywood movies, TV series, bestsellers, hit parades' and art. Huyssen writes, 'the SDS analysis goes beyond Adorno, who also condemns the culture industry, but keeps insisting that if high art rejects economic utilization,[79] it can offer the only realm of withdrawal for creative, non-alienated labor'.[80]

What is remarkable about this account is (1) that Huyssen sees the SDS group as 'going beyond' Adorno precisely insofar as it rules out the possibility of artistic labour being categorised as non-alienated labour (according to their militant critique, art must be understood as incorporated into capitalism without remainder), and (2) that Huyssen provides a more coherent formulation of the principle of artistic labour as non-alienated labour than Adorno ever did.[81] Also in 1975, Patrick Brantlinger constructed a picturesque image of non-

77 Ibid.
78 Jauss and Heath 1975, p. 199.
79 Huyssen's half-hearted, ironic or disingenuous formulation of the principle of the artist potentially engaged in non-alienated labour is based on a perception of the artist withdrawing from capitalist economics without distinguishing between withdrawal from the market and withdrawal from the wage system. His terms 'economics utilization' and 'realm of withdrawal' appear to be fashioned precisely as noncommittal in this regard. This means that, in principle, Huyssen is deliberately leaving open the possibility that non-alienated labour could result, directly or indirectly, from interventions in the processes of circulation rather than through the transformation of the relations of production.
80 Huyssen 1975, p. 87. Thanks to Hito Steyerl for help with the German text.
81 In fact, Adorno spoke of alienation in countless varieties but he wrote nothing directly on alienated labour and nothing at all on non-alienated labour. It is possible to reflect on questions about art and non-alienated when Adorno says art 'puffs itself up out of guilt over its participation in society, [which] redounds to its honor as mockery of the honesty of socially useful labor' (2002 [1970], p. 254), but Adorno does not here, or elsewhere, openly and unambiguously thematise art as non-alienated labour. Another example of Adorno coming close to theorising a relationship between art and non-alienated labour, but not quite committing to it, is in the following suggestive passage: 'social labour aesthetically mocks bourgeois pathos once the superfluity of real labor came into reach. The

alienated labour in his review of William Morris's *News From Nowhere* for the
Victorian Studies journal, describing Morris' utopia through the supersession of
the category of work.[82] In Morris's projection, he argues,

> the distinction between 'artist' and 'artisan' or worker has been abolished:
> labor has become 'attractive labor', and everyone is an artist. The products
> which the characters make, the tasks which they perform, and the com-
> munal relations between them are all based on Morris' interpretation of
> what non-alienated labor would be like.[83]

Brantlinger understands the dissolution of the distinction between the artist
and the artisan and worker in ambitious terms that anticipate the abolition of
art within post-capitalism on the basis that '"art" is unnecessary as a separate
activity because all life has become art'.[84]

dynamic in artworks is brought to a halt by the hope of the abolition of labor and the
threat of a glacial death ... The potential of freedom manifest in it is at the same time
denied by the social order, and therefore it is not substantial in art either' (2002 [1970],
pp. 224–5). It is not even possible, I think, to draw such an argument out of Adorno's
various remarks on art's autonomy, which he always kept mobile, complex, contradict-
ory and dialectical rather than identifying it with a single feature such as non-alienated
labour. Also, it is symptomatic of the lack of any substantive discussion of alienated and
non-alienated labour in Adorno's aesthetic theory that whenever he talks about labour in
relation to art, he prefers to restrict himself to the properties of objects.

82 Defending Morris's vision, Brantlinger argues that 'it is only the reign of "organized greed"
 which has so diminished the status of "Arts and Crafts" that they seem trivial rather
 than universal, mere hobbyhorses rather than the whole category of non-alienated labor'
 (Brantlinger 1975, p. 38). Brantlinger claims, with some justification, that '[f]ar from being
 a mere "Arts and Crafts Utopia", *News from Nowhere* is the best fictional vision of the future
 according to Marxism in English' (Brantlinger 1975, p. 39).

83 Brantlinger 1975, p. 44.

84 Brantlinger 1975, p. 38. He adds more detail to this argument as follows: 'under the most
 favourable socialist conditions "art" might cease to exist altogether. "Popular art" would
 be indistinguishable from common labor; there would be no need for systems of sub-
 stitute gratifications because life itself would be gratifying' (ibid.). However, there is an
 indeterminacy in Brantlinger's theory of art's relationship to non-alienated labour, here,
 insofar as he equates art both with the social division of labour under capitalism and
 with its supersession when there is no differentiation between art and life. While it has
 been demonstrated in earlier chapters of this book that Brantlinger is correct to say that
 it 'is only in modern times, under capitalistic conditions, that the separation of art from
 labor and from life has occurred' (Brantlinger 1975, p. 37), what remains to be determined
 is whether art within capitalism can be theorised as non-alienated labour, which Brant-
 linger appears to deny, and whether art will survive into post-capitalism as an aspect of
 non-alienated labour, which Brantlinger appears to condone.

Although Jauss and Heath, Huyssen, and Brantlinger are separated by important political and theoretical differences, they dispute the virtues of a shared conception of non-alienated labour and judge art's status as non-alienated labour through an analysis of art's relationship to capitalism. For these writers, non-alienated labour is still attached to the supersession of capitalism more generally but appears to anticipate this in the specific practice of the production of art. Unlike Mills, non-alienated labour is not conceived in terms of relative subjective expressions of satisfaction in work but abides in the relationship between the producer, the product and the processes of production. As for Sánchez Vázquez, the concept of art as non-alienated labour contested here turns on whether the artist escapes from the regimens of alienated labour in order to practice an extant form of non-alienated labour within capitalism itself.

The outlines of this growing consensus can be traced within Carol Gould's 'critical reconstruction'[85] of Marx's ontology of labour in 1978. She reads Marx's theory of labour in positive terms as 'an activity of self-creation'[86] in which she stresses 'labor as an activity of objectification'[87] rather than alienation.[88] 'Marx's account of objectification', she says without differentiating this from alienated labour, 'is analogous to Aristotle's account of made objects, that is, of productive activity or art'.[89] There appears to be no need for an additional concept of non-alienated labour when labour is understood as objectification and self-creation in this way, and there appears to be no need to envision a postcapitalist society as eliminating alienated labour.[90] Art, alienated labour and labour as self-creation all appear to be remarkably similar in a reading of Marx

85 Gould 1978, p. xxiii.
86 Gould 1978, p. 40.
87 Gould 1978, p. 41.
88 Gould reasserted the primacy of philosophy over the relationship between art, handicraft and labour, and in doing so she restored the primacy of the concept of alienation over that of alienated labour within her Marxian account of labour. The absence of alienated labour and non-alienated labour from Gould's account of labour in Marx is explained by acknowledging two judgements of emphasis. Despite her recognition that 'Marx's analyses of surplus value and of the function of machinery under capitalism and his theory of crises cannot be understood without his concept of alienation' (Gould 1978, pp. xiv–xv), she separates and elevates the concept of alienation from alienated labour.
89 Gould 1978, p. 44.
90 It is possible, perhaps, to interpret her remark that 'Marx regards the full achievement of concrete freedom as the result of historical development' (Gould 1978, p. 117) as a coy reference to proletarian revolution, and she also refers to 'the three social stages of precapitalist societies, capitalism and communal society' (Gould 1978, p. 119), but Gould does not adequately differentiate between alienated labour and non-alienated labour, nor does she thematise labour through the distinction between wage labour and labour after the abolition of the wage system.

in which, 'as for Aristotle, laboring activity is a purposive activity that gives form to matter'.[91] In effect, therefore, Gould sublimates the debates on art and non-alienated labour into a the thesis that 'Marx sees freedom not as the freedom from labor, but rather as activity or labor itself, conceived as an activity of self-realization'.[92] As such, we can say of Gould what Marx said of Hegel when he wrote: 'He grasps *labour* as the *essence*, as man's essence in the act of proving itself; he sees only the positive and not the negative side of labour. Labour is man's *coming-to-be for himself* within *alienation* or as *alienated man*'.[93]

As this new consensus on art as non-alienated labour developed, it is important to acknowledge that throughout the whole period from the 1930s onwards, the concept of non-alienated labour remained under suspicion in some quarters. Chris Arthur, for instance, who has written extensively on alienation has said little or nothing on non-alienated labour. Arthur focuses instead on the difference between alienated labour under capitalism and the stages of communism in which he states the '[a]bolition of estrangement requires the abolition of private property',[94] which coincides precisely with Marx's definition of communism as 'the *positive* supersession of *private property* as *human self-estrangement*'. G.A. Cohen, likewise, does not mention non-alienated labour in his discussion of 'concrete freedom and disalienation',[95] and even speaks scornfully about the 'earlier, much romanticized, craft labour',[96] which serves as a model of non-alienated labour for those Marxists who stress the producer's control over production processes. Cohen adds:

> Many observers of the emerging factory civilization pictured the ancestral work scene as a garden from which capitalist development expelled the producers, to deposit them in an industrial hell. The artistic work of the handicraftsman, performed for its own sake, not merely for the living it yields, appeared in favourable contrast to the alienated toils of working-class life. Traces of this outlook may be found in Marx's writings. But he does not finally accept the romantic attitude that the new society disrupted a preindustrial idyll.[97]

91 Gould 1978, p. 44.
92 Gould 1978, p. 102.
93 Marx 1959 [1844], p. 152, original emphasis.
94 Arthur 1986, p. 37.
95 Cohen 1988, p. 193.
96 Cohen 1988, p. 183.
97 Cohen 1988, p. 184.

NON-ALIENATED LABOUR 237

Cohen's rejection of handicraft as the model of non-alienated labour is necessitated by his more general conviction that 'freedom inside communist industry is regrettably limited, and Marx looks for what he calls the freedom beyond the economic zone'.[98] This is why André Cohen reads Marx's comments on communism as expressing the 'need to forecast a virtual disappearance of labour',[99] without suspecting that Marx means the disappearance of alienated labour. And this is why Cohen speaks of 'activity – be it labour or not',[100] rather than non-alienated labour, which reverts to a more Schillerian vocabulary and a more aesthetic model of the supersession of capitalism. Around the same time Fredric Jameson declared that '[i]t used to be affirmed that art or the aesthetic in our time offered the closest accessible analogy to, constituted the most adequate symbolic experience of, a non-alienated labor otherwise unimaginable for us'.[101]

If enthusiasm for the concept of art as non-alienated labour is not universal among Marxists, for some it becomes fundamental. John Molyneux, the prominent British Trotskyist, draws on Sánchez Vázquez to attach the question of non-alienated labour to art, arguing that the question 'What is art?' should be replaced by the question 'what is the peculiar social character of the labour that produces what we call art?' The Marxist formulation of the question, for Molyneux, permits the following answer: ' "art" is the product of non-alienated labour'.[102] To clarify how art can result from non-alienated labour within the

98 Cohen 1988, p. 207.
99 Cohen 1988, p. 208.
100 Cohen 1988, p. 205.
101 Jameson 1991, p. 146.
102 Molyneux explains precisely how he uses the term non-alienated labour in regard to art: 'By non-alienated labour I do not mean labour that exists "outside" of capitalism (which is increasingly non-existent), or labour that does not produce commodities (the massive commodification of art under capitalism is obvious), or even labour that people enjoy (some people "enjoy" some alienated labour and some non-alienated labour is not enjoyable). Still less do I mean that "artists" are not alienated or that their work does not reflect and express alienation – alienation affects everyone in capitalist society' (Molyneux 1998, np). Molyneux's *rejects* are as instructive as his one true definition of non-alienated labour. However, their referents are not always easy to identify. Does his first rejected interpretation of non-alienated labour refer to production under actually existing socialism (and would this non-capitalist mode of production be non-alienated?) or does it refer to the hypothesis that the artistic mode of production is a remnant of late medieval handicraft and has not been converted to the capitalist mode of production? Setting aside the question of whether artists produce commodities (or more specifically, whether they produce capitalist commodities), Molyneux is right to reject the basis of art's non-alienated labour on the circulation of its products since artworks are evidently alienable and are routinely bought and sold. Molyneux is also right to reject the claim that artistic produc-

capitalist division of labour, he states: 'What I mean [by non-alienated labour] is labour that remains under the control and direction of the producer'.[103] Clearly, therefore, Molyneux boils down the various aspects of alienated labour (from the product, sale of labour power, the hostile force of products, capital as dead labour, etc.) to a single criterion and regards the absence of this one feature of alienated labour as the single prerequisite of non-alienated labour.

Andrew Hemingway and Stephen Eisenman's session for the Radical Art Caucus at the College Art Association annual conference in 2003 turned on the claim that artistic labour is non-alienated. 'It has often been claimed (and not just by Marxists) that artistic labour is in some degree exempt from the normal constraints of work under capitalism, and stands for the ideal of non-alienated self-fulfilling activity in which individuals freely realise themselves'.[104] One of the contributors to Hemingway and Eisenman's panel, Frances Stracey, wrote on Situationism between 2001 and 2009, and proposed a new term for what we have been referring to as non-alienated labour. In opposition to 'the aestheticization of life'[105] she proposed 'an aesthetico-political transformation of life into a non-alienated creative sociality' which she named a 'Gesamtlebenswerk – my term for a "total work of life" or "liberating life-praxis" – in which the alienated division of labour is overcome and transformed into a non-alienated, creative life'.[106] Here, an expanded field of non-alienated labour is clearly modelled on the earlier tradition of artistic production but extended to the production of 'situations' rather than artworks. Hence, 'the Situationists searched for new

tion is pleasurable as the decisive factor in the question of whether or not artistic labour is alienated, not only because of the empirical existence of displeasure in the artist's studio and pleasure in the factory or call centre but also because of the principle that alienation in Marxism is not measured by high levels of suffering. His claim that artists are alienated, as everybody is, appears to leave the Marxist discourse of alienated labour altogether (giving his discussion of alienation an existential tinge), and therefore his rejection (of the idea that artists might not be alienated like everyone else), can itself be rejected as irrelevant to the Marxist question of whether artistic labour is non-alienated labour.

103 On these terms, non-alienated labour is commensurable with the formal subsumption of labour under capital but is eroded by the progressive real subsumption of labour under capital.

104 Hemingway and Eisenman 2005, p. 292. They explain: 'In the liberal Enlightenment tradition, art-making is understood as a creative, non-instrumental endeavour ... that enables individuals to realise their ideas and desires' while the 'activity of labour, on the other hand, is understood as an instrumental activity, the goal of which is the production or acquisition of commodities or property, or the obtaining of a quantity of money' and therefore 'is also understood as an activity that may be legitimately alienated'.

105 Stracey 2014, p. 42.

106 Ibid.

forms of non-alienated abundance, and found it in forms of wasteful expenditures, exemplified by self-destructive artworks and by the desire to give away the fruits of one's creative labours'.[107]

For Stracey, Situationism amounts to 'a simultaneous critique of the labour processes of both artistic and industrial modes of production'.[108] Stracey holds a position that hovers over central questions about the relationship between non-alienated labour and capitalism, remarking that 'as Marx indicated, it is within the realm of abundance, and not scarcity, that questions about the production of a free, life praxis emerge. And for the Situationists one such realm of abundance was that of culture'.[109] There is, she claims, a 'critical potential' in the 'creative residue or remainder' in those activities that 'escape or at least fail to be totally recuperated by the alienating machinations of the spectacle'.[110] Stracey thus deploys a concept of non-alienated labour that retains fidelity to the tradition of thinking hinged to Marcuse and expressed more clearly by Braunschweig, Sánchez Vázquez, Schapiro and Brantlinger, and yet she invokes Debord and Asger Jorn in a radical gesture that indicates a limit which she seeks to cross. An assessment of her formulation of the supersession of alienated labour, therefore, depends on the results of an inquiry into (1) whether post-capitalism will be characterised by non-alienated labour or by the abolition of labour altogether, and (2) whether art prefigures in any way the supersession of alienated labour.

Non-alienated labour continues to divide opinion among Marxists. 'Artistic activity', Sayers claims, 'is truly free activity, free creation'. He adds that for 'Marx too, art is the highest form of creative activity, free creative activity, the highest form of work', whereas Malcolm Bull refers to dealienation in relation to a 'fourfold form'[111] of alienation and therefore calling for a correspondingly fourfold 'dealienation' that does not include non-alienated labour. Musto, on the contrary, concludes his essay on alienation with a brief portrayal of 'dealienation' that turns on the historical supersession of wage labour but does not reiterate the discourse on non-alienated labour. For Marx, the 'post-capitalist system of production' is not conceived of as the reign of free time or the era in which everyone is an artist but, in the words of Musto,

107 Stracey 2014, p. 43.
108 Stracey 2014, p. 16.
109 Stracey 2014, p. 43.
110 Ibid. She speaks, also, of 'the importance of holding out for a realm of surplus energies, for immanent remainders, in the form of poetry or whatever else you can name as retaining a residue of non-alienated, non fully co-opted experience' (Stracey 2005, p. 405n).
111 Bull 2010, p. 23.

together with scientific-technological progress and a consequent reduction of the working day, creates the possibility for a new social formation in which the coercive, alienated labour imposed by capital and subject to its laws is gradually replaced with conscious, creative activity beyond the yoke of necessity, and in which complete social relations take the place of random, undifferentiated exchange dictated by the laws of commodities and money. It is no longer the realm of freedom for capital but the realm of genuine human freedom.[112]

While the concept of alienated labour remains under the shadow of the more general concept of alienation, it is difficult to ascertain whether the abolition of alienated labour will result in the reign of non-alienated labour or the abolition of labour and therefore render the concept of non-alienated labour redundant. Is non-alienated labour the technical Marxist name for 'the realm of genuine human freedom' after the abolition of alienated labour or is non-alienated labour a foreign concept to Marx's discussion of communism? Does the concept of non-alienated labour fail to grasp the extent of the supersession of alienated labour or do the alternatives to thinking about non-alienated labour (preferring to speak of human activity and so forth) retreat from Marx's critique of German Idealism?

Since non-alienated labour is a concept that foreshadows labour under conditions in which all the species of capitalist social relations have been abolished, philosophers such as Marcuse and Ollman have written about it in terms that too easily return to the abstract and universal ontology of 'man' rather than worker, of labour as human transformative activity rather than work, and of the relationship between producer and product characterised by self-realisation rather than hostility, estrangement and property. Marx made some similar proclamations. And it follows from the historical concept of alienated labour that some kind of supersession can or must take place. However, the elimination of alienated labour cannot be adequately expressed through the terminology of classical bourgeois humanism. If, in some sense, non-alienated labour is impossible without something along the lines of the full development of the capacities of each individual, it is vital that this is differentiated from the classic bourgeois conception of the universal individual or of the realisation of the bourgeois ideal of what constitutes human liberty, freedom and happiness. The point of dismantling capitalism is not to universalise the bourgeois ideal of humanity but to bury it. Marx did not introduce the concept of alienated labour

112 Musto 2010, p. 101.

against the Hegelian concept of objectification in order to help bring about a world in which the Hegelian concept finally found a home in communism.

To the degree that art is regarded as unalienated *per se*, rather than an example of non-alienated labour specifically, we can say that Marx's conception of the supersession of alienated labour is being marginalised in favour of a more Schillerian, Feuerbachian, existential or theological concept of alienation. In the non-Marxist tradition of thinking about alienation, individual and isolated instances of nonalienation are more easily conceived than in the Marxist tradition when it is more typical to understand the supersession of alienated labour as dependent on the supersession of capitalism. When Marxists theorise artistic labour as an existing form of non-alienated labour within capitalism or as prefiguring post-capitalist labour in the present, they do so the assumption that capitalism is hostile to art and art has in some key respect resisted the capitalist transformation of labour. In some of these arguments, artistic labour is seen as non-alienated because it is pleasurable or remains a handicraft practice or is non-mercenary in some respects or because the artist objectifies herself in her products. If alienated labour can be recognised not only in the alienation of the product and the production process but also in the affirmation of rest, relaxation, leisure and laziness, then the notion that art represents non-alienated labour might be best understood as an expression of alienated labour.

Peter Hudis concludes a close reading of Marx's theory of alienated labour by saying 'wage-labour will come to an end with the abolition of alienated labour'.[113] At the heart of alienated labour is the problem of exchange which 'represents an object-object relation',[114] and therefore at the heart of non-alienated labour – or the supersession of alienated labour – is the abolition of earning a living from labour, abstract labour, value and private property. Hudis adds a novel philosophical ingredient to the concept of alienated labour which gives non-alienated labour a distinctive character. Alienated labour, he says, insofar as it is characterised as the worker's activity 'turned against him' (the words are Marx's), can be understood as the application of Marx's early 'critique of subject-predicate inversion to the labour-process'.[115] He quotes Marx's first discussion of labour in post-capitalism, proposing the following: 'Let us suppose that we had carried out production as human beings ...' rather than as wage labourers; 'Our products would be so many mirrors in which we saw reflected our essential nature' – because 'my work would be a free manifesta-

113 Hudis 2012, p. 119.
114 Hudis 2012, p. 56.
115 Hudis 2012, p. 61. He explains: 'The very activity of the subject becomes the predicate – a thing apart that dominates and controls the *real* subject' (Hudis 2012, p. 61).

tion of life, as would yours'.[116] Hudis underlines how Marx does not argue for the conversion of labour into enjoyment, in the style of Hess, but how, in communism, 'the whole opposition between work and enjoyment disappears'.[117] Labour 'as an activity distinct from the enjoyment of a wealth of sensuous possibilities', Hudis argues, 'is *abolished*'.[118]

It is vital that we acknowledge the depth of this abolition. It is not merely a certain modality of labour (e.g. factory toil or boring work) that is laid waste to in the transition to post-capitalism: what must end is alienated labour in full. Not only the end of wage labour or productive labour, but the end of value and the supersession of the inversion of the subject-predicate relation. Hudis reminds us that Marx's critique of utopian socialism hinged on his rejection of imposing a social system on the working class, 'irrespective of its own needs and desires',[119] in favour of basing the new society on what workers consciously want. This is not because workers are always right but because workers must act as subjects instead of objects in order for communism to come about. This is the vital element in what has been called, rightly or wrongly, non-alienated labour.

Those who argue that non-alienated labour is satisfying work or the highest form of human transformative activity fail to register this dynamic agency of workers and impose, instead, an ideal of labour. When we think of non-alienated labour in terms of the reassertion of the subject within work after the alienation of the producer from the production process and the product, we neglect the real historical presence of the subject in the transformation of labour in the transition from capitalism to post-capitalism. That is to say, the subject of the worker who becomes the agent of work after the supersession of alienated labour does not have to be modelled on the aesthetic subject (the individual oriented by pleasure, enjoyment, beauty and the consumption of experiences and products), but might, instead, be modelled on the political subject, the critical subject, the individual member of the collective, the organiser, and so on. The need to imagine alternative subjects for the communist supersession of alienated labour is underlined by two critical traditions that I will discuss in the following two chapters, namely the critique of the aesthetic subject in the avant-garde tradition of anti-art and the activist tradition of anti-work, both of which reject the last traces of handicraft within the utopian discourse of non-alienated labour.

116 Hudis 2012, p. 58.
117 Marx quoted in Hudis 2012, p. 82.
118 Hudis 2012, p. 82. Original emphasis.
119 Hudis 2012, p. 78.

The Critique of Labour

This chapter responds to the rise of anti-work politics in the wake of the European political convulsion in 1968 characterised by the diminishment of the workers' movement as a political force and the rise of the 'new' movements. While this immediately signalled a decline in the politics of work and the triumphant dismissal of the politics of labour seemingly characteristic of the so-called 'traditional left' of Marxism, Trade Unionism and Social Democracy, it eventually led to an expansion of the category of work and its political terrain. 1968 is a political watershed, therefore, because it simultaneously propelled visions of non-alienated *jouissance* into the political imaginary, and eroded the assumptions operating within certain strands of the historical affiliation of art and labour that I have been tracing in this book.

In this chapter I will challenge the narrative that underpins contemporary post-work theory. According to this story, the goal of the so-called 'traditional left' was the emancipation through work whereas the goal of twenty-first-century post-capitalism is the emancipation from work. For the most part, the category of the traditional left is not clearly defined within post-capitalist theory, although it is spoken of as if we all understand what it is and what is (or was) wrong with it. Moishe Postone defined the traditional left as bearing a twin commitment to redistributive economics and the affirmation of work. This, arguably, is the official politics of the reformist labour movement (the trade unions, social-democratic parties and so on), but the term 'traditional left' also evokes, for some, Leninism, Trotskyism, Stalinism, Maoism or Marxism generally (sometimes treated as one unified tradition), or refers to the socialist and communist movements prior to May '68. Always, we can say, the traditional left is a category deployed to identify only those specific elements of the Left to be jettisoned by the new generation or the new politics and therefore it is necessarily a distortion. As such, the primary problem with the category of the traditional left is that it represents the breadth of socialist and communist traditions from the perspective of what they lack and therefore when the workers' movement aligned itself with anti-colonial, feminist, ecological and peace movements, for instance, these instances are extracted from the traditional left as if they did not belong there.

Contemporary anti-work politics consists principally of three mutations of the politics of work: it is post-Marxist; it contests the capitalist designation of what counts as work; and it reanimates the politics of work through a multitude

of diverse struggles. One of the great advantages of the anti-work movement, therefore, is that it inserts the politics of work into a broad framework of protest and activism encompassing social reproduction theory, intersectionalism, the politics of precarity and left accelerationism as a micropolitics of work. Hence, work is preserved as a theatre for social change after the global decline of the traditional left and the workers' movement. Ronaldo Munck acknowledges a metamorphosis of the politics of labour in 'the "new" social movements around environmental, gender and peace issues', saying 'a certain type of trade-union and labour politics may well be defunct, [but] the workers' movement has been at the forefront of many "new" movements for change'.[1] He explained: 'They stress their autonomy from party politics and prioritise civil society over the state. Power itself is redefined not as something to be "seized" but as a diffused and plural element woven into the very fabric of society'.[2]

Anti-work theory redefines the politics of work as the social force of the workers' movement declines and its hegemony within the struggle against capitalism palpably wanes. The material basis for the marginalisation of class and work within anti-work politics is not only the diminished power of the labour movement under conditions of neoliberal deregulation and the seeming obsolescence of workers within a projected future of full automation, but also the spatial asymmetries of the exploitation of workers in which the lifestyle of Western workers 'depends on the low wages and the barbaric working conditions in the "developing" world'.[3] At the same time, feminism rejected the hierarchy of work in which wage labour dominated to acknowledge the labour and value of sex, shopping, leisure and everything else performed ostensibly for 'love'.

In her book *Work: The Last 1,000 Years*,[4] Andrea Komlosy differentiates her theory of work from the traditional left by saying the labour movement stuck to a very narrow concept of work. Housework and subsistence work were not included in their definition of work or their conception of exploitation and appropriation and this denied non-paid, household and care activities the character of work. She claims that a feminist and postcolonial framework allows us to include all types of work and labour including commodified labour, reciprocal or subsistence labour and tributary labour. It may be possible to identify certain individuals or organisations within the workers' movement of the nineteenth and twentieth century that held such a narrow conception of

1 Munck 2002, p. 20.
2 Ibid.
3 Streeck 2016, p. 25.
4 Komlosy 2018.

work, but other examples could be found – particularly within the Marxist tradition – which acknowledge at least as wide a variety of modalities of labour that Komlosy enumerates. It is not the case that work is a more capacious category than labour. This appears to be the case only if the micropolitics of works regards the Marxist theory of labour to be restricted to the subcategory of productive labour.

I hope the previous chapters in this book have shown that the history of the politics of labour on the left cannot be summarised accurately as the affirmation of work or as the isolation of industrial wage labour as the only legitimate form of work. Every nineteenth-century communist from Owen to Proudhon and from Hess to Marx argued, in relative terms, for the reduction of the time spent in work and an increase in the time spent in forms of rest, leisure and self-development, and in absolute terms, for the abolition of the wage system altogether. Contemporary post-capitalist theory replaces this with an emphatic demand for the abolition of work in response to the traditional left's alleged advocacy of labour. From a value theory perspective, visions of a world without work, the absence of the wage or the absence of a boss fall short of the abolition of the wage system and the more far-reaching vision of the absence of abstract labour measured in units of average socially necessary labour time. If we accept that the abolition of capitalism depends upon the abolition of value production, then the contemporary political tendency of post-capitalism does not adequately align the abolition of work with the supersession of capitalism.

Marxism, indeed, politicises the difference between 'useful labour' which produces useful things or use values, and 'productive labour', which is specific to capitalism and is defined as that labour which produces surplus value. Also, Marxism challenges the simplistic division between paid and unpaid labour by demonstrating that wage labour always contains an unpaid portion and slavery and other non-waged labour always contains a portion of 'necessary labour' in which the worker reproduces her own life rather than producing surplus. Marxism provides the resources for a theoretical reformulation of what is at stake in the specifically anti-capitalist critique of labour. In particular, contemporary Marxist value theory can explain why anti-work theory, despite its breadth of appeal and expansion of the toolbox for a politics of labour, ultimately falls short of what is required of a post-capitalist theory of labour.

Post-work politics begins with post-Marxism. The classic example of this is Baudrillard's argument that Marxism's theoretical emphasis on labour and political support of the labour movement are deeply complicit with capitalism itself. Baudrillard made this case in his influential book, *The Mirror of Production*, published in the mid-1970s. Here, Baudrillard introduced the term 'productivism' into the vocabulary of the politics of work. Baudrillard's critique

of labour has been adopted by some early advocates of the feminist politics of housework, left accelerationism and contemporary post-capitalism. At the time, though, Baudrillard's book was, first and foremost, a swipe at the organised left in France that failed to recognise the political significance of May '68. In doing so, he formulated an abiding critical framework that was deliberately as anti-Marxist as it was anti-capitalist.

Baudrillard's 'break with Marx'[5] is announced, in the first line of the preface, in the form of a satirical inversion of the opening sentence of Marx and Engels's *Communist Manifesto*: 'A specter haunts the revolutionary imagination: the phantom of production. Everywhere it sustains an unbridled romanticism of productivity'.[6] Hence, he accused the workers' movement of contributing to its own condition by affirming the value or dignity of labour and calling for security of employment, higher wages and so forth. 'Marxism assists the cunning of capital', he said, by convincing 'men that they are alienated by the sale of their labor power, thus censoring the much more radical hypothesis that they might be alienated as labor power'.[7] Regardless of whether Baudrillard successfully snares Marx in his own contradictions by discovering a common denominator for capitalism and its critique, the accusation has stuck.

Baudrillard's grievance with Marx and Marxism derived in part from his conviction that simulation had replaced production as the logic of a postmodern society. At the same time, nevertheless, he also introduced a conceptual merging of the critique of work and the critique of the workers' movement. For those who suspect that white working-class men are part of the problem rather than the solution (of patriarchy, racism, sexism, colonialism, ecological devastation, industrialism, etc.), Baudrillard offered philosophical support. The argument that Marxism and the workers' movement represent the mirror of capitalism rather than its fatal opposition is based, partly, on the generalisation of the specific condition of the trade-union movement within industry within the Keynesian variant of Fordism, but for Baudrillard the most vivid prompt for the critique of Marxism was the student revolts of May '68. As Mark Poster recounts: 'The events of May 1968 confirmed for Baudrillard the poverty of the Marxist notion of revolution. It shattered in one brilliant display of semiolo-

5 Poster 1995, p. 108. Baudrillard explains in a footnote: 'Evidently Marx played an essential role in the rooting of this productivist metaphor. It was he who definitively radicalized and rationalized the concept of production, who "dialectized" it and gave it its revolutionary title of nobility. And it is in large part by unconditional reference to Marx that this concept pursues its prodigious career' (Baudrillard 1975, p. 18 n. 1).

6 Baudrillard 1975, p. 17.

7 Baudrillard 1975, p. 31.

gical fireworks the notion of the party with its intellectuals, its theory, its cadre, its careful organization and strategy, its duplication of the bourgeois world that it would supplant'.[8]

Baudrillard threatens to indict Marx's entire analysis of capitalism but ultimately concedes, in the final chapter, that the accusation of productivism pertains only to the period of consumerism.

> The bourgeoisie knew how to make the people work, but it also narrowly escaped destruction in 1929 because it did not know how to make them consume ... [T]he problem was no longer one of production but one of circulation. Consumption became the strategic element; the people were henceforth mobilized as consumers; their 'needs' became as essential as their labor power.[9]

Productivism is problematic for Baudrillard primarily because it fails to recognise the explosion of advertising and the boom in consumption in the 1950s and 1960s as well as the oligopolistic reorganisation of capitalism in Keynesian planning in concert with the rise of identity politics. In this regard, Baudrillard's analysis belongs not to post-capitalist literature but to the theory of the post-industrial society that Daniel Bell was formulating at the same time as characterised by computerisation, service industries, information economies and so on. What Bell and Baudrillard share is that they identify precisely those emergent features of what Ernest Mandel called 'late capitalism' that appear to discredit or marginalise the Marxist critique of political economy.

The philosophical argument for the rejection of production in Baudrillard is flawed. By choosing the vague idea of production and its normative and absolute representation *productivism*, Baudrillard sacrifices analytical efficacy for the sake of polemical advantage. His merging of capitalism and Marxism renders Baudrillard's own theory incapable of distinguishing between productivity (a measurable increase in the proportion of economic output to economic input), the labour theory of the production of value (i.e. average socially necessary labour time), and the production and maintenance of material wealth (viz. all societies produce material wealth of various kinds – for example, food, clothes, tools, houses, weapons, jewellery and music – but only capitalist society produces value).

8 Poster 1995, p. 115.
9 Baudrillard 1975, p. 144.

The eclipse of production and the politics of the workers' movement is an effect of the post-industrialism, post-Fordism, changes in the morphology of the labour process, and so on. Raniero Panzieri, Mario Tronti and Antonio Negri founded the journal *Quaderni Rossi* as an organ for the reorientation of politics in the wake of the disappointment of response of the workers' movement to the wave of political movements in the late 1960s. The Italian post-Marxist intellectual movement that fostered the radical thought not only of Tronti and Negri but also of 'Bifo' Berardi, Paolo Virno, Carlo Vercellone and others was also spurred on by the student protests of the late 1960s and formulated the phrase 'refusal of work' as one of its core slogans. Indeed, Michael Hardt has gone as far as saying: 'Some like to say that whereas 1968 lasted only a few months in France, in Italy it extended over ten years, right up until the end of the 1970s. And the Italian experiences were no weak echo of Berkeley in the 1960s or May in Paris'.[10] The Italian heterodox Left saw itself as opposing the strategy of the official Left in the 1970s that 'aimed at pitting the workers who have a regular job against the irregular, unemployed, precarious, underpaid young proletarians',[11] and pursued this with the joint demand of 'zerowork for income' and 'automate all production'.[12]

Originally Tronti, arguing that 'specific moments of the class struggle ... have determined every technological change in the mechanisms of industry',[13] understood 'the class struggle' not as a one-sided agency of worker resistance that forced capitalists to adjust their operations but as the 'interaction' between 'working class struggles and capitalist initiative'.[14] If the Industrial Revolution sparked the utopian demand for the humanisation of labour, for attractive labour and the realisation of the personality of the worker in labour and its products, then the post-Fordist incorporation of the worker's personality into wage labour requires not the aestheticisation of work but its abolition. More fundamentally, though, the slogan 'refusal to work' was a principled counter-position to the slogan 'the right to work' and similar demands for fair wages, full employment, and so on based on an anthropology of 'homo faber'.[15]

10 Hardt 1996, p. 2.
11 Berardi what all I want to talk to me again 2009, p. 22.
12 Berardi 2009, p. 24.
13 Tronti 1965, p. 30.
14 Ibid.
15 Negri 2009, p. 26. Negri says: 'Our problem then was that of reinventing the anthropology of labor. The "refusal of work" was not in fact a voluntaristic act but an operation that took place from within the system of machines; it was not a cultural operation for the transformation of nature but a new, natural-cultural organization: not simply a political act but an act constitutive of another humanity' (Negri 2009, p. 26).

Negri differentiates between an absolute and a determined refusal of work. 'No one has ever spoken of an absolute refusal of work',[16] he points out. From the outset, he says, 'it was a completely determined refusal, through which it was possible to contest working hours, wages, the subjection of free time, rents, et cetera. It's the same thing today: the refusal of work is an absolutely determined refusal'.[17] Berardi draws a line from the specific to the general: 'We want to make possible a general reduction in working time and we want to transform the organization of work in such a way that an autonomous organization of sectors of productive experimental organization may become possible'.[18] For Berardi, the 'refusal of work' is the position of the insubordinate section of workers and is expressed through 'absenteeism and sabotage'.[19] In some sense these workaday refusals and resistances anticipated the full revolutionary abolition of work, though it was not necessary for insubordinate workers to understand their actions in this way.

As a political practice, the refusal of work was a form of vigilance by workers in their daily encounters with bosses, regulations, time sheets, targets, measures of productivity and so on. It consists of taking sickies, getting clocked on or clocked off by your mate, stretching your tea breaks and lunch breaks, reading in the toilets, taking your time between jobs, mucking about on the job, dawdling and other little tricks. As such, the refusal of work was a programme for manifold daily refusals that exists on a continuum with insurrection and revolution. As a concept it tends towards abstraction because the notion of *work* has no empirical referent and the act of *refusal* lacks political direction.[20] Such measures typically confront the unions as much as the bosses since the unions developed the strategy of securing higher wages with promises of increased productivity. However, when the power of the unions is eroded by neoliberalism, the wriggle room of insubordinate workers is also eroded.

In 'Farewell to the Working Class'[21] and 'Paths to Paradise: On the Liberation from Work',[22] André Gorz presents a theory of the critique of work that reson-

16 Negri 2010, p. 12.
17 Ibid.
18 Berardi 1980, p. 159.
19 Berardi 2009, p. 93.
20 In fact, Tronti appears to have introduced the term 'refusal' for this very reason in 1965 when he sought to define a political interval between the formation of class consciousness and the development of a class politics in which the proletariat understood itself as 'a class against capital'. 'In the intervening period', he said, 'there is the refusal – collective, mass, expressed in passive forms' what you are (Tronti 1965, p. 29).
21 Gorz 1982 [1980].
22 Gorz 1985 [1983].

ates more with the contemporary micropolitics of work and the suspicion of the workers' movement that can be detected in certain strands of the feminist and postcolonial theory. Hardt and Negri describe Gorz's anti-work thesis as 'an analysis that appropriates central elements of [the Italian post-workerist] project but ultimately fails to capture its power'.[23] Despite this, Gorz's anti-work politics has become the filter through which the Italian 'refusal to work' has entered into certain prominent sections of contemporary political theory. His first of nine theses for a future left asserts: '[i]ts central theme is the liberation of time and the abolition of work'.[24] He characterises work narrowly as 'activities carried out for a wage'[25] and proceeds to distinguish work on this basis from 'self-determined activity'[26] which he narrowly conflates with 'free time' which is 'its own end'.[27] If he provides the template for contemporary anti-work politics, he does so on the basis of a weakly formulated binary distinction. His opposition between work and life takes side with use value against exchange value and life against economy but these are conceived in one-dimensional terms that correspond more or less to the dominant categories of work and leisure. Hence, his vision of the liberation from work appears to be little more than an extension of leisure: 'The abolition of work means the freeing or liberation of time. Freeing time – so that individuals can exercise control over their bodies, their use of themselves, their choice of activity, their goals and productions'.[28]

'Whatever else it may be, the vision of postcapitalism privileged in the autonomist tradition', Kathi Weeks stresses, 'is not a vision of the work society perfected, with its labors rationally organized, equally required, and justly distributed. Rather, it is a vision of the work society overcome'.[29] Weeks proposes a more far-reaching systemic critique of capitalism. Weeks carefully navigates the 'problem' of work between the critique of the 'work ethic' and the recognition of political value of the feminist campaign for wages for housework. Within her impressively formulated argument for a 'life beyond work', Weeks makes a case for rejecting the kind of distinction between work and labour that is exemplified by Hannah Arendt's differentiation of work, labour and activity. (I will do the same thing for different reasons below.) Weeks describes her rejection of distinguishing between work and labour as a method for 'blocking

23 Hardt and Negri 2000, p. 422 n. 16.
24 Gorz 1982 [1980], p. 1.
25 Ibid.
26 Gorz 1982 [1980], p. 2.
27 Ibid.
28 Ibid.
29 Weeks 2011, p. 101.

access to a vision of unalienated and unexploited work in the guise of living labor'.[30] The 'political project of "life against work" ',[31] she claims, addresses the relationship between production and reproduction that had been raised more narrowly in the wages for housework campaign as well as the abolition of the wage labour system and the rejection of the traditional left's affirmation of the dignity of labour.

Weeks acknowledges how the opposition of work and life has been co-opted within the management of labour itself in the exploitation of what Peter Fleming calls the 'authenticity' of the worker in their jobs. Nevertheless, the terms of Weeks's opposition of work and life appears to fall some way short of Miya Tokumitsu's critique of the 'unofficial work mantra for our time', namely 'do what you love'. Peter Frase, in his compact book *Four Futures: Life After Capitalism*, steers away from a Marcusean-style 'erotics' of labour but nevertheless extrapolates the effects of automation and the implementation of a universal basic income to decommodify labour to the extent that 'work wouldn't be work at all any more, it would be what we actually choose to do with our free time'.[32] Mark Fisher, also, focused on the psychopathologies of work. For him, politics is an aesthetic practice of the transformation of subjectivities and lived experience. 'The kind of reconstruction of subjectivity and of cognitive categories that post-capitalism will entail', Fisher argued, 'is an aesthetic project as much as something that can be delivered by any kind of parliamentary and statist agent alone'.[33] Fisher pivots the politics of work from political economy to ideology. Similarly, the critique of the work ethic in productivism is a politics of work focused on ideology. Effectively, the politics of anti-work, in this register, can be redescribed as the theoretical disclosure of the ideological reproduction of capitalism through the norms of workers themselves who have, over generations, been persuaded that work is good. One of the difficulties, here, is that the perception of the 'work ethic' as the dominant social imaginary of work imposed on workers by the bourgeoisie eclipses more detailed analysis of counter-hegemonic theories of labour within the socialist and communist movement, the bourgeois antipathy to manual labour and the reiteration of the bourgeois utopia of contemplation and the aesthetic life in the drive to abolish all work.

Weeks argues that the Protestant ethic 'mandates at once the most *rational* and *irrational* behaviours, promotes simultaneously *productivist* and *consum-*

30 Weeks 2011, p. 15.
31 Weeks 2011, p. 230.
32 Frase 2016, p. 41.
33 Fisher 2013, np.

erist values, and advances both individual *independence* and social *dependence*'.[34] The politics and theory of anti-work or post-work acknowledges that work is the precondition for the preservation of the social system that evangelises work as integral to any legitimate life and simultaneously brings about the systematic 'degradation of labour'[35] and the exploitation of workers and the programmatic diminishing of the worker's control over production. However, since the case against work must also be a case for the value of human activity to be recognised outside and beyond the system of work, the politics of anti-work cannot merely affirm non-work, as this does no more than invert the norms of the dominant system. Even though the principal theorists of anti-work are anti-capitalists and many anti-capitalists have adopted variants of anti-work theory, anti-work often allows its anti-capitalism to take a back seat to its critique of the voluntary subservience of workers to the system of work, especially the norms and practices of organised labour, even while it continues to conceive of this critique of organised labour within the class struggle against capital, capitalists and capitalism.

Weeks is right to point out that in their critique of work rather than demand for it, the Italian workerists 'certainly follow in the footsteps of Marx – the Marx who, for example, insisted that freedom depended on the shortening of the working day'.[36] However, Marx did not expedite his critique of capitalism, alienated labour and the wage system through the concept of *work* and its absolute negation or determined refusal. Weeks rejects the Marxist concept of labour as preferable to the term work because, she argues, it retains traces of a productivist affirmation of work. Weeks follows the Italian workerists when she argues that work is best understood, politically, as a power relation in which workers are subordinated to bosses. This is an echo of real subsumption but lacks precision.[37]

Marx spoke of the real subsumption of labour under capital, not the real subsumption of labourers under capitalists. The difference is worth underlining. Capitalists and their agents are not at liberty to be tyrants over their work-

34 Weeks 2011, p. 42.

35 See Braverman 1998 [1974].

36 Weeks 2011, pp. 97–8.

37 It is possible for political purposes to characterise the relationship of workers to capitalists or their agents in terms of an asymmetry between decision-making and certain empirical forms of control but this has two disadvantages. First, the distinction between labour relations and other power relations is lost. Second, the projection of power onto the capitalists or their agents takes the emphasis off capital or capitalism as a systemic mode of class domination.

ers willy-nilly: insofar as they are capitalists, they must implement whatever is required and available to increase productivity. Capitalism is the tyranny of capital, not capitalists. This political misperception is a necessary consequence of the conceptual problems of preferring the single term 'work' to the various subcategories of labour. The concept of work inscribed in the refusal of work, however, was not only formulated in relation to the industrial workplace but retains in some measure the distinction between work and non-work in which work is coextensive with the wage labour. Non-waged work is not recognised in the refusal of work and little or nothing is said by its main protagonists about how the refusal of work might be applied to domestic work, political work, philosophy, art and other activities that exist outside the official labour market. There is, therefore, a conceptual and strategic deficiency in the refusal to work. Work lacks specificity with regard to the distinction between waged and unwaged labour, productive and unproductive labour, living and dead labour, alienated and non-alienated labour, and so on; and refusal is noncommittal about the nuances that really matter in political activity: reform/revolution, individual/collective, pragmatic/utopian, etc.[38]

Weeks has articulated a radical conception of anti-work. Extrapolating from the workplace activism of insubordinate workers and the confrontation between workers and bosses, Weeks says the refusal of work 'is best understood in very broad terms as designating a general political and cultural movement – or, better yet, as a potential mode of life that challenges the mode of life now defined by and subordinated to work'.[39] As well as referring to a very specific confrontation, in its broadest sense, the refusal of work is a political slogan that has the potential to unite Communists, Anarchists, Socialists, libertarians, bohemians and aesthetes. However, the political programme that Weeks advocates is simultaneously utopian and modest: 'not only to contest the necessity of capitalist control, but to reduce the time spent at work, thereby offering

38 What this means is that the phrase has no single denotation or connotation but rather is abstracted from any specific meaning it might have and therefore comes to represent a wide spectrum of phenomena and thought. As such, the politics of the refusal to work is often overtaken by philosophical reflections on it rather than the other way around. Nevertheless, such philosophical abstractions can prove to be politically potent, as with Virno's reconstitution of Arendt's distinction between work, labour and action, which he deploys in order to oppose absolutely political action and work so that the refusal of work becomes the prerequisite of the resistance to capitalism. Virno says: 'The key to political action (or rather the only possibility of extracting it from its present state of paralysis) consists in developing the publicness of Intellect outside of Work, and in opposition to it' (1996, p. 196).

39 Weeks 2011, p. 99.

the possibility to pursue opportunities for pleasure and creativity that are out-
side the economic realm of production'.[40] I will return to the question of pleas-
ure and creativity below.

The refusal of work, for Negri, 'wasn't an invitation to laziness, nor to leisure,
nor indigence',[41] nor even a prelude to a fully realised humanity: it is an active
accumulation of proletarian powers, demands and needs. 'There is a workers'
"hoarding" that is as relevant as the capitalist one', Negri says, and the 'unfolding
of the commodity toward capitalist totality comes to a halt when the accumu-
lation of workers' self-valorization sets an alternative unfolding into motion ...
[which] feeds the explosion of subjectivity'.[42] Which is to say, the 'class com-
position' of workers is 'twofold: both object of exploitation and subject of self-
valorization'.[43] In capitalism, 'workers' self-valorization means the possibility of
not working hard, of living better, of enjoying a guaranteed wage',[44] and so on,
although, clearly, this 'is not enough'.[45] Nevertheless, even though the refusal
of work is also a rejection of the 'new humanism ... a communist humanism',[46]
that was formulated by Maurice Merleau-Ponty and others in the first half of
the twentieth century, which Negri characterises as 'the realism of a social, non-
alienated transformation of the labouring subject',[47] the refusal of work has
its own designated moment for the worker as aesthetic subject. The difference
between the humanisation of work and the refusal of work is that the former
merges labour and aesthetic activity whereas the latter splits them apart.

Similarly, the 'jobless future' described in the *Post-Work Manifesto* is a uto-
pian extrapolation of tendencies already underway in the advanced economies
towards unemployment and part-time work. Instead of fighting for the jobs
that are being lost in unprecedented numbers, the advocates of post-work
envision a hefty reduction in time spent working without loss of income or
any ascetic consequences, in a determined shift away from the right to work
towards the right to rest. These are important issues but I want to dwell on the
specific question of what constitutes a properly anti-capitalist politics of labour
and how this relates to a politics of artistic labour. Before outlining my own pos-
ition, I will turn my attention briefly to one of the most prominent arguments
within anti-work theory that develops out of an analysis of art.

40 Weeks 2011, p. 103.
41 Negri 2009, p. 24.
42 Negri 2005, p. 217.
43 Negri 2005, p. 218.
44 Negri 2005, p. 219.
45 Negri 2005, p. 219.
46 Negri 2009, p. 26.
47 Ibid.

Maurizio Lazzarato inverts both the affirmation of labour and the affirmation of the artist as a non-alienated labourer by arguing that the exemplar of the refusal of work is Duchamp.[48] This artist who exemplifies the absolute antagonism to handicraft in art by appearing to do as little as possible, the refusal of work does not correspond with the insubordinate or militant sector of workers. Instead, the focus on Duchamp allows Lazzarato to converge the refusal of work with an indifference towards even those radical workers who were dissatisfied with the conservatism of the workers' movement and the unions. Duchamp is not an insubordinate worker stealing time from the bosses but an artist without a boss. His reluctance to work was not a political weapon against capital but an expression of privilege and a romanticisation of privilege. His remoteness from work was typical of his class although it was not typical of artists of his generation. Even so, for an artist to shun work, especially waged labour, is not to disrupt social roles but to confirm the Academic, Kantian and Romantic definition of art as non-mercenary. His case, therefore, combines a post-Marxist critique of the affirmation of labour with the demand for the abolition of art, but although his advocacy of laziness is attached to the critique of capitalism, he neglects the actual history of the refusal of work in favour of a *rentier* ethic of idleness.

The vindication of the refusal of work resonates with two distinct traditions of the critique of work. First, it inserts the strike into a broader micropolitical resistance to workplace discipline through the tactics of absenteeism and sabotage. Second, it revives the utopia of non-work as form instead of content, that is to say not a celebration of leisure and rest or laziness as the antidote to work, but non-work and the refusal of work as the political confrontation with capital. In some sense, therefore, it resonates with both a Romantic anti-capitalism that begins with the German Idealist poets who rejected work in favour of play or spirit as well as the nineteenth century communists who confronted the wage system and insisted on the worker as the bearer of capacities beyond those assigned to the labouring class.

This is why it is important to dwell for a moment on the rejection of all forms of labour in the anti-work movement. In part this is justified insofar as it distances itself from the eighteenth-century ideal of aesthetic labour, the nineteenth-century utopia of handicraft and the twentieth-century concept of non-alienated labour at the same time that it rejects domestic drudgery, slave labour and the wage system. However, Bruno Gullì criticises the refusal of work

48 See Lazzarato 2014.

on the basis of its flawed conception of labour, saying 'it is difficult and danger-
ous to speak about the end of labor, the abolition of work, or even the refusal of
work'.[49] Gullì's book *Labor of Fire: The Ontology of Labor between Economy and
Culture* is a work of philosophy that uses a close reading of Marx's *Grundrisse*
in order to elaborate the conceptual relationship between art, capitalism and
human being. Gullì develops a social ontology of human species being based on
a concept of labour that is exemplified by artistic production. As an argument
to reinstate labour at the heart of the political imaginary, Gullì's book supplies a
vivid re-reading[50] of the concept of labour for debates around precarity, wages
for housework, post-Fordism and the refusal of work.

'The curse is not labor', Gullì says, appositely, 'but the subsumption of labor
under capital'.[51] The mistake of the refusal of work, for him, therefore, is the fail-
ure to 'distinguish between productive labor (a category of political economy)
and the productive power of labor (a category of ontology)'.[52] The abolition of
labour subsumed under capital, or the destruction of 'the value form of labor',[53]

49 Gullì 2005, p. 67.
50 Gulli presents the politics of work through a defence of artistic labour against the capit-
 alist mode of production. This resonates powerfully with the need to build a case for art
 in the face of neoliberal austerity and the anti-intellectualism of rightwing populism. The
 argument for art and its specific social forms of labour has not yet been fully articulated
 without leaning on Romantic anti-capitalism and the aestheticist tradition. Gulli is right,
 I believe, to develop this argument through the Marxist sub-categories of labour but the
 affirmation of labour as "all sensuous activity, all practice" (p. 18) risks returning the debate
 to the ahistorical and abstract conception of labour that Marx's complains as assumed by
 classical political economy.
51 Gullì 2005, p. 70.
52 Gullì 2005, p. 69. When discussing whether labour is an eternal category or a modern
 one, of whether labour might one day be eradicated in the way that anti-work theory
 anticipates, Gullì turns to Polanyi rather than Marx. Polanyi argued that labour is 'only
 another name for human activity' (p. 3) whereas Marx argued that the concept of labour
 in general, as opposed to specific types of work, originated with political economy in the
 eighteenth century even through it did so in a form that presumed that labour, includ-
 ing labour in general, was a timeless phenomenon. Playing down the historical specificity
 of the concept of labour in general, Gullì uses Polanyi to back up his claim that 'labor
 was not absent in past society, and it will not disappear in the future' (p. 3); in fact,
 he takes a position that is antagonistic to the refusal of work and Marx when he says
 'those who predict the end of labor are as mistaken as those who think that labor *as
 such* emerged at one point in time'. He ontologises the concept of the *labour as such* and
 therefore rather than concede that the concept of *labour as such* has a historical origin
 in the Enlightenment, projects this concept back over the whole history of human activ-
 ity.
53 Gullì 2005, p. 69.

therefore, 'becomes then a means to the possibility of free action, the object-
ive ground of subjectivity'[54] and 'clears the ground for the return of the subject
of labor to itself'.[55] Hence, the conceptual distinction between labour under
capitalism and labour after the abolition of capitalism allows Gullì to propose
that post-capitalist labour 'is not a curse, but the liberation of the plurality
of possibilities',[56] or 'praxis: the action of freedom, the self-realization of the
subject'.[57] Gullì is the contemporary standard-bearer for the concept of non-
alienated labour insofar as he claims that labour is 'the inner substance of
human praxis'[58] and therefore 'the esthetic dimension of labor is labor's fun-
damental and univocal disposition'.[59] Instead of the refusal of work, Gullì calls
for the erasure of the distinction between 'mere production and artistic pro-
duction'.[60]

The refusal of work resists this formulation of post-work bliss because it is
not handicraft or artistic production but absenteeism from work that is exem-
plary for the advocates of anti-work. If, however, absenteeism is also the time in
which individuals can enjoy themselves, develop their capacities and engage in
care for the self (hence, the reassertion of the aesthetic subject as non-worker),
this is not reducible to the demand for attractive work or for work to express the
subjectivity of the labourer. In effect, anti-work and the refusal of work vigil-
antly disaggregate work from aesthetic activity[61] (pleasure, enjoyment, self-
development, etc.). The politics of the refusal of work points to a world of
post-capitalist human activity that it does not articulate except through sug-
gestive but rather familiar condensations of the aesthetic tradition. Hence, it
would be possible, in principle, to supplement the refusal to work with the pos-
itive ontology of labour as human transformative action and self-realisation.
There is a hidden Schillerian moment of the refusal to work in the celebration
of play and a Marxist dimension to it in the anticipation of the abolition of
(alienated) labour in post-capitalism.

54 Ibid.
55 Ibid. To speak of a 'return', here, signals the adoption of the philosophical concept of ali-
 enation and therefore suggests that the destruction of the value form of labour amounts
 to something analogous to non-alienated labour.
56 Ibid.
57 Gullì 2005, p. 70.
58 Gullì 2005, p. 146.
59 Gullì 2005, p. 148.
60 Gullì 2005, p. 150.
61 The advocates of the refusal of work hint at a post-work future formulated as compatible
 with theories of non-alienated labour but too sketchily expressed to take a definite stance
 on the metaphysics of non-alienated labour.

While the refusal of work can be conceived of as the political precondi-
tion for the elaboration of a post-capitalist future, its exponents have been
guarded about what kind of human activities or social relations of produc-
tion the refusal affirms. Negri has countered this, somewhat, by arguing that
the old philosophical distinction between labour and activity has been can-
celled by new valorising tendencies in post-industrialism 'when the complete
subjection of *bios* to power has been realized and the canonical division of
modern thought (and work) – namely, nature and culture, labor and tech-
nique, factory and society etc. – are no longer given'.[62] The struggle to turn
labour into activity, which might be seen as the aim of the workers' move-
ment, had, in effect, been realised by capitalism. As a result, the refusal of
work rejects the utopian socialist and *sans culottes* dream of the reorganisa-
tion of labour according to the model of self-determined handicraft. The 'no
collar' workers in high tech startups, despite the fact that they 'can only be sub-
jugated to capitalist command with tremendous difficulty',[63] were not to be
taken as a sign of a humane workplace to come, but the onset of the erosion
of the distinction between work and non-work, of the full subjection of the
individual to work. As Federici puts it, 'nothing so effectively stifles our lives
as the transformation into work of the activities and relations that satisfy our
desires'.[64]

The extrapolation of work into the space of leisure has also characterised
the analysis of the online prosumer by Christian Fuchs and others. Identify-
ing leisure and rest as work has become the trigger of a new politics. Work
has taken on novel political meanings as a result of the diminished power of
the labour movement in the passage from welfare-state capitalism to glob-
alisation but also due to the transformation of debates on work by femin-
ist and postcolonial activists and theorists. In particular, for this investiga-
tion of politics of labour, work has been both depoliticised and repoliticised
within the discourses of post-capitalism as a sphere of micropolitical contest-
ation.

However, the recasting all leisure as work is no cure for the flawed distinc-
tion between work and leisure. Consider physical exercise, gardening, cooking,
shopping, protesting, organising, reading, thinking, playing music and writ-
ing. Each item on this list can be paid work, unpaid work, leisure or some
hybrid form. It is not the morphology of the activity that determines in which

62 Negri 2009, p. 22.
63 Negri 2009, p. 25.
64 Federici 2012, p. 3.

category it belongs. I include writing in the above list because a number of thinkers who have contributed to contemporary debates on work and workless-ness have failed to thematise their own work on essays and books except with reference to it being unpaid, badly paid or in some way necessary for the reputa-tional economy of an academic career. While such comments are true, it strikes me that they do not amount to the whole truth of writing a politically engaged study of work. In my own case, for instance, the work of writing this book, mostly written in the evenings, weekends and holidays in time left over after paid work in the academy and domestic chores at home, has been an experi-ence of the most difficult and demanding work which at turns can appear as drudgery, craft, pleasure, self-indulgence and self-realisation. As work, it occu-pies time slot of leisure and in some regards feels like leisure (my geeky version of gardening and DIY perhaps), but it is also political work (not the bod-ily urgency of direct action, of course, but political nonetheless) and therefore not merely the private activity of a hobbyist.

In thinking about writing as work, I have deliberately combined tropes from the discourses of toil and non-alienated labour because neither is adequate and yet the erasure of them seems too hasty. While the aesthetic model of non-alienated labour is a pathetic dilution of the range of measures required to overcome the manifold dimensions of alienated labour, focusing narrowly on the presence of pleasure within the labour process rather than the common ownership, control, management and governance of production and work, the aesthetic element of work cannot be fully jettisoned from the radical vision of work in post-capitalism, or even of the work we do today. Pleasure in work is not the goal of revolutionary politics, nor is it the proof that the 'work ethic' has lodged itself in our hearts. Recognising that the history of thinking about work and pleasure has been a sequence of botched jobs should not be enough to persuade us to stop thinking about work and pleasure. We do not need an erotics of work but we do need a political theory of work that recognises the full expanse of labour and all its subcategories. In this regard, the concept of artistic labour as the anticipation of non-alienated labour has been a great imped-iment to thinking through the politics of labour in full rather than reducing the politics of labour to the binary of the pleasurable and the tedious or redu-cing the supersession of capitalism to the morphological transformation of the labour process itself or to the handicraft model in which the worker controls the labour process from start to finish, like the nineteenth-century painter or sculptor.

Postone, who was an early advocate of the post-capitalist critique of the traditional left's affection for labour and the labourer, has contributed to the political narrative that underpins contemporary post-work arguments and yet

he also spells out what a truly post-capitalist politics of labour must be. Postone distinguishes between theories of post-capitalism that are distributive (or re-distributive) and the historical elimination of abstract labour. Only the latter, he argues, constitutes the supersession of capitalism understood as a social system that mediates production and consumption through the abstract opera-tion of value (average socially necessary labour time). In my reading, therefore, Postone's argument rejects equally the affirmation and disaffirmation of work in favour of a more pointed negation of abstract labour.

At the heart of abstract labour, Peter Hudis points out, is the problem of exchange which 'represents an object-object relation',[65] and therefore at the heart of the supersession of abstract labour is the abolition of earning a liv-ing from labour. Abstract labour, he says, insofar as it is characterised as the worker's activity 'turned against him' (the words are Marx's), can be under-stood as the application of Marx's early 'critique of subject-predicate inversion to the labour-process'.[66] When an individual worker takes 3 hours to produce something that is only worth 1 hour of socially necessary labour, it is clear that external, objective forces dictate and regulate the activity of the individual. That is to say, in a social system based on capital and the accumulation of value, the 'very activity of the subject becomes the predicate – a thing apart that dom-inates and controls the *real* subject'.[67] Post-capitalism consists, therefore, not only of the end of work or wage labour or productive labour, but the end of value and the supersession of the inversion of the subject-predicate relation.

Hudis concludes his close reading of Marx's theory of post-capitalism by say-ing 'wage-labour will come to an end with the abolition of alienated labour'.[68] This is why Hudis rejects Marcuse's argument against work. 'Marcuse is led to conclude that a new society, for Marx, entails the abolition of labour *per se*',[69] rather than the abolition of alienated labour specifically. Marcuse repeats the same mistake when he describes a socialist (or post-capitalist) society as one 'in which free time, not labour time is the social measure of wealth and the dimension of the individual existence'.[70] Hudis underlines how Marx does not argue for the conversion of labour into enjoyment, in the style of Hess, but

65 Hudis 2012, p. 56.
66 Hudis 2012, p. 61.
67 Ibid.
68 Hudis 2012, p. 119.
69 Hudis 2012, p. 203. See below my reiteration of Chris Arthur's discussion of the necessity
 of reading 'labour' as 'alienated labour' in Marx's writing on the supersession of capitalism
 and the 'abolition of labour'.
70 Marcuse 2000, p. xxiii. Quoted in Hudis 2012, p. 202.

how, in communism, 'the whole opposition between work and enjoyment disappears'.[71] Labour 'as an activity distinct from the enjoyment of a wealth of sensuous possibilities', Hudis argues, 'is *abolished*'.[72] It is vital that we acknowledge the depth of this abolition. It is not merely a certain modality of labour that is laid waste: what must end is abstract labour. Anti-work is a resonant political slogan but the only route to post-*capitalism* is through the abolition of labour reduced to average socially necessary labour time.

Speaking of work rather than labour in post-capitalist theory has to be understood as conceptually impoverishing insofar as the discourses of work (from Weber onwards especially) sacrifice the analytical precision of the subcategories of labour such as concrete labour, abstract labour, necessary labour, surplus labour, living labour, dead labour, productive, unproductive and useful or "reproductive" labour, as well as the formula of average socially necessary labour time. The discourses of work do not have equivalents for these subcategories of labour and therefore inevitably conflate and confuse them. To be for or against labour (or work) is too blunt, therefore, since capitalism is not characterised specifically by the presence of work but only by the dominance of abstract labour over concrete labour.

Heinrich clarifies certain questions about labour that have been misperceived in post-work politics:

> The difference between services and physical objects consists of a distinction of the material content; the question as to whether they are commodities pertains to their social form, and that depends upon whether objects and services are exchanged. And with that, we have sorted out the matter of the frequently stated argument that with the 'transition from an industrial to a service economy' or in the left-wing variant of Hardt and Negri – the transition from 'material' to 'immaterial' production – Marx's value theory has become outmoded.[73]

Reading Marx's formulation of the relationship between concrete labour (making things and doing things) and abstract labour (producing value), Heinrich states emphatically that 'not all labor has a twofold character but rather only *commodity-producing* labor'.[74] This has been stated before but it takes on new meaning in the context of post-capitalism in which every act of labour – con-

71 Marx quoted in Hudis 2012, p. 82.
72 Hudis 2012, p. 82. Original emphasis.
73 Heinrich 2012, p. 44.
74 Heinrich 2012, p. 48.

sidered under the general heading of 'work' – appears to produce value or is considered to be identical with or only contingently differentiated from wage labour.

Assorted versions of the refusal of work appear to discredit only that narrow band of the historical affiliation of art with labour in which art appears to anticipate a future of work indistinguishable from pleasure. A deeper and broader survey of the changing relationship between art and labour reveals, in fact, that a very early variety of the refusal of work was operative within the elevation of the Fine Arts above handicraft and that the category of art in general was initially shaped by a hostility to work, the wage, workers and industry, among other things. What the history of art as a social form of labour demonstrates, I would argue, is that the refusal of work and the aggression against craft cannot be reduced to a single political project or restricted to a certain historical period.

The persistence of the aesthetic subject within anti-work politics needs to be be addressed. Conceived in contrast with the Romantic and Utopian idea of pleasure in work, anti-work theory affirms pleasure and creativity outside work. Gorz presents the classic formulation of this but it can be found also in variations by Weeks, Lazzarato, Tronti and others. If art often acted as a paradigm of the dissolution of the division between work and pleasure in the eighteenth and nineteenth century, it returns here, in the guise of a certain kind of subject, as the opposite of work. Although it is important that we acknowledge the absence of the artist as a model for workless activity in anti-work theory, the aesthetic subject of the non-worker requires a deeper engagement with the history of the politics of work in art than the contemporary politics of work has managed so far.

The aesthetic subject is not immune from the politics of work but is a particular expression of it. It is, as I have shown in this book, a peculiar conceptual concoction that mixes work and worklessness, production and consumption, activity and inactivity, rules and lawlessness. The aesthetic retreat from work depends upon an ideological abstraction from work itself, an abstraction that is based, historically, on the struggle between the guild and the court. In the history of art's social form of labour from which the aesthetic subject derives, the politics of labour is expressed as a hostility between art and the mechanical in at least three phases. First, it is the mechanical arts which are opposed and suppressed; second, it is mechanisation which is identified as the enemy of art and the aesthetic; and third, the machine is embraced as the antidote to the aesthetic within anti-art. If anti-work theorists elaborated on the positive image of the aesthetic subject freed from work, would we find the codified heritage of the hostility to handicraft?

None of the variations of the hostility to handicraft in the history of art are anti-capitalist gestures in the way that the refusal of work occasionally presents itself today. The first is a pre-capitalist affirmation of nobility against the 'mechanick'; the second confronts industrialisation rather than capitalism specifically; and the third sets itself up against bourgeois culture rather than the bourgeois mode of production. It is perhaps inevitable that the opponents of work end up as the advocates of the aesthetic subject not only freed from wage labour and unpaid drudgery but also from the activity of producing art itself. The myth of the artist appears too productivist and is therefore substituted by the myth of the consumer. Given that the bourgeoisie remodels the virtue of aristocratic idleness in the image of the consumer as a sovereign of self-expressive choice, the pleasure and creativity of the non-worker in anti-work politics cannot be asserted without dragging up the entire history of art, aesthetics and labour.

Although the discourses of attractive work, aesthetic labour, pleasure in work, alienated labour, non-alienated labour, the refusal of work and even the advocacy of craft and the humane workplace fall well short of the supersession of capitalism they must be credited with providing a continuous critical resource for the labour movement and and the diversity of anti-capitalist struggles. Aesthetics, art and artistic labour has played a significant but often overlooked part in the formation of the critical discourse of work including the postcolonial theory of slavery and the self-determination of people of colour. At the same time, debates on work have played a decisive role, albeit a suppressed one, within the formation of art as a category and the artist as an outlier of the wage system. In this regard, the critique of labour has been a permanent feature of the capitalist world and a conspicuous element of the infrastructures of dissent that have been built within and against it. Under present conditions it is not idiotic to demand security in employment, more jobs, better jobs, higher wages, better working conditions and so forth, but it is correct to point out that such demands are entirely internal to the capitalist mode of production and only the demand for the abolition of the wage system and everything that goes with it.

Conclusion

The historical episodes of art as a social form of labour that I have reconstructed in this book do not supply a single, remote causal event for a persistent, unchanging condition for the production of art. By extending the historical timeline for interpreting the political meaning of art's relationship to work, industrialisation, commerce, the division of labour, mechanisation, deskilling, automation and the wage, I have sought to intervene in current debates on art as work, the artist as worker, art and robotisation, art and capitalism, and work and pleasure through a narrative of the formation of art as a social form of labour through various iterations of the hostility to handicraft.

My purpose has not been to discover an earlier historical conjuncture that sets the conceptual or normative frame within which modern and contemporary debates on art and labour are to be placed. In other words, I am not claiming that recent developments of the politics of labour in art are nothing but echoes of a more fundamental historical event that took place in the Renaissance or the formation of the Fine Arts in the seventeenth century or the social division of labour brought about by the industrialisation of the production of artists' supplies in the eighteenth century or the development of the art market in the nineteenth century. I have no intention to observe all the subsequent entwined history of art and labour through the lens of a single historical moment but to narrate the various forms taken by the hostility to handicraft from the rejection of the mechanical arts to the displacement of mechanisation from the studio to the embrace of the machine in anti-art, amongst others.

There is no single event – for example, the valorisation of skill over raw materials, the passage from the workshop to the studio or the Duchampian or Conceptualist elimination of the handmade – that acts as a switch from a handicraft configuration of labour to art. Nor is the distinction between handicraft and art, or the artisan and the artist, fixed and stable through time and from region to region. Nevertheless, events take place within a world system characterised by uneven and combined development, which means that nothing in the history of art's social form of labour occurs in isolation. As well as variations of a specific condition of artistic production, such as the specific ways in which the academy system took hold in different parts of the world, there are also historical chains of translation, metamorphosis and mutation through which the hostility to handicraft is preserved by shedding its old forms.

Typical of the kind of transmutation I want to highlight here is how the systemic tension within the dual system of the guild and academy is expressed in a distinction between the apprentice and the pupil that is carried forward

into the art school as a methodological differentiation between rote learning and innovative or critical thinking. Accusations that artisans are capable only of *copying* what academically accredited painters and sculptors *invent* crystallise as norms and, in the absence of both the guild and the academy, re-emerge, amongst other things, as a distinction between art and kitsch or as the critique of the author in the critical practice of appropriation in which the artist is distinguished from the designer or manufacturer by choosing rather than making their work.

If there is one recurrent feature of the hostility to handicraft within the long history of the intertwinement of art and labour that secures the distinctiveness of art and the Fine Arts from both the artisanal and industrial modes of production, it is the augmentation of practice with what has come to be known as art theory. Scholarship was initially proof of the elevation of the painter and sculptor above handicraft and therefore scholar-painters and scholar-sculptors were meant to know things that could not be taught to the apprentice. Academicians taught their scholars principles not techniques. Advocates of not-knowing, the primacy of the visual, aesthetic experience, risk-taking, judgement and discovery-through-doing typically present themselves as antagonists of art theory but, viewed through the lens of the history of art as a social form of labour, they are off-shoots of the same rejection of the mechanical production of works of art.

Conceptualism and Greenbergian formalism, despite their sometimes ferocious opposition, share the same family tree, as do Brechtian techniques of producing critical subjectivity and aestheticist forms of scrupulousness. Theory in art, understood as rooted historically in the distinction between the scholar and the apprentice (and later between the artisan and the artist) during the rise of the academy system in competition with the guilds, is only rarely motivated by the truth operations of science and the humanities. Even those tendencies in art and art theory characterised by the most demanding levels of philosophical or technical complexity, such as political modernism in the 1970s or postmodernism in the 1980s, are motivated by the attempt to dislodge old truths rather than to establish new certainties. I would hazard that, even at its most didactic, art theory has always sought to establish a specific starting point for art practice rather than acting as a recipe for the production of works of art.

Let's consider, as an extreme example, those Dada, Minimalist and Conceptualist works that were executed according to specific, detailed instructions. Perhaps, on the face of it, making an artwork strictly according to a sequence of mechanical acts laid down in advance appears to contradict my claim that art theory has not typically – or never – consisted of providing recipes for art-

works. Three examples will suffice to identify what is at stake here. Tristan Tzara's instructions for a Dada poem mimic a recipe and follow the step-by-step process of mechanical operations that begin with a readymade example of existing culture (an article in a magazine chosen quantitively) which is cut up with scissors, placed in a bag, drawn out from the bag and then copied out in the order that chance has determined. Sol LeWitt's wall drawings are produced according to strict geometrical instructions that include decisions made by the 'drafter' and even hand-drawn elements.[1] In the early 1960s, Yoko Ono made 'instructions paintings' and 'event scores' containing a mixture of poetic ideas (e.g. 'draw a map to get lost') and mechanical operations for viewers to execute, such as 'listen to a heart beat' and 'cut a hole in a bag filled with seeds of any kind and place the bag where there is wind'.

Despite their different historical contexts, what instructional artworks have in common is that the mechanical procedures specified for their completion are neither artistic techniques nor are they decisive in determining whether or not a thing or action is art. It is significant that in each case the artist is not the person imagined to follow the instructions, but even in cases where artists do enact a sequence of predetermined tasks (performance is emblematic of this), the division between the artist and the executor of the work exists in the difference between two types of activity. Using approximate terms, we can say that the production of instructional works consists of two phases: ideas and making. The artist has a monopoly on the ideas but the execution of the work can be carried out by the artist or someone else. The question, therefore, that such works raise is this: what kind of labour must be performed by the artist and what kind of labour in the production of art can be entrusted by the artist to someone else?

The presence of perfunctory procedures within these works and others like them does not signify a return to handicraft in art in the form of a revocation of the hostility to the mechanical. On the contrary, the technical interval between idea production and mechanical execution is heightened in these works to conform to a hierarchy that can trace its roots to the recasting of painting and sculpture as scholarly activities. Handicraft and the mechanical return to the technical repertoire of modern and contemporary art to the degree that specifically aesthetic techniques associated with the special hand or eye or talent of the artist are deposed. Mechanical procedures are no longer ejected from

1 For example: Using a hard pencil draw a 6″ × 6″ grid covering the wall. Within the squares draw freehand lines horizontally, vertically, diagonally left to right and diagonally right to left. Draw only one kind of line within each square, as many lines as desired but with at least one line within each square.

the studio or added to the work of art by other hands when they stand as proof that the artist is an intellectual rather than a dazzling producer.

The mechanical is the cure for the persistence of virtuosity within the artwork after the scholarly and aesthetic critique of handicraft. In other words, the conspicuous display of technical formulaicism in modern and contemporary art preserves and extends the rift between the informed producer and the delicate manoeuvres of both the artisan and the aesthete. What John Roberts calls 'general social technique' is not proof of art's technical paucity but an increase in the identification of the artist with intellectual work. Mechanical procedures in art are not avowals of the mechanical but signify the authority of the rule-giver. As such, the return of the mechanical in art is a continuation of the hostility to the mechanical in works of art.

Deskilling in art is economically distinct from deskilling in the capitalist mode of production and yet both share a hostility to handicraft. Capitalism augments relative surplus value with the introduction of machinery and the conversion of skilled labour into unskilled labour, but art's hostility to handicraft is older than this assault by capital and consists, rather, in the affirmation of the scholarly, the intellectual, the discursive and the theoretical. So much so, in fact, that this book can be seen as the result of the entire history of the repositioning of the artist as distinct from the artisan through the adoption of the humanities, science, political theory, psychoanalysis, semiotics and so on. A book-length analysis of the political economy of artistic labour may not yet be a routine test of legitimacy for an artist, but the ability to sustain an argument and assemble textual evidence retain their validity in art schools no longer persuaded of the necessity of life drawing or any other staples of Fine Art education (drawing from drawings, perspective, proportion, etc.). My argument, here, is not that theoretical techniques have replaced techniques of the hand and eye in the production of artworks, but that the theoretical has become essential in identifying the artist as the bearer of a social form of labour.

The hostility to handicraft does not only affect the technical composition of artistic labour and the differentiation of the artist from the artisan and worker; it is also the normative basis for art's economic exceptionalism. From an economic point of view, art is economically exceptional if and only if its mode of production deviates from the capitalist mode of production (specifically insofar as artistic labour has not been subsumed under capital in the form of wage labour), but the history of the hostility to handicraft explains how art has been able to hold off the pressure to allow the production of art to be determined by effective consumer demand. There is, we can say, a counter-pressure, which has taken various forms. Although the production of works of art was not eco-

nomically exceptional in the Renaissance, the divide between guild and court established the conditions for a minority of prestigious painters and sculptors to regard themselves as something akin to a gentleman scholar who cannot be persuaded to sacrifice the noble pursuit for excellence by the promise of a sum of money.

Regardless of how resonant these episodes in the Renaissance biographies of painters and sculptors remained within the changing conditions of the hostility to handicraft, the faux nobility of the painter and sculptor does not survive without being transformed into a statute of the academy system or a virtue of the bohemian rejection of the bourgeois affectation of nobility. One of the most striking off-springs of the courtly protection of painters and sculptors from the commerce of the guild was the invention of public subsidies for 'the arts' after the Second World War. Certainly, there are multiple factors in play when the welfare state was developed but art would not have been included alongside the provision of housing, unemployment benefit, pensions and universal healthcare without some trace of the aristocratic dismissal of commerce and the 'trades' that had lodged itself within the normative and institutional condition of art as a social form of labour.

Having said that, the public subsidy of the 'arts' is not decoded politically by asserting that it is an elite aristocratic ethos for culture foisted onto state expenditure. Art extends its opposition to commerce and the market with the public dimension of the Salon, the national public museums of art and the Romantic anti-capitalist critique of industrialisation as well as the socialist, postcolonial and feminist demand that art belongs to all. All the varieties of public subsidy for art, from tax relief for collectors and corporate sponsors to grants for artists and project funding, operate according to one version or another of the conviction that the production of artworks cannot entirely be entrusted to the market. Sometimes the emphasis is given to questions of quality and in other instances the emphasis is on the independence of the artist or the public interest of a national or global culture; nevertheless some form of decommodification is introduced to protect art from the law of supply and demand.

Publics and markets for art co-exist. In some cases, the market appears to colonise the public (when, for instance, public museums take their cues from the commercial gallery system), while in others art's publics set the agenda for the market (when, for instance, political and ethical debates on culture transform the conditions under which art is produced and displayed). As such, the tension between the publics and markets for art is expressed in many instances as a specific kind of coalescence or accommodation. The tension between the discursive appraisal of art and the price it fetches (if any) cannot be elimin-

ated so long as art remains a social form of labour not fully subordinated to the capitalist mode of production and the evaluation of art by art critics, art historians, curators and other professional representatives of art's public continue to count. This is why there is so much discussion today about the reputational economy of art.

What I have attempted to spell out in this book is not only the historical emergence of the conditions under which art's markets and publics come into conflict but also what would need to change in the social organisation of artistic labour for this dynamic to dissolve. Current and recent discussions of the crisis in art criticism, the death of the public, the commodification of art history, the annexation of the museum by big business and so on, as important as these are, need to be measured against the scale of discursive and institutional sedimentation of art's hostility to handicraft and the statute against opening a shop that eventually accompanied it and was then sublimated in the economic exceptionalism of art.

Art's strained relationship with capitalism, which is not primarily a question of content but its specific social form of labour, is not something to be taken for granted, not something impervious to social change, but a result of concrete social struggles that have been opposed at every step. Art's hostility to capitalism, which has never been complete or guaranteed, developed out of the hostility to handicraft, commerce and manufacturing and therefore can be eroded within a politics of work that is indifferent to the specific social forms of labour or affirms the ethical principal of the wage relation for all work. By tracing the history of art's social form of labour within concrete systems of production characterised by conflict, I hope to have demonstrated that the relationship between art and capital must continue to depend on actual specific struggles.

Precarity is a contemporary political concept which attempts to unite diverse political constituents across the globe in a shared politics of labour and insecurity in post-Fordism. Precarity is a macropolitical category for countless specific micropolitical struggles. Artists, who tend to operate within a gig economy and are often underpaid or not paid at all, join forces with the unemployed, migrant workers, domestic labourers, indigenous populations, service workers and others in a recognition of a shared condition. Art's economic exceptionalism is the material basis for the precarity of artists but this is often misperceived by activists and theorists who have challenged instead the myths of the artist that appear to underpin and perpetuate the dissociation of artistic labour and the wage. If *Art and Value* provided a deeper economic explanation of the non-subsumption of artistic labour under the wage that casts doubt on the short-term political strategy of extending the wage relation into those

modes of production that have until now managed to resist it, *Art and Labour*
extends this analysis by unpacking the difficulties of associating the artist with
the worker or identifying the artist with the antidote to work.

Wages for artists is a campaign that makes most sense as a Situationist joke.
Like wages for housework, it can be realised fully only by abolishing the wage
system and the attachment of work and the wage. It proceeds on the basis
that the abolition of slavery could have been brought about by demanding
that everyone – including slaves – should have the right to own slaves. The
infinity of the wage – wages for the unwaged! – erodes the social basis of the
wage system, which remains the production of profit for capitalist employers
even as the state takes up more and more of the slack of the unproductive
labour required to keep the capitalist world system afloat. However, the con-
viction that artists ought to be paid for the work that they do is possible only
on the basis of the history of art's elevation above handicraft as a universal,
public culture, and presupposes the public funding for art in order to draw
funds from publicly funded art institutions. Fees for artists as a right is com-
ical because it demands an income in the absence of both bosses and market
demand which means it is a plea for communism for an elite of workless work-
ers.

Artists who today make an ethical display of refusing to work without pay or
give an ethical defence of their rejection of an invitation to donate artworks to
fundraising auctions collapse (a) the identification of the artist with the worker,
and (b) the academic ethos that the artist should not derive their income from
sales. This is because the demand for wages or fees *presupposes* that artists
should not be expected to live off sales of their works. This contrasts sharply
with the identification of artists with workers in the 1970s in New York whereby
the Artist Workers' Coalition (AWC) fought for, amongst other things, the rights
of artists to receive a portion of the profit from the secondary market in their
works. The shift from an extension of property rights to a demand for an exten-
sion of the wage system signals a fluctuation between two aspects of the legacy
of the hostility to handicraft that have not been fully articulated within the
micropolitics of work in art.

The most politically significant development in the contemporary politics of
work in art is the extension of the recognition of non-artist art workers in the
global division of labour of the production, circulation, display and reception
of art. As part of this, the recognition that art operates within the university
and the museum not only as institutions of canonical knowledge but also as
workplaces has provided a new set of political urgencies that displace those of
institutional critique in the 1980s and 1990s. Like the posthumanist critique
of the humanities, which had failed to predict the neoliberal assault on the

existence and legitimacy of the humanities within the university sector, institutional critique in contemporary art reached its limit when the global credit crunch acted as a foil for, amongst other things, increasing levels of debt for art students and job losses in museums and universities. These are the immediate circumstances in which the politics of social reproduction theory has taken root in the museum and university sector.

Clearly, the extension of the politics of work in art from the aesthetic labour of the artist to the full variety of waged and unwaged activity within art galleries, museums, studios, pedagogical institutions and publishing is ethically and politically justified. The historical episodes that have been outlined in this book suggest an extra dimension to this political scene. While it remains true that no account of the politics of work in art that restricts itself to aesthetic labour is adequate to the task, orienting the politics of work in art around everything but artistic labour – and, in so doing, remodelling the artist on the worker in a more standard sense – collapses the historically significant distinction between the social form of artistic labour and the social form of wage labour. No doubt, for the most part, this is precisely the intention of the current micropolitics of work in art but, so long as we understand that the exaggerated independence of the artist has a social basis that is historically overdetermined, it simply replaces a perceived falsification with an actual falsification.

Ontologically, art is work in the most capacious sense of the term but, historically, the artist is not a worker in the narrow sense of the term. While the difference between the artist and worker has typically been overloaded with cultural and ethical baggage, and for this reason alone has been the justified target of politically motivated demystification (including the overstatement of the identity or alliance of the artist with the worker), the analysis of the social form of artistic labour confirms the economic analysis of art's exceptionalism. However, this historical reconstruction in no way justifies the claims made on behalf of artistic labour by those who have contributed to its historical bifurcation from handicraft and industry. In particular, the discourses of handicraft which proliferated within the academy system and were preserved after it, in which the artisan is nothing but a skilled 'mechanick' with no powers of invention, no taste and so on, were false from the start.

If we take our cues not from art's social form of labour but from, say, the distribution of wealth among the various workers within the social division of artistic labour (in which, say, the studio assistant or fabricator – i.e. the skilled producer who produces the works – is paid less than the artist), then the claim that art is an atypical form of labour appears to be the normative basis for the extraction of profit from the work of others. Similarly, the deviation from artisanal economies has underpinned the misperception that art is simply superior

to craft, design, manufacture and so on. This falsehood was actively put about by the advocates of the academy system and has never fully receded into history as it ought to have.

In certain respects, modernism and the avant-garde partly recognised the validity of the artisanal against the outmoded hierarchies of the academy. In the late nineteenth century, the possibility of affirming the artisanal appeared to somebody like William Morris only in the form of a radical anti-capitalist nostalgia, but early in the twentieth century, for someone like Walter Gropius, the embrace of design and industry appeared to cancel the hostility to handicraft. Bauhaus modernism did not put a hostility to art in the place of the hostility to handicraft and therefore retained many of the real and symbolic privileges that had historically accompanied the success of artists differentiating themselves from guild artisans, capitalist entrepreneurs, wage labourers, and so on.

Modernism and avant-gardism, including anti-art, restaged the relationship between art and handicraft through a polemical endorsement of the everyday, the popular, the industrial and the philistine, including the savage and the primitive. If we can say that the arts existed in all cultures throughout history but art is modern, then, from the perspective of art's social form of labour, the immersion in folk art, mechanisation, ritual, geometry and chance in the twentieth century all had the same purpose, namely to reconnect art as a world system to the manifold world cultures which it had subsumed. If art re-establishes the universality of the arts as an abstract universality in which art is a global culture that belongs to the human race, reversing the polarity of art's historical hostility to handicraft had the effect of securing art's universality in a catalogue of particularities now firmly classified within a single abstract category. To use Derrida's neologism to designate the mastery implied in the host-guest relationship, this is art's 'hostipitality' to handicraft.

The period of modernism's naïve heroism has long passed. Ecological disaster and the replacement of industrialisation with financialisation has deprived technology of its erstwhile promise. Nevertheless, today, perhaps more than ever, automation and acceleration have emerged discursively as the saviours of humanity once again. 'The real emancipatory potential of technology remains unrealized', our Xenofeminist comrades say. There is certainly a case for arguing that capitalism has always subverted the emancipatory potential of the machine, mechanisation, automation and acceleration. What would it take for the machine to be allied with the revolutionary forces pitted against market mechanisms? We must concede, first of all, that such a victory against capitalism by the machine will not be an automatic effect of the emancipation of technology. Art, surprisingly perhaps, has a role to play in the evaluation of such hypotheses.

The history of the proposed technological emancipation of humankind is intertwined with the history of aesthetic labour. If labour will be eliminated by technologies of rest, it has often been argued, then the indifference to unpleasant work enjoyed by the artist might become universal. This case has also been put in culturally normative terms, of course, as part of the argument that the abolition of work through technology will permit an increasing proportion of the population to enjoy art or to produce aesthetically or even to become artists. These particular scenes of post-capitalist rest are conspicuously redacted from the projections of Left Accelerationism and Xenofeminism today presumably because they are associated with an old-fashioned version of a post-work future in which nineteenth-century cultural values mould the image of a future that is unlike the past only insofar as the experience of domestic labour, colonial toil and proletarian work has been eradicated from it.

If art's historical opposition to work and commerce is flawed, and it is, then what exactly is wrong with it and how can the opposition to work and commerce be better formulated? Also, if art's hostility to handicraft is misplaced, and if the left-wing defence of handicraft is also misplaced, then what vision of human flourishing can be outlined to replace it? What these questions and others like them indicate is that it is not enough to affirm the abolition of work or the replacement of work with rest, laziness and idleness (the negatives of work), or with leisure, play, free time and voluntary activity (the rivals of work within the wage system) or with satisfying work (work modelled on bourgeois practices of consumption). What exactly, we need to ask, does not working look like and what exactly are its merits?

Prophecies of the abolition of work, the absence of the wage or the lack of a boss fall short of the vision of the absence of abstract labour measured in units of average socially necessary labour time. I have already outlined in this book the argument that it is alienated labour or abstract labour that must be abolished rather than work in general. This is not because I have a soft spot for work and I only want to abolish its worst instances, as the enemies of industrialism did. Rather, I am guided in my critique of work by the Marxist analysis of the capitalist mode of production and the pivotal role of abstract labour for that system. It is not that I want to abolish only wage labour and retain all other forms of unwaged labour (slave labour, domestic labour, etc.) in a bid to overthrow capitalism before addressing any other political urgencies, although it is true that I believe we need more precision in identifying the kind of labour that must be abolished in order to bring about post-capitalism.

Since, as I have already stated, capitalism is not characterised specifically by the presence of labour or work but only by the dominance of abstract labour over concrete labour, no adequate politics of labour can lead to post-capitalism

on the basis of an affirmation of labour or a refusal of work. Domestic labour has to be eradicated in its current form partly because of its gendered division of labour but also because it is a form of concrete labour which is both excluded from and dominated by abstract labour. That is to say, it is the domination of abstract labour over concrete labour which is the basis for the domination of the wage labourer over the non-waged domestic worker. However, the cure for the domination of abstract labour over concrete labour is not the infinite extension of the wage system but the abolition of the wage system altogether.

Historically, artistic labour has been proposed as an antidote to work, but this argument has run its course. One of the reasons why artistic labour no longer serves as the model of unalienated labour in post-capitalism, as it did for Adolfo Sánchez Vázquez, Carol Gould, Phillip Kain in the 1970s and continues to do so for Gullì today, is that the production of contemporary art is no longer characterised exclusively by aesthetic processes of composing, authoring, making and mark-making. Readymades, paintings produced over the telephone, photomontages and monochrome paintings, or producing art through acts of buying, finding, spilling, instructing, gluing, tracing and erasing, deliberately confronts not only the presence of handicraft in art but also the politics of labour that turns on art as a paradigm of non-capitalist labour. This is why the avant-garde so often realises its critique of aesthetic labour by embracing mechanisation, automation, commerce and business.

What the history of the hostility to handicraft from Leonardo to Santiago Sierra reveals is that the opposition to work has not always correlated in any precise way to an anti-capitalist or emancipatory politics. Partly, of course, this is because the specific struggles which ignited the hostility to handicraft in art were pre-industrial and this set a pattern which could be redeployed as part of an anti-capitalist politics but were not confined to this project. Hostility to work more generally can be plotted within the history of art as a social form of labour to anticipate certain struggles within anti-capitalism, but it can also be charged with noble sentiments and colonial values that replicate the ethos of the aristocratic gentleman and the experience of the work-shy settler. Likewise, the rejection of commerce in art is not specifically anti-capitalist but is also a noble virtue.

The politics of work in art cannot be expressed adequately by restricting the analysis to events after the eighteenth century. Art as a social form of labour does not disclose itself on close examination only of the results of the invention of art during the Romantic period. For a full understanding of the politics of work in art we need to revisit the separation between art and handicraft that preceded the transition from the Fine Arts to art in general. This book is an attempt to resituate these debates on a more adequate historical basis, albeit

one that must, at this stage, exist only in outline or in episodic fragments. Impatient histories of modernity showing itself before its time do not provide the narratives of the transformation of artistic labour that we need in order to follow the changing resonance of work within the history of art and revolutions in the social significance of art within the history of labour.

In extending the temporal scale of the intertwined history of art and labour deeper into the preconditions for the advent of aesthetic labour in the eighteenth century, I have also, perhaps, already implied that the dismantling of the current condition of art and labour in capitalism will be overcome only through a similar length of time and through a proliferation of specific struggles. The Communisation thesis that post-capitalism is not to be put off but has to be enacted in the here and now is correct insofar as daily struggles against the dominance of abstract labour constitute the material basis of post-capitalism, but it is false insofar as these daily struggles will more than likely produce subordinate and insubordinate modes of production that continue to operate in the shadow and subject to the violence of the capitalist mode of production. Despite all of its failings, therefore, art, along with its distinctive social form of labour must be defended against commodification, financialisation, empire and patriarchy partly because it has shielded itself from the capitalist mode of production for so long but mainly because everything should be fortified against capitalism in order to do away with it.

Bibliography

Abrams, Lynn 2002, *The Making of Modern Woman: Europe 1789–1918*, London: Longman.

Adamson, Glenn 2007, *Thinking Through Craft*, London: Bloomsbury.

Adamson, Glenn 2013, *The Invention of Craft*, London: Bloomsbury.

Addison, Joseph 1970, *Addison and Steele: Selections from The Tatler and The Spectator*, edited by Robert Allen, New York: Holt, Rinehart and Winston.

Adorno, Theodor and Max Horkheimer 1973 [1944], *Dialectic of Enlightenment*, translated by John Cumming, London: Verso.

Adorno, Theodor 1984 [1970], *Aesthetic Theory*, translated by Christian Lenhardt, New York: Routledge.

Adorno, Theodor 2002, *Aesthetics and Politics: The Key Texts of the Classic Debate Within German Marxism*, edited by Fredric Jameson, New York: Verso.

Adorno, Theodor 2002 [1970], *Aesthetic Theory*, translated by Robert Hullot-Kentor, London: Continuum.

Agamben, Giorgio 2009, *What is an Apparatus? And Other Essays*, translated by David Kishik and Stefan Pedatella, Stanford, CA: Stanford University Press.

Agamben, Giorgio 2010, *The Signature of All Things*, New York: Zone Books.

Althusser, Louis 2005 [1965], *For Marx*, translated by Ben Brewster, London: Verso.

Althusser, Louis 2014 [1971], *On the Reproduction of Capitalism*, translated by G.M. Goshgarian, London: Verso.

Ames-Lewis, Francis 2013, *The Intellectual Life of the Early Renaissance Artist*, New Haven, CT: Yale University Press.

Anthony, P.D. 1977, *The Ideology of Work*, London: Tavistock Publications.

Aragon, Louis 2006 [1920], 'Dada Manifesto', in *The Dada Reader*, edited by Dawn Ades, London: Tate.

Arendt, Hannah 1998 [1958], *The Human Condition*, Chicago: University of Chicago Press.

Arthur, Chris 1983, 'Hegel's Master-Slave Dialectic and a Myth of Marxology', *New Left Review*, 142: 67–75.

Arthur, Chris 1986, *The Dialectics of Labour*, Oxford: Basil Blackwell.

Arthur, Chris 2004, *The New Dialectic and Marx's Capital*, Leiden: Brill.

Arvatov, Boris 2017 [1926], *Art and Production: Boris Arvatov*, edited by John Roberts and Alexei Penzin, London: Pluto Press.

Ayres, James 2014, *Art, Artisans and Apprentices*, Oxford: Oxbow Books.

Bailey, Robert 2015, *Art & Language International: Conceptual Art Between Art Worlds*, Durham, NC: Duke University Press.

Balibar, Etienne 2007 [1993], *The Philosophy of Marx*, London: Verso.

Banaji, Jairus 2011, *Theory as History: Essays on the Modes of Production and Exploitation*, Chicago: Haymarket Books.

Banks, Mark 2007, *The Politics of Cultural Work*, New York: Palgrave Macmillan.

Barrell, John 2009 [1980], *The Dark Side of the Landscape: The Rural Poor in English Painting 1730–1840*, Cambridge: Cambridge University Press.

Barrell, John 1986, *The Political Theory of Painting from Reynolds to Hazlitt*, New Haven, CT: Yale University Press.

Barrell, John 1983, *English Literature in History 1730–80*, London: Hutchinson.

Basso, Luca 2014 [2008], 'Between Pre-Capitalist Forms and Capitalism', translated by Kathryne Fedele, in *In Marx's Laboratory: Critical Interpretations of the Grundrisse*, edited by Riccardo Bellofiore, Guido Starosta and Peter D. Thomas, Chicago: Haymarket.

Battersby, Christine 1989, *Gender and Genius: Towards a Feminist Aesthetics*, London: The Women's Press.

Batteux, Charles 2015 [1746], *The Fine Arts Reduced to a Single Principle*, translated by James O. Young, Oxford: Oxford University Press.

Baudrillard, Jean 1975, *The Mirror of Production*, translated by Mark Poster, St Louis: Telos Press.

Beder, Sharon 2000, *Selling the Work Ethic*, London: Zed Books.

Beech, Dave 2015, *Art and Value: Art's Economic Exceptionalism in Classical, Neoclassical and Marxist Economics*, Leiden: Brill.

Beech, Dave 2017, 'Modes of Assembly: Art, the People, and the State', *Former West: Art and the Contemporary After 1989*, edited by Maria Hlavajova and Simon Sheikh, BAK: Utrecht, pp. 559–70.

Beech, Dave and John Roberts (eds) 2002, *The Philistine Controversy*, London: Verso.

Beecroft, Alexander 2008, 'World Literature Without a Hyphen', *New Left Review*, 54 Nov/Dec: 87–100.

Bell, Daniel 1959, 'The "Rediscovery" of Alienation: Some Notes along the Quest for the Historical Marx', *The Journal of Philosophy*, 56, no. 24: 933–52.

Benhabib, Seyla 1992, 'Models of Public Space: Hannah Arendt, the Liberal Tradition, and Jürgen Habermas', in *Habermas and the Public Sphere*, edited by Craig Calhoun, Cambridge, MA: The MIT Press, pp. 73–98.

Benjamin, Andrew 2006, *Marxism and the History of Art*, London: Pluto Press.

Benjamin, Walter 1998, *Understanding Brecht*, translated by Anna Bostock, London: Verso.

Bennett, Tony 1995, *The Birth of the Museum*, London: Routledge.

Berardi, Franco 'Bifo' 1980, 'Anatomy of Autonomy', translated by Richard Reid & Andrew Rosenbaum, *Autonomia: Post-Political Politics*, edited by S. Lotringer and C. Marazzi, Los Angeles: Semiotext(ew), pp. 148–70.

Berardi, Franco 'Bifo' 2009, *The Soul at Work: From Alienation to Autonomy*, translated by Francesca Cadel and Guiseppina Mecchia, Los Angeles: Semiotext(e).

Bishop, Claire 2004, 'Antagonism and Relational Aesthetics', *October*, 110 (Autumn): 51–79.

Blanning, Tim 2010, *The Romantic Revolution*, London: Weidenfeld and Nicholson.

Bourdieu, Pierre 1984 [1979], *Distinction: A Social Critique of the Judgment of Taste*, translated by Richard Nice, Cambridge, MA: Harvard University Press.

Bourdieu, Pierre 1995 [1992], *The Rules of Art: Genesis and Structure of the Literary Field*, translated by Susan Emanuel, Cambridge: Polity Press.

Bourriaud, Nicolas 2000, *Postproduction*, New York: Lukas and Sternberg.

Bowie, Andrew 1990, *Aesthetics and Subjectivity: From Kant to Nietzsche*, Manchester: Manchester University Press.

Brantlinger, Patrick 1975, 'News from Nowhere: Morris's Socialist Anti-Novel', *Victorian Studies*, 19, no. 1: 35–49.

Braunschweig, Max 1936, 'The Philosophic Thought of the Young Marx', *Partisan Review*, III, no. 6: 12–15.

Braunschweig, Max 1964, 'The Philosophic Thought of the Young Marx', in *Alienation: The Cultural Climate of Our Time*, edited by Gerald Sykes, New York: George Brazillier.

Braverman, Harry 1998 [1974], *Labor and Monopoly Capitalism: The Degradation of Work in the Twentieth Century*, New York: Monthly Review Press.

Bromwich, David 1985, 'Reflections on the Word Genius', *New Literary History*, 17, no. 1: 141–64.

Bruno, Paul W. 2010, *Kant's Concept of Genius: Its Origin and Function in the Third Critique*, London: Continuum.

Buchloh, Benjamin 1990, 'Conceptual Art 1962–1969: From the Aesthetic of Administration to the Critique of Institutions', *October*, 55: 105–43.

Buchloh, Benjamin 2003, *Neo-Avantgarde and Culture Industry: Essays on European and American Art from 1955 to 1975*, Cambridge, MA: The MIT Press.

Buelow, George 1990, 'Originality, Genius, Plagiarism in English Criticism of the Eighteenth Century', *International Review of the Aesthetics and Sociology of Music*, 21, no. 2.

Bull, Malcolm 2010, 'Vectors of the Biopolitical', *New Left Review*, 45: 7–25.

Buren, Daniel 1979 [1971], 'The Function of the Studio', *October*, 10: 51–8.

Bürger, Peter 1984 [1974], *Theory of the Avant-Garde*, translated by Michael Shaw, Minneapolis: University of Minnesota Press

Bürger, Peter 1985–86 [1974–75], 'The Institution of "Art" as a Category in the Sociology of Literature', translated by Michael Shaw, *Cultural Critique*, 2: 5–33.

Bürger, Peter and Christa Bürger 1992, *The Institutions of Art*, translated by Loren Kruger, Lincoln, NE: University of Nebraska Press.

Burgh, James 1994 [1764], 'An Account of the First Settlement, Laws, Form of Government, and Police, of the Cessares, A People of South America: In Nine Letters, From Mr. Vander Neck, One of the Senators of that Nation, to His Friend in Holland', in *Uto-*

pias of the British Enlightenment, edited by Gregory Claeys, Cambridge: Cambridge University Press, pp. 71–136.

Burke, Richard 1971, '"Work" and "Play"', *Ethics*, 82, no. 1: 33–47.

Burn, Ian 1975, 'The Art Market: Affluence and Degradation', *Artforum*, 13, no. 8: 34–7.

Campbell, Sally Howard 2012, *Rousseau and the Paradox of Alienation*, New York: Lexington Books.

Carlyle, Thomas 1986, *Selected Writings*, edited by Alan Shelston, London: Penguin.

Carter, Michael 1990, *Framing Art*, Sydney: Hale and Iremonger.

Chaplin, Joyce 2016, 'The Problem of Genius in the Age of Slavery', in *Genealogies of Genius*, edited by Joyce Chaplin and Darrin McMahon, Basingstoke: Palgrave Macmillan.

Chaplin, Joyce and Darrin McMahon (eds) 2016, *Genealogies of Genius*, Basingstoke: Palgrave Macmillan.

Chapman, H. Perry 2005, 'The Imagined Studios of Rembrandt and Vermeer', *Inventions of the Studio, Renaissance to Romanticism*, edited by Michael Cole and Mary Pardo, Chapel Hill, NC: University of North Carolina Press, 108–46.

Charmois, Martin de 2000 [1648], 'Petition to the King and to the Lords of his Council', *Art in Theory 1648–1815: An Anthology of Changing Ideas*, edited by Charles Harrison, Paul Wood and Jason Gaiger, Oxford: Blackwell.

Cohen, G.A. 1988, *History, Labour, and Freedom: Themes from Marx*, Oxford: Clarendon Press.

Cole, Michael and Mary Pardo 2005, *Inventions of the Studio, Renaissance to Romanticism* Chapel Hill: University of North Carolina Press.

Crow, Thomas 1985, 'Modernism and Mass Culture in the Visual Arts', *Pollock and After*, edited by Francis Frascina, London: Harper and Row.

Crow, Thomas 1991, *Painters and Public Life*,

Dalla Costa, Mariarosa and Selma James 1972, *The Power of Women and the Subversion of the Community*, London: Falling Wall Press.

Darnton, Robert 1984, *The Great Car Massacre and Other Episodes in French Cultural History*, New York: Vintage.

David, Jacques-Louis 2000 [1794], 'The Painting of the Sabines', in *Art in Theory 1648–1815: An Anthology of Changing Ideas*, edited by Charles Harrison, Paul Wood and Jason Gaiger, Oxford: Blackwell, pp. 119-125

Davidson, Neil 2012, *How Revolutionary Were the Bourgeois Revolutions?*, Chicago: Haymarket.

Davis, Angela 2016, *Freedom is a Constant Struggle: Ferguson, Palestine, and the Foundations of a Movement*, Chicago: Haymarket Books.

Dean, Deborah 2005, 'Recruiting a Self: Women Performers and Aesthetic Labour', *Work, Employment & Society*, 19, no. 4: 761–74.

Debray, Régis 2007, 'Socialism: A Life Cycle', *New Left Review*, 46: 5–28.

Defoe, Daniel 1704, *Giving Alms No Charity and Employing the Poor*, London.

Derrida, Jacques 2006 [2003], *Geneses, Genealogies, Genres and Genius: The Secrets of the Archive*, translated by Beverley Bie Brahic, New York: Columbia University Press.

Diderot, Denis 2011, *Art and Artists: Anthology of Diderot's Aesthetic Thought*, edited by Jean Seznec, translated by John Glaus, Washington: Springer.

Dieckmann, Herbert 1941, 'Diderot's Conception of Genius', *Journal of the History of Ideas*, 2, no. 2: 151–82.

Dobb, Maurice 1963 [1947], *Studies in the Development of Capitalism*, London: International.

Dubos, Abbé Jean-Baptiste 1748 [1740], *Critical Reflections on Poetry, Paintings and Music Volume 2*, translated by Thomas Nugent, London: John Nourse.

Duncan, Carol 1995, *Civilizing Rituals: Inside Public Art Museums*, London: Routledge.

Duncan, Carol and Alan Wallach 1980, 'The Universal Survey Museum', *Art History*, 3, no. 4: 448–69.

Duro, Paul 2007, 'Imitation and Authority: The Creation of the Academic Canon in French Art, 1648–1870', in *Partisan Canons*, edited by Anna Brzyski, Durham, NC: Duke University Press.

Duve, Thierry de 1999, *Kant After Duchamp*, New York: October Books.

Eagleton, Terry 1984, *The Function of Criticism*, London and New York: Verso.

Edwards, Steve 2001, 'Factory and Fantasy in Andrew Ure', *Journal of Design History*, 14, no. 1: 17–33.

Eitner, Lorenz 1971, *Neoclassicism and Romanticism 1750–1850: Sources and Documents Volume 1 Enlightenment/Revolution*, London: Prentice-Hall International.

Epstein, Stephan 2008, 'Craft Guilds in the Pre-modern Economy: A Discussion', *Economic History Review*, 6: 155–74.

Evans, Mel 2015, *Artwash*, London: Pluto Press.

Farr, James 2000, *Artisans in Europe, 1300–1914*, Cambridge: Cambridge University Press.

Federici, Silvia 2012, *Revolution at Point Zero: Housework, Reproduction, and Feminist Struggle*, New York: PM Press.

Félibien, André 1999 [1669], 'Conférence de l'Académie Royale de Peinture et de Sculpture', translated by Linda Walsh, in *Art and its Histories: A Reader*, edited by Steve Edwards, New Haven, CT: Yale University Press.

Félibien, André 2000 [1667], 'Preface to Seven Conferences', in *Art in Theory 1648–1815: An Anthology of Changing Ideas*, edited by Charles Harrison, Paul Wood and Jason Gaiger, Oxford: Blackwell, pp. 108–18.

Fernbach, David 1969, 'Avineri's view of Marx', *New Left Review*, 56: 62–8.

Ferry, Luc 1993, *Homo Aestheticus: The Invention of Taste in the Democratic Age*, translated by Robert De Loaiza, Chicago: University of Chicago Press.

Feuerbach, Ludwig 2008 [1841], *The Essence of Christianity*, translated by George Eliot, New York: Dover Publications.

Fischer, Ernst 1971 [1959], *The Necessity of Art: A Marxist Approach*, translated by Anna Bostock, London: Penguin Books.

Fisher, Mark 2013, 'A Social and Psychic Revolution of Almost Inconceivable Magnitude: Popular Culture's Interrupted Accelerationist Dreams', *e-flux*, 46, available at: https://www.e-flux.com/journal/46/60084/a-social-and-psychic-revolution-of-almost-inconceivable-magnitude-popular-culture-s-interrupted-accelerationist-dreams/

Fitzsimmons, Michael 2010, *From Artisan to Worker: Guilds, the French State, and the Organization of Labor 1776–1821*, Cambridge: Cambridge University Press.

Force, Pierre 2003, *Self-Interest Before Adam Smith*, New York: Columbia University.

Foster, Hal 1994, 'What's Neo About the Neo-Avant-Garde?', *October*, 70: 5–32.

Foucault, Michel 1990, *The Use of Pleasure: The History of Sexuality*, Volume 2, New York: Vintage.

Fourier, Charles 1901, *Selections from the Works of Fourier*, translated by Julia Franklin, Perth: Cowan and Co.

Fourier, Charles 1996 [1808], *The Theory of the Four Movements*, edited by Gareth Stedman Jones and Ian Patterson, Cambridge: Cambridge University Press.

Fox, Celina 2009, *The Arts of Industry in the Age of Enlightenment*, New Haven, CT: Yale University Press.

Frase, Peter 2016, *Four Futures: Life After Capitalism*, London: Verso.

Fraser, Nancy 2013, *Fortunes of Feminism: From State-Managed Capitalism to Neoliberal Crisis*, London: Verso.

Frayne, David 2015, *The Refusal of Work: The Theory and Practice of Resistance to Work*, London: Zed Books.

Fried, Michael 1980, *Absorption and Theatricality: Painting and Beholder in the Age of Diderot*, Chicago: University of Chicago Press.

Fromm, Erich 2002 [1961], *Marx's Concept of Man*, London: Continuum.

Gellner, Ernest 1956, 'Morality and Je Ne Sais Quoi Concepts', *Analysis*, 16, no. 5: 97–103.

Gibson, Katherine and Graham, Julie 2006, *Postcapitalist Politics*,

Gielen, Pascal and Thijs Lijster 2017, 'The Civil Potency of a Singular Experience', in *The Art of Civil Action: Political Space and Cultural Dissent*, edited by Philipp Dietachmair and Pascal Gielen, Amsterdam: Valiz, pp. 39–66.

Gigante, Denise 2005, *Taste: A Literary History*, New Haven, CT: Yale University Press.

Gilroy, Paul 1999 [1993], *The Black Atlantic*, London: Verso.

Godwin, William 1823, *The Enquirer: Reflections on Education, Manners, and Literature*, Edinburgh: John Anderson.

Goetschel, Willi 2000, 'Kant and the Christo Effect: Grounding Aesthetics', *New German Critique*, 79: 137–56.

Gorz, André 1982 [1980], *Farewell to the Working Class*, translated by Mike Sonenscher, London: Pluto Press.

Gorz, André 1985 [1983], *Paths to Paradise: On the Liberation from Work*, translated by Malcolm Imrie, London: Pluto Press.

Gould, Carol 1978, *Marx's Social Ontology: Individuality and Community in Marx's Theory of Social Reality*, Cambridge, MA: The MIT Press.

Graña, César 1964, *Bohemian Versus Bourgeois: French Society and the French Man of Letters in the Nineteenth Century*, New York: Basic Books.

Granter, Edward 2009, *Critical Social Theory and the End of Work*, London: Routledge.

Guattari, Felix 1995, *Chaosmosis, an Ethico-Aesthetic Paradigm*, translated by Paul Brains and Julian Pefanis, Indiana: Indiana University Press.

Gullì, Bruno 2005, *Labor of Fire: The Ontology of Labor Between Economy and Culture*, Philadelphia: Temple University.

Habermas, Jürgen 1989 [1962], *The Structural Transformation of the Public Sphere*, translated by Thomas Burger, Cambridge, MA: The MIT Press.

Hall, Stuart 2010, 'Life and Times of the First New Left', *New Left Review*, 61: 177–96.

Hansen, Miriam 1991, 'Foreword', in *Public Sphere and Experience: Toward an Analysis of the Bourgeois and Proletarian Public Sphere*, Minneapolis: University of Minnesota Press, pp. ix–xli.

Hardt, Michael 1996, 'Introduction: Laboratory Italy', *Radical Thought in Italy: A Potential Politics*, edited by Paolo Virno and Michael Hardt, Minneapolis: University of Minnesota Press.

Hardt, Michael and Negri, Antonio 2000, *Empire*, Cambridge, MA: Harvard University Press.

Harootunian, Harry 2015, *Marx After Marx: History and Time in the Expansion of Capitalism*, New York: Columbia University Press.

Harreld, Donald 2008, Review of 'Craft Guilds in the Early Modern Low Countries: Work, Power, and Representation', *The Sixteenth Century Journal*, 39, no. 1: 133–5.

Harrison, Charles, Paul Wood and Jason Gaiger 2000, *Art in Theory 1648–1815: An Anthology of Changing Ideas*, Oxford: Blackwell.

Harvey, David 2015, *Seventeen Contradictions and the End of Capitalism*, London: Profile Books.

Haskell, Francis 1963, *Patrons and Painters: A Study in the Relations Between Italian Art and Society in the Age of the Baroque*, London: Chato and Windus.

Hauser, Arnold 1951, *The Social History of Art: Volume One*, London: Routledge & Kegan Paul.

Hegel, Georg Wilhelm Friedrich 1977 [1807], *Phenomenology of Spirit*, translated by A.V. Miller, Oxford: Oxford University Press.

Hegel, Georg Wilhelm Friedrich 1993 [1820–29], *Introductory Lectures on Aesthetics*,

translated by Bernard Bosanquet, edited by Michael Inwood, London: Penguin Books.

Heinrich, Michael 2012, *An Introduction to the Three Volumes of Karl Marx's Capital*, translated by Alexander Locascio, New York: Monthly Review Press.

Heller, Henry 2010, *The Birth of Capitalism*, London: Pluto Press.

Hemingway, Andrew 1987 [1979], *The Norwich School of Painters 1803–1833*, Oxford: Phaidon.

Hemingway, Andrew 2014, 'Arnold Hauser: Between Marxism and Romantic Anti-Capitalism', *Enclave Review* 10: 6–10.

Hemingway, Andrew and Stephen Eisenman 2005, 'Introduction: College Art Association Radical Art Caucus: Papers from the 2003 Conference Session', *Oxford Art Journal*, 28, no. 3: 291–3.

Hess, Moses 2004, *The Holy History of Mankind and Other Writings*, edited by Shlomo Avineri, Cambridge: Cambridge University Press.

Hill, Christopher 1985 [1940], *The English Revolution 1640*, London: Lawrence and Wishart.

Hill, Christopher 1986 [1964], *Society and Puritanism in Pre-Revolutionary England*, London: Penguin Books.

Hill, Christopher 1988 [1972], *The World Turned Upside Down*, London: Penguin.

Hilton, Rodney 1976, *The Transition from Feudalism to Capitalism*, London: Verso.

Hirsch, Jean-Pierre 2010, 'Revolutionary France, Cradle of Free Enterprise', quoted in Michael Fitzsimmons, *From Artisan to Worker: Guilds, the French State, and the Organization of Labor 1776–1821*, Cambridge: Cambridge University Press.

Hobsbawm, Eric 1968, *Industry and Empire*, London: Penguin.

Hobsbawm, Eric 2001 [1969], *Bandits*, Abacus: London.

Hobsbawm, Eric 2010 [1962], *The Age of Revolution: 1789–1848*, London: Abacus.

Holloway, John 2002,

Horowitz, Asher 1986, 'Will, Community and Alienation in Rousseau's *Social Contract*', *Canadian Journal of Political and Social Theory*, X, no. 3: 63–82.

Hudis, Peter 2012, *Marx's Concept of the Alternative to Capitalism*, Leiden: Brill.

Hudis, Peter 2018, 'Racism and the Logic of Capital: A Fanonian Reconsideration', *Historical Materialism*, 26, no. 1: 199–220.

Huelsenbeck, Richard 1981 [1920], 'Collective Dada Manifesto', in *The Dada Painters and Poets: An Anthology*, edited by Robert Motherwell, Cambridge: Belknap-Harvard.

Hume, David 1740, *A Treatise of Human Nature*, available at: https://www.gutenberg.org/files/4705/4705-h/4705-h.htm.

Hundert, E.J. 1972, 'The Making of Homo Faber: John Locke between Ideology and History', *Journal of the History of Ideas*, 33, no. 1: 3–22.

Hutchinson, Mark 2015, 'Dada Contra Art History', *Dada/Surrealism*, 20, available at: http://ir.uiowa.edu/dadasur/vol20/iss1/26/.

Huyssen, Andreas 1975, 'The Cultural Politics of Pop: Reception and Critique of US Pop Art in the Federal Republic of Germany', *New German Critique*, 4: 77–97.

Huyssen, Andreas 1986, *After the Great Divide: Modernism, Mass Culture, Postmodernism*, Indianapolis: Indiana University Press.

James, Susan 1997, *Passion and Action: The Emotions in Seventeenth-Century Philosophy*, Oxford: Clarendon Press.

Jameson, Fredric 1991, *Postmodernism, or, The Cultural Logic of Late Capitalism*, Durham, NC: Duke University Press.

Jameson, Fredric 2009, 'Sandblasting Marx', *New Left Review*, 55: 134–42.

Jameson, Fredric 2015, 'The Aesthetics of Singularities', *New Left Review*, 92: 101–32.

Jauss, Hans Robert and Peter Heath 1975, 'The Idealist Embarrassment: Observations on Marxist Aesthetics', *New Literary History*, 7, no. 1: 191–208.

Jay, Martin 1973, *The Dialectical Imagination: A History of the Frankfurt School and the Institute of Social Research 1923–1950*, London: Heinemann.

Jay, Martin 1984, *Marxism and Totality: The Adventures of a Concept from Lukács to Habermas*, Berkeley: University of California Press.

Johnson, Geraldine 2005, *Renaissance Art: A Very Short Introduction*, Oxford: Oxford University Press.

Jones, Caroline 1996, *Machine in the Studio: Constructing the Postwar American Artist*, Chicago: University of Chicago Press.

Kain, Philip 1982, *Schiller, Hegel and Marx: State, Society, and the Aesthetic Ideal of Ancient Greece*, Kingston: McGill-Queen's University Press.

Kant, Immanuel 1987 [1790], *Critique of Judgment*, translated by Werner S. Pluhar, Indianapolis: Hackett.

Kant, Immanuel 2000 [1790], *Critique of the Power of Judgement*, translated by Paul Guyer and Eric Matthews, Cambridge: Cambridge University Press.

Kaplan, Steven and Cynthia Koepp 1986, *Work in France: Representations, Meaning, Organization, and Practice*, Ithaca: Cornell University Press.

Kaprow, Allan 1993, *Essays on the Blurring of Art and Life*, edited by Jeff Kelley, Berkeley: University of California Press.

Kaufmann, Thomas DaCosta 2001, 'Antiquarianism, the History of Objects, and the History of Art before Winckelmann', *Journal of the History of Ideas*, 62, no. 3: 523–41.

Kearney, Richard 1988, *The Wake of the Imagination*, London: Routledge.

Kemp, Martin 1977, 'From "Mimesis" to "Fantasia": The Quattrocento Vocabulary of Creation, Inspiration and Genius in the Visual Arts', *Viator: Medieval and Renaissance Studies*, 8: 347–98.

Kermode, Frank 1986, *Romantic Image*, London: Ark.

Kivy, Peter 2001, *The Possessor and the Possessed: Handel, Mozart, Beethoven, and the Idea of Musical Genius*, New Haven, CT: Yale University Press.

Klingender, Francis 1875, *Art and the Industrial Revolution*, St. Albans: Paladin.

Koepp, Cynthia 1992, 'The Order of Work: Attitudes and Representations in Eighteenth-century France', PhD dissertation, Cornell University.

Komlosy, Andrea 2018, *Work: The Last 1,000 Years*, translated by Loren Balhorn and Jacob K. Watson, London: Verso.

Kristeller, Paul 1951, 'The Modern System of the Arts: A Study in the History of Aesthetics Part I', *Journal of the History of Ideas*, 12, no. 4: 496–527.

Kristeller, Paul 1983 '"Creativity" and "Tradition"', *Journal of the History of* Ideas, 44, no. 1.

Kristeller, Paul 1990, *Renaissance Thought and the Arts*, Princeton: Princeton University Press.

Kristeva, Julia 2004, 'Is There a Feminine Genius?', *Critical Inquiry*, 30, no. 3: 493–504.

Kunst, Bojana 2015, *Artist at Work: Proximity of Art and Capitalism*, London: Zero Books.

La Font de Saint-Yenne, Etienne 1979 [1747], 'Reflections on the Present State of Painting in France', in *The Age of Enlightenment: An Anthology of Eighteenth Century Texts*, edited by Simon Eliot and Beverley Stern, London: Ward Lock Educational.

Lacoue-Labarthe, Philippe and Nancy, Jean-Luc 1988, *The Literary Absolute: The Theory of Literature in German Romanticism*, New York: State University of New York.

Landes, Joan 1988, *Women and the Public Sphere in the Age of the French Revolution*, Ithaca: Cornell University Pres.

Lazzarato, Maurizio 2014, *Marcel Duchamp and the Refusal of Work*, translated by Joshua David Jordan, Los Angeles: semiotext(e).

Le Blanc, Abbé Jean-Bernard 2000 [1747], 'Letter on the Exhibition of Works of Painting, Sculpture etc.', in *Art in Theory 1648–1815: An Anthology of Changing Ideas*, edited by Charles Harrison, Paul Wood and Jason Gaiger, Oxford: Blackwell.

Lévi-Strauss, Claude 1966 [1962], *The Savage Mind*, Chicago: University of Chicago Press.

Linebaugh, Peter 2006, *The London Hanged: Crime and Civil Society in the Eighteenth Century*, London: Verso.

Lizardo, Omar 2010, 'Beyond the Antinomies of Structure: Lévi-Strauss, Giddens, Bourdieu, and Sewell', *Theory and Society*, 39, no. 6: 651–88.

Locke, John 1986 [1689], *The Second Treatise on Civil Government*, New York: Prometheus Books.

Löwy, Michael and Robert Sayre 1984, 'Figure of Romantic Anti-Capitalism', *New German Critique*, 32: 42–92.

Luhmann, Niklas 2000

Lukács, Georg 1971 [1923], *History and Class Consciousness: Studies in Marxist Dialectics*, translated by Rodney Livingstone, Cambridge, MA: The MIT Press.

Lukács, Georg 1980, *Labour: The Ontology of Social Being*, translated by David Fernbach, London: Merlin Press.

Lütticken, Sven 2016, 'The Coming Exception', *New Left Review*, 99: 111–36.

Lyotard, Jean-Francois 1984 [1979], *The Postmodern Condition: A Report on Knowledge*, translated by Geoff Bennington and Brian Massumi, Manchester: Manchester University Press.

Macpherson, C.B. 1962, *The Political Theory of Possessive Individualism: Hobbes to Locke*, Oxford: Oxford University Press.

Maharaj, Sarat 2012, 'The Jobless State: Work, Global Assembly Line, Indolence', in *Work Work Work: A Reader on Art and Labour*, edited by Cecilia Widenheim, Lisa Rosendahl, Michele Masucci, Annika Enqvist and Jonatan Habib Engqvist, Stockholm: Sternberg Press.

Mandel, Ernest 1971, *The Formation of the Economic Thought of Karl Marx: 1843 to Capital*, translated by Brian Pearce, New York: Monthly Review Press.

Manuel, F.E. 1956, *The New World of Henri Saint-Simon*, Cambridge, MA: Harvard University Press.

Marcuse, Herbert 1955, *Eros and Civilization*, Boston, MA: Beacon Press.

Marcuse, Herbert 1956, *Reason and Revolution*, London: Routledge and Kegan Paul.

Marcuse, Herbert 1972, *Studies in Critical Philosophy*, translated by Joris de Bres, London: New Left Books.

Marcuse, Herbert 1990 [1978], *The Aesthetic Dimension: Toward a Critique of Marxist Aesthetics*, Basingstoke: Macmillan.

Marcuse, Herbert 2000 [1958], 'Preface', in *Marxism and Freedom: From 1776 Until Today*, by Raya Dunayevskaya, Amherst: Humanity Books.

Marcuse, Herbert 2001, *Critical Theory of Society: Collected Papers of Herbert Marcuse Volume Two*, edited by Douglas Kellner, London: Routledge.

Martins, Luiz Renato 2017, *The Conspiracy of Modern Art*, edited by Steve Edwards, Leiden: Brill.

Marx, Leo 1956, 'The Machine in the Garden', *The New England Quarterly*, 29, no. 1: 27–42.

Marx, Karl 1904 [1859], *Contribution to a Critique of Political Economy*, translated by N.I. Stone, Chicago: Charles H. Kerr Company.

Marx, Karl 1959 [1844], *Economic and Philosophical Manuscripts*, translated by Martin Milligan, London: Lawrence and Wishart.

Marx, Karl 1973 [1857–58], *Grundrisse*, translated by Martin Nicolaus, London: Penguin.

Marx, Karl 1975, *Early Writings*, translated by Rodney Livingstone and Gregor Benton, London: Penguin.

Marx, Karl 1990 [1867], *Capital: A Critique of Political Economy*, Volume One, translated by Ben Fowkes, London: Penguin.

Marx, Karl 1996 [1845], 'Theses on Feuerbach', in *The German Ideology*, edited by C.J. Arthur, London: Lawrence and Wishart.

Marx, Karl and Frederick Engels 1996 [1845], *The German Ideology*, edited by C.J. Arthur, London: Lawrence and Wishart.

Marx, Karl and Frederick Engels 2015 [1848], 'The Communist Manifesto', in *The Cambridge Companion to The Communist Manifesto*, edited by Terrell Carver and James Farr, Cambridge: Cambridge University Press.

Mason, John Hope 1993, 'Thinking About Genius in the Eighteenth Century', in *Eighteenth Century Aesthetics and the Reconstruction of Art*, edited by Paul Mattick Jr, Cambridge: Cambridge University Press.

Massey, Doreen 1984, *Spatial Divisions of Labour: Social Structures and the Geography of Production*, London: Macmillan.

Massey, Doreen 2005, *For Space*, London: Sage.

Mattick Jr, Paul 1993, *Eighteenth Century Aesthetics and the Reconstruction of Art*, Cambridge: Cambridge University Press.

McNulty, Paul J. 1973, 'Adam Smith's Concept of Labor', *Journal of the History of Ideas*, 34, no. 3: 345–66.

Mengs, Anthony Raphael 1796, *The Works of Anthony Raphael Mengs: Volume 1*, translated by Don Joseph Nicholas D'Azara, London: R. Foulder.

Mészáros, István 1986 [1970], *Marx's Theory of Alienation*, London: Merlin.

Meyer, Paul 1985, 'Recent German Studies of the Quarrel between the Ancients and the Moderns in France', *Eighteenth-Century Studies*, 18, no. 3: 383–90.

Miliband, Ralph 1954, 'The Politics of Robert Owen', *Journal of the History of Ideas*, 15, no. 2: 233–45.

Michel, Christian 2018, *The Académie Royale de Peinture et de Sculpture: The Birth of the French School, 1648–1793*, translated by Chris Miller, Los Angeles: The Getty Research Institute.

Mills, C. Wright 1963, *Power, Politics and People: The Collected Essays of C. Wright Mills*, edited by Irving Louis Horowitz, New York: Oxford University Press.

Mills, C. Wright 1972 [1951], *White Collar: The American Middle Class*, Oxford: Oxford University Press.

Mitter, Partha 1994, *Art and Nationalism in Colonial India 1850–1922*, Cambridge: Cambridge University Press.

Molesworth, Helen 2005, 'Rrose Sélavy Goes Shopping', in *The Dada Seminars*, edited by Leah Dickerman and Matthew S. Witkowsky, Washington, D.C.: National Gallery of Art.

Molyneux, John 1998, "The Legitimacy of Modern Art", https://www.marxists.org/history/etol/writers/molyneux/1998/xx/legitimacy.htm. Accessed 24 March 2020.

Montias, John Michael 2002, *Art at Auction in 17th Century Amsterdam*, Amsterdam: Amsterdam University Press.

Möntmann, Nina 2006, *Art and Its Institutions*, London: Black Dog Publishing.

Moretti, Franco 2000, 'Conjecture on World Literature', *New Left Review*, 1 (January/February): 54–68.

Moretti, Franco 2003, 'More Conjectures', *New Left Review*, 20 (March/April): 73–81.

Moriarty, Michael 1988, *Taste and Ideology in Seventeenth-Century France*, Cambridge: Cambridge University Press.

Morris, William 1993, *News From Nowhere and Other Writings*, edited by Clive Wilmer, London: Penguin.

Morris, William 2008, *Useful Work Versus Useless Toil*, London: Penguin.

Moses, Claire 1982, 'Saint-Simonian Men/ Saint-Simonian Women: The Transformation of Feminist Thought in 1830s' France', *The Journal of Modern History*, 54, no. 2: 240–67.

Mulhern, Francis 1974, 'The Marxist Aesthetics of Christopher Caudwell', *New Left Review*, 85: 37–58.

Munck, Ronaldo 2002, *Globalisation and Labour: The New 'Great Transformation'*, London: Zed Books.

Musto, Marcello 2010, 'Revisiting Marx's Concept of Alienation', *Socialism and Democracy*, 24, no. 3: 79–101.

Musto, Marcello 2015, 'The "Young Marx" Myth in Interpretations of the Economic–Philosophic Manuscripts of 1844', *Critique*, 43, no. 2: 233–60.

Nancy, Jean-Luc 1996, *The Muses*, translated by Peggy Kamuf, Stanford, CA: Stanford University Press.

Negri, Antonio 2005, *Books for Burning: Between Civil War and Democracy in 1970s Italy*, translated by Timothy S. Murphy, London: Verso.

Negri, Antonio 2009, 'An Italian Rupture: Production Against Development', *Diacritics*, 39, no. 9: 21–7.

Negri, Antonio 2010, '"The Revolution Will Not Be an Explosion Somewhere Down the Road": An Interview with Antonio Negri', with Filippo del Lucchese and Jason E. Smith, *Grey Room*, 41: 6–23.

Negri, Antonio, Filippo del Lucchese, and Jason E. Smith 2010, '"The Revolution Will Not Be an Explosion Somewhere Down the Road": An Interview with Antonio Negri', *Grey Room*, 41: 6–23.

Negt, Oskar, and Alexander Kluge 1993, *Public Sphere and Experience, Toward an Analysis of the Bourgeois and Proletarian Public Sphere*, trans. Peter Labanyi, Jamie Owen Daniel and Assenka Oksiloff, Minnesota: University of Minnesota Press.

Newman, Barnett 2005 [1947], 'The First Man Was an Artist', in *Art in Theory*, edited by Charles Harrison and Paul Wood, Oxford: Blackwell, pp. 574–7.

Newman, Edgar Leon 1979, 'L'arme du siecle, c'est la plume: The French Worker Poets of the July Monarchy and the Spirit of Revolution and Reform', *The Journal of Modern History*, 51, no. 4: D1201–D1224.

Newman, Michael 2007, 'Towards the Reinvigoration of the "Western Tableau": Some Notes on Jeff Wall and Duchamp', *Oxford Art Journal*, 30, no. 1: 83–100.

Nickson, Dennis, Chris Warhurst, Anne Marie Cullen, and Allan Watt 2003, 'Bringing in the Excluded? Aesthetic Labour, Skills and Training in the New Economy', *Journal of Education and Work*, 16, no. 2: 185–203.

Noble, Richard 2005, 'Some Provisional Remarks on Art and Politics', in *The Showroom Annual*, London: The Showroom Gallery.

Nochlin, Linda 1989, *Women, Art and Power and Other Essays*, London: Thames and Hudson.

Noys, Benjamin 2012, *Communization and its Discontents: Contestation, Critique, and Contemporary Struggles*, New York: Autonomedia.

Ogilvie, Sheilagh 2008, 'Rehabilitating the Guilds: A Reply', *Economic History Review*, 61: 175–182.

Ollmann, Bertell 1971, *Alienation: Marx Conception of Man in Capitalist Society*, Cambridge: Cambridge University Press.

Ortega y Gasset, José 1968, *The Dehumanization of Art and Other Essays on Art, Culture, and Literature*, translated by Helene Weyl, Princeton: Princeton University Press.

Osborne, Peter 2013, *Anywhere or Not At All*, London: Verso.

Ostrow, Saul 2001, 'Review of Christine Jones's *Machine in the Studio*', *The Art Bulletin*, 83, no. 1: 165–8.

Overend, Tronn 1975, 'Alienation: A Conceptual Analysis', *Philosophy and Phenomenological Research*, 35, no. 3: 301–22.

Palomino, Antonio 2000 [1724], 'The Pictorial Museum and Optical Scale' in *Art in Theory 1648–1815: An Anthology of Changing Ideas*, edited by Charles Harrison, Paul Wood and Jason Gaiger, Oxford: Blackwell, pp. 317-326.

Pappenheim, Fritz 1959, *The Alienation of Modern Man: An Interpretation Based on Marx and Tönnies*, New York: Modern Reader Paperbacks.

Pearsall Smith, Logan 1925, *Words and Idioms: Studies in the English Language*, London: Constable and Co. Limited.

Perloff, Marjorie 1986, *The Futurist Moment: Avant-Garde, Avant Guerre, and the Language of Rupture*, Chicago: University of Chicago Press.

Pevsner, Nikolaus 1973 [1940], *Academies of Art Past and Present*, New York: Da Capo Press.

Pirenne, Henri, 1937, *Economic and Social History of Medieval Europe*, New York: Harcourt, Brace.

Plant, Sadie 1992, *The Most Radical Gesture*, London: Routledge.

Poster, Mark 1995, *The Second Media Age*, Cambridge: Polity Press.

Postone, Moishe 1993, *Time, Labor, and Social Domination: A Reinterpretation of Marx's Critical Theory*, Cambridge: Cambridge University Press.

Potts, Alex 1994, *Flesh and Ideal: Winckelmann and the Origins of Art History*, New Haven, CT: Yale University Press.

Precarious Workers Brigade 2012, *Training for Exploitation?*, London: The Journal of Aesthetics and Protest.

Prothero, Iorwerth 1979, *Artisans and Politics in Early Nineteenth-Century London: John Gast and His Times*, London: Routledge.

Pye, David 2002 [1968], *The Nature and Art of Workmanship*, Cambridge: Cambridge University Press.

Rancière, Jacques 1986, 'The Myth of the Artisan', in *Work in France: Representations, Meaning, Organization, and Practice*, edited by Steven Laurence Kaplan and Cynthia J. Koepp, Ithaca: Cornell University Press.

Rancière, Jacques 2002, 'The Aesthetic Revolution and its Outcomes', *New Left Review*, 14 (March–April): 133–51.

Rancière, Jacques 2004, *The Politics of Aesthetics*, translated by Gabriel Rockhill, London: Continuum.

Rancière, Jacques 2013, *Aisthesis: Scenes from the Aesthetic Regime of Art*, translated by Zakir Paul, London: Verso.

Raven, James 2001, 'The Book Trades', in *Books and Their Readers in Eighteenth Century England: New Essays*, edited by Isabel Rivers, Leicester: Leicester University Press.

Rée, Jonathan 2000, 'Apocalypse Unbound', *New Left Review*, 4: 163–7.

Rifkin, Adrian 1994, 'History, Time and the Morphology of Critical Language, or Publicola's Choice', in *Art Criticism and Its Institutions in Nineteenth Century France*, edited by Michael Orwicz, Manchester: Manchester University Press.

Roberts, John 2007, *The Intangibilities of Form: Skill and Deskilling in Art After the Readymade*, London: Verso.

Roberts, John 2010, 'Art After Deskilling', *Historical Materialism*, 18, no. 2: 77–96.

Robinson, Eric 1958, 'Joseph Wright of Derby: The Philosophers' Painter', *The Burlington Magazine*, 663: 214–15.

Rosen, Charles and Henri Zerner 1984, *Romanticism and Realism: The Mythology of Nineteenth Century Art*, New York: Viking Press.

Rosenberg, Harold 1952, 'The American Action Painters', *Art News*, 51, no. 8: 22–3 and 43–50.

Rothko, Mark 2005 [1947], 'The Romantics were Prompted ...', in *Art in Theory*, edited by Charles Harrison and Paul Wood, Oxford: Blackwell, pp. 571–3.

Rousseau, Jean-Jacques 2012 [1762], *Of the Social Contract and Other Political Writings*, translated by Quintin Hoare, edited by Christopher Bertram, London: Penguin.

Rudé, George 2005 [1964], *The Crowd in History: A Study in Popular Disturbances in France and England 1730–1848*, London: Serif.

Ruskin, John 1985, *Unto This Last and Other Writings*, edited by Clive Wilmer, London: Penguin Books.

Russell, Bertrand 2004 [1935], *In Praise of Idleness*, London: Routledge.

Saisselin, Rémy G. 1961, 'Ut Pictura Poesis: DuBos to Diderot', *The Journal of Aesthetics and Art Criticism*, 20, no. 2: 144–56.

Saltz, Jerry 2007, 'Same River Twice', *Artnet*, available at: http://www.artnet.com/magazineus/features/saltz/saltz5-15-07.asp

Sánchez Vázquez, Adolfo 1973 [1965], *Art and Society: Essays in Marxist Aesthetics*, London: Merlin Press.

Sayers, Sean 2003, 'Creative Activity and Alienation in Hegel and Marx', *Historical Materialism*, 11, no. 1: 107–28.

Sayers, Sean 2011, *Marx and Alienation: Essays on Hegelian Themes*, New York: Palgrave.

Schapiro, Meyer 1979, *Modern Art: 19th and 20th Centuries: Selected Papers*, New York: G. Braziller.

Schiller, Friedrich 1954, *On the Aesthetic Education of Man*, translated by Reginald Snell, New York: Dover Publications.

Schiller, Friedrich 1875 [1795], *Essays Aesthetical and Philosophical*, anonymous translation, London: Bohn's Standard Library.

Schiller, Friedrich 1993 [1800], Essays, edited by Walter Hinderer and Daniel O. Dahlstrom, London: Continuum.

Schmidt, Alfred 1971 [1962], *The Concept of Nature in Marx*, translated by Ben Fowkes, London: New Left Books.

Scholar, Richard 2005, *The Je-Ne-Sais-Quoi in Early Modern Europe*, Oxford: Oxford University Press.

Schwarzer, Mitchell 1995, 'Origins of the Art History Survey Text', *Art Journal*, 54, no. 3: 24–9.

Scott, Katie 1998, 'Authorship, the Académie, and the Market in Early Modern France', *Oxford Art Journal*, 21, no. 1: 29–41.

Scruton, Roger 2008, 'The Craftsman by Richard Sennett', *The Sunday Times*, 10 February, available at: https://www.thetimes.co.uk/article/the-craftsman-by-richard-sennett-z2qqhdpv5dx.

Sewell, William 1980, *Work and Revolution in France: The Language of Labor from the Old Regime to 1848*, Cambridge: Cambridge University Press.

Sewell, William 2014, 'Connecting Capitalism to the French Revolution: The Parisian Promenade and the Origins of Civic Equality in Eighteenth-Century France', *Critical Historical Studies*, 1, no. 1: 5–46.

Shiner, Larry 2001, *The Invention of Art: A Cultural History*, Chicago: University of Chicago Press.

Sholette, Gregory 2010, *Dark Matter: Art and Politics in the Age of Enterprise Culture*, London: Pluto Press.

Sidbury, James 1995, 'Slave Artisans in Richmond, Virginia, 1780–1810', in *American Artisans: Crafting Identity, 1750–1850*, edited by Howard B. Rock, Paul A. Gilje and Robert Asher, Baltimore: Johns Hopkins University Press.

Siep, Ludwig 2014, *Hegel's Phenomenology of Spirit*, translated by Daniel Smyth, Cambridge: Cambridge University Press.

Sieyès, Abbé 1971 [1789], 'What is the Third Estate?', in *Revolutions 1775–1830*, edited by Merryn Williams, Middlesex: Penguin.

Smith, Adam 1976 [1776], *An Inquiry into the Nature and Causes of the Wealth of Nations*, 2 volumes, edited by R.H. Campbell and A.S. Skinner, Oxford: Clarendon.

Smithson, Robert 1996, *The Collected Writings*, edited by Jack Flam, Berkeley: University of California Press.

Snell, Reginald 1954, 'Introduction', in *On the Aesthetic Education of Man*, by Friedrich Schiller, translated by Reginald Snell, New York: Dover Publications.

Soboul, Albert 1977, *A Short History of the French Revolution 1789–1799*, translated by Geoffrey Symcox, Berkeley: University of California Press.

Soboul, Albert 1980, *The Sans-Culottes: The Popular Movement and Revolutionary Government 1793–1794*, translated by Remy Inglis Hall, Princeton: Princeton University Press.

Sohn-Rethel, Alfred 1978, *Intellectual and Manual Labor*, Atlantic Highlands, NJ: Humanities Press.

Solomon, Maynard 1979 [1973], *Marxism and Art: Essays Classic and Contemporary*, Detroit: Wayne State University Press.

Sonenscher, Michael 1998, 'Enlightenment and Revolution', *The Journal of Modern History*, 70, no. 2: 371–83.

Sonenscher, Michael 2008, *Sans-Culottes: An Eighteenth-Century Emblem in the French Revolution*, Princeton: Princeton University Press.

Spang, Rebecca 2000, *The Invention of the Restaurant: Paris and Modern Gastronomic Culture*, Cambridge, MA: Harvard University Press.

Srnicek, Nick and Alex Williams 2015, *Inventing the Future: Postcapitalism and a World Without Work*, London: Verso.

Staley, Edgcumbe 1905, *The Guilds of Florence*, London: Methuen.

Stark, Suzanne 1998, *Female Tars: Women Aboard Ship in the Age of Sail*, London: Pimlico.

Stedman-Jones, Ralph 1971, 'The Marxism of the Early Lukács: An Evaluation', *New Left Review*, 170: 27–64.

Stracey, Frances 2005, 'Pinot-Gallizio's "Industrial Painting": Towards a Surplus of Life', *Oxford Art Journal*, 28, no. 3: 393–405.

Stracey, Frances 2014, *Constructed Situations*, London: Pluto Press.

Streeck, Wolfgang 2016, *How Will Capitalism End: Essays on a Failing System*, London: Verso.

Sykes, Gerald (ed.) 1964, *Alienation: The Cultural Climate of Our Time*, New York: G. Braziller.

Tatarkiewicz, Władysław 1963, 'Classification of the Arts in Antiquity', *Journal of the History of Ideas*, 24, no. 2: 231–40.

Tatarkiewicz, Władysław 1980 [1975], *A History of Six Ideas: An Essay in Aesthetics*, translated by Christopher Karparek, Warsaw: Polish Scientific Publishers.

Taylor, Keith 1982, *The Political Ideas of the Utopian Socialists*, London: Frank Cass.

Taylor, Charles 1989, *Sources of the Self: The Making of Modern Identity*, Cambridge: Cambridge University Press.

Therborn, Göran 1973, 'The Working Class and the Birth of Marxism', *New Left Review*, 79: 3–15.

Thompson, Dorothy 1984, *The Chartists: Popular Politics in the Industrial Revolution*, Aldershot: Wildwood House Press.

Thompson, E.P. 1961, 'The Long Revolution', *New Left Review*, 1, no. 9: 24–33.

Thompson, E.P. 1991 [1963], *The Making of the English Working Class*, London: Penguin.

Thompson, E.P. 2011 [1976], *William Morris: Romantic to Revolutionary*, Oakland: PM Press.

Tilgher, Adriano 1931, *Work: What it has meant to Men through the Ages*, translated by Dorothy Canfield Fisher, London: George Harrap.

Tomba, Massimiliano 2014 [2008], 'Pre-Capitalist Forms of Production and Primitive Accumulation: Marx's Historiography from the *Grundrisse* to *Capital*', in *In Marx's Laboratory: Critical Interpretations of the Grundrisse*, edited by Riccardo Bellofiore, Guido Starosta and Peter D. Thomas, Chicago: Haymarket.

Toscano, Alberto 2008, 'The Open Secret of Real Abstraction', *Rethinking Marxism*, 20, no. 2: 273–87.

Toscano, Alberto 2011, 'Now or Never', in *Communization and its Discontents: Contestation, Critique and Contemporary Struggles*, edited by Benjamin Noys, New York: Autonomedia.

Trevor-Roper, Hugh 1967, *The Crisis of the Seventeenth Century: Religion, the Reformation and Social Change*, New York: Harper and Row.

Tronti, Mario 1965, 'The Strategy of Refusal', in *Italy: Autonomia: Post-Political Politics*, edited by Sylvère Lotringer, Los Angeles: semiotext(e), pp. 28–33.

Tucker, Robert 1971, *Philosophy and Myth in Karl Marx*, Cambridge: Cambridge University Press.

Tzara, Tristan 1977, *Seven Dada Manifestos and Lampisteries*, translated by Barbara Wright, London: Calder.

Uglow, Jenny 1997, *Hogarth: A Life and a World*, London: Faber and Faber.

Virno, Paolo 1996, 'Virtuosity and Revolution: The Political Theory of Exodus', translated by Ed Emory, in *Radical Thought in Italy: A Potential Politics*, edited by Paolo Virno and Michael Hardt, Minneapolis: University of Minnesota Press, pp. 189–209.

Vishmidt, Marina 2005, 'Precarious Straits', in *Precarious Reader*, edited by Benedict Seymour, London: Mute Publishing.

Wackernagel, Martin 1981 [1938], *The World of the Florentine Renaissance Artist: Projects and Patrons, Workshop and Art Market*, translated by Alison Luchs, Princeton, NJ: Princeton University Press.

Walsh, Linda 2017, *A Guide to Eighteenth-Century Art*, Chichester: Wiley Blackwell.

Wang, Orrin N.C. 2000, 'Kant's Strange Light: Romanticism, Periodicity, and the Cata-chresis of Genius', *Diacritics*, 30, no. 4: 15–37.

Warwick Research Collective 2015, *Combined and Uneven Development: Towards a New Theory of World-Literature*, Liverpool: Liverpool University Press.

Waterfield, Giles 2009, *The Artist's Studio*, Norwich: Hogarth Arts.

Weber, Max 2003 [1904–05], *The Protestant Ethic and the Spirit of Capitalism*, translated by Talcott Parsons, New York: Dover Publications.

Weeks, Kathi 2011, *The Problem with Work: Feminism, Marxism, Antiwork Politics, and Postwork Imaginaries*, Durham, NC: Duke University Press.

White, Harrison C. and Cynthia A. White 1993 [1965], *Canvases and Careers: Institutional Change in the French Painting World*, New York: John Wiley & Sons.

Wikström, Josefine 2012, 'Practice Comes Before Labour: An Attempt to Read Performance Through Marx's Notion of Practice', *Performance Research*, 17, no. 6: 22–7.

Wilde, Oscar 1990 [1895], *The Soul of Man Under Socialism*, Oxford: Oxford University Press.

Williams, Raymond 1976, *Keywords*, London: Fontana Press.

Williams, Raymond 2013 [1958], *Culture and Society 1780–1950*, Nottingham: Spokesman.

Winstanley, Gerrard 1973, *The Law of Freedom and Other Writings*, edited by Christopher Hill, Cambridge: Cambridge University Press.

Wittkower, Rudolf 1961, 'Individualism in Art and Artists: A Renaissance Problem', *Journal of the History of Ideas*, 22, no. 3: 291–302.

Wolff, Janet 1981, *The Social Production of Art*, London: Macmillan.

Wollen, Peter 2000, 'Government by Appearances', *New Left Review*, 3: 91–106.

Wood, Christopher 2005, 'The Imagined Studios of Rembrandt and Vermeer', in *Inventions of the Studio, Renaissance to Romanticism*, edited by Michael Cole and Mary Pardo, Chapel Hill, NC: University of North Carolina Press, pp. 36–72.

Woodmansee, Martha 1984, 'The Genius and the Copyright: Economic and Legal Conditions of the Emergence of the "Author"', *Eighteenth-Century Studies*, 17, no. 4: 425–48.

Woodmansee, Martha 1994, *The Author, Art, and the Market: Rereading the History of Aesthetics*, New York: Columbia University Press

Wrigley, Richard 1998a, 'The Class of '89?: Cultural Aspects of Bourgeois Identity in France in the Aftermath of the French Revolution', in *Art in Bourgeois Society, 1790–1850*, edited by Andrew Hemingway and William Vaughan, Cambridge: Cambridge University Press.

Wrigley, Richard 1998b, 'Between the Street and the Salon: Parisian Shop Signs and the Spaces of Professionalism in the Eighteenth and Early Nineteenth Centuries', *Oxford Art Journal*, 21, no. 1: 43–67.

Wu, Duncan 2015, *30 Great Myths About the Romantics*, Oxford: Wiley.

Young, Edward 1971 [1759], 'Conjectures on Original Composition', in *Critical Theory Since Plato*, edited by Hazard Adams, Irvine: University of California Press.

Young, James O. 2014, 'On the Enshrinement of Musical Genius', *International Review of the Aesthetics and Sociology of Music*, 45, no. 1: 47–62.

Young, James O. 2015, 'Translator's Introduction', in *The Fine Arts Reduced to a Single Principle*, by Charles Batteux, translated by James O. Young, Oxford: Oxford University Press.

Index